GERMAN EXPRESSIONIST PROSE

An extreme sensitivity to gathering social crisis, an accompanying angry enthusiasm for artistic experimentation and renewal – this compelling mix in German art, poetry, and drama of the period 1910 to 1925 continues to draw both scholarly attention and intense popular interest. In this book Augustinus Dierick focuses on another significant but hitherto neglected medium of German Expressionist thought – short narrative prose – in order to illuminate and evaluate the contribution of that genre to one of the twentieth century's most powerful artistic movements.

Dierick's study includes a thorough analysis of the works of a broad range of Expressionist prose writers, from those of such specialists in the genre as Edschmid, Heym, Benn, Loerke, Frank, Sternheim, Ehrenstein, and 'Mynona' to the shorter prose works of such major figures as Alfred Döblin, Heinrich Mann, Max Brod, and Franz Werfel. Dierick isolates the thematic obsessions common among Expressionist writers: the pathos of the self in confrontation with nature and with God, the tension between self and the institutions of bourgeois society, and the attractions and dangers of eroticism. Throughout Dierick stresses the interrelationship between themes and their formal expression. He examines many apparent excesses in style and tone, many aberrations in structure and generic characteristics, and identifies them not as needless experimentation but as a necessary result of the attempt to find appropriate forms for extreme situations and complex ideas.

Dierick's analysis makes clear that Expressionist prose has an intrinsic artistic value and, because of certain nuances and different accents, must be included in any estimation of the nature and importance of Expressionism as a whole.

AUGUSTINUS P. DIERICK is Associate Professor of German at Victoria University in the University of Toronto.

AUGUSTINUS P. DIERICK

GERMAN Expressionist PROSE

THEORY AND PRACTICE

UNIVERSITY OF TORONTO PRESS
Toronto Buffalo London

© University of Toronto Press 1987
Toronto Buffalo London
Printed in Canada

ISBN 0-8020-2612-5

Design: William Rueter RCA

Canadian Cataloguing in Publication Data

Dierick, Augustinus Petrus, 1940–
German expressionist prose

Bibliography: p.
Includes index.
ISBN 0-8020-2612-5

1. Expressionism. 2. German prose literature –
20th century – History and criticism. I. Title.

PT772.D53 1987 830'.9'0091 C87-094586-6

This book has been published with the help of grants from the
Canadian Federation for the Humanities, using funds provided by the
Social Sciences and Humanities Research Council of Canada, and from Victoria
University in the University of Toronto.

CONTENTS

ACKNOWLEDGMENTS

THE SUBJECT OF THIS BOOK is of such magnitude that only an author working under the initial supervision of an extremely experienced and well-organized scholar and teacher may hope to bring his efforts to fruition. Such a scholar is Professor G.W. Field, and to him I owe an immense debt. He supervised the doctoral thesis which first acquainted me with Expressionist prose, and he again read the manuscript of the present book with his usual painstaking care. I hope he is happy with the final result.

I am grateful to Ron Schoeffel at University of Toronto Press, who immediately expressed an interest in a topic which in North America needs to be presented with more than the usual amount of persuasion; and I am especially delighted to be able to thank Will Rueter for having suggested that we (Ron, he, and myself) discuss the feasibility of the project.

To my editor, Susan Kent, many thanks for her comments and her patience in dealing with a bulky and complex manuscript. Her professionalism inspires humility; her friendliness makes working with her a pleasure.

I owe thanks to the personnel of the Robarts Library in the University of Toronto, who assisted me during the research for the initial doctoral thesis, and to the staff of the Deutsches Literaturarchiv in Marbach/ Neckar, for their help during my research activities there in 1984–85.

Victoria University has graciously extended financial support for this publication, for which I would like to express my warmest thanks.

For financial support from the Social Sciences and Humanities Research Council of Canada I am equally indebted.

Finally, my deepest gratitude is reserved for my wife, Anna, whose confidence in my work and whose unflagging support have seen me through this and other projects with a minimum of discomfort.

PREFACE

IN THE SOMEWHAT POLEMICAL PREFACE to his *Prosa des Expressionismus* Armin Arnold writes: 'Jedes Jahr werden auf dem Gebiet der Germanistik mehrere hundert Bücher veröffentlicht. Dass unter solchen Umständen auch nur ein einziges Feld der deutschen Literatur von der Forschung ignoriert werden könnte, ist unglaublich. Aber es ist so ... Zu den fast völlig unbekannten Gebieten gehört die Prosa des Expressionismus' (S10/6).

Since Arnold wrote this, there have been sufficient changes to warrant the appearance, in the 'Sammlung Metzler,' of a *Forschungsbericht* by Wilhelm Krull devoted exclusively to Expressionist prose (S124). Nevertheless, even there Krull had to admit 'Obgleich durch die Veröffentlichungen der letzten Jahre die Prosa etwas von dem Ruf verloren haben dürfte, ein "Stiefkind der Expressionismusforschung" ... zu sein, ist es noch immer schwierig, bibliographische Angaben über die Arbeiten zu einzelnen, insbesondere den weniger bekannten Autoren zu finden' (S124/5).

The following study is intended to deal with Expressionist prose in all its aspects. In particular, an attempt will be made to situate prose within the general context of the movement. The earliest major writings on Expressionism, by Albert Soergel for all genres and by W.G. Klee for prose (S219; S110), had at least the virtue of seeing in the latter a legitimate form of expression for the movement's goals. Later critics, to be discussed in the course of this study, were less generous, and have denied prose the eminent status which contemporaries were certainly eager to accord it. Sometimes the criteria used by later critics in the evaluation of prose were inappropriate, since they referred to characteristics applicable only to other genres. At other times, prose became the victim of attempts to

define all of Expressionism in terms of either style or *Weltanschauung*. Expressionism is incapable of definition in either term exclusively. In particular, however, it has become clear in the last ten years or so that any stylistic definition of Expressionist prose, without regard for content or context, must fail. Commenting on Walter Sokel's attempts to describe all of Expressionist prose as operating between the two poles of an 'expressionist-subjective' and a 'naturalist-objective' style, Wilhelm Krull writes:

Obwohl es sich hier um eine wichtige Beobachtung handelt und es zunächst verlockend erscheinen mag, die expressionistische Prosa nach Erzählstrukturen und -perspektiven zu typologisieren, sind die Schwächen dieser Konstruktion kaum zu übersehen: Sie verengt nicht nur die Vielfalt der Ansätze in der expressionistischen Prosa auf zwei formal ausgerichtete Konzepte ... sondern verstellt sich auch die Möglichkeit, die literarische Praxis expressionistischer Schriftsteller als Resultat der Bearbeitung verschiedener Stoffe unter den Bedingungen einer besonderen historischen Denkform zu begreifen. (S124/3)

To do justice to Expressionist prose and to Expressionism in general it is imperative that we take the 'special historical forms of thought' to which Krull refers into account. Hence the justification for the first three chapters of the present study, in which the theory of Expressionism (which for this movement implied much more than aesthetic or formal theory only) is worked out in some detail. In the chapters which then follow I will return to what seems to me to have been an approach too readily discarded by subsequent scholarship, namely Soergel's and Klee's emphasis on a thematic treatment of Expressionist prose. This leads to a much broader range of authors and titles than can otherwise be allowed. It also makes possible the inclusion of what from a strictly aesthetic point of view might be minor works, but which often give a much better insight into the aims and aspirations of the movement than the so-called masterpieces.[1] Mere familiarity was in any case never a criterion, though accessibility was: hence the preference for those texts which are now (still) available in anthologies (mainly of the sixties) or in reprints.

Since unfamiliarity *is* a problem, however, it was necessary in a good number of cases to do rather more of a plot summary than is considered in good taste in scholarly work. Expressionist prose may not be completely unmapped territory in Germany itself; in North America it certainly is.

A fundamental question must be disposed of here. Although I propose to study a wide range of prose texts, the novel is conspicuous by its

absence. There are two reasons for this. The debate about even the existence of an 'expressionist' novel rages on unabated. True, Expressionists themselves pointed to some novels which they felt fulfilled the criteria of Expressionism; or at least they perceived such a form to be on the verge of coming into existence. But we may well question the validity of such claims. The question is in any case too large to be settled within the pages of this particular study: it merits a treatment of its own. The second reason the novel is absent is that, even though aesthetic and formal criteria are not primary ones in my approach, I feel that the novel does pose different formal problems, which would destroy whatever unity this study might have. That such a unity can be established, despite the seemingly overwhelming richness of materials and forms of expressions, I hope to demonstrate in what follows, though no single formula, no matter how felicitous, could do justice to the range and interest of Expressionist prose. It is only by studying what is there, over and over again, that this mass of writing, probably unprecedented since the explosion of publications at the end of the eighteenth century, yields to understanding, and even attachment.

A word about the bibliographies and about the quotes within the texts. This book contains a list of primary sources that includes a catalogue of all the stories discussed in the text, with their dates of first publication; then a list of important contemporary theoretical writings. The bibliographies which follow indicate other primary sources in *book form* and then secondary sources, in the usual manner. These lists are numbered consecutively. References in the text are indicated as follows: a number in brackets preceded by P indicates references to the title of a *primary source*; the number in brackets preceded by S refers to the title of a *secondary* source. In both cases the number after the slash refers to the page number. In those cases where P is followed by = P or = S, the latter entry is the edition used. Entries appearing in brackets without S or P refer to page numbers of the last previously mentioned title.

PART ONE: FUNDAMENTAL PROBLEMS

ONE

Introduction:
Aims and Methods

THE LITERARY HISTORIAN, even the best-intentioned one, is apt to fall into a number of interrelated traps. The solipsistic interpretation causes him to draw conclusions about the work of art from the theory accompanying it, and at the same time tempts him to formulate similar theories about the work of art he is interpreting. In doing so, he innocently passes from work to context and back, without distinguishing clearly between the two. He also generally believes in causal connections. In describing literature as history, as temporal sequence, the historian believes he can prove from the simple 'one after the other' a causal connection between phenomena and events. But the causal interpretation is usually also a teleological one, for the historian believes that the 'end-product' is contained germinally in the 'beginning.' The historian works steadily in the direction of an 'advanced' level, for which early phases (in the temporal sense only) are seen as preparations (in a qualitative sense). By necessity, the beginning and end are thus relativized and phenomena interpreted in the light of linear development, not for their intrinsic value. The historian makes the further mistake of believing that his selection of material is unprejudiced, that his objectivity is unquestionable, and that the laws and dynamics which his selection of material reveal are inherent in the events and phenomena themselves, and not part of his own interpretation. All these assumptions and methods of procedure enter into a closed system, constantly reinforcing each other, until the ultimate object of literary theory is reached: the frozen state, the definition, the point-form characterization, the catchword.

Are these pitfalls avoidable? Should they be avoided? What could be put in place that would do greater justice to the literary phenomenon (author,

work, genre, period, style), and what would the end result be, if not definition, catalogue, catchword?

Here the roads divide. The interpreter of literature may divert his attention from the phenomena of literature themselves to the method by which he can apprehend them, in which case he will most likely never read another work of fiction from beginning to end and in the most favourable case will end up with results like those of which Richard Brinkmann once wrote: 'Der theoretische Berg, der verheissungsvoll schwanger ging, gebärt verhältnismässig magere ... Interpretationsmäuse, die man im übrigen zum Teil schon früher sonstwo springen gesehen hat, jedenfalls in ähnlicher Gestalt' (S27/123). Or he will rush in headlong, ignoring the more hesitant angels who fear to tread on such problematic grounds. In the latter case the innocent writer will be told by his critics that he is not allowed to make such generalizations, that he is twisting and bending his material to come to his questionable conclusions. His efforts will be condemned as 'unscientific,' 'subjective,' 'arbitrary,' and 'impressionistic' (not only a curse word for Expressionists!). He will also most likely find his executioner somewhere, for of such stuff, unfortunately, reviews are made. If he is a stoic, the writer will carry on regardless, putting aside what Arnold Toynbee has called the 'will-o-the-wisp of perfection' in order to follow Toynbee's advice to write, write, write.

The study of the theory and practice of short Expressionist prose which is developed in the following pages is the result of the second type of thinking, for by definition the first type cannot produce a book bearing a title like the present one, but at most 'Prolegomena for all future writings about prose of Expressionism.'

Yet the madness is, I believe, not without its system. For one thing, the stubborn efforts of a number of similarly innocent scholars and writers have produced, over a period of more than fifty years, a sizeable body of factual information, interpretative proposals, frameworks, and even (in the more flexible sense) certain methodologies which come to terms with a discernible phenomenon called Expressionist prose. Critical tools, even when they are blunt, may in the end result in the sculpting and shaping of at least a semblance of consensus, and although, in the discussion of Expressionism, prose is still, in the words of Brinkmann again, 'das dünnste Kapitel,' one may note with satisfaction also, 'Ganz so schütter wie zur Zeit des früheren Berichts [1960/61] ist die Forschung zur expressionistischen Prosa nicht mehr' (S27/265).

What follows is in many respects not new; nor ought it to be, for we cannot advance our understanding by reinventing the wheel. Much of

what is said about the sociological background of the Expressionist movement, about its ties with contemporary philosophy, science, and the arts, is public domain (as it usually is in expositions of Expressionist literature). These matters have by now been sufficiently established and substantiated; they need not be presented in an elaborate, detailed fashion. North American readers long ago advanced beyond the stage encountered once by the Dutch historian Johan Huizinga, who was told while visiting an American university that European historians were arrogant in their use of footnotes, because they assumed that Americans had access to the books to which they referred.

Certain principles must nevertheless be stated in advance, for they are crucial to my own particular approach. The first principle is the most obvious, but also the most frequently overlooked. The discussion of the character of any literary movement can only be undertaken with the tacit assumption that such a movement does indeed exist. To assume that there was an Expressionist movement, of which prose was a part, is an act of faith for which the visible signs of confirmation have in some cases obviously been insufficient. The question whether there was such a thing as Expressionism was answered by some in the negative long before actual interest and scholarship began. Our faith in Expressionism is tested in the process of reading, just as our faith in God is tested in living.

A second principle, equally important, underlies the manner of presentation of the following study. If we believe that Expressionism exists and that it is a movement (not necessarily a school), then our manner of presentation must of course be that of analysis, with a view towards synthesis. Synthesis is the task of all self-respecting scholarship, but where the existence of a movement is already assumed, such synthesis is in the order of an a priori. In other words, it is not the task of this presentation to describe individual authors exclusively on their own merit (though of course their merit is neither denied nor neglected, and detailed analysis is undertaken wherever appropriate). Rather, individual authors and their works are made a priori to appear within a larger framework: that of Expressionism itself.

If one assumes the existence of Expressionism in advance, several problems suggest themselves immediately, all of which make it understandable why so many critics abandon the whole idea of Expressionist prose or of Expressionism. Who belongs to Expressionism? By what criteria? How are these criteria formulated, and by whom? By contemporary scholarship, or subsequent theory? What use are we to make of statements of principle, acts of faith, confessions of affinity by the authors themselves?

These questions have been asked, have been answered, re-asked and re-answered, as they have about other literary movements such as the Baroque or Romanticism, and with similar results. Here as in those movements, it is a more or less general consensus which must be seen as the highest level of 'science' which can be achieved. To me this appears sufficient. Expressionist authors themselves have given many helpful hints in this direction, by including or excluding contributors to their anthologies, journals, periodicals, pamphlets, readings, and meetings, though of course the wisdom of hindsight has corrected many errors of judgment, and our own catalogues are undoubtedly more refined and sophisticated. Nevertheless, the presence of certain authors in this study may raise the eyebrows of some critics, whereas the absence of other authors may appear questionable to others. Particularly Rilke, Kafka, and Musil have been discussed frequently in secondary literature as having intimate connections to Expressionism. Claude David, Wilhelm Bausinger, and Paul Raabe have treated the problem without solving it.[1] Brinkmann writes about such speculations: 'Der Expressionismus-Begriff bricht nicht, wie manche fürchten oder hoffen, zusammen, wenn nicht alle "wichtigen" Schriftsteller der Epoche so oder so "einzuordnen" sind' – a wise but also deliciously malicious comment. If Kafka, Musil, and Rilke are absent from this discussion, it is not a reflection on their belonging or not, but rather because the selection of authors is based on the belief that it is often in the lesser writers that a movement expresses itself best.

The treatment of individual authors and their works primarily from the point of view of their place within a larger context creates problems of which the perspicacious critic is usually aware. When Bruno Markwardt introduced his discussion of Expressionism in the context of his *Geschichte der deutschen Poetik*, he wrote: '[es] sei ... versucht, das Kunstwollen einer ganzen Kunstrichtung von ihrem Kunstschaffen abzuleiten. Der Nachteil eines derartigen Verfahrens liegt in der Arbeitshypothese, dass überhaupt so etwas wie ein kollektives Kunstwollen für eine Reihe von Einzelkünstlern angenommen werden darf. Der Vorteil liegt darin, dass etwas tiefer in das Gesamt einer Kunstbestrebung eingedrungen werden kann, deren Einzelvertreter dem Gegenwartsbewusstsein nicht mehr so ohne weiteres als nachlebbar oder "nachvollziehbar" aufgedrungen werden können' (S144, vol. 5/608–9). Christoph Eykman, in his book on Expressionism, points to a similar problem connected with the presentation of literary works within a pre-established larger context: 'Die Gefahr des willkürlichen und oberflächlichen Zusammenstückens aus dem Kontext gerissener Elemente ist ... kaum zu überschätzen.

Andererseits muss mit Nachdruck daran festgehalten werden, dass ein künstlerisches Werk in einem weiten Kraftfeld situiert ist, in welchem überindividuelle Impulse verschiedenster Art wirksam sind. Was der Einzelanalyse an Tiefe verlorengehen mag, wird, so hofft der Verfasser, durch die Weite des Umblicks wettgemacht' (S56/7). With this hope expressed by Eykman I can only identify. At the same time it is to be emphasized that in precisely those instances in which a more detailed analysis of individual works seemed appropriate to me, the larger context of Expressionism itself appeared also all the more clearly. Individual analysis and interpretation do not stand in contrast to the synthetic, synoptic view of literature but complement it.

A final principle must be stated. Though literature appears in the following pages under no circumstances as *causally* connected with events taking place in the empirical world of 1910–25, the relationship between the work of art and the historical, socio-economic and political context in which it springs up is everywhere tacitly assumed, and at times specifically stated. It has been the great achievement of R. Hinton Thomas to establish this relationship as crucial for our understanding of Expressionism, and most recent scholarship (for example, Knapp) maintains this view (S112). What must be made clear about the relationship between art and life is, however, that it is at all times a mediated one. What the world is, must be forever a subject of speculation; our interest goes to the world as it is apprehended by the authors and, by extension, by the larger wholes of group, movement, and generation. Precisely the examination of these mediating modes of perception gives us the clearest insight into what we may call Expressionism.

Expressionism is a profoundly dualistic movement. This dualism is the result of certain categories of perception by which this generation of authors 'filtered' reality. That these categories are themselves related to external reality as it presented itself around 1910, of this there can be no doubt. But simply to interpret superstructures as translations into 'myths' of socio-economic conditions is to fall victim to a vulgar form of reflection theory. Instead, there is a constant reinforcement by external phenomena of inherent modes of thought (Eykman), and an externalization (to a large extent also via literature and philosophy) of inner convictions, aspirations, and fears. The Great War, for example, is as much the externalization of inner psychic conflicts, the diseases of the modern mind and temper, as it is the obvious confirmation of the gradual process of decay and breakdown of social and political relationships. This conviction has led me to a much greater emphasis on spiritual, intellectual, and ideologi-

cal factors in the presentation of the material than of stylistic, structural, or linguistic factors, and of course to a relative neglect of the purely social and political factors, though they are discussed at some length in chapter 3. Though style cannot be denied as having its inherent laws and its intrinsic development (of which, unfortunately enough, Bruno Markwardt especially gives us little evidence in a book which ought to have dealt with this *in extenso*), style is more often a tool allowing the exposition of *Weltanschauung*, particularly in Expressionism, one of whose stated aims is to give expression to an inner 'essential view.' Style will therefore appear in my discussion primarily as mediating between mode of thought and reader.

To delineate more clearly some of the more practical problems attached to the presentation of Expressionist prose, it might be useful to refer to an early article by Paul Raabe (1961), 'Das literarische Leben im Expressionismus,' in which he attempts to give an outline of the development of Expressionism from 1910 to 1920 (S187/1–22). I take Raabe's article not because it has greater merit than most, but because it provides one possible way of dealing with what appears to be a particularly unwieldy subject. The article gives, for once, a relatively straightforward picture of the actual, concrete development of the movement and a framework which lends itself particularly well for subsequent comments and elaborations. Historic sketches had been attempted in a number of places before Raabe and have been repeated since. What was special about Raabe's article, and inspired by his great talent as a collector and organizer of materials, dates, and facts, was his attempt to understand Expressionism specifically in terms of the sociology of the group. This approach has not generally been pursued further, though it forms of course the basis of much of what other critics have to say about Expressionism as a movement. Without some form of cohesion, some tendency on the part of individuals to identify with a larger whole, we would hardly be able to speak of Expressionism as a movement at all. Similar sociological premises underly Romanticism, and it too may be fruitfully analysed that way. Of course Raabe's approach is extremely one-sided, for it gives little insight into the reasons why these people came together, what principles they in fact shared, and what precisely caused both the initial adhesion and the consequent breaking apart. Above all, Raabe's article tells us nothing about the actual content of the movement or its most fundamental views of reality; nor does it give us much information about the nevertheless profound ideological and spiritual differences which existed from the start. All of this is

consciously avoided by Raabe, because his contention is that along those lines no useful information can be conveyed, and no unity can be established. Instead, Raabe allows us to follow the advance, triumph, and decline of Expressionism as a publishing phenomenon, as a collective event, albeit without giving us any indication as to what the event was all about. Yet this type of presentation has its merit, because it clears away a number of obscuring details and opens up a vista of unproblematic progression with a discernible beginning, middle, and end. All the same, even while consciously avoiding ambiguities and without ever touching upon the basic assumptions of the movement, Raabe gives us valuable insights into the problems of scholarship concerning Expressionism and indicates some of the important characteristics which distinguish Expressionism itself.

Raabe begins by saying that contemporaries had recognized 'dass das Jahr 1910 ein Einschnitt in der Entwicklung der deutschen Literatur war' (S187/1). To be sure, he is cautious enough to continue his statement with a modifier: 'Wir sind heute skeptisch geworden gegenüber solchen Periodisierungen, denn die Geschichte des Geistes scheint sich der historisierenden Tendenz zu entziehen.' But he goes on to reaffirm his original contention: 'Und doch ist dieses Datum zu verteidigen und zu rechtfertigen. Eine neue Dichtergruppe, von Kurt Hiller organisiert, trat in diesem Jahr an die Öffentlichkeit, und von hier datiert ein literarisches Leben, das man Expressionismus nennen kann. In der Gruppenbildung, in dem gemeinsamen Auftreten junger Autoren liegt ja vor allem die Einheit dieser Bewegung, viel weniger in Stil und Sprache ihrer Werke.'

Several problems of current Expressionist scholarship are revealed in Raabe's statement. There is first of all the note of caution which runs through almost all critical writings on this period and which is the result of the fact that hardly any other literary-historical term has met with so much controversy. The statement also reveals both the stubborn search for fixed borderlines in time and the realization that such periodization is something of an illusion. Yet, as Raabe's own work shows, the search goes on, with one date or another being advanced as beginning and end, birth and death of Expressionism. Furthermore, Raabe's comments reveal the concern to come to a definition of the movement, be it in term of sociology (group-building), aesthetics (style and language), or some other criterion not specifically mentioned by him (philosophy or politics, for example). Finally, Raabe indicates a concern shared by all critics that one must try to establish the fundamental unity of this movement in order to be able even to speak of it as a movement. We will do well to look in turn at

each of the problems touched upon by Raabe, since they have multiple implications, and though none of them has been settled definitely, the proposals and counter-proposals surrounding them allow a great deal of insight into the characteristics of Expressionism itself.

There is first of all the question of periodization, and with it of course that of origin. Not only the beginning and end of Expressionism are under dispute; there is not even a clear consensus as to the origin of the word 'Expressionismus' itself. Raabe, in an article entitled 'Der Expressionismus als historisches Phänomen,' states: 'Es ist bekannt, dass mit dem Wort "Expressionisten" – von zwei früheren zufälligen Anwendungen in Frankreich abgesehen – , zum ersten Mal im April 1911 eine Gruppe moderner französischer Maler bezeichnet wurde, die in der Berliner Sezession ausstellte: Pablo Picasso, Henri Manguin, Othon Friesz, Kees van Dongen u. a.' (S179/6). It was, according to Raabe, 'ein Wort, das sich zur rechten Zeit einstellte,' and which was quickly used to cover, or recover, 'Die Brücke' and 'Der blaue Reiter.' That the original French use was 'contaminated' by the German equivalents 'Ausdruck' and 'Ausdruckskunst,' with their multiple implications, and that the transfer from painting to literature was not as easily made as is often assumed – of all this we may take note in an elaborate article by Donald E. Gordon, 'On the Origin of the Word "Expressionism,"' which in turn is elaborately discussed in Geoffrey Perkins's book of 1974, *Contemporary Theory of Expressionism* (S171). What we need to retain from such detailed investigations is that, starting with painting in France, then in Germany, an artistic code was formulated with which literary figures could identify, which they saw as similar to their own efforts, and which they came to understand (apart from such other terms as 'Ausdruckskunst' or 'neues Pathos') as more or less adequately defined by the term 'Expressionist.'[2] Equally certain is the fact that Berlin, and particularly Kurt Hiller, played a crucial role in organizing these scattered efforts and impulses into some kind of consciously adhesive group, the 'Neue Club' (1910) and the subsequent 'Neopathetische Cabaret.' Hiller's organizational talent in bringing together writers like Georg Heym, Jakob van Hoddis, Ernst Blass, Else Lasker-Schüler, Robert Jensz, Erich Unger, Ferdinand Hardekopf, and Ludwig Rubiner is responsible for the fact that we can discern Expressionism as having a certain contour. We should not forget that it was Hiller who, in an essay in the *Heidelberger Zeitung* of July 1912, stated unequivocally: 'Wir sind Expressionisten' (P217 = S8/33).

Of course it does not do, ultimately, to consider the advent of the Neue Klub as the absolute start of the Expressionist movement, though it does

provide a crucial moment in the self-understanding of the authors mentioned as Expressionists. No literary movement springs to life full-blown, as even Raabe would admit. There are nuances, overlaps with previous epochs; there are contemporaries with whom these shared some traits. Above all, the problem with which much research has been concerned but which needs still further clarification is that of the actual resemblances and differences between Expressionism and the roughly contemporary movements of Impressionism, Neo-Romanticism, and the slightly older Jugendstil and Naturalism.[3] For one thing, at its origin Expressionism was understood to be a radical departure from the movement of Naturalism and to stand in opposition to other movements. But Horst Fritz, in his study *Literarischer Jugendstil und Expressionismus* of 1969 (S68), has shown, by using Richard Dehmel's poetry as an example, how the lines of demarcation between at least these two movements are fluid and that Dehmel, coming from Naturalism, went through a development which ultimately fitted him to as outspoken an Expressionist periodical as *Der Sturm*. What Fritz shows is what we suspect to be true for all of Expressionism: that a prototype Expressionism existed in older figures such as Dehmel, Rilke, Musil, Heinrich Mann, Hermann Hesse (at least in one work, 'Klingsors letzter Sommer'), and Jakob Wassermann. Where the contemporary might see only dichotomies, as between Impressionism and Expressionism, Naturalism and Impressionism/Expressionism, later critics might show multiple relationships and affinities. Hence, for example, Bruno Markwardt's choice of title for his particular investigation: 'Das Wegsuchen zwischen Impressionismus und Expressionismus' (S144, vol. 5/ chapter 3). What Markwardt claims to have found is not dispersement or rejection of Impressionist stylistic and structural features but an incorporation into the latter. Particularly one achievement of Impressionism, the stress of inner over outer world, which put Impressionism itself in a situation of opposition to Naturalism, is a crucial element in Expressionism also. It is Paul Raabe again who, in another article (S176), gives us an essential insight into the actual way the Expressionist movement was established: 'Dass die Autoren schnell berühmt wurden und Nachahmer fanden, war das Verdienst der älteren Literaten. Sie sahen ihre Zeit gekommen, als in Cafés und an Vortragsabenden die neuen Dichter die Proben ihres Talents vortrugen ... Manche unter ihnen erlebten ja damals selbst ihr Damaskus, die anderen aber machten sich zu Förderern des neuen Geistes in der Literatur' (S176/9).

Nevertheless, for a movement which denoted *Aufbruch* and a new beginning, its protagonists needed to stress first and foremost that it was

profoundly different from previous schools and other contemporary trends. In the theoretical writings which quickly began to accompany the purely literary activity of the Expressionists, there is time and again stated the awareness that after the impasse of the 1890s a new era had started. Neo-Romanticism and Impressionism were designated as the typically stagnant, imitative, death-and-decay–oriented literature to be overcome. Of course the young authors had read this literature, had even admired authors like Stefan George, Richard Dehmel, Huysmans, Maeterlinck, and D'Annunzio. Yet they themselves were 'Abenteurer des Geistes,' as Raabe calls them, 'tathafte junge Dichter, die das Leben mehr liebten als den Tod, das Heute und Morgen mehr als das Gestern, die den Willen gegen das Hinnehmen, die Intensität gegen die Passivität setzten' (S188/9). The program of these newcomers was proclaimed by Hiller in his essay, 'Die Jüngst-Berliner': 'Was wollen wir? – Zunächst mal: Wir wollen mit nichten Tyrannen stürzen. Kitschzelebritäten, darauf vertrauen wir, sinken von selber zusammen ... Wir bekämpfen Richtungen, Theorien – nicht Meister. Ob wir den revolutionären Gestus haben, entzieht sich meiner (wundervollen) Distanzlosigkeit – dass nie eine Gruppe der Jugend frömmer, begeisterter, autoritätengläubiger war als wir, steht fest' (P217 = S8/33). Hiller's enthusiasm and that of his fellow authors must have been contagious, for within a few years others, equally talented, equally enthusiastic about the prospect of a literary revolution, had come to consider themselves part of the great Expressionist movement. And talents there were in an unusual measure, and in many places. Along the lines of the Neue Klub they met in similar circumstances, in Leipzig and Heidelberg (the Freie Studentenschaft), in Munich (Der neue Verein), Vienna (Der akademische Verband für Literatur und Musik), in Prague, Dresden, and Mannheim. Everywhere talented writers banded together in clubs, some around journals, partly sponsored by energetic young editors, partly financed and distributed by the authors themselves. The list of authors who within the short period between 1910 and 1920 established themselves is almost endless. In addition to the ones already mentioned by Hiller we could cite Franz Werfel, Walter Hasenclever, Johannes R. Becher, Alfred Wolfenstein, Theodor Däubler, Albert and Carl Ehrenstein, Wieland Herzfelde, Georg Trakl, Hugo Ball, Gottfried Benn, Alfred Döblin, Max Herrmann-Neisse, and many others, several of whom we shall encounter also in our discussion of Expressionist prose.

Since most literary historians agree with Raabe that Expressionism as a movement may be said to have started in Berlin, and as a movement primarily of poets, it is relevant at this point to ask to what extent the

subject of our study, prose, participated in these origins and to what extent it shared in this development. Even if we accept Raabe's date of 1910 as crucial, where does prose fit into the pattern? Raabe himself gives only a tiny hint about the relative importance of the genres in the expansion of Expressionism, and not a word is devoted to the possible separate functions or differences in themes which appear in the different genres. He does state, correctly, that in the early phases it is especially lyric poetry which catches the audience's imagination, no doubt because of the richness and variety of talents available and the dynamism and energy of the authors involved. A great deal of the notoriety of the Expressionist movement in its initial phase comes no doubt from the uncompromising attitude of the young poets, whose products were often (at least we must assume from the reported reactions of contemporary audiences) calculated for shock effect. That there existed at the same time a much more personal, intimate, and profoundly tragic type of poetry, such as that of Georg Trakl, or that even those who so noisily presented themselves to the Berlin audiences could write intensely quiet, introspective poetry, as is the case with Georg Heym, or that some of these authors wrote prose of an extremely high quality, all this may have escaped a good number of people. What emerges from contemporary accounts is that poetry seemed best suited to convey the feeling of a situation of crisis in which hope mingled with despair. Since poetry preceded the other genres, it might be argued with caution that drama and prose naturally adopted the language, syntax, vocabulary, and rhythms of poetry. That Expressionist prose is often characterized by contemporary and later critics as 'lyrical' would certainly be justified where early Expressionism is concerned, and likely for the reasons advanced. Definite affinities can in any case be established between Heym's poetry and prose, and Heym's talent in poetry might be argued in some cases to have clouded the narrative quality of his prose, in other cases to have given him the perfect vehicle for extremely complex modes of presentation, as will be argued below. The case of Heym certainly tends to undermine the claim, advanced by Kasimir Edschmid, that prose in its Expressionist variety came about through the publication of his own collection of novellen, *Die sechs Mündungen*, in 1915. If we consider that Heym died in 1912, that his collection of novellen, *Der Dieb*, dates from 1911, and that it contains some of the most typically Expressionist themes and employs an undeniably Expressionist style and vocabulary, we are once more made aware of the dangers of periodization.

Much the same can be said about the other date advanced in Raabe's

article, the one denoting the end of Expressionism. Ernst Alker, not one of the more felicitous interpreters of Expressionism, seems to have considered the dates 1901 to 1923 to mark the outer limits of the movement, to which, by the way, he applied above all the criterion of an 'ästhetisches Anderssein' (S3/621). Alker accepts a very early date for the 'Wegbereiter' (whom he sees as forming part of a larger, mannerist, grotesque, and surrealist trend), but he is adamant about the final date: 'Auffällig, wie viele Expressionisten nach 1923 rasch den Expressionismus aufgeben,' he writes (631). His definition of Expressionism is in any case based on the output of those he considers the 'core' Expressionists, 'jene Persönlichkeiten, die dauernd Expressionisten geblieben, und ... jene, die sehr jung gestorben sind, meistens als Opfer des Ersten Weltkrieges,' or, in an even more restricted sense, 'nur die Frühverstorbenen' (660). All others became 'Übergänger von Ekstasen zu Ernüchterungen.' Equally rigorous is Raabe himself, who considers it completely wrong to count the 1920s as part of Expressionism, for 'die idealistische Aufbruchssituation des expressionistischen Jahrzehnts 1910–1920' has nothing to do with the 'nüchternen Arbeitswelt der Maschinen-Rhythmen des folgenden Jahrzehnts' (S188/20). Richard Brinkmann· argues correctly against such a view of the twenties, for this period is not, according to him, simply 'nachexpressionistisch' (S27/73). Moreover, the time-lag which we noted earlier between poetry and prose would logically suggest a similar time-lag at the end. More generally, contemporaries did not feel the rupture between the pre- and post-revolutionary period as dramatically, and certainly when the continuing boom in utopian and/or socialist writings after 1918 is taken into account, it appears wrong to adopt positions that are too rigid. The more flexible dates suggested by Armin Arnold, 1910 to 1925 (S10), though admittedly advanced for his own reasons, seem both appropriate and productive.

Raabe's relatively unencumbered sketch of Expressionism, with which I have been concerned here and which can be supplemented by his essay written in 1965, 'Der Expressionismus als historisches Phänomen' (S179), has given us an idea of the importance of periodization in literary scholarship. By emphasizing different characteristics, not only can we achieve a different periodization but the movement itself, or the prose within it, may come to represent quite different things. It remains the great merit of Raabe's efforts, however, to have stressed the importance of the group in Expressionism. Hiller's Neuer Klub indeed provided the prototype for many other such organizations, and their mere presence and the similar-

ity of their activities and productions indicates that Expressionists everywhere understood themselves to be part of a larger whole, no matter how vociferously they might argue along lines of different ideologies, politics, artistic methods, or linguistic principles. That such divisions came about cannot be used to deny the movement's original cohesion: it is a law of all groupings and associations. There can be no doubt that in the idea of group-building Raabe has discovered one of the main features of the Expressionist movement as a concrete historical phenomenon.

Although he did not refer to it as a distinguishing feature of the Expressionist character, Raabe nevertheless discovered another sociological factor which facilitated the spread of the movement, namely its systematic appropriation and modification of existing publications and the creation of a series of new ones to get its message across. It is a uniquely modern aspect of Expressionism and perhaps in the final analysis more characteristic than any perceived contrast in an aesthetic sense between itself and its predecessors. Particularly during the First World War and its aftermath the existence of a variety of publications sympathetic to Expressionism lent it prestige and made the movement widely known in literary circles and beyond. While at first the Expressionists were dependent on established journals (Hiller writes in 1911: ' wir sind meist noch jung – und die Berliner Journale, zumal die "literarischen," meist auf dem Hund' [S8/33]), they quickly realized the importance of having their own forum. Thus Herwarth Walden, who had already directed the journals *Morgen, Der neue Weg,* and *Das Theater,* finally founded, in March of 1910, *Der Sturm,* 'und schuf damit eines der bedeutenden und vorbildlichen Unternehmen des Expressionismus' (S188/6).' When the poet August Stramm joined *Der Sturm* in 1914 he revolutionized the journal, 'und begründete, ohne es selbst zu wissen, eine Dichterschule abstrakter, emotioneller, syntaxloser Lyrik, von Herwarth Walden als "expressionistische Wortkunst" bezeichnet' (6), which lasted into the 1920s. By contrast, Franz Pfemfert, the founder of the journal *Die Aktion* (February 1911), a strong competitor of *Der Sturm,* was, as Raabe calls him, 'ein politischer Kopf' (6), which was reflected in the journal itself. It became the forum for politically oriented writers, later a strong voice for pacifism against the general chorus of pro-war sentiments preceding 1914. A third journal, *Die weissen Blätter,* acquired a profile of its own, particularly under the editorship of René Schickele. From these models there sprang up, in the provinces, like the groups imitating the Berlin literary clubs, literary periodicals of an immense variety, some reproduced as mere broadsheets, some astonishingly beautiful in layout, graphics, and print.

A further proof both of the awareness of their collectivity and of their essentially similar characteristics, as well as of the editorial and communicative skills of a large number of Expressionists, are the many anthologies and book series which were beginning to appear in mostly newly founded publishing houses. First and foremost to be mentioned in this context is Ernst Rowohlt in Leipzig, who courageously promoted lyric poetry anthologies at a time when the Expressionist label was a distinct liability. He was followed in 1911 by Kurt Wolff, who ultimately published more Expressionist literature than any other publisher, notably the series *Der jüngste Tag*, in which the most prominent authors of the period were presented in artistically praiseworthy definitive editions.[4]

A third crucial element in Expressionism, and again one which brings into focus both the collective nature of the movement and its modernity, was its openness to the fine arts and to music (see S79; S86). We have already seen how Expressionism in its origins was closely tied to contemporary painting, that in painting it found a model to emulate. Because Expressionism was not a purely literary movement (at least not in the beginning), it was also able to define its own objectives by referring to the fine arts. This also explains a number of double talents (Kokoschka, Barlach, Kubin). Moreover, Expressionism as a literary phenomenon profited and borrowed from a number of works dealing primarily with Expressionism in the fine arts, notably Wilhelm Worringer's *Abstraktion und Einfühlung*, to which we shall have occasion to refer frequently (P293).

A fourth and final factor which goes into the character of Expressionism, and one in no small measure responsible for the spread of the movement and its ideas, is the fact that since its earliest beginnings the movement was interested in clarifying its positions in theoretical writings. Geoffrey Perkins writes: 'Scarcely any other movement in art and literature may be said to have been accompanied by so much contemporary theoretical writing. Expressionism must rank among the most self-conscious movements in history' (S171/11). The implications of this important fact are multiple and complex. All theory (apart from being grey) is problematic in relation to practice: contemporary theory is problematic to an even greater degree; hence the tendency (again Perkins) 'of both literary historians and art-historians to ignore contemporary utterances or dismiss them as dated or out of date – and even to separate an artist's theory from his work in the belief that the last person to have any real idea of the value and significance of his work is the artist or writer himself' (23).

No literary historian can completely ignore contemporary theoretical

utterances, for there is an insidious way in which they influence contemporary literary output. For Expressionism it is especially tempting to use contemporary theory to throw light on the intentions of the movement and then to compare the creative works with the aims advanced in the theory. That this is a highly problematic way of proceeding is clear, however, and Perkins specifically warns us against it. On the one hand he states that, contrary to popular belief, 'there was such a thing as a cohesive theory of Expressionism'; on the other hand he claims that it is doubtful 'whether this theory has anything to do with either art or literature between 1905 and 1920 in Germany' (18). It is undeniable, in any case, that theories about Expressionist literature were abundant and continued to be expounded well beyond the actual period of the movement's flourishing, the half-decade 'überschattet von den Vorahnungen kommenden Unheils,' between 1910 and 1914, 'die fruchtbarsten Jahre der expressionistischen Literatur' (S176/37). To be sure, we may note that from the moment when theoretical writings began to multiply, after the First World War, one of the most vexing aspects of Expressionism also came to the fore, namely the question of the sincerity and integrity of its individual professed adherents. It was one of the kingpins of Expressionist criticism, Kasimir Edschmid, who insisted on the fact that the young Expressionists whom he was introducing to a Scandinavian audience in 1910 enjoyed artistic experimentation rather than theoretical speculation. Even that which eventually found its way into the portly volumes by Paul Pörtner, Paul Raabe, Wolfgang Rothe, and most recently Thomas Anz and Michael Starke does not always deserve the name theory (P333; P329; P325; S8). Moreover, such collections lump together many sub-movements which one would hesitate to call Expressionist; at the same time those sub-movements which did develop a consistent theory of aesthetics (for example, the *Sturm* group) or ethics (Pfemfert and *Die Aktion*) could not be taken as typical or representative of the whole movement. Certainly Expressionism also had its share of theorizing after the fact, and one is struck by the differences in emphasis between the literature of early Expressionism and the theorizing about it, or the tracing of its sources, around 1920. It is equally difficult to reconcile the accounts of the general mood of the participants of the Neue Club with the literature being written,[5] and the works produced at the time cannot easily be squared with Hiller's and Kurt Pinthus's theoretical writings produced later. The matter gets even more complex when we attempt to read Expressionist writings in the light of the many memoirs published after the Second World War.

Nevertheless it can be stated that much of the critical and theoretical writings published in the periodicals and journals which flourished during the period 1910–25 has immediate bearing on the movement itself. These writings were undoubtedly read with great interest and found at least a minimum amount of approval or consent by the practitioners of literature. If in retrospect we may note a fair amount of contradiction, a greater amount of misunderstanding, and a very large measure of self-importance in these theoretical speculations, this does not mean that the basic aims of Expressionism cannot be delineated by means of a careful and objective choice of these documents. This is also the opinion of Silvio Vietta and Hans-Georg Kemper, who write: 'gegen die Anknüpfung am Selbstverständnis einer Epoche bei der wissenschaftlichen Begriffsbildung [ist] per se noch nicht viel einzuwenden' (S236/17).

But it is important to draw up one's strategy carefully. In the Expressionist self-awareness there is seldom a clear differentiation among individual, social, and aesthetic principles and goals. Indeed, it is one of the more frustrating aspects of this movement that it is not definable explicitly and exclusively in one or another of these terms. This is a weakness, for it entangles the Expressionist in a web of vaguely worded, often mutually exclusive goals nevertheless advanced with unending enthusiasm. Contradictory ideologies find shelter under one aesthetic roof, and mutually exclusive aesthetics go hand in hand for the sake of social programs and ideologies. Any attempt to separate 'existential' (intellectual) issues from aesthetic or social ones is to tear apart a somewhat baroque structure for the sake of analysis. In Expressionism all things are related, and the attempt to construct an aesthetics independent of or in ignorance of the Expressionist feeling about life, or apart from socio-economic impulses and utopian goals, would be ill advised. Even when arguing against other artistic movements, Expressionists understand themselves to be defining their art also as contrastive philosophy. Thus they see themselves, for example, to be in reaction 'not only against artistic ideals, but ... against the whole philosophy of life associated with Impressionism' (S171/93). Art and life are never separated in Expressionism. On the contrary, 'gegen die ästhetizistische Trennung von Kunst und Leben hatte der Expressionismus stets entschieden opponiert' (S8/xx–xxi). Even in one of the earliest documents about the Jüngst-Berliner, Hiller states: 'Weder auf Technik noch auf Stil kommt es an ... Es kommt uns wieder auf den Gehalt, das Wollen, das Ethos an' (P217/34). Expressionist art is not a mere preoccupation with the beautiful, for the movement does not shy away from the ugly in order to make its point. Nor does it see its goal as

that of imitating nature (it considers this neither possible nor desirable). Not even the expression of the most individual emotions suffices for it, since this would go against its aim of reaching a more universal level. Rather, Expressionism is based on the awareness of a crisis situation, which it first expresses and for which it then seeks to find a solution. To express this feeling of crisis the Expressionist is in search of an 'appropriate' form, which is neither god-given nor inherent in the subject itself. It must be discovered in the process of creating and will in the ideal case be the best tool for the twofold goal of expression and solution.

Raabe sought to define Expressionism in terms of a concrete literary movement whose unity could be grasped in the phenomenon of group-building. The preceding pages may already have suggested that the questions of definition and unity are infinitely more complex and need to be examined each in turn. This will be the task of the next two chapters.

TWO

From Crisis to Expression

HE CRISIS SITUATION implicit in Expressionism is threefold: existential, social, and aesthetic. In all three areas the period between 1900 and 1910 is crucial, because scattered sentiments and intimations crystallize into a distinct feeling of a historic turning-point and a specific feeling about life, which has been called the Expressionist 'Lebensgefühl.' Actually, the term 'Lebensgefühl' has its disadvantages. For one, it is rather vague, and used by critics mainly in an attempt to provide a certain unity to a period, style, and movement which is otherwise difficult to characterize. Detlev Schumann wrote about the Expressionist *Lebensgefühl*: 'I cannot agree with Stammler when, with regard to expressionism, he states ... "was alle Dichter zusammenhält, ist allein das gemeinsame 'Lebensgefühl.'"' This can be accepted only if the expressionist "Lebensgefühl" is reduced to the common denominator of emotional intensification as such, regardless of direction or content' (S215/526).

Such a rigorous reduction is by no means necessary, however. Like *Weltgefühl*, *Lebensgefühl* may very well be seen in those terms which Emil Ermatinger proposes as having to do with the 'notwendige Auseinandersetzung des Ich mit der Welt' (S55/212). Through this dialogue there results a particular atmosphere which, when it is shared by a sufficient number of authors, may become a collective feeling. Ermatinger makes the point (anticipating Schumann's objection) that this may be more of an intellectual or of an emotional atmosphere. No doubt we are in Expressionist literature dealing with a dialogue between man and world which shows 'eine starke Erschütterung des Gefühls' (218), hence also the attitude of pathos of many Expressionists. Yet the intellectual element is by no means lacking. This is in any case Wolfgang Rothe's contention when he writes that Expressionist criticism of social, cultural, and intellectual

aspects of the contemporary scene possesses a strong cognitive quality: 'Sie verneint keineswegs doktrinär jegliche Ratio, sondern nur deren Perversion zu einem Rationalismus' (S201/275). In writings such as those by Carl Einstein or Gottfried Benn it is not wide of the mark to speak of a kind of 'intellectual pathos.' In both authors an intellectual and emotional *Lebensgefühl* may be discerned. A passage by Gottfried Benn may demonstrate both the cognitive aspect associated with the Expressionist *Lebensgefühl* and strong feelings as well as the 'pathetische Haltung' most often considered a characteristic of the movement. It also leads us directly into the heart of the Expressionist crisis.

In 'Heinrich Mann. Ein Untergang,' Benn wrote: 'Früher in meinem Dorf wurde jedes Ding nur mit Gott oder dem Tod verknüpft und nie mit einer Irdischkeit. Da standen die Dinge fest auf ihrem Platze und reichten bis in das Herz der Erde. Bis mich die Seuche der Erkenntnis schlug: es geht nirgends etwas vor; es geschieht alles nur in meinem Gehirn ... Nun gab es nichts mehr, das mich trug. Nun war über allen Tiefen nur mein Odem. Nun war das Du tot. Nun war alles tot: Erlösung, Opfer und Erlöschen' (P339, vol. 5/1181).

The use of the word 'I,' Benn is arguing, be this I a cognitive entity which discovers itself in the process of reasoning (the Cartesian premise) or a being which is 'thrown' into the world as a mere 'existence' (Existentialism), involves the subject in a series of interdependent consequences. First, the subject's discovery of self means, by definition, a break with the totality of creation or nature. Crucial is the fact that in Expressionism this break is experienced as pain, as Benn's quote shows.[1] Consciousness, individuation, mean the rupture with an original harmony – a harmony, however, of which we can only have the most vague notion, since it is our very reasoning power which blocks us from ever arriving at a description of it. We can now only intuit the original unity. Moreover, since images of unity are generally mythological, beyond science and reason, the break with nature is experienced also as a break with or a loss of God. As the most powerful image of unity, as the guarantor of harmony, God must become problematic as soon as the self has reached a more or less complete state of autonomy vis-à-vis the world, nature, the cosmos. God becomes 'dark,' unknowable, absent, a *deus absconditus*. Finally, any traditional world-view in which order emanates from God in a more or less strictly defined hierarchy must also become questionable. When order no longer resides in things as such, it can only be re-established as a mental construct (of which man has an undeniable need), as the result of reasoning – the very same 'tool' which we have seen standing in the way of

modern man's grasping the original unity of the cosmos. Whatever the end result of such reasoning, therefore, the mental construct is absolute in one sense, because it is independent of reality (to which it nevertheless refers and is applied), and in another sense it is completely non-binding, since it does not cover reality as it is.

All the consequences of the 'curse' of understanding, of the discovery of the self as a thinking subject, had been dealt with before the advent of Expressionism. What sets Expressionism apart and what allows us to speak of the birth of the modern temper is that the problems posed here are no longer merely understood and debated but are acutely felt, and experienced as a crisis. Expressionism is the first movement which draws the extreme conclusions concerning the collapse of the sciences, of the idea of progress, of the loss of God and a cohesive world-view. It may do this intellectually. In the short novel *Bebuquin* (P51) Carl Einstein writes about the mental construct 'Es gibt nicht Eines, wohl aber eine Tendenz der Vereinheitlichung' (quoted S364/13). We are to understand by this that human reasoning is forced to seek unity – ultimately a single concept to explain the cosmos. But Einstein denies this concept any correspondence with reality, while at the same time admitting that we are forced (limited) to thinking in terms of such synthesis. Ernst Nef comments: 'Wenn es aber die grosse Ordnung, die Einheit, auf die es das Erkennen seiner Art nach abgesehen hat, gar nicht gibt, kann dieses Erkennen auch nicht zum Ziel gelangen' (13). Bebuquin's claim at the beginning of the novel, 'Ich suche das Wunder,' announces his search for unity, but this unity does not establish itself; it is a 'miracle' which remains outside human experience. If there is a sense to the world (and Einstein does not explicitly deny this), it remains ungraspable with human reasoning powers. Man is limited to playing 'games': he casts a net of terms, definitions, and concepts in which reality cannot be caught. In fact, as Nef explains: 'Das Denken wird zu einer Selbstbeschäftigung des menschlichen Geistes. Das Denken denkt nicht mehr etwas, es denkt nur noch für sich' (14-15). This realization may, in turn, have two consequences: a sense of infinite freedom, since man's projects are as multiple as his powers of reasoning and imagination; or a sense of despair, because such constructs are games without issue. The two positions are neatly taken by Benn (whose nihilism is clear) and by Einstein, who argues that the negativity of the discovery may be turned into something positive. Human thought has a new meaning as a purely spiritual activity; its conclusions are no longer valid vis-à-vis reality, but according to its own laws. As a perfect example of this 'activity for itself' Einstein cites mathe-

matics. Most abstract, furthest removed from reality, it is concerned with its own laws first and foremost. The consequence of this thinking for Einstein the writer is a kind of pure poetry, independent of the world. To be sure, in handling language he must use words which relate to the world; but for Einstein the world becomes a means, language the goal: 'Die Welt ist das Mittel zum Denken,' he writes in *Bebuquin* (quoted P364/17).

What we have been describing in the works of Benn and Einstein is part and parcel of the philosophy of subjectivism, which is at the root of the Expressionist world-view as well as its art. It is not unique to Expressionism, and Expressionist theoreticians themselves have gone back to the eighteenth century in their search for ancestors for their philosophy and aesthetics. In the doctrines of the philosophy of Idealism, notably those proposed by Kant, Fichte, and Hegel, Expressionists found the belief that the truth or value of ideas is situated absolutely and exclusively within the thinking subject. The Expressionist thinker Rudolf Kayser saw in the philosophy of Kant a clear anticipation of the philosophical premises of Expressionism: 'Das Bewusstseins-Ich war an die erste Stelle der Lebenswirklichkeiten gerückt worden, alle Ideologien in die Gefolgschaft des seelischen Daseins gezwungen' (P228/348). This is precisely the starting point also of the Expressionist view of reality. Aware that the knowledge of nature is no longer possible, because of the absolute rift which separates him from it, and aware also that this same distance separates him from knowing God or the transcendental, the Expressionist feels that truth can only be located in the self, and in a relative sense only. Particularly in the wake of Schopenhauer, Nietzsche, Martin Buber (whose *Ekstatische Konfessionen* was published in 1911), and the precursors of Existentialism, the universe appears to the Expressionist as a theatre of chance 'in which the gulf between man and nature, which Kant ... had opened, yawns wider than ever without being bridged either by the pantheistic mysticism of the Romantics or by the moral law of Kant and Schiller' (S220/25).

In such a universe man, being subject to chance like all creatures, no longer carries his own justification for being: he is 'absurd,' 'strange' like all objects, for as an object *for* himself he becomes alienated *from* himself. Yet he can grasp himself in a different sense (though the most consistent thinkers like Benn and Einstein would deny even that possibility). He cannot understand himself in the traditional sense and cannot rationalize his being here; hence 'naturalistic' knowledge is denied him (to use a word suggested by Husserl in his *Ideen* of 1913 [S93/48]). Yet his existence is given to him immediately as a powerful personal feeling from the inside

or, to use another of Husserl's terms, from the 'natural standpoint.' Moreover, for the Expressionist as for the Existentialist the feeling of existing is augmented by an immediate awareness of the certainty of death, of the finite nature of man.

Life and death are two givens immediately accessible to man, even though all other knowledge becomes relativized. But Expressionists (and Existentialists) do not stop there, for they seek to achieve the same sort of immediate knowledge about other human beings and indeed about all the surrounding world as they have been given about themselves. Hence the paradoxical situation in which all traditional knowledge is proclaimed futile and yet the desire to know is stronger than ever. Expressionists seek to penetrate behind the veil of appearances, to understand the meaning of things, this 'meaning' of course being based solely on the intuiting subject. Meaning and essence of the intuited world always remain tied to the intuiting self; outside the self there is no meaning, and the desire to grasp reality remains in Expressionism firmly anchored in the belief that the self is the centre of the universe, that man belongs in the middle, and that all of creation is subject completely to the consciousness of the individual who confronts it.

Subjectivism is one of the basic possibilities of seeing the world, and as such it has a long tradition. Yet it is in Expressionism that this philosophy appears most powerfully stated, and in forms which seem almost excessive in both their positive and negative formulations: as freedom and as chaos. This remains true when subjectivism is transferred to the realm of art. Expressionist art, according to Rudolf Kayser, originates in the will of the author or artist to subject reality to his ideas about it (S228/41). Certainly when the existential freedom is extended to the realm of art a certain giddiness and light-headedness can be detected in Expressionist theory. Käthe Brodnitz, for example, writes: 'Es gibt so viele Welten wie Ich-Existenzen,' and hence each of these worlds is of equal value and truth (P168/46). The joy of experimentation which is evident in much Expressionist poetry or in the dramas, for example, of Georg Kaiser (often called *Denkspiele*) has its foundation in such beliefs. But it would be wrong to limit the discussion of subjectivism in Expressionism to such positive consequences. Much more frequently, subjectivism implies the admission of failure of the traditional world-view or has the function of an act of revolt against the increasingly powerful forces of anonymity which threaten the autonomy of the subject. If on the one hand there is a glorification of the self, a proclamation of the renewal of the self now that

absolute freedom has been granted it, there is at the same time a darker side: the threat to the self of a chaotic, incomprehensible world, which lends to Expressionism its note of urgency.[2]

About early Expressionism in particular it can be said that its basic *Lebensgefühl* is one of constant fear of being exposed to threats from the outside, not only in human form but in the form of natural forces. This is certainly true for Georg Heym, and what Alfred Beigel says about Albert Ehrenstein holds good for the majority of the early Expressionists: 'Die Angst des Alleinseins, Furcht vor dem Untergehen, nihilistische Verzweiflung, Ironie, Zynismus, sentimentale Selbstbespiegelung, Aggressivität und Machtwille, Flucht in die Natur aus einem sinnlosen Dasein, absoluter Widerspruch zur Welt, prometheische Auflehnung gegen Gott, Gefühle der Schuld, Unwürdigkeit und Ohnmacht, sinnliche Leidenschaft, die Qual des Geistes, Reue über die verfehlte Existenz: dies sind die hervorstechenden Manifestationen des dichterischen Schaffens Ehrensteins' (S19/61–2). Beigel attributes these characteristics to the excessive preoccupation of Ehrenstein with the self. In this form, subjectivism has deteriorated from being a source of power, or at least a defence mechanism, into yet another source of suffering.

Those who appear to interpret the centrality of the self positively nevertheless often reveal quite clearly from what dangers they deem themselves to have escaped. Even in so fervent a proclamation as Ludwig Rubiner's 'Der Mensch in der Mitte,' in which the latter makes man's acts as absolute and his creation as valid as God's, it is revealing to see *why* Rubiner stresses man's activity with such fanaticism. Man must create his own world in order not to be devoured by *the* world: 'Nur dies gilt: Der Welt, die mit Millionen von einrauschenden Sonderklängen und nachleuchtenden Sonderfarben uns als ihr Objekt aufschlucken will, keine Eigenexistenz zuzubilligen. Sondern, umgekehrt, an ihr den göttlichen Schöpfungsplan zu gestalten: mit ihr den Wert durchzusetzen, die Heiligung des Lebens' (219). Even when the prospect of change is proclaimed with fervour, it seems, the problematic aspect of reality reveals itself.

The question of why precisely at this time the individual had come to feel himself so vulnerable, so impotent in his dialogue with the world, concerns a number of theoreticians of Expressionism itself. Clearly, the primacy of the self does not per se imply its vulnerability. Yet what had seemed to be an achievement in Kantian and Fichtian philosophy at the beginning of the nineteenth century had turned to a liability by the end of that century. The liberation of man from self-imposed laws, which had

only been 'mechanisms' resulting from his own thinking, had been halted, even reversed by other mechanisms and restraints from without and/or within. Other chains, though more subtle ones, had been imposed.

Several Expressionist writers see the nineteenth century as a period of growing awareness that the world had become a dangerous place; by 1900 many feel that a crisis stage has been reached. Ernst Blass, in his article on Ernst Bloch's *Geist der Utopie*, writes: 'Wir wollen wieder "sein"; alles Andere trete hinter dies Bestreben zurück. Denn wir sind in grauenhafter Weise abhanden gekommen. Irgendwohin sind wir versteckt worden; wir träumen hinter Dornen. Das Leben draussen ist unheimlich geworden ... Wir haben uns zu den Dingen begeben und unser Selbst verlassen. Nun fehlt es uns, wir haben Vieles, aber das Eine müssen wir qualvoll suchen, und wir haben vergessen, was wir suchen wollten' (S164/238–9). Blass pleads for a period of 'lange Besinnung,' a rethinking of reality, for which he sees the beginning in Ernst Bloch's work. Blass has grasped the malaise of the period before the First World War, but also the sense of crisis out of which Expressionism sprang.

A large share of the blame for modern man's feeling of helplessness vis-à-vis external reality falls, according to Friedrich Markus Huebner, on the world-view elaborated during the nineteenth century, a world-view determined by 'naturalism':

Die Natur als Wirklichkeit, die Natur als Übermacht, die Natur als regulierendes Gesetz, dies gilt um 1820 ebenso unverrückbar wie um 1850 oder um 1880 ... Da die Natur, hinter deren ganze schreckliche Gewalt man vermöge der mannigfachen Entdeckungen auf dem Gebiete der Technik, der Chemie, der Heilkunde, der Physik sehen gelernt hatte, es schlechthin verbot, sich aufzulehnen, musste der Mensch, um von ihr nicht überhaupt erdrückt zu werden, von ihr, der Natur selbst die Gesetze ablesen, die sein Dasein sichern konnten. So verlor er Schritt um Schritt das Gefühl der persönlichen Freiheit, welches die Aufklärung des 18. Jahrhunderts dem Menschen für immer erkämpft zu haben vermeinte. (P221 = S8/3)

Darwin, Taine and Ibsen are some of the people in whose works the naturalistic view of the world and of man crystallizes into an image, figure, or myth. Since these thinkers and writers allowed the iron laws of nature to limit severely the scope of man's actions, the delicate balance between man and world was destroyed: 'Der Mensch war zum blossen Anhängsel der Natur geworden' (S8/4). Only after the catastrophe of 1914–18 could man begin to undertake the task of restoring that balance.

True, the Expressionist feels hostility towards nature; he knows man's analysis of nature to be faulty, his tools inadequate, his science suspect. But this allows him to attain freedom: 'Der Expressionist glaubt an das All-Mögliche' (S8/5). Man can ignore his own tradition and begin anew, innocent of limitations, aware that the world is *his* representation.[3]

For Hugo Ball there are three things which have shattered traditional views of the world: 'Die von der kritischen Philosophie vollzogene Entgötterung der Welt, die Auflösung des Atoms in der Wissenschaft, und die Massenschichtung der Bevölkerung im heutigen Europa' (P161 = S8/124). Ball is referring here specifically to Nietzsche's critique of religion, science's discovery of radioactive decay and of the electron (Becquerell, 1896, and J.J. Thomson, 1897), and the theoretical writings dealing with the phenomenon of the masses (Martin Buber, Ferdinand Tönnies, whose *Gemeinschaft und Gesellschaft* appeared in Leipzig in 1887). These developments cause a complete transformation of the world: 'Eine tausendjährige Kultur bricht zusammen. Es gibt keine Pfeiler und Stützen, keine Fundamente mehr, die nicht zersprengt worden wären. Kirchen sind Luftschlösser geworden, Überzeugungen Vorurteile. Es gibt keine Perspektive mehr in der moralischen Welt. Oben ist unten, unten ist oben. Umwertung aller Werte fand statt. Das Christentum bekam einen Stoss. Die Prinzipien der Logik, des Zentrums, Einheit und Vernunft wurden als Postulate einer herrschsüchtigen Theologie durchschaut. Der Sinn der Welt schwand' (S8/124). This view of things is also very much that of Kurt Pinthus. In his 'Zuvor' to the anthology of Expressionist lyric poetry *Menschheitsdämmerung*, Pinthus writes about the situation around 1910: 'der Mensch und seine geistige Betätigung schienen nur da zu sein, um psychologisch, analytisch betrachtet, nach historischen Maximen definiert zu werden ... Aber man fühlte immer deutlicher die Unmöglichkeit einer Menschheit, die sich ganz und gar abhängig gemacht hatte von ihrer eigenen Schöpfung, von ihrer Wissenschaft, von Technik, Statistik, Handel und Industrie, von einer erstarrten Gemeinschaftsordnung, bourgeoisen und konventionellen Bräuchen' (P262 = S8/55–6). Pinthus sees a connection between the view of man as suggested by science and technology and that held by society itself: the liberation from the straightjacket of the one is as important as that from the other. The word 'mechanism' applies to both the scientific and social philosophy of man: moreover, the awareness of the inadequacy of the contemporary view of reality also meant for Expressionists the inadequacy of reality itself, and hence the fight against conventions is also a fight against reality as such.

The catastrophic views of Ball and Pinthus offer nevertheless a certain

degree of hope. The collapse of the old world is for them as for most Expressionists the pre-condition of a new world: if the 'meaning' of the world has disappeared, it is the task of the Expressionist author to create a new sense and a new world, against the spirit of the nineteenth century. It is not difficult to gather what this new world ought to be like. Underneath all specific suggestions about spiritual and social renewal, to which we shall return in later chapters, there is the explicit or implicit assumption that the reunion of man and nature is the condition *sine qua non* for a truly harmonious human existence. The rupture between man and nature, so dramatically proclaimed in idealist philosophy, carries with it the moral imperative to strive for the regaining of the original unity.

The impulse towards unity takes many forms in Expressionism. In its most exalted form it is *Rausch*, the ecstatic moment in which the individual soul fuses with the whole of creation and the *Weltgeist*, as in Franz Werfel's poem 'Veni creator.' Often this moment of union is of a religious or quasi-religious character, for union with God implies union with the creator of reality. At other times ecstasy is of a frankly erotic nature; in such cases the union is brief, often illusory, often the prelude to even greater deception, despair, and loss of stability (see chapter 9). In sex there is both fascination and fear: the loss of self in the union of the couple is at times experienced as an emotional vortex, at other times as the prefiguration or (more problematically) as a substitute for the union of man with all of creation. Madness, too, has an ambivalent character, for it may indicate a heightening of the conflict between individual and world, and hence be accompanied by suffering and pain; or it may, conversely, mean the elimination of barriers, the fusion of the I with the Not-I, and hence result in peace and tranquillity under changed signs. The attempt to escape from the modern world into a realm of myth, as Gottfried Benn undertakes it in his Rönne novellen, must be understood as springing from a similar desire to efface the borderlines between a hyperintellectual ego and an irrational, intuitive, and pre-logical form of existenc. By contrast, the denial of any significant contradictions between man and nature in the erotic early stories of Alfred Döblin makes union not a desideratum to be realized but a truth to be discovered. For many authors the desire to achieve harmony and unity takes the form of social commitment. In the brotherhood of man is perceived the first and foremost step towards a total synthesis, and the social utopia is by many seen as the necessary context for a general reunification between man and creation. This is all the more valid because the establishment of the utopia is made conditional on an inner, quasi-mystical transformation by which man

gains an immediate and essential insight into the true character of himself and the world.

All these attempts, which we will discuss in the course of our study, show an acute awareness that the situation of modern man is one of profound crisis. No modern author can assume otherwise; ever since Hegel, for whom the Greek model of art was synonymous with perfection, denied *modern* art access to this kind of perfection, because the identity between the particular and the general had been disrupted, art has tacitly or emphatically accepted this premise, and created from it as a starting-point.

This is not to say that the realization of crisis must of necessity take the form of the type of manifesto written by Hugo Ball or Kurt Pinthus. It is extremely rare to find the intellectual and moral causes of the general malaise described with the lucidity demonstrated by these critics, or by authors like Benn and Einstein. Far more frequently, the expression of a sense of futility or loss takes the form of a confused, vague, disoriented confession: 'ich verstehe überhaupt nicht, wie ich in diesen Zustand versunken bin. Um mich, in mir herrscht die Leere, die Öde, ich bin ausgehölt und weiss nicht wovon,' writes Tubutsch, in the story of the same name by Albert Ehrenstein (P47 = S358/277). Gustav Sack, borrowing his vocabulary from the sciences, arrives, in his description of the world, at an image not of neutrality but of horror. 'Etwas Grauenhaftes ist ausgebreitet, klanglos, lichtlos, eine finstere Häufung erboster Atome ... Wohl weiss ich die Formel dafür ... aber es ist Finsternis und Schweigen, finsterster, schweigendster Wahnsinn (...) Das ist deine Welt ... Aber sie genügt mir nicht' (P113 = S406/173). Georg Heym, in a famous diary entry of 27 November 1905, writes: 'Die Jahre aber sind fürchterlich,' and again, 18 October 1906: 'das Leben ist mir bis auf den Tod feindlich' (P372/72).

What such statements share, whether they are autobiographical, semi-autobiographical, or pure fiction, is a sense of discomfort with life and the world, an intuition that life is elsewhere, that there somehow 'must be more.' Thus Heym experiences a painful dichotomy between what is and what could be, or ought to be: 'Wahrhaftig, der Zwiespalt wird zu gross. Auf der einen Seite das brennende, ungestillte Schönheitsgefühl, auf der anderen das absolut Nichtdurchkommenkönnen im Leben, der Mangel an jeder Lebenspraktik' (P372/64). On 5 April 1907 he invokes once again the 'ganze Unmöglichkeit, auch nur einmal jene Bilder ['von dionysischen Hainen, von dem Tanz wilder Schleierlosen im Abendrot'] zu verwirklichen. Im Staub der Tiefe lebe ich' (P372/84).

Heym provides a good example of the way in which personal experi-

ences colour these writers' view of reality in general. From the single event, the momentary emotion, there is elaborated a set of values and norms which come to represent the total attitude of the author towards the world. This is of course a phenomenon which applies to some degree to all art and artists. But the subjective bias of Expressionism (as opposed, for example, to Realism or Naturalism) is particularly striking. Without our acceptance of this bias, much of Expressionist literature may appear strange, even irritating. Such is the extent to which Expressionist authors voice their attitudes in immediate, almost confessional ways that the notion of *Erlebnisdichtung* inevitably suggests itself. Stories like Alfred Lemm's 'Weltflucht' or Max Herrmann-Neisse's 'Himmelfahrt zu Gott vaterlos' must be the product of experiences lived through. Dangerous though it may be to apply too readily the label of *Erlebnisdichtung* to any literature, and particularly to prose (because of its greater objectivity, according to widely held critical belief), and though the assumption that *Lebensgefühl* can be translated into art without some process of mediation is patently false, it is nevertheless an undeniable fact that many critics have seen in the proximity of world-view and art a major characteristic of Expressionism. When Peter Fischer writes, for example, about Franz Jung, 'Er erreicht eine fast absolute Identität zwischen dem konkreten Zustand der Wirklichkeit und ihrer distanzierten Um -und Neugestaltung aus seinem Sprachbewusstsein heraus' (S60/118), his opinion conforms to that held long before him by Paul Hatvani: 'Prosa ist nicht mehr nur das erzählende oder raisonnierende Medium der Gedanken, sondern auch Welt und Weltbild eigenen Erlebens' (P208 = P333, vol.1/301).

Precisely the belief that what individuals experience as reality *is* reality makes of Expressionist art a source of irritation from a traditional point of view. Yet Expressionist art is also most fascinating from this perspective, since it anticipates what the modern novel and short story have by now established as common practice. The truths of Expressionist aesthetics have become the *Binsenwahrheit* of the art of our day. At the same time, too narrow a definition of Expressionist art as a merely subjective vision does considerable damage to the reputation of the movement and obscures the complexities involved. Though it is true that the subjective experience is crucial to the Expressionist formulation of a worldview, it cannot be an author's goal simply to give 'expression' to such experiences or feelings but to lift them to the appropriate level of art. With this problem Expressionist aesthetics are most intensely concerned, in so far as aesthetics can be said to be normative for Expressionist art. The relationship between art and experience, we shall see, plays a far

larger role in Expressionist thinking than concrete principles of art themselves.

The amount of theory devoted to aesthetic, poetic, and stylistic principles in Expressionism is infinitesimal when compared with the amount of theory devoted to the elaboration of the 'spirit of the times.' Indeed, many critics have despaired about the possibility of talking about style at all. Paul Raabe's attempt to define Expressionism according to the principles of sociology is at least partly inspired by his belief that style (and content) are insufficient means for definition. Ulrich Weisstein, more recently, threw up his hands in despair when faced with 'the gap, both stylistic and thematic, which sunders Georg Trakl and Else Lasker-Schüler from August Stramm and Johannes R. Becher' (S241/264), all of whom appear in Pinthus's collection of poetry, *Menschheitsdämmerung*. And when Walter Falk, struggling with the definition of Expressionism, makes the comment, 'Dass das Formale die nötigen Auschlüsse gebe, ist zweifelhaft,' he joins a multitude of critics old and new (S58/69). Expressionists themselves were far less worried about such matters. Kurt Hiller, for example, writes: 'Wir meinen, dass jedweder Stil absolut gut sei – wenn er nur dem Stilisierten adäquat ist. Man muss auf sämtlichen Instrumenten spielen können; freilich auf jedem zu passender Stunde. In allen Punkten des Kunstschaffens hat man herrisch zu sein ... bloss im Stile sklavisch: die Gestalt soll sich stets in die Knechtschaft des Gehalts begeben' (P217 = S8/34). A similar unconcern, or what Weisstein calls distaste for stylistics is expressed by Käthe Brodnitz: 'Solange uns Bild oder Dichtung dazu verhilft, eine neue Welt in uns zu schaffen, ist das Kunstwerk gelungen' (P168/44). That it is not impossible, despite such apparent unconcern with poetics and style on the part of most Expressionists (notable exceptions are Einstein, Benn, Döblin, and Eschmid), to come to a number of features which could collectively be considered the stylistic canon of Expressionism was already indicated by Walter Falk when he suggested: 'Das Spezifische einer epochalen Welterfahrung manifestiert sich weder an den Formen noch an den Inhalten, sondern an einem dritten Moment des literarischen Werkes ... Wie eine Gattung, so manifestiert sich auch eine epochale Welterfahrung an einem Stil, nämlich am Epochenstil' (S58/70).

Falk's belief in an epochal style goes back to a notion which Josef Nadler elaborated almost within the lifetime of the Expressionist movement itself, namely in his article entitled 'Das Problem der Stilgeschichte.' Here Nadler argues first of all against any conception of style as peren-

nial; style is for him 'gegenüber dem jeweils Allgemeinen das Besondere. Stil ist principium individuationis' (S158/378–9). Style only becomes obvious when it is contrasted with poetics (which are a norm) and with other styles (379). Style is therefore always relative and contrastive, and it was quite correct therefore when the Expressionists themselves attempted to define their style in contrast with others. The second point Nadler makes is equally important. He warns specifically against too narrow an application of the word 'style,' since even a close investigation of certain characteristics and qualities of individual authors can give us very little security without dates and documentation to back up our beliefs. Genres can be distinguished and style groups discovered, but conclusions about indidivual authors are extremely chancy. The reason for this, and the reason why we are on so much more solid ground when speaking of an epochal style, is that the creative process is by no means completely autonomous and individualistic: 'Denn jeder Schöpfer steht, wie immer Grenzfälle liegen mögen, unter dem Gesetz der Norm. Norm aber heisst ein Doppeltes: Poetik und Publikum. Poetik und Publikum wiederum bedeuten soziologische Mächte, die also von aussen her oder schon durch Abkunft und Bildung im Individuum einbezogen den schöpferischen Vorgang von der Wurzel aus beeinflussen. Poetik und Publikum sind stilbildende Kräfte' (378). We might add, of course, that Paul Raabe's investigation (among others) has shown that Expressionism in particular is fundamentally determined by sociological factors. But the power of poetics and public *always* applies: 'Der Bereich des Individuellen ist verhältnismässig eng, enger als eine sentimentale Auffassung vom Künstlertum wahrhaben möchte' (396) – so claims Nadler, arguing for the treatment of Expressionism as a movement and against those who would like to reduce these authors to their individual output. To be sure, Nadler wrote at a time when collectivizing tendencies were becoming popular, especially those which interpreted literary works as products of *Volk* or *Stamm*. Nevertheless, a certain truth cannot be denied Nadler's statements. In any case Nadler for one would be quite in favour of the idea that Expressionist prose can be treated as a stylistic unity.

Like Bruno Markwardt, Falk has attempted to characterize the style of Expressionism by contrasting it with Impressionism. Both followed thereby the efforts of many Expressionists, who also sought to contrast their writings with those of Impressionism or Naturalism. This playing out of Expressionism against predecessors begins early, first of course in the domain of fine arts. Already in the catalogue of the Sonderbund Ausstellung in Cologne in 1912 we read: 'Die diesjährige vierte Ausstellung

des Sonderbundes will einen Überblick über den Stand der jüngsten Bewegung in der Malerei geben, die nach dem atmosphärischen Naturalismus und dem Impressionismus der Bewegung aufgetreten ist und nach einer Vereinfachung und Steigerung der Ausdrucksformen, einer neuen Rhythmik und Farbigkeit, nach dekorativer oder monumentaler Gestaltung strebt' (S8/15–16). When Paul Hatvani (in *Die Aktion* of 1917) and Kasimir Edschmid (in *Die neue Rundschau* of 1918) drew up their 'programs' of Expressionism, they too found it convenient to define the movement's goals in terms of a contrast with Impressionism. Edschmid attempted a stylistics-oriented definition and admitted that Impressionism at least had the merit of being interested in form (a merit he denied Naturalism): 'Der Impressionismus begann, die Synthese ward versucht. Sie ward sogar erreicht in einem gewissen Bezirk ... Das eigentliche, der letzte Sinn der Objekte, erschöpfte sich noch nicht ganz' (P183 = S8/44). A little later, however, he denies most vociferously that Expressionism is the result of an intensification of Impressionism: 'Der Expressionismus ... hat mit dem Impressionismus nichts zu tun. Er kam nicht aus ihm. Er hat keinen inneren Kontakt, nicht einmal den des neuen, der den alten erschlägt' (S8/45). He then comes to the 'true' definition of Expressionism, and we notice the typical shift away from technique, poetics, and style, to a stylistic 'attitude.' He says of the Expressionist writers: 'Ihnen entfaltete das *Gefühl* sich masslos. Sie sahen nicht. Sie schauten. Sie photographierten nicht. Sie hatten Gesichte ... Vor allem gab es gegen das Atomische, Verstückte der Impressionisten nun ein grosses umspannendes *Weltgefühl*' (S8/46). For Edschmid, then, surface phenomena are, in the final analysis, of secondary importance.

Paul Hatvani does in fact not even concern himself with such surface phenomena. For him the contrast between Impressionism and Expressionism is one of philosophy and existence: 'Im Impressionismus hatten sich Welt und Ich, Innen und Aussen, zu einem Gleichklang verbunden. *Im Expressionismus überflutet das Ich die Welt*' (P208 = S8/39). The centrality of the self is for Hatvani the 'Copernican' revolution of Expressionism, for from it flows quite naturally the work of art and its 'logical' form: 'So ist also die grosse Umkehrung des Expressionismus: das Kunstwerk hat das Bewusstsein zur *Voraussetzung* und die Welt zur *Folge*; es ist also schöpferischer, als es das impressionistische Kunstwerk sein konnte' (41). One result of this revolution is that content and form have entered into a new relationship, one quite different from their relationship in Impressionist art. One could in fact say that the dichotomy of form and content has been completely eliminated in a new synthesis: 'Die Form wird beim

Expressionismus zum Inhalt: Sie macht einen bedeutungsvollen Schritt über sich selbst hinaus ... Das expressionistische Kunstwerk ist so konzentriert, dass scheinbar für die Form weder Zeit noch Raum übrigbleibt' (39). How this synthesis is achieved in practice and what the new work of art looks like, Hatvani refuses to tell us. For him it is sufficient to understand that the priority of the artistic creator is the distinguishing feature of Expressionist art: all else will flow from this.

Naturally, such vagueness in the use of terminology, even when backed up by enthusiasm of the Edschmid variety, could not go completely unchallenged. *Das literarische Echo* found fault specifically with the contrast between Impressionism and Expressionism as formulated in the theories just cited and warned that 'Ausdruck der Innenwelt' as opposed to 'Eindruck der Aussenwelt' only described 'ein[en] Gegensatz, der die Geschichte der Künste seit alters durchzieht' (quoted S8/29). The same article suggested that the conscious distortion of reality was perhaps the essential trait of the new art. By drawing attention to this latter phenomenon, however, the article pointed not only to surface phenomena but to their source – namely, the 'psychocentric' orientation of the new art – and hence, probably unwittingly, harked back to Hatvani's philosophical definition of Expressionism. A shift away from the dichotomy of *Aus/Eindruck* had in fact already been proposed by Kurt Hiller in 1913, in his article 'Expressionismus' in *Die Weisheit der Langenweile*: 'Man stellt sich unter [Impressionismus] heut weniger einen Stil vor als eine unaktive, reaktive, nichts-als-ästhetische Gefühlsart, der man als allein bejahbar eine wieder moralhafte entgegensetzt (Gesinnung; Wille; Intensität; Revolution)' (S8/37). Hiller's effort to take Expressionism out of the merely stylistic sphere is repeated by Iwan Goll, in 'Films,' where he writes: 'Expressionismus entfernt sich streng von [Romantik und Impressionismus]. Er verleugnet jene Kunstgattungen des l'art pour l'art, denn er ist weniger eine Kunstform als eine Erlebnisform' (P204 = S8/37). Similarly, René Schickele, though granting that Expressionism had 'eine technische Ausdrucksform,' claimed: 'Er bedeutet aber vor allem den Wunsch, neben die Schilderung einen moralischen Willen zu setzen' (38). Though it must be admitted that such attempts at contrast tell us very little about the actual workings of Expressionism, they do provide us at least with a mood or attitude out of which these works originate.

Even Falk, in the article cited, appeals to the principle of contrast in order to define Expressionism. He demonstrates the progression from Impressionism to Expressionism by juxtaposing Stefan George's poem 'Komm in den totgesagten Park' and Georg Heym's poem 'Der Gott der

Stadt.' From the comparison he draws the conclusion that what in Impressionism (and we could say Neo-Romanticism) had been a desire to dominate reality spiritually (after all, the dichotomy man/nature was felt acutely already in the nineteenth century) had in Expressionism become a transformation or even a distortion of reality, with one important stipulation: 'Der transformistische Wille tendiert nicht allein auf die Verwandlung äusserer Wirklichkeit, sondern auch auf die vergöttlichende Transformierung des Ich' (77). The dichotomy man/world is intensified when it is phrased in absolute terms on both sides: a demonic reality (often mechanistic, or in the case of the city presented as 'demonic space') is confronted by an idealized self, the latter's transfiguration being the result of the demonizing of the former.

The key word 'distortion' and the notion of a transformation of reality which we encountered in the contrast between Impressionism and Expressionism leads us to one of the most important controversies connected with Expressionism as a literary style and philosophy – namely, that over the degree of 'realism' of Expressionist art. Because Expressionists interpret their art as expression of a world-view rather than as a search for a specific style, any aestheticizing movement had to be rejected by them. Kurt Pinthus states: 'Niemals war das Ästhetische und das L'art pour l'art Prinzip so missachtet wie in dieser Dichtung' (P262 = S8/58). Because Expressionist art is 'ganz Eruption, Explosion, Intensität' (qualities drawn upon to oppose reality), it must reject the depiction of reality as means of representation, 'so handgreiflich auch diese verkommene Realität war.' Moreover, if the basic experience of Expressionism is one of catastrophe, it is only to be expected that Expressionist art would break with the tradition which sees art as an imitation of nature and which aims for 'realism' understood in terms of proximity to the perceived model in the empirical world. Indeed, when Colette Dimic, writing about Expressionist practitioners of the *Groteske*, says: 'alle verwarfen die Wirklichkeit' (S43/211), she is also saying, in a profoundly ambivalent way, something about almost all Expressionists. For, as we have seen, they reject it either by simply not taking it into account or by protesting against it. Both attitudes towards the world, and both types of literature which result from it, share the rejection of the notion of mimesis in the Aristotelian sense: Expressionism is a non-mimetic art.[4]

In claiming Expressionism as a non-mimetic art we are making no claims to its uniqueness. According to Friedrich Gaede, the end of the mimetic tradition in art and the abandonment of Aristotelian principles date from as far back as German classicism. It was the consequence of the

Kantian revolution described above – namely, the awareness that the philosophical basis for the theory of imitation, the idea that the world as a whole can be grasped from the isolated object or event, had changed from an obvious principle to an idealistic and non-realizable construction (S71/15). The Romantics drew from this the conclusion that not the imitation of nature but the work of art itself had exclusive claim to truth. The extreme consequence of this line of thinking is the rejection of all outside criteria and the proclamation of the autonomy of the work of art. Walter Sokel has traced this development for German literature and claims Expressionism as a direct descendant of this tradition. The reason for the rejection of the theory of imitation is of course the fact that man has lost his naïve attitude towards nature; for modern man nature is something alien, for which he experiences fear: 'Die Natur ist das Aussergeistige, das Antigeistige, der Feind' (quoted S171/94).

Two attitudes now suggest themselves in the theory of art: the artist can search for a reconciliation, by means of an idealistic construct (in the form of an idyll or utopian fiction), or he can insist on the irreversibility of the rupture and on man's fallen state (in the form of satire). In the most extreme case such insistence on the 'schlechte Wirklichkeit' may even take the form of the grotesque, in which the world as a point of reference is abandoned altogether. Both those who concentrate on man's fallen state and those seeking reconciliation operate with similar concepts. Their world is a world without gods, in which man is alienated, and suffering from his individuation. Both work with the model of history (whose origin is the Gnostic tradition) which posits a golden age in the beginning and a falling away from this idyllic existence. But whereas the idealist projects a return to the state of harmony, the realist, rejecting idyll and utopia, clings to the idea of irreversible loss. He uses the observable facts of this world: reification of nature and man, the feeling of isolation, the alienation from life processes and from one's fellow man, the awareness of the absurdity and purposelessness of creation, and the inevitability of death.

Being a realist or idealist is an existential choice. It obviously also has social connotations and is, in literature, even reflected in matters of style. Many Expressionist techniques are associated with realism as defined by Gaede. Expressionism stresses the independence of the parts over the whole (a 'broken' world); it rejects perfect unity as a possibility; it prefers the fragment; it uses 'open' rather than 'closed' forms – all proof that the realist tradition, already visible in outline in Storm and Stress and in Naturalism, carries on into Expressionism. At the same time there is a

powerful idealist current, which insists not only on the desirability of a return to a golden age but on its inevitability. This current works far less with satire than with rhetoric: it projects the utopia as imminent;[5] it prophesies and proclaims rather than analyses. This current sometimes uses different forms, though this is not necessarily so, for even in the latter type of literature reality does not appear in its traditional form. Neither in idealism nor in realism as defined in this sense is there the desire to be realistic in the Aristotelian sense.

To what misunderstandings the ignoring of this fact may lead the literary scholar may be demonstrated by referring to the so-called Expres-sionismus-Debatte – a debate which was provoked by an article in *Das Wort* by Klaus Ziegler and which culminated in the opposition between Georg Lukács and Ernst Bloch (and later Bertolt Brecht).[6] According to Lukács, neither Naturalism nor Expressionism nor Surrealism can faith-fully 'mirror' reality, since in none of the three movements can the claim to depict reality 'as it is' be maintained. All three movements only achieve the description of surface phenomena since the writer cannot free himself from his subjective perspective. The 'truth' of this type of literature, its 'realism,' is therefore highly suspect. A crucial notion in the debate is that of *Realitätsverlust*. There can be no doubt that the sense of loss of totality which is reported by writers like Georg Heym, Georg Trakl, and Gottfried Benn is first of all a subjective feeling, since the claim that the decay is located in the external world cannot be verified. Rather, the feeling that the external world is 'breaking down' (because the observer views the self as a static point and the world as changing) overlooks the rather more important fact that the sense of breakdown is first and foremost an idea in (of) the mind of the subject as observer. Of course the Expressionists were well aware of the true nature of the process of *Realitätsverlust* or *Realitätsverfall* and interpreted it as a subjective projection. Only, they did not consider the individual experience 'closed' or in any way unique and unrepeatable. On the contrary, Ernst Bloch, who in the debate became the most important opponent of Lukács, stressed the universality of the *Realitätsverlust* experience. He maintained that the very image of the world which Lukács rejected as resulting from mere subjectivism in fact 'mirrored' the crisis stage into which the modern world had entered. Instead of considering those characteristics of Expressionist art against which Lukács directs his attacks as *dis*advantages, Bloch urges us to see them as eminently appropriate means. Nina Pawlowa writes: 'Die Miss-achtung des Konkreten, die Verzerrung der Form, die leidenschaftliche Subjektivität – es wäre sinnlos zu bestreiten, dass gerade diese Eigen-

schaften in vieler Hinsicht den Expressionismus bestimmen' (S167/142). But this socialist critic continues by saying that to deny these writings 'soziale Aussage' would be very wrong. Bloch in any case saw in the formal means of Expressionism an indication of the Expressionist feeling about life, and hence a suitable means of rendering the world as perceived by them.

Expressionist self-understanding indeed confirms that notions of realism of the Lukács variety were never normative for Expressionist art. But even disregarding such external evidence, we might well agree with Bloch that precisely the awareness of *crisis* gives Expressionism its high cognitive content. This is in any case Wolfgang Rothe's opionion when he writes that 'die expressionistische Geistesbewegung das fortgeschrittenste Bewusstsein jener Jahre repräsentierte und eine erstaunliche Schärfe der Erkenntnis grundlegender Zeitprobleme besass' (S201/151). That this sense of crisis is experienced first of all as a personal feeling is only natural, though the term *Erlebnisdichtung*, when used to describe the literary rendition of this experience of crisis, is problematic, and needs elaboration and clarification.

Expressionists themselves and those who accepted their doctrine at face value have made much of the 'immediacy' with which feelings and experiences are supposed to be translated into art in this movement. Georg Heym and Georg Trakl are often cited as authors who bypass reflection and objectivization; their poems, it is argued, present the basic feeling of these authors about life. Some critics, like F.J. Schneider, have gone so far as to speak of an 'expressiver Mensch' (S210). Such anthropological types are indeed tempting, but it would be surprising to find 'Expressionist Man' to be so very different from any other (preceding or succeeding) man. The differences lie not so much in an actual inner anthropological structure as in a psychological and social constellation. For this reason we must also be very careful about applying to Expressionist literature too narrow a definition of *Erlebnisdichtung*. Aesthetic theory suggests that experience and art are two entities of a complex and multivalent nature. Even the most subjective lyric poetry incorporates an element of memory, of distance between actual experience and its translation into art. In the creative process the subjective experience is objectivized and thus allowed to reach a level properly called symbolic. Poetry uses language, which already entails objectivization. To be sure, the efforts of the modern poet go in the direction of de-objectivization of language as spoken by the tribe (Mallarmé). Yet, as Gottfried Benn expressed it once: 'Der Knabe spricht, aber der psychologische Komplex

ist vorhanden, auch ohne ihn' (P339, vol. 5/1215). Benn moreover draws our attention to the fact that the poem is something *made*, not something which occurs. The sheer process of composition entails a move away from direct experience. Despite many Expressionist protestations to the contrary, the idea of the work of art as artifact was never totally abandoned. Immediacy is therefore always only an approximation. And finally, in our particular study yet another factor must be considered. There is a general critical consensus that prose exhibits stronger tendencies towards objectivity than poetry. If, therefore, lyric poetry is under question as far as immediacy is concerned, prose must be even further removed from such immediacy, and lyric tendencies in prose need further definition.

Despite such reservations, it may nevertheless be stated that many Expressionists are indeed very close to their material and are involved with it in an emotional, often polemical sense. They often work with pathos, which aims to remove distance and which also involves an emotional appeal to the reader. Attempts are made to reach a maximum of intensity, often by means of first-person narratives, a consistent (usually restricted) point of view, concentration and elimination of inessentials – all intended to yield a created world approximating virtual identity with the world-view held by the author. We certainly cannot follow Kurt Mautz's suggestion, for example, that we deny the status of *Erlebnislyrik* altogether for so striking a personal poet as Georg Heym. Surely when Mautz writes: 'Nur ganz selten spricht in Gedichten Heyms noch ein "Ich," das sich mit dem Ich des Autors identifizieren liesse, wie das in der sogenannten Erlebnislyrik der Fall war' (S151/113), he is placing undue emphasis on what after all is a mere surface phenomenon. The use or non-use of the word 'I' says by itself very little about the personal involvement and emotional content of a poem.

Of course such statements must be seen in context. Mautz's book was written specifically to counter F.J. Schneider's, in which he saw as typical for this art 'ekstatisch-visionäre Schau,' 'kosmische Entgrenzung der Persönlichkeit,' and the struggle to achieve 'die unio mystica von Ich und All' (quoted S151/9). One can only agree with Mautz that Schneider's characterization applies to an extremely small (albeit very important) segment of Expressionism. Yet this argument is in itself not sufficient to prevent us from seeing in Heym's poetry the expression of an *Erlebnis*, although quite different from that which Schneider proposes. The experience of vulnerability of the self is a profound one, and one which struggles to express itself with the same or even greater intensity than experience of a more traditional character, such as love, nature, birth, or death. That such

an experience might be more in the nature of a *Gedankenerlebnis* (Ermatinger, see above) does not deny it validity. Moreover, even when the lyric poet experiences the vulnerability of the self intellectually, he may still *express* this experience through a very personal cry of despair.

But the postulate of a near-identity of created world and intuited world does not exhaust the subject of Expressionist aesthetics. Like all genuine art, Expressionism attempts to transcend the arbitrary, the accidental and personal, and aspires to the universal. Even when writing about personal experiences, the Expressionist is in search of the One which unites the Many. Ernst Blass's complaint, 'wir haben Vieles, aber das Eine müssen wir qualvoll suchen' (S8/238), shows that, despite Carl Einstein's doubts, the Expressionist is in search of a miracle. And precisely when the Expressionist seems interested in man at the moment of highest tension, in existential situations, he is stressing *not* the individual situation but a universal one, for in such moments his nature becomes transparent. Falk's suggestion that we could call Expressionists 'aeternists,' because man is shown as being subject to 'Mächte, [die] ihre Heimat jenseits der Zeit im Ewigen haben,' has as its obverse the idea that the human situation is also eternal.[7]

To substantiate such claims of essentiality and universality, however, traditional references can no longer be used. Expressionism cannot resort to traditional symbolism since it cannot resort to mimesis. György Vajda writes: 'The artistic realism of the nineteenth century, which built on the basis of a materialistic epistemology, forcefully separated the world of reality from that of consciousness and imagination' (S233/57). In nineteenth-century literature the world existed outside of man; the artist's task was to imitate or copy this reality. The Kantian revolution does not specifically deny the existence of the outside world, but it makes it ungraspable, and hence inimitable. What remains is our own consciousness, and the consciousness's consciousness of reality. Yet the paradoxical result of an absolute limitation to individual consciousness is objectivity: 'If the creative individual is a conscious and active participant in the structure of the reality of which he forms part, then his will manifests itself by representing, criticizing, and changing that structure by means of self-expression, since his subject, in an aesthetic sense, represents objective reality. Therefore objective reality emerges through his subject, and the objective social goal through his art' (58). Unfortunately, Expressionists themselves did not see this 'subjective objectivism' as clearly as it is described by Vajda. With their characteristic vagueness they were able

only to hint at what a process of universalizing might entail. Rudolf Kayser, for example, wrote: 'Der erste Kunstgriff des Erlebnisses ist es daher, seinen zufälligen Gegenstand zu verwandeln: aus der Einzelheit des natürlichen Geschehens in die ideale Allgemeingültigkeit des Geistes' (P228/351). He thereby expressed an idea about the nature of art with which even Goethe would have agreed. Something similar is also Pinthus's ideal; he contends that the work of art must aspire to 'das Allgemeine,' 'die grossen Menschheitsideen' (P262 = S8/58). What Expressionists clung to, in any case, was the belief in a revelation that went beyond the 'atomistic' experience typical of Impressionism, and beyond the superficial description of primarily materialist phenomena in Naturalism. The idea that Expressionist art can reveal essentiality (*Wesen*), that it is a spiritual art, concerned with *Geist*, makes the claim of a higher truth part and parcel of its credo.

But how could this claim be substantiated in practice? A number of specific 'techniques' are at the disposal of the non-mimetic orientation in art. Three in particular stand out in Expressionist aesthetics: abstraction, rejection of psychology, and distortion.

The transformation of the arbitrary multiplicity of phenomena constituting an event or experience into an abstraction is the most important technique in Expressionist theory (S167/153). But abstraction is for the Expressionist not only a tool for the understanding of the structure of reality, or a means to make possible the transformation of experience into art. It is, as we might expect, linked to the overwhelming problem of crisis, and its elimination in salvation. Geoffrey Perkins has described the process which leads the Expressionist, or at least the Expressionist theorizer about art, to argue for the necessity of a more abstract art. The basis for Expressionist aesthetics is provided by the extremely important book by Wilhelm Worringer, *Abstraktion und Einfühlung*, which deals with Expressionist *art* but which, through the instigation of Worringer himself, became seminal also for the theory of Expressionist literature. According to Perkins, in the Expressionist situation 'the attention is directed to the reality behind appearances ... Man is filled once more with "die Sehnsucht nach Gestaltung des Wesens"' (S171/94) – what Gaede would call the idealist impulse. This relationship of longing between man and world is understood by Worringer to be 'Gothic,' and Northern man is interpreted as a tormented seeker of God. It is also the result, however, of an acute contemporary spiritual malaise. Modern man, like primitive man, is in a state of fear, this time fear of civilization. Civilization is seen as hostile to all things spiritual. Expressionism in this

sense is the expression of a situation 'in which man becomes aware of his God or of a higher spiritual order in the universe, the knowledge of which is not, and can never be exhausted by man's own efforts' (97). The role of art was now to be 'the expression of a specific desire in man for harmony, a desire which, it was felt, was conditioned by the quality of the relationship between man and nature in the age and nation involved' (98). In this view of art, the *situation* inevitably determines the *form* of art. With Egyptian, Gothic, Baroque, Indian, and primitive art Expressionism shares to a greater or lesser extent the deformation of the natural object. As a manifestation of the kind of art created by situations similar to that of the art movements previously cited, Expressionism creates an art which is both 'distorted' and 'abstract.'

As reasons for this tendency towards abstraction and distortion Worringer advances the idea that, in the words of Perkins, 'man, faced with chaos, automatically feels the urge to free himself from this confusion by creating in art abstract symbols which, through their own logic, order and necessity, provide a counterbalance to the chaos surrounding him' (100). In this way abstraction puts up a barrier against chaos: art saves. Art styles such as Expressionism and Baroque concentrate on things in isolation rather than on relationships, on the fragment rather than the integrated whole, and on the object taken out of its usual context. In this fashion the 'elementary' may be deduced: 'Der Weg zum Elementaren ist die Abstraktion. Allerkonsequenteste Abstraktion führt bis ins Element: über die Form hinaus, die sie zerstört, bis sie im Ursprung des Inhaltes landet' (P208 = S8/39). If the artist is to achieve such a high degree of abstraction as truly to master the chaotic situation, he must suppress the realist or naturalist detail. Kurt Pinthus in fact speaks of a shift from 'Umwirklichkeit' to 'Unwirklichkeit' (P262 = S8/56). Problematic in this line of thinking is of course the role which prose can play in such a configuration. Though in drama the degree of abstraction can be quite high, since characters can be reduced to figures, to representatives rather than psychological entities and characters in the round; and though poetry can push abstraction to the very limit of 'poésie pure,' prose incorporates always more 'world,' and hence the tendency towards abstraction is limited. Moreover, 'pure abstraction ... was shunned, at least outside the *Sturm*-circle, because ... it sacrifices content to form, ignores the human element and undercuts the productive tensions on which truly Expressionist art must thrive' (S241/273).[8] If art is associated with salvation, then abstraction which eliminates the human element is in danger of diverting attention from this idea and hence stands to some extent in

contradiction to other stated aims and intentions of the movement, notably its social aims. We may see here an example of what Perkins claims is the gap between theory and practice in Expressionism. Indeed, Worringer's theory, which is undoubtedly important for Expressionist thinking *about* art, does not cover the range of thinking *in* art. Far from it – abstraction and empathy reside side by side, depending on the predominance of one set of intentions over another. Specifically, the theory of genre comes into play here, though the Expressionists themselves gave little attention to the ability of a genre to serve as a vehicle for certain ideas or styles. To this problem we shall return shortly.

The second way in which Expressionism moves away from the imitation of nature and in the direction of abstraction is in the rejection of psychology. In a crucial essay on the Expressionist interpretation of man, 'Der beseelte und der psychologische Mensch,' Paul Kornfeld writes: 'wir wollen nicht untergehen im Schlamm des Charakters, wollen uns nicht verlieren im Chaos der Eigenschaften und ihrer Zuckungen, und wollen uns dessen bewusst sein, dass in manchen, heiligeren Stunden unsere Hülle sich auftut und Heiligeres uns entschreitet' (P230 = S8/222–3). Kornfeld revolts against the vulgar and materialist view of man, and stresses man's sanctity. Psychology cannot reveal the dual nature of man, his pathos: the divine spark imprisoned in the mortal body. Only art can give us this idea. Alfred Döblin, in his essay 'An Romanautoren und ihre Kritiker' (P171), adopts the same bellicose stance. Already in his essay 'Gespräche mit Kalypso über die Musik' he had written: 'Ich höhne auch der Dichtkunst, die sich sättigt im Seelenentwickeln – alles nur verstehen heisst alles erniedrigen' (P177). In the erotic-mystic universe of Döblin's early stories psychology has no place.

Expressionist alternatives to psychological literature, to which Döblin refers in both essays mentioned, can best be observed in the theatre. There psychological nuances are shunned; the dramatist reduces his characters to types. On the stage he achieves this reduction by means of gestures, by monotony of speech, by elimination of names, social and biographical background, by repetition of certain reactions and situations, by giving generic appellations to the main characters, such as 'the father,' the 'son,' 'the beggar.' Perhaps the most striking play of this kind is Reinhard Sorge's *Der Bettler*, of which Walter Sokel says: 'The drama is a composition of the hero's essential existence, and each character plays the role of a musical leitmotiv expressing an aspect or a possibility of the hero' (S220/36). Such a drastic reduction of man to a mere leitmotif remains rare in prose, yet here too we may find a tendency to use protago-

nists as functions of a composition, situations which are reduced to a minimum, and heroes who act in a space-time frame that is not always clearly recognizable. What counts is the existential situation, not naturalistic depiction in its broad spectrum of motivation, psychological nuance, and material detail. Especially in early Expressionism the essential moment figures prominently. This is true of Heym's novellen, but also of Kasimir Edschmid's *Die sechs Mündungen*, whose heroes' function *is* to be heroic. Especially women are often reduced to their role as *Weib* – that is, their sexual role – witness the writings of Heym, Gustav Sack, Oskar Loerke, Ernst Weiss and Franz Jung, all of whom we shall discuss in chapter 9.

Almost from the beginning, as we saw in the 1917 article in *Das literarische Echo*, distortion had come to be considered the most striking aspect of the new literature, and plenty of authors and critics viewed the artistic endeavours of the Expressionists with no little misgiving and doubt. Franz Herwig, in 1916, wrote of Carl Sternheim's novellen: 'Rausch steht neben Rausch, man verachtet den Realismus und wirft mit ihm, wie das immer so geht, auch sein Gutes zum Fenster hinaus ... Sie erzählen vor allen Dingen vom Ungewöhnlichen, von überhitzten Verhältnissen, überhitzten Menschen ... Geschlechtlichkeit und Pathologisches beherrscht ihren Darstellungskreis volkommen' (P212 = P329/32). Besides the obvious irritation with its sexual and pathological preoccupations, it was primarily the unusual and unconventional means of representation which caused critical rejection of Expressionism in its early stages. The Expressionists themselves defended their position by referring to their ethical and philosophical bias.[9] So, for example, Käthe Brodnitz, who writes that the work of art is successful if it creates a new world, 'so verzeichnet es auch vom anatomischen oder psychologischen Standpunkt aus sein mag. Wir wollen keine Realien lernen, unser *produktives* Wissen soll durch die heutige Kunst bereichert werden' (P168 = P329/46). Brodnitz rejects any kind of rationalistic approach to both reading and writing, and instead suggests that literature should approach the pure forms of music: 'Wie sich Musik nicht pedantisch deuten lässt, so hat man auch in der Poesie versucht, berauschende Bilder aneinanderzureihen, deren logischer Sinn dunkel bleibt' (47). Such efforts should not be restricted to poetry: 'Kunst ist es, beispielsweise eine Novelle zu schreiben, in der die einzelnen Ereignisse derartig hart aufeinander stossen, dass es kreischend wie eine einzelne Dissonanz in unserer Seele schreit. Seelentöne sollen in Farbe, Wort und Musik wiedererweckt werden' (47). The starting-point for such different practices is of course a different way of *seeing* reality.

Partly because this generation for the first time in German history grows up in large cities, it attempts to cope with reality as if coping with the chaos of such large cities themselves. J.L. Windholz has described a typical attempt to render the reality (the essence) of the city (P290 = S8/122). For him the city itself is an aesthetic problem, and tied to categories of perception which, until recently unknown, now influence the sensibilities of these authors. Windholz suggests that traditional means of achieving appropriate representation do not suffice in the case of phenomena like the city. He even advances the idea that a 'verbindendes und ergänzendes Gehirn' may very well stand in the way of attaining suitable representation, because it organizes before it truly grasps and understands.

Seen against the background of traditional ideas of realism, these characteristics of the new art – abstraction, distortion and the rejection of psychology – appear problematic. Yet the foundations for this art were laid long before the advent of Expressionism, notably in the Kantian revolution of the eighteenth century. Moreover, in the Expressionists' understanding of their art, in their formulations and particularly in those of Worringer, Expressionist art is to some extent considered inevitable in the history of styles, determined as it is by conditions and the moment in time, and above all of course by the personal and collective *Lebensgefühl*.

It is this *Lebensgefühl* which inspires the series of dualisms typical of the movement's thinking and art. The original dichotomy of self and world gives rise to a number of other oppositions. In seeing the self in terms of spirit, of *Geist*, and the world as dead matter, as obstacle to transcendence, the Expressionist tends to eliminate all nuances and shades of interpretation. For him the existential situation becomes an opposition between good and evil. Since this opposition is absolute, all oppositions relating to it are also seen as absolute. This tendency is even extended to personal and social contrasts. As a movement of the young, the Expressionists tend to equate young with good, old with evil. With youth is associated idealism, with old age corruption and compromise. Youth spells revolt against a system of authority and suppression. This opposition already exists at home, in the conflict between the father and the son. It provides the starting point for the larger complex of individual freedom versus the state, school, and church, or rebellion versus obedience, autonomy versus social strictures, community versus society, individual versus masses. Life itself is an absolute good; but decay and stagnation, corruption and death as its enemies make of it sometimes a quasi-unattainable ideal. Thomas Anz and Michael Starke sum up the

Expressionist tendency to think in polarities as follows: 'Gemäss dem vorherrschenden syntagmatischen Grundmuster folgt in den expressionistischen Texten der Darstellung einer Ekel, Angst, Langeweile, Verzweiflung oder zerstörungswütigen Hass provozierenden gegenwärtigen alten Welt und des in ihr gefangenen und beschädigten Individuums die pathetische Verklärung des neuen Zustands. Titel wie *Verfall und Triumph, Tod und Auferstehung, Umsturz und Aufbau* . . . fassen dieses rhetorische Schema formelhaft zusammen' (S8/128).

Lebensgefühl also explains the relative frequency of certain modes and their accompanying stylistic features. First and foremost we note the pervading mode of pathos, especially in early Expressionism. To give expression to dichotomies such as the ones outlined above, Expressionists predominantly use the pathetic mode, with its hyperboles, intensifications, syntactical distortions, its vocabulary and imagery of charnel house, prison, darkness, solitude, and death. The typical Expressionist *Schrei* over the abyss separating the idyll from the 'schlechte Welt' is but one form which this pathos might take. By contrast, the other *Schrei*, that of ecstasy, stands at the opposite pole and denotes the attainment, however brief, of unity in a moment of privilege or epiphany. The frequency of hyperbole may similarly be explained by reference to the crisis situation. Rhetorical extremes, specific contrasts, exaggerations, repetitions, direct address, constructive syntaxes, and climax-building periods are tools which Expressionists use to argue rather than analyse, to convince by force of emotion rather than logic. Particularly with the greater degree of politicization during and after the First World War, this mode comes to the fore not only in political tracts but in literature also. At the same time the absence of irony (which, according to Ermatinger, relies on a calm and intellectual play with the world, 'im Bewusstsein eigener Überlegenheit' [S55/219]) should not surprise us, since the dichotomy of man and world is experienced as painful and does not allow feelings of superiority.

Style and poetics in Expressionism, then, are inextricably bound to the concept of art itself and to its two-fold function: to express the situation of crisis (through appropriate art forms and a valid style) and to attain a solution to that crisis. By describing style as volition, ethics, and salvation, Expressionism shows a link with both Kierkegaard's idea of aesthetic man (as one possible form of existence) and Nietzsche's notion of a redemption through the work of art. In our subsequent discussion we shall see that the proposition that art may be the handmaiden of politics can be turned around and that politics itself may in fact be pressed into

the service of art. In the latter case artistic concerns may well stand in the way of political action.

As we have seen, Kurt Pinthus suggested that the social dimension ought not to be depicted in detail but that preoccupations with social reality ought to lead the writer to stress the 'great ideas of mankind.' Bruno Markwardt has argued, however, that the Expressionist emphasis on the 'great ideas' might well reveal a tendency merely to praise a remote utopia, whereas Naturalism had dealt with the nearby concrete reality in a more courageous way (S144, vol. 5/395). The shift from realism to irrealism propagated by Pinthus could similarly be seen as an 'Ausweichen vor allem Greifbaren in die Unverbindlichkeit des Nicht-Greifbaren' (395). Even when Expressionism is most completely submerged in reality – in politics – it can never forget its premises both philosophical and aesthetic. And whereas it tries to achieve a collective and quasi-anonymous art of groups and subgroups, it is loath to abandon art as a means of salvation, even though by 1918 it had become clear that man could only be saved by man himself.

In view of what has been said so far, it would be futile to look for a characterization of Expressionist art which would embrace all of its manifold stylistic manifestations. Nevertheless, such attempts have from time to time been made, especially in the early, more innocent stages of Expresssionist scholarship. More frequently, Expressionist style is defined by listing a number of features – a procedure which has at least the merit of offering a choice. Few if any more recent historians have been able to sunder the relationship between world-view and style which Expressionists themselves stressed from the beginning. In the course of our study we shall have ample occasion to reinforce this relationship, and perhaps most particularly where prose is concerned.

THREE

Expressionism and the Modern World

T HE SOCIETY in which Expressionism sprang up was one of expanding capitalism, industry, and technology. The Expressionist movement is almost exclusively interested in problems associated with urban, industrialized, and highly organized contexts, and particularly with the nature and function of the city. Because of this focus, it has been argued that Expressionism is the first truly modern literary movement in Germany. From its initiation, however, Expressionists had an ambivalent attitude towards the urban setting, never taking it as uncritically for granted as did most of their contemporaries. Given the idealistic trends within the movement, it is not surprising that the Expressionists want to answer first of all the question of whether the city enhances or degrades the human condition.

Expressionist criticism hinges on the notion of progress. Since the turn of the century doubts about the direction in which society was going had been expressed by intellectuals and even by the leading class, the bourgeoisie. The idea that society was in fact in a state of decadence gained ground gradually; not only the rapid industrialization and the apparent decline of traditional culture, but the ideological foundations of modern society themselves – liberalism and the belief in the natural sciences – were viewed with suspicion. There are strong ties here with Naturalism, the continuation of whose social awareness can be seen in the treatment of themes and motifs like the city, pauperism, and alienation.[1] At the same time, the attempt to aestheticize reality is denounced vociferously. Critics have shown how Expressionism at times exceeds Naturalism in its cult of the ugly and of the demonic and destructive aspects of reality. Yet Naturalism itself is ultimately rejected, not only because of its artistic principles but because of its deterministic and materialistic psychology

and philosophy: 'Die neue Einstellung [Expressionism] bedeutet Angriff auf die banale Atmosphäre des Reinäusserlichen, in der das Gefolge des Naturalismus ... breit und lähmend gebietet. Sie heisst Kampf gegen den Selbstzweck der Materie, gegen die Herrschaft realer Einzelheiten, gegen die Physik des Alltags. Erstrebt ist die Verdeutlichung der seelischen Struktur' (P237 = P333, vol. 2/276). But this does not mean that all Expressionists would agree simply to do away with the scientific and technological achievements of the nineteenth and twentieth centuries. The misery of the contemporary scene invites a number of strikingly different solutions, and whereas the 'true' (mostly early) Expressionists see in technology and industry only decay, hypertrophy, and death, others, notably the politically committed groups collectively known as Activists, come to see in them the tools for the realization of utopia. Similarly, one group of Expressionists may look back to the past, to an idyllic form of society on an agricultural basis, whereas others believe in a total and absolute commitment to science and technology.

Because social criticism in Expressionism shows such extremes, P.U. Hohendahl has suggested that the movement simply did not have an adequate grasp of the facts, of the position of man in modern society, and that this finally had to result 'in utopischen Überspannungen oder in pessimistischen Klagen' (S88/60). There can be no doubt that the Expressionists tended to be *weltfremd*. At the same time it must not be overlooked that much of Expressionist writing does not even attempt to grasp the workings of modern society. Expressionism does not report; it carries a message. The prophetic impulse is what counts, not merely the coincidence of empirical and fictional world. This is one of the most frustrating aspects of the movement and one that separates us most dramatically from it. Yet the Expressionists believed that their method of abstracting rendered an essential insight vastly superior to that of analysis. It was in the nature of the movement to turn away from analysis in economic terms, precisely because the definition of society and social relations in such terms appeared perverse and totally unacceptable to them. Rather than taking over sociological vocabulary and the thinking behind it, the Expressionists escaped into a realm of moral, spiritual, and aesthetic criteria. Their complete rejection of the materialism which was at the base of the society which they were discussing prevented them, it is true, from understanding adequately what they abhorred. At the same time it allowed them to place themselves at least temporarily outside the system in order to present it in categories extraneous to it. That this placing oneself outside the system is in the final analysis an illusion is clear; it

explains the failure of the movement in concrete political terms. But as far as its cognitive value is concerned, it could be argued that extremely valuable insights were gained by Expressionists by virtue of their refusal to look at bourgeois and capitalist society on *its* terms.

The preoccupation with *Geist* in Expressionism entailed of necessity a complete rejection of the most fundamental philosophy of both the bourgeoisie and of socialists and communists (hence the hostility of most Marxist critics towards Expressionism), namely, materialism. If we are to assess the Expressionists correctly, we must remember that theirs was an attempt to infuse socialism with spiritual values, since vulgar Marxist theories could not be acceptable to them. The exclusive, quasi-obsessive concern for the acquisition of goods and property as guarantors of a happy life, which the Expressionist witnessed in bourgeois life, surely could not become more palatable to them in the form of a purely materialistic socialism or communism; and although the worker-poet Gerrit Engelke realized that no historical epoch can truly liberate itself from its material conditions, he saw in the spiritualization of the material the way to a better world and assigned to art a crucial role in this process: 'Die neue Weltdichtung kann uns vom starren, unfruchtbaren Materialismus, zu dem unsre Zeit mit ihrem gesteigerten Aussenleben natürlicherweise neigt ... erlösen' (P365/227).

Engelke's ideal is not unique. In his story 'Das Liebespaar' Leonhard Frank not only blames materialism for the outbreak of the war but condemns it as the secret philosophy of the workers themselves, the victims of the war: 'Dieses rapid ins Geldverdienen hineingeratene Volk hat, aus einem öden Materialismus heraus, vor dem Kriege "hoch" geschrien, bei Kriegsanbruch nichts als "hoch" geschrien. Und jetzt schreit es nur deshalb nicht mehr hoch, weil der Magen schreit' (P367/131). Organized workers did not protest against the war, according to Frank, because their allegiance lay with an organization which only drilled them for the class struggle and for material advantages (131). Against concerns of this kind Frank proclaims the need for a return to spiritual values. His hero in 'Der Vater' claims: 'Die Kultur eines Volkes ist unabhängig vor der Besitzanhäufung,' a lesson which at the time of writing (1918) was by no means universally accepted (57). On the contrary, statements such as Frank's clashed rather violently with the claims of those who saw themselves as spokesmen of the working classes, and caused severe rifts in the camp of those authors concerned with the social welfare of the nation. Equally unwelcome must have been the claim by Heinrich Mann: '[die Arbeiter] verstrickten sich täglich tiefer in die Sorge, Gewinn zu ziehen aus der

Welt, wie sie ist. Ihr Denken war zuletzt kapitalistisch – mit Vorbehalt oder wissentlich oder in der Färbung der Heuchelei; aber kapitalistisch' (quoted S24/84). We are reminded of the much later portrait drawn by Bertolt Brecht of Mother Courage, another little person trying to succeed in the world as it is.

Wolfgang Rothe has characterized bourgeois society's two principal tenets, its two gods, as 'platter Materialismus und schamloser Egoismus,' qualities which most Expressionists attack with rigorous, at times desperate criticism (S201/229). At the same time Rothe notes about bourgeois society: 'Geltung und Wirklichkeit, Schein und Sein fielen ... hoffnungslos auseinander, Genusssucht und seelenlose Besitzgier, Machtstreben und Protzentum triumphierten nunmehr, die berühmt-berüchtigte "doppelte Moral" herrschte' (229). For it is the nature of the bourgeoisie to obscure its true motives by resorting to metaphor, idealization, and glorification. Materialism parades as 'Impressionismus' in Carl Sternheim's story 'Heidenstam'; in Heinrich Mann's 'Der Vater' we hear about the 'struggle for life,' and in Leonhard Frank's *Der Mensch ist gut* there is repeatedly talk of the national defence of the 'heiligste Güter,' which are, however, anything but holy. When soldiers are killed, according to constantly reiterated slogans 'in heiliger Sache,' and sacrificed on the altar of the fatherland, such linguistic manipulations obscure or intend to obscure the cruel realities of economics and *Realpolitik*. Many figures in Frank's novellen go through a learning process in which they come to realize the falseness of such clichés. In many of Ernst Weiss's stories the use of quotation marks denotes his intention to show how clichés are used, and almost all of Gustav Sack's works represent an attempt to combat clichés and kitsch.

Unfortunately, one of the most important sources of obscurantism, clichés, and kitsch is provided by art itself. In order to advance the most dubious claims of power and wealth, German classicism in particular was plundered for ammunition. Carl Sternheim has given us a most striking example of such use in his novelle 'Posinsky,' which is based on the tension between a straightforward philosophy of survival and a philosophy of life based on vague metaphysical references and allusions to literary and artistic models. The painter Posinsky's unique preoccupation with food, drink, and physical pleasure during the height of the First World War is contrasted with that of a young actor-couple whose experiences are drawn exclusively from the myths and illusions of bourgeois culture. To Posinsky 'schien des Leibes krasse Notdurft an der Metapher-

vergötterung Stelle erstes Kredo menschlicher Natur'; in view of the acute hunger all around him, he notes: 'Wichtiger als "Rätsel der Weltenseele," "Kritik aller Offenbarung" blieb ein Rezept, schmackhaftes Gemüse aus Brennesseln und Unkräutern zu machen' (P129 = P411/227). The dramatic works of Friedrich Schiller, which the couple next door are constantly rehearsing, seem to Posinsky to epitomize both the obscuring function of philosophy, especially German Idealism, and the true function of bourgeois metaphorical art. For Sternheim, poets have themselves become conspirators in the process of obscuring the true structures underlying society, which Expressionists were at pains to reveal as a society with a suppressive character (S201/230).

A whole series of organizational systems maintains this suppression by society. The most comprehensive, the state, is criticized in the very first issue of *Die Aktion* and regularly from then on (1911). Various aspects of state dominance enter into the discussion: the absolute demands which the state makes on its own citizens; its claim to represent justice, truth; its claim that it alone may make moral, even existential decisions. Though it would be wrong to claim anarchism as the appropriate term for most Expressionist political convictions, limitations to personal freedoms are fought with particular zeal. The criticism of the state is at least partly focused on its immobility, its inability to change and correct itself. Once again a vitalistic view of the world confronts a 'frozen' reality. Above all, the tacit acceptance of violence, brutal or subtle, as a means to maintain order is attacked repeatedly by Expressionists. Moreover, the state's tendency to throw up barriers against other states and to advance territorial claims, particularly in the age of imperialism, is seen as detrimental to international intellectual and artistic life. The behaviour of most states tends towards war rather than peace and isolation rather than communication.

In Germany, and especially in Prussia, theories about the state had emphasized the common interest over the individual and the idea of system over that of participation. When some authors, in their fiction, present figures who refuse to participate in the state, or rather to be dictated to, they choose options which are not to be mistaken for escapism but rather to be interpreted as gestures of protest. That such figures put themselves in a very precarious position by doing so is made clear in Gustav Sack's story 'Das Tagebuch eines Refraktionärs,' whose hero initially refuses to go to war for the state. Having become separated from his comrades during military activities, he is captured by the enemy but refuses to be returned to his own country: instead he chooses death. Sack

himself did not resort to such a drastic refusal and, tragically, died in 1916 for the state he had so categorically rejected. As we shall see later, the pacifist and internationalist orientation of most Expressionists, at least after 1915, put them in a position of alienation, their attempts to redefine the role of the state often being received with great mistrust. Whereas their attitude towards the military (the symbol par excellence of the oppressive state) exposed them to censure, imprisonment, and public outrage, the public's view of the poet as dangerous to the state made his messianic role all the more difficult.

In the Expressionist view of the churches, too, there is a criticism of power structures, obscured by the churches' claim to transcend earthly concerns. For most Expressionists, churches do not come under attack because of a general hostility towards religion. On the contrary, it is felt that the churches have become institutions whose spiritual concerns have been superseded by materialist considerations. Precisely the failure of the churches in the domain of the transcendental explains the search for spiritual values outside them. Furthermore, the claim of absolute authority in matters of morality, even of jurisprudence, is necessarily dismissed by Expressionists, as in the case of the state. The close connection between the churches and the state, their decline into mere instruments of the state, and the pact between throne and altar reveal to the Expressionists the essential identity of the churches as power structures. That this pact leads to increasing neglect of the social misery of the lower classes is predictable. Those Expressionists who consider the social question an integral part of their artistic activities cannot but attack all institutionalized forms of religion. Yet, as Rothe points out, the search for a religious dimension continues notwithstanding such outspoken criticism.

Though there is a general consensus in Expressionism about the nature and role of capitalism – specifically, that it corrupts and destroys society – the angle of attack of each Expressionist writer may vary greatly. Often capitalists themselve are the focus of attack; in such cases we may see in the capitalist another type of bourgeois. Since the tradition of Naturalism prevails, the capitalist as seen by Expressionists appears somewhat outmoded. Even in Brecht's work, we remember, the bourgeois is conceived of as a rather stereotypical villain, without much nuance. In this form he appears at the end of Leonhard Frank's novelle 'Die Kriegswitwe.' Well dressed, driving a carriage, the capitalist lands amid an angry crowd demonstrating against the war. When he attempts to halt the demonstration,

his carriage is overturned, despite the admonitions of the demonstration's leader. Frank advocates a peaceful revolt in these novellen: even the capitalist, according to his message, is capable of change.

Though the petty bourgeois is much more visible in Expressionist prose than the capitalist, there are some memorable portraits of the latter. Sternheim's Heidenstam, the hero of the novelle of the same name, believes that his enormous income places him safely above events. His capital is distributed over many segments of state and industry, from state and municipal bonds to munitions and arms factories. Manipulating large sums of money is for him one of the few true pleasures of life and a constant source of excitement. Heidenstam's financial position remains fairly secure, not only because he can count on the German popular character to protect and promote his interests, but also because God himself is on his side: 'Er lebte der Überzeugung: der liebe Gott war ein bewundernswerter Präsident der Gesellschaft "Deutschland," der bei billigen Löhnen gutem Verdienst für seine Heidenstams Bedürfnisse, die Geschäfte gehen zu lassen, verstünde' (P124 = P411, vol. 4/64). Church and state are working in harmony for the same goal, ever-increasing wealth for Heidenstam. Art and literature are to Heidenstam mere ornaments of life, ultimately tied to production processes which allow him his life of ease and unconcern – a way of life which Sternheim calls Impressionism. Heidenstam looks with suspicion on the tendency towards democratization after 1900. He resents the coming of new money. But even the outbreak of war at first only strengthens his position, since he now finds a way to exploit German nationalist sentiments. However, as the war continues, it proves to have an unpredictable and inscrutable character, and Heidenstam begins to make mistakes. In the end the war explodes the myth of his financial invulnerability; the 'iron age' destroys him. 'Heidenstam' illustrates the essential egocentricity of the capitalist, which causes him to look upon the world as his private property. In peace and in war, the world is subjugated to the wishes of the individual. State, church, art, and ideology are all means to one end: that of increasing the wealth of the few; morality and business have little if anything in common.

This message is reiterated in 'Yvette,' in which Sternheim argues that the social contract has no moral, only economic conditions (P134 = P411, vol. 4/384). The protagonist of this novelle lives accordingly. At birth Yvette is the heiress to an enormous fortune; she is constantly surrounded by people who pamper her, a faceless crowd of officious people, mere instruments of service. Any desire, material, spiritual, or sexual, is

instantly satisfied. There is neither deprivation nor censure in her life. In business Yvette's passion for financial deals, her aptitude for dealing with competitors, exceeds even that of her father, since she has absolutely no scruples. Like Heidenstam she uses institutions for her own benefit, and the apparent willingness of others to be exploited she accepts without question. There is something terrifying about Yvette's single-minded acceptance of her role: in both 'Heidenstam' and 'Yvette' capitalism has the appearance of something fateful, something in the order of the inevitability of the laws of nature themselves.

In 'Vanderbilt' Sternheim's portrait of the capitalist even acquires mythical overtones. By cleverly situating the perspective of the story in the mind of a hysterical woman, whose longing for the extraordinary has prepared her to see the millionaire Vanderbilt in a transfiguring light, Sternheim is able to describe the latter in religious and ecstatic language. Frau Printz's idolatrous attitude towards the powerful financier is not unique, however. Her own husband is not only in awe of Vanderbilt himself; he even sees greatness in his wife, because of her relationship with the millionaire (264). The mere mention of Vanderbilt's name in subsequent sexual encounters between the couple results in added titillation, until the husband 'mit jedesmal grösserem Respekt vor höheren Mächten in sein Weib verging' (265).

Perhaps the most powerful portrait of the capitalist was drawn by Heinrich Mann in 'Kobes.' But the capitalist system itself is also given a more intense and elaborate treatment in this story. Even more than in Sternheim's 'Vanderbilt' mythical overtones combine with satiric and grotesque elements to reveal certain basic assumptions about the capitalist system. Mann's novelle could be called a *reductio ad absurdum*; yet in its distortions and eccentricities the basic structures of captialism are laid bare and its inner, ultimately destructive logic is revealed.

In the allegorical opening, written in the nervous, paratactical, non-discursive style most often associated with Expressionism,[2] the middle classes, personified by a single messenger, run themselves to death in order to announce to the billionaire Kobes that he has once more been elected, to what is immaterial. The 'death' of the middle classes signifies that they are now integrated into the 'system' and part of 'Wirtschaft statt Staat' (P100 = P393/310). But the ambitions of Kobes's advisers do not end there. It is now the turn of the workers, for labour, as Marx taught, represents wealth (311). Human lives as such are of no consequence; it is the economic system which must survive. For this aim to be realized, all activities of the state must be subordinated to the idea that the state is,

above all, an economic unit. The government pays for the maintenance of industry's effective control of the state; scientific research is financed by the state but is intended to promote industry. War is a function of industry and finance, and subtle pressures to continue the war despite human sacrifices are exerted. Kobes buys up everything: economic enterprises, but also academic work such as that carried out by a 'little man.' The arts are enslaved: the actor Dalkony is first used to propagate the Kobes myth; then he is eliminated. In this futuristic yet chillingly recognizable state, organized to the point where there are 'Rayonchefs' even for things like 'Völkisches' and 'Parlamentarisches,' the workers are subjected to a constant stream of propaganda about the achievements of industry and the virtues of their employer. Kobes is called 'erhaben,' 'unser Grösster' (309), even 'Herr der Heerscharen' (320). So great is he in fact that there are doubts whether he really exists or is merely a mythical invention and the personification of the forces of nature (313). His fabulous wealth, too, even before 1914 an amount of one hundred million Goldmarks, and immeasurably increased by the war, grows to mythical proportions.

Kobes and an American millionaire conspire to divide the world between them: 'Die Weltwirtschaft wird glatt Privatsache' (325). Accused of being a swindler, Kobes retorts that he does not work for money alone; he prides himself on his morals and is shocked when his American partner proposes to have him sleep with his wife as a condition for their merger. In the interest of business, however, he must give in, but Privatdozent Sand proposes to rescue Kobes's 'moral personality' (330). In reality he plots Kobes's destruction by allowing events to demonstrate to the public that Kobes's activities must logically lead to the destruction of the capitalist system. The new myth, which consists of ever more extreme demands on the workers, climaxes in the demand for an absolute proof of submission through self-sacrifice in a burning blast-furnace. Sand's ambitions are discovered, however, and he is tricked out of his victory and invited to commit suicide. The Kobes myth continues, with the final, chilling consequences glossed over. Clearly, Mann's story is not meant primarily as amusement, despite its humorous exaggerations. Rather, it reveals facts usually obscured by metaphors. Sand's failure gives the Kobes myth and capitalism itself a quality in the nature of fate.

For many authors the clearest symbol of undiluted capitalism is America; it appears in this role especially in the Activist writings of Franz Jung (for example, *Joe Frank illustriert die Welt*), where it is coupled with vehement social protest. In Richard Hülsenbeck's 'Verwandlungen' America is the land where the German bourgeois flourishes best, as is illus-

trated by his hero's growing from dwarf-like stature to gigantic propor-
tions once he arrives in America. By contrast, his opponent, the artist,
shrivels to insignificance. The image Kasmir Edschmid presents in 'Der
Lazo' of the great metropolis of New York is equally problematic, though
for reasons other than (or in any case over and above) social criticism. In
the same story Edschmid celebrates quite another America in his depic-
tion of the wide-open spaces and (what he considers) the more natural life
of the cowboy. Perhaps the most positive image of the new world appears
in Robert Müller's 'Manhattan Girl,' a dreamlike sequence in which the
utopia is born out of mass civilization and the great city is celebrated in
almost hymnic terms.

Some more lucid authors are aware that the dominance of the bourgeoi-
sie is to a large extent dependent on the collaboration of the other social
classes. The lack of solidarity within the parties of the political opposi-
tion accounts for the absence of a true resistance against the exploitation
of the many by the few. In Paul Zech's story 'Der Anarchist' this fact is
referred to in passing when the engineer Valotti, who is in sympathy with
the cause of the strikers in the mines of the Belgian Borinage, attempts to
urge solidarity upon the workers during a union meeting. Amidst the
constant fighting and squabbling, his plea goes unnoticed.

Max Herrmann-Neisse and Max Brod have also given us portraits of
acquiescent and consenting members of society. The element of stasis in
bourgeois society is largely dependent on such yes-men, who pay lip-
service to the status quo, who hypostatize the powers in command, and
who glorify the rights and abilities of others to rule. In the figure of
August Nachreiter, protagonist of the novelle 'August Nachreiters Atten-
tat' (P14), Brod draws the character of a mousy bookkeeper in a large firm
who has allowed the management to exploit him for over twenty years
before he finally revolts – to no avail. Max Herrmann-Neisse's portrait of
'Die Klinkerts' (P64) is both analytical and satirical. The Klinkerts are
presented as a genuine social subgroup. They become representative of a
whole segment of German society. The Klinkerts are a historical phenom-
enon; they have a continuity and consistency all their own, and they
always act in predictable ways, which makes them eminently exploitable.
They accept the facile optimism of their rulers and are in the final analy-
sis in agreement with their oppressors. They can be manipulated through
propaganda, will extoll war, patriotism, and even revolution. As we follow
them through the chronicles of the First World War and the revolution, we
witness how their cringing attitude remains a constant throughout. Even
when the revolution seemingly opens up a possibility of escape from their

servitude, Joseph Klinkert, the head of the family, is cleverly manoeuvred into becoming an instrument of the restoration. To be sure, he does manage to profit temporarily from certain circumstances, but only to die for a cause that is not his. Herrmann-Neisse argues that even when they do get organized, the Klinkerts are incapable of questioning the status quo, and are exploited in the long run. Only at the end of the story, as the family gathers at the graveside of Joseph Klinkert, does the narrator for the first time abandon his tone of amused irony, finally to voice his anger towards these characters: 'Eine stattliche Menge. Wenn man sie über-blickt, denkt man: Gnade Gott, wenn die einmal zusammen unzufrieden werden und aufbegehren und die Welt für sich mit Beschlag belegen. Aber sie werden schon nicht. Sie sind stets hübsch manierlich' (P64 = P371/214). Thanks to the Klinkerts, 'eine weitverbreitete Art,' the propertied classes can remain at ease.

With the criticism of the industrial world of workers, bosses, factories, and capitalists, a complex looms up which leads us away from the world of the bourgeoisie to the modern western world in general. The criticism of the one is of course already contained in the other, since beyond the criticism of capitalism as such there is the criticism of the *results* of capitalism, the social problems posed by the industrial proletariat, the misery of large industrial cities, which the Expressionists knew only too well from personal experience, and the dangers of *Vermassung*. These problems lead them to question the basic assumptions underlying the idea of progress.

Especially the problem of *Vermassung* concerns the Expressionists, since for most of them the masses are at the opposite pole of what they consider an absolute value: the individual. In the confrontation between the individual and the collective, the masses are usually portrayed as a threat: they inspire fear; they are an incomprehensible force, formless, deprived of thought or judgment, always under the sway of demagogues and false prophets. But while it is felt by most that urbanization and industry destroy the humanistic values held high by the Expressionists,[3] the crowd can nevertheless be experienced as temptation. As the desire for integration grows, the collectivity increases in attraction. Since a major aim of Expressionists is to achieve a reunion with society (see the next chapter), the urban crowd at times seems to them to offer concrete means to achieve this. The 'curse' of individuation is given an alternative in the faceless anonymity of the masses. Thus Heym's 'Der fünfte Oktober' shows a dangerous fascination with their power, their energy

and potential. The same may be said of Leonhard Frank's series of novellen *Der Mensch ist gut.* Unfortunately, the latter's crowds are in constant need of leaders; their ability to change the world is dependent on the presence of strong personalities who may pose a threat of their own. Whereas Heym's crowd soon dismisses its leader (in fact going against his wishes), Frank's individualistic stance and his belief in the necessity of enlightened individuals prevent him from giving the crowd his full support.

Expressionism resorts to a much more abstract treatment of the masses than does Naturalism. In the latter movement the crowd still had individual faces – witness especially the last scene of Gerhart Hauptmann's play *Die Weber.* In Expressionism the masses are reduced to a mob, or a single individual or force. In the drama of Expressionism this is reinforced by the use of choruses, of uniforms, and by co-ordinated gestures and stylized body movements. Prose cannot go so far towards abstraction, but there is nevertheless a clear emphasis on the formlessness of the masses. Heym's story 'Der fünfte Oktober,' for example, sees the masses in terms of natural forces like storms and flowing rivers. There is indeed a tendency in Expressionism to allegorize the masses or to exaggerate their characteristics into grotesqueness. 'Objective' depiction is never a concern for Expressionist writers.

As we might expect, the scientific, technological, and industrial developments by which Expressionist writers saw themselves confronted are similarly never presented in a calm, objective way. They are always considered in light of the overriding question of whether they threaten the well-being of the soul or, by contrast, have potential as building materials for the future utopia. The treatment of specifically modern elements in the society of the early twentieth century therefore shows a peculiarly subjective bias on the one hand and a profound dualism on the other.

While in the last third of the nineteenth century a belief in steady progress was still very much alive (a good example can be seen in David Friedrich Strauss's *Der alte und der neue Glaube* [1872]), the turn of the century had brought the first doubts about its inevitability to the surface, partially because of a number of crises of adjustment in the 1880s. It was the very success of the rapid industrialization of Germany in fact which caused a series of disturbing features to become visible: 'Since every technical advance and industrial and commercial innovation caused painful dislocation in living habits, work and working-place, the environment, familiar social relationships, familiar ideas and expectations, a bewilder-

ing variety of conflicting attitudes fought for adherents,' writes Roy Pascal (S164/18). A general confusion about the role of technology and its consequences – industrialization, reorganization of society and human relationships in general – is therefore not surprising. Expressionists born around 1890 were faced by a number of ambiguities, and hence quite often expressed ambiguous attitudes themselves. Armin Arnold has shown that Futurism (whose influence on early Expressionism he discovers in Alfred Döblin and Kasmir Edschmid, as well as August Stramm) had a decidedly enthusiastic attitude towards technology (S10). There is praise for the speed of automobiles and airplanes in Edschmid's stories, and Döblin holds out a bright future thanks to technological innovations. K.-H. Daniels, after examining the literature just preceding Expressionism, comes to the same conclusion: 'Zu Beginn unseres Zeitabschnittes also wird das Thema Technik in jubelnder Bejahung unüberhörbar präludiert' (S33/172). He associates with this generally positive assessment of technology the latter's ability to change man's material world for the better. All the same, there is also a sizeable body of dissenting opinions about the blessings of technology – enough in any case to make Daniels conclude 'dass das Thema Technik und Arbeit den Dichtern alle Regungen zwischen Verzweiflung und Verherrlichung, zwischen Preisung des Tatmenschentums und sozialer Anklage, zwischen Verteuflung und Vergötterung abzunötigen vermag' (177). That the assessment of modern features in society underwent a drastic change towards uniform condemnation after the outbreak of the First World War will be shown a little later. It is safe to state here already that a profound hostility towards industrialization, late capitalism, and its social consequences was felt by many.

The gradual dissolution of a world-view in which God and nature were enthroned as dual principles of meaning and order played an important role in this context. A new reality, secular, scientific, non-metaphysical, bare of mystery and substance, had come about – a reality greeted by some as liberation, but more often with confusion and distress. It is a reality full of paradoxes, for it poses the question of whether its appropriate description is system or chaos, achievement or curse. Edgar Piel, in a profound book about the problem of subjectivity in modern literature, has argued: 'In einer Welt, die zum ersten Mal ihr Vermögen und ihre Fähigkeit zur eigenen und komfortablen Wohlorganisation realistisch in den Blick nehmen zu können glaubte, breitet sich zugleich die Angst aus, vor Enge ersticken zu müssen. Die Reduktion einer unendlichen Welt auf das umgrenzte Reservoir und allenfalls noch unendlich variierbare Reper-

toire all dessen, was am Ende der Fall ist, wurde mehr und mehr ahnungs-
voll als ein unrevidierbarer Prozess erlebt; ein Prozess, dessen Konsequen-
zen nur selten begriffen worden sind' (S174/117). Piel sees the *Angst* of
the early twentieth century in terms of reduction and restriction – as
being associated with too much system. The opposite view, that reality is
in fact unorganized, strange and unknowable, is not a contradiction of this
fact but an obscurely understood parallel truth. For the kind of thinking
which frantically organizes its knowledge 'vor einem versinkenden Hin-
tergrund' (P339, vol. 5/575) obviously attempts to cover up its own aware-
ness of the essential unknowability of the world.

For the Expressionist author the question of scientism has even more
important ramifications. When an all-pervading tendency towards defini-
tion, classification, and, consequently, reification is present in modern
industrial society, the ability of the artist to function is severely limited.
According to Wilhelm Emrich, the writings of the moderns reflect the
concerns of artists living in a society whose perception of the world is a
thoroughly rational one. The artist finds himself therefore confronted
with a thoroughly rational and 'constructed' language, used as a tool to
subjugate reality, a language 'in der alle unmittelbaren seelischen Aus-
drucksmöglichkeiten einem System berechenbarer und mechanisierter
Vermittlungsbezüge aufgeopfert werden' (S53/138). This constructed lan-
guage, the result of the scientific and technological world-view, has lost
the ability to make statements about the inner, essential man. Moreover,
the tendency to use language to subjugate nature results in the subjuga-
tion of man himself: the subject becomes an object to himself. The desire
of the poet to break out of this impersonal, supra-personal language, to
express the *human* condition, is central to the moderns and to Expres-
sionism. It leads to the realization of a *Sprachnot*, whose history Inge Jens
has traced back to Hugo von Hofmannsthal's Lord Chandos letter and
whose influence she shows in the writings of Musil, Rilke, and Kafka
(S97/31–108). Ironically, of course, a language which makes of man a mere
object demonstrates at the same time the ability to make of the object a
'riddle': man is reduced to an object, and the object is reduced to a mere
imagining of man.

Some early Expressionists did indeed have a dark awareness of the
inhumanity of the scientific world-view; others warned of the futile hope
of expecting from science the salvation of a doomed society. The rejection
of science as a means of revelation of meaning is in fact quite widespread
in Expressionism. Carl Einstein claims: 'Die Wissenschaft ist stofflich zu
doktrinär und nicht unmittelbarer Seinsinhalt, da sie jeweilig bewiesen

werden muss, warum sie als unmittelbarer Akt ausscheidet. Sie ist lediglich Spiel der Denkkategorien und variiert gemäss den kontrastierenden Antagonismus des Denkens' (quoted S170/54). A similar interpretation of 'Denkkategorien' can be encountered in the work of Gottfried Benn (see chapter 7). All of the *Grotesken* of Mynona (Salomo Friedlaender) are inspired by the wish to replace a scientific world-view with that of magic, fantasy, and imagination. The *Groteske*[4] is indeed a singularly appropriate vehicle for the projection of alternative worlds in which a different law and logic operate. At the same time this form also allows Mynona to depict, under the guise of the cosmic fantasy, the utopia of the New Man, as for example in 'Der Sonnenmissionar.' Mynona's anti-scientific writings (often in the form of satire, as in 'Eines Kindes Heldentat') unite the subjective view of all Expressionist art with the longing for the New Man. Characteristic of Mynona's philosophy is his statement 'Der Mensch projiziert seine eignen Leblosigkeiten als Naturgesetze. Der Mensch und mit ihm seine gesamte Natur ist so scheinlebendig wie scheintot. Das Zerbrechen der identischen Weltseele in diese Menschenscherben, deren armseligster Splitter noch von Göttlichkeit brilliert, ist tragikomisch. Sie konstatieren eifrig Naturgesetze, ohne die innerste eigne unermesslich schöpferische Freiheit zu erkennen, der diese entstammen' (P333, vol.1/97).

Despite such early awareness of the problematic nature of science and technology, the connections between the modern world and the pre-conditions for it were not often realized until the war. But around two images, those of the city and of the machine, there crystallizes even in early Expressionism an as yet obscure awareness that certain modernist tendencies have potentially catastrophic consequences.

Both images appear in a particularly striking story by Alfred Lemm, 'Weltflucht.' It is the story of a young man who commits suicide under circumstances which lead his family and friends to conclude that he must have become mad (P88 = S335/245). We are soon made aware, however, that other reasons exist: there had apparently been no relationships with other people, and the narrator himself suggests that suicide seemed to Henry easier than compromising the purity of his soul by living in this world. Henry has in truth become the victim of the catastrophic clash between his over-sensitive soul and an absolutely hostile environment. A number of confrontations are briefly described in the story: in one episode, at a social gathering, Henry hears men discuss their most private moments with women but notices that they hide the truth about their

financial affairs (247). He sees fathers react violently to sons and hears men proclaim support for freedom, morality, and public education, as long as it costs nothing. Soon he comes to the conclusion that there is no purpose in maintaining relations with people.

A truly terrifying event for him occurs when he witnesses the return of a holiday crowd to the city. The description unites two elements which are of immediate interest to the present discussion: the machine and the crowd:

In der Ferne schwoll ein Rasseln und Pfeifen. Eine Welle lief durch die Menge. Die Köpfe reckten sich. Ein Sausen unter der Erde und vom Himmel kam näher. Die Steine des Bahnsteigs zitterten. Die Menge dehnte sich und zog sich zusammen. Dann öffnete sich unter eisernem Brausen weit zwei grosse gelbe liderlose Augen und betrachteten gemessen und herrschbewusst die Wartenden. Die Vordersten wurden fast auf die Schienen gedrängt ... Männer und Weiber zerrten einander an den Gliedern um den Vortritt. Sie benutzten die Arme als Hebel, um andere vom Platz zu schieben ... Sie bohrten mit den Fäusten in die fleischerne Masse der sie Umgebenden oder hieben sich mit ihnen den Weg frei. Kläffende Kinder wurden von schreienden Müttern in die Höhe gehalten. Junge Leute aus den hinteren Reihen sprangen auf die Rücken der Vordermänner und gelangten durch die Fenster in den Zug. Sich quetschend und die Kleineren zertretend schob sich die Masse ineinander und riss sich Kleider und Haut ab ... Fussgelenke zerkrachten splitternd in zugeschlagenen Türen. Händefleisch wurde in wütenden Angeln zerquetscht. (248)

Henry, who has observed from the sidelines, decides not to return to the city but instead to remain in an inn in the village, where he can lead a simple life. Here he recovers enough to face the city once more. But already in the train on the way home he fears the latter's approach: 'Durch die breiten Fenster stach ein spitzer weisser Funke in seine Augen, dass sie brannten. Dieses mörderische elektrische Licht ging von einem glitzernden Fabrikgebäude aus, das wie ein grosser Operationssaal mit vielen blanken, tödlich scharfen Instrumenten in der ersten Sonne blitzte. Da wusste Henry, dass die grosse Stadt nahe war; und er merkte mit ohnmächtigem Zorn, wie sie seine Stärke davontrug' (252). This does not augur well for the renewed confrontation between Henry and the city, and one early morning the second catastrophic encounter with a hostile reality takes place. This time it is the city in its most oppressive aspect: 'Die Stadt war bedeckt mit den schalen Abfällen eines wahllos verschlungenen Nachtmahls, an dem sich alle Einwohner beteiligt hatten. Wie

Bissen, die von dem einen ausgespuckt, vom Nebenmann wieder gegessen und wieder ausgespuckt waren, standen die Strassenmädchen speichel-beschmutzt auf den verlassen weissen Tischdecken des Asphalts. Gleich gebrauchte Servietten war Papier herumgeworfen. Umgestülpte lagen im Rinnstein' (253). To protect himself against further confrontations of this kind, Henry moves to the suburbs. But he must face one last ordeal: in a grotesque scene in a lawyer's office he must submit to the inhuman procedures of state and bureaucracy. He does not survive.

In its melancholic tone, its subdued resignation, the story seems to belong to a period some time prior to Expressionism. But in three instances the atmosphere of moody, death-oriented fatalism is decidedly ruptured, and in each instance we are dealing with an unambiguously modern phenomenon. At these points, grotesque elements enter upon the scene: the anthropomorphizing or rather demonizing of the machine, the degradation of humans into objects to be swept away into the gutter (we think of Kafka's *Die Verwandlung*), and the transformation of faceless clerks into law-books, quoting the state's prerogatives while confronting pathetic, mentally disturbed citizens. In these instances Henry faces the 'Schrecken der wahren Wirklichkeit' (Piel) and is destroyed by it.

To Lemm applies what Wolfgang Rothe has said about most Expressionists: 'Die Maschine begegnet ... bei expressionistischen Autoren als das dem Menschen feindliche Prinzip, als eine auf sein Verderben zielende Macht' (S201/245). This is not only because the machine is devilish, but because it symbolizes what lies behind it: the transformation of all reality into a kind of gigantic, all-embracing machinery and the reduction of man himself to a mere machine. Industrial machinery in particular is interpreted as a curse, as a tool of enslavement and impotence. The machine is an instrument of exploitation in Paul Zech's cycle of novellen, *Der schwarze Baal*. Machines, workers, bosses, capitalism, and materialism are all intertwined; together they create a system in which work is reduced to a form of slavery. In the factory the worker sinks to the level of yet another machine, to the level of statistics and brute facts. In the chain of production he is not a goal but a means. In Expressionist drama the indignation of the workers is sometimes directed towards the machine in an atavistic way. The awareness that the workers themselves are mere tools does not go beyond an immediate, destructive impulse. But when in Toller's *Masse-Mensch* the chorus of young female workers chants 'Nieder die Fabriken, nieder die Maschinen,' Toller has his heroine Sonja correctly point out that the return to pre-machine conditions is 'ein Traum von Kindern, die vor der Nacht erschreckt.' Instead, she suggests

that only the elimination of the system of exploitation itself can create conditions in harmony with man's dignity.

Particularly indicative of the confusion created by technology is the frequent oscillation between the view of the machine as a symbol of an all-pervasive *control* (which extends to human lives also) and that of it as a symbol of a complete *loss* of control, because the machine itself is soulless and senseless. At the same time, the machine itself can get out of control, causing in turn the breakdown of industry, the city, and mass society. The most obvious instance of this breakdown is of course war, and it is therefore not surprising that the fight against war takes the shape also of a fight against civilization itself. The very mechanistic way in which the First World War was declared ('war by timetables'), the inability of the politicians and strategists to stop the mobilization once it had started, all this becomes itself proof of the limitations of a mechanistic society, in which all power is concentrated in the hands of a few engineers.

Of course the Expressionist hostility to machinery has above all to do with the tenacious struggle of the individual to maintain his own inalienable character. When Sternheim attributes the objectionable state of modern man to the mechanization of life, when Georg Kaiser's billionaire's son (in *Gas I*), convinced that man has sacrificed his soul, advocates a return to nature, we are witnessing not only an attempt to turn back the clock but also the attempt to reclaim an ego which has become increasingly vulnerable during the nineteenth century. Certainly the positively phrased early Enlightenment view of man as machine (La Mettrie) is countered by Expressionism's view that man and machine are irreconcilable enemies. Man, after all, represents 'life,' the machine dead matter. In this view technology stands in violent contrast to all those values which Expresssionism claims as absolute: spontaneity, soul, freedom, expansion, mystery, substance.

'Neben der Industrielandschaft steht die moderne technisierte Grossstadt als typische Lebensform unserer Zeit,' writes K.-H. Daniels (S33/177). The city, like technology, is described in Expressionist writing in terms oscillating between enthusiasm (primarily for its energy) and fear (of its monstrosity, hostility to man, and its destructive qualities). Some poets, such as René Schickele, are fascinated by the optical and acoustical elements of the city. They see the city as a machine, and stress its rationality and purposefulness. Others see the city as a new Sodom and Gomorrah. For Hugo Ball the city is but one more element contributing to the destruc-

tion of the old world-view. In the mass culture of the large city he sees one more reason why a revision of thinking and of art has become necessary: 'Das Individuelle Leben starb, die Melodie starb. Der einzelne Eindruck besagte nichts mehr. Komplektisch drängten die Gedanken und Wahrnehmungen auf die Gehirne ein, symphonisch die Gefühle. Maschinen entstanden und traten an die Stelle der Individuen. Komplexe und Wesen entstanden von übermenschlicher, überindividueller Furchtbarkeit. Angst wurde ein Wesen mit Millionen Köpfen' (P160 = S8/125). This evocation of the metropolis poses the question of the correct approach by which such a monster can be understood. Ball's is a cognitive as well as an artistic question, more typical of Expressionism than the purely moral and social emphasis of the Naturalists, who had after all already tried to cope with the city in their day. A similar emphasis can also be seen in Otto Flake's essay 'Von der jüngsten Literatur,' in which he describes Expressionism as resulting at least partially from the fact that its authors lived in large cities. The *Lebensgefühl* of city dwellers is obviously quite different from that of the inhabitants of small towns or of the country. This is expressed in a different kind of mental disposition (P195 = P329/60). Flake has taken over a theme which Georg Simmel had already treated in 1903 in his essay 'Die Grosstadt und das Geistesleben,' in which he wrote: 'Die psychologische Grundlage, auf der der Typus grosstädtischer Individualitäten sich erhebt, ist die Steigerung des Nervenlebens, die aus dem raschen und ununterbrochenen Wechsel äusserer und innerer Eindrücke hervorgeht' (P273 = S8/116).

Flake's interpretation of the metropolis is relatively neutral. Such assessments are rare, however; far more frequently, violent opposition is expressed. In such cases the city is *not* experienced as an aesthetic phenomenon, or even as a possible sociological option. In Lemm's 'Weltflucht' it is unambivalently the antechamber of Hell. Its filth, its degradation and dehumanizing aspects are not open to analysis, for the impact of the city is too great: what is given is a totality. The protagonist's reaction to the city does not need to be elaborated; the vocabulary tells all. And what Lemm does in 'Weltflucht,' Alfred Wolfenstein and Georg Heym do in both poetry and prose. They demonize the city, or tend towards the grotesque. 'Die Stadt ist lange sentimental gesehen worden,' writes Oskar Maurus Fontana, 'mit dem Blick des hinzukommenden und entwurzelten Provinzlers.' New ways of seeing the city have been unsuccessful, however. The trouble is that the city lends itself badly to any definition: 'Eine sinnlose und luftlose Aneinanderhäufung von Häusern wurde Stadt genannt' (P200/1653). What is observed often overwhelms the observer

and escapes him, rendering him powerless. To overcome this sense of impotence, Paul Zech proposes, in the sketch 'Auf der Terrasse am Pol' (P157 = P335), the pursuit of the self as an antidote. The narrator, sitting on a terrace collecting the multiple impressions about his surroundings, gradually, from an initially neutral viewpoint and simple observation, gains a certain understanding of the city, an insight into the ambitions, lust for power, and sexual experiences of the ever-changing crowds. Out of seeming disparity there grows a totality which suggests uncertainty and strife. More importantly, life in such a totality (a mob) must inevitably lead to a loss of humanity. Faced with this danger, the ramifications of which he has come to understand during the process of gathering and abstracting, the witness himself gradually creates a certain distance; he refuses to become completely involved: 'Wohl ahne ich die letzte Armut. Ich ahne die Art ihrer Geschwister und will mein Leben hindern, in das familiäre Blutmeer zu fliessen' (194). Inevitably, by refusing to immerse himself totally in the city, the narrator-observer becomes an individual living on the margin of society, 'ein brennend Angezogener. Ein Abgestossener' (195). He defends himself against the pull of the city by retreating, and he prophesies the end of this carousel in his anticipation of the First World War, which will end it all.

On the positive side, modern man dwelling in the city has greater freedom in the choice of roles he may decide to play. This opinion is expressed by Kurt Pinthus, Kurt Hiller, and by Otto Flake. But there is again another side to this freedom, namely the possibility that the very multiplicity of roles may lead to the elimination of the core personality, that identity may become fluid, that the borderlines between individuals may be effaced because of the reduction to stereotype. Carl Sternheim, for example, interprets the acceptance of many roles as a form of escapism, as an abdication before the greater demands of the *eigene Nuance*, the inalienable immanent and innermost character of the individual. Thinking about the nature of the city even results in a different treatment of prose itself. The city is responsible for the discovery of new narrative structures. In Lemm's 'Weltflucht' it is the use of the perspective of the disturbed mind which makes the statement about the city appear so forceful. The bipolarity of city and country, with exaggerations in the descriptions of both, not only makes up the content of the story but also provides its structure. In the same sense the use of a single centre of consciousness at its most subjective, in Zech's 'Auf der Terrasse am Pol,' paradoxically brings out to best advantage the complex character of the city. At other times, the use of multiple perspectives of narrative, as for

example in Döblin's early stories, seems more appropriate. Still other methods are possible – for example, the use of an 'objective' style, which conveys the nervous pace and hectic character of the metropolis. The syntax itself is often used to serve this goal, as in Döblin's 'Der Kaplan' and 'Die Helferin,' both of which take place in large cities.

If doubts about the direction in which society was going were in evidence before 1914–18 (though perhaps as intuition rather than as theory), the outbreak of the First World War can be considered the watershed in the discussion of the idea of progress. If one viewed technology in a positive way, the enormous potential that was laid bare by developments in Germany up to 1910 seemed to warrant the belief in an unbroken progression towards a reconciliation between the social classes, between the individual members of these classes, and between nations. Associated with the enthusiasm of orthodox bourgeois thinking for technology, the machine, and the factory was the idea of ever-expanding wealth, leisure, and freedom from want. Utopian theories before the war suggested that communications would facilitate harmony and establish general prosperity. Yet in the minds of more sceptical thinkers the discrepancy between progress in a technical sense and in a moral sense became ever more obvious. When war broke out, it was suddenly clear that technology could serve the cause of a narrow nationalism, that it could find a perverse perfection in weaponry, and that the strategy behind industrial progress could also precipitate a moral and economic catastrophe. This realization took time, however. Even before the fact, war had seemed to some to be desirable as an alternative to the boredom and banality of everyday life. Because it also seemed to be an antidote to the perils of modernism, the war was enthusiastically welcomed, not as 'politisches, ökonomisches oder militärstrategisches Geschehen, sondern als qualitativ neue Erlebnisquelle' (S8/294). Even in artistic circles the war was greeted as liberation, as a welcome affirmation of the essential correctness of Expressionist art and philosophy. Friedrich Markus Huebner wrote: 'Der Krieg ist nicht der Verneiner der sogenannten Neuen Kunst, sondern sein ungeahnter, sieghafter Zu-Ende-Bildner' (P222 = S8/312). War, in its early stages, was understood as a vitalistic moment, as an odd mixture of collectivism and individualism. With the feeling of national purpose was mingled at the same time the idea, soon shown to be illusory, that individual courage, the personal gesture, fuses with the will of the collective. Silvio Vietta writes:

Man sah sich mit Schwert und Schild nach dem Muster alter Heldensagen in den

Kampf gegen den Erbfeind ziehen und wurde in Wahrheit als 'Menschenmaterial' in grosstechnischen Materialschlachten verheizt. Man sah sich rauschhaft in Heldenpose 'hervorbrechen' und erlebte sehr bald das Grauen und die Banalität der Grabenkämpfe an der Front. Man glaubte in einen 'Heiligen Krieg' für Gott und Vaterland zu ziehen und war in Wahrheit Opfer einer seit Jahren fehlgesteuerten Aussenpolitik geworden, jener imperialistischen Machpolitik aller Grossmächte, die in ihrer Mischung aus Drohgestus und latenter Angst schon lange vor Kriegsaubruch mit dem Krieg gespielt hatte. (S235/194)

By 1915 it had become clear that the German nation in general, and German intellectuals to perhaps an even greater extent, had been the victims of what Vietta considers the main three fallacies about the war: 'Fehlsteuerung der politischen Einbildungskraft durch die Sprache,' 'ersatzreligiöse Aufputzung nationalistischer Machtpolitik,' and 'das rauschhafte vitalistische Pathos' (195-6). By now the war had come to seem chauvinistic folly. William II's idea of a *Volksgemeinschaft* was recognized to be a poor substitute for those principles which Expressionists had preached before 1914: fraternity, community, non-violence, and world citizenship. As early as 1 August 1914 Franz Pfemfert had stated in *Die Aktion*: 'der Chauvinismus ist die ständige Lebensgefahr der Menschheit. Er, allein er, kann über Nacht aus Millionen Vernunftwesen Besessene machen' (P258 = S8/203). Even Social Democrats, Pfemfert notes with bitterness, failed at this moment because they had been drilled in nationalism for years. Franz Marc, writing from the front in 1916-17, had come to the same conclusion; though not abandoning all his esteem for Germany, he wrote: 'Der kommende Typ des Europäers wird der deutsche Typ sein, aber zuerst muss der Deutsche ein guter Europäer werden' (P245 = S8/305).

In war, many contemporaries of Pfemfert and Marc felt, certain aspects of modern civilization merely showed themselves in a more pronounced fashion; in their view war was not a contradiction of nineteenth-century developments but their logical extension. Sigmund Freud, in the essay 'Zeitgemässes über Krieg und Tod,' wrote in a subsequently censored passage that the state had claimed a right which it denies its individual citizens, that of violence in all its forms (P201 = S8/318). The violence inherent in the pre-war state had shown itself publicly: the Expressionists could not but draw their own conclusions, and the consensus against the state was close to unanimous by 1915-16. The critique of the war, by turning its attention to causes rather than events, therefore broadened into a critique of civilization, and of the notion of progress. This was

clearly the intention of a series of articles in *Die weissen Blätter* of 1918 by Svend Borberg. Their sheer size (one fifth of the one hundred pages of the first quarter of the year) indicates the importance that the editor, René Schickele, attached to these articles. Borberg tries to illuminate the causes of the war, and he finds them in the social development of pre-war Europe, of which the political constellations are but the symptoms. For him, the dominance of the natural sciences in the nineteenth century is to blame for the spiritual and moral decline of Europe. Utilitarian thought has neglected ideals; the emphasis on technology has led to a complete disregard for mind, heart, and soul. Europe has been drawn into the war not by a few demagogues but by the pre-war *Zeitgeist* itself. Technical speed has far outpaced the speed with which individuals and nations once exchanged ideas. Borberg therefore comes to a fatalistic view of the war as a direct and inevitable result of pre-war conditions. War is symptomatic of a crisis in Western civilization. This entails, however, that a reorganization according to an *inner* transformation must precede the establishment of a new society. As is the case with Leonhard Frank, specific questions about the establishment of peace, of the economic and social restructuring of nations, remain conveniently outside of Borberg's discussion – a typical, though of course regrettable, symptom of Expressionist thinking.

Schickele himself echoes Borberg's sentiments in a number of essays in *Die weissen Blätter*. Just before the end of the war he reiterates the dichotomy between spirit and matter; he makes the machine responsible for man's loss of soul, though in reality the machine is but a *pars pro toto* for industrialized society, against which his criticism is ultimately directed. Schickele's essentially conservative attitude can also be observed in his reaction to the Bolshevik Revolution of October 1917. His hopes for non-violent change in Russia, which had made him react positively to the February Revolution, had now been dashed. He rejects, therefore, the second revolution and maintains his earlier position of non-violence: 'Ich hoffte auf eine Revolution durch keine andere Gewalt als die des Herzens, der Überredung und des frohen Beispiels' (quoted S117/45).

Schickele is by no means unique in this conservatism about fraternity based on the heart. Even for socialists and anarchists the binding elements in society are spirit and soul, even after the war. An extreme example of anti-modernism can be seen in Paul Kornfeld's essay 'Der beseelte und der psychologische Mensch,' mentioned earlier, in which he shows a turning away from all sociological aspects of modern life to a purely spiritual concern. No longer interested in social evils of varying

degrees, Kornfeld turns his attention to the metaphysical question of good and evil. Absolute good replaces proposals for a 'better' society, since for Kornfeld the first is the inevitable pre-condition for the second.

There is in all this a surprising continuity in thought between the period before and after the war. With regard to the 'true' principles of the desirable society this can also be shown if one compares Erich Mühsam and Ludwig Rubiner. Mühsam, while discussing Gustav Landauer's projects for a renewed society, had already in 1911 sketched a society based on groups with common interests rather than bureaucratic structures (P252 = S8/256). Ludwig Rubiner, writing in *Zeit-Echo* 3 (1917) returns to the same themes, even the same vocabulary for *his* vision of the new society (P267 = S8/258). He too sees the new as a return to the old: 'Es ist Zeit, vor dieser Neuordnung ... sich auf sein Gewissen zu besinnen. Auf die eigentlich sittlichen Fähigkeiten. Auf den eigenen Trieb zur unbedingten Hingabe an das Geistige' (259). In this later phase of Expressionism the word 'Gemeinschaft' tends to replace 'Gesellschaft' as indicator of the social ideal – witness Franz Blei's essay 'Philosophie und Gemeinschaft' and Ludwig Rubiner's 'Die neue Schar.' There is even a religious aura around the idea of community, as can be gathered from Kurt Hiller's 'Der Aufbruch zum Paradis.'

Christopher Eykman has shown that such ideas are based on models of community which lie partly in the past and are partly geographically removed from modern Germany. He cites as sources the communes of the Russian and Swiss models (the *Allmende*), Tolstoy's writings, Tönnies's *Gemeinschaft und Gesellschaft* (1887), and Paul Tillich's *Masse und Geist* (1922). But he comes to the conclusion that 'der Expressionismus ... kein konkretes Modell einer neuen Gesellschaft vorgelegt [hat]. Er hat aber seine Vorstellungen von einer besseren und menschlicheren Gesellschaft auf eine kleine Zahl soziologischer Grundbegriffe ausgerichtet' (S56/28). These few main ideas fit completely within the basic philosophy of Expressionism: they are consistent with it, but also open to all the criticism levelled at Expressionism in other areas. Radically different, often atavistic modes of social life are substituted, but the proposals remain vague and the techniques to propagate them ineffective. The deeper reason for this failure lies in the fact that Expressionist literature of protest is not so much inspired by specifically German conditions as by a more general 'Unbehagen in der Kultur.' This is borne out by the abstract, sometimes timeless quality which characterizes not only the fiction but also the social programs of the movement. Certainly in their fiction the Expressionists preferred a quasi-allegorical treatment of con-

temporary problems. Richard Samuel has claimed that this allegorical treatment 'added to the strength and effectiveness of their attacks' (S204/ 89); at the same time such allegorizing is sharply condemned by Lukács, Ladislao Mittler, and Hans Kaufmann.[5]

The reasons for the particular slant with which Expressionism approached the question of social criticism is clear. As the essays by Hugo Ball, Otto Flake, and Paul Kornfeld indicate, behind the structures of society there lie, the Expressionists know, the assumptions on which such structures are based. Behind the factory and the machine is postulated an unremitting belief in science, progress, rationalism, analysis, and law. The reification of man is the result not merely of a manipulation by capitalism (reducing man to the function of consuming and producing): this dehumanization is also the result of man's being reduced to a scientific object. As early as 1910 Erich Unger had warned against the tendency to treat man as object of science. Intellect is by nature driven to dogma, according to Unger, and the close of the nineteenth century had led to a seemingly complete view of reality. But the period around 1910 is one in which the 'umfassender Standpunkt' has been shown to be illusory (P283 = S8/118). Nietzsche, whom Expressionists looked upon as their great predecessor, had already shown the effort to create order in a chaotic universe as a futile though forgiveable weakness of mankind. What has become problematic is that man has increasingly to resort to subterfuge; he must 'fool' himself in order not to panic before chaotic reality: 'Am Ende der Erziehung des Menschengeschlechtes steht deshalb der mit Scheuklappen von der Wirklichkeit abgekehrte Mensch,' writes Edgar Piel. Modern man is a manipulator who is himself manipulated, a classifier of objects who has himself become one of these objects (S174/113). To break out of this vicious circle, not only a rejection of the manipulating structures of society but also of those of his own thought processes is necessary. Hence the metalanguage of Sternheim, the anti-psychological writings of Döblin, the cosmic fantasies of Mynona. We are back to the pre-conditions of the movement outlined in the previous chapter: in Expressionism all parts belong together.

In the long run Expressionist efforts to create *ab ovo* a new society were futile, in the social as well as the intellectual realm. To change reality via radically different thought and art, to transform the existing social battlefield into a utopia – for this Expressionism was not strong enough, nor, probably, could any other artistic movement have been, though it was the stated intention of Expressionists to do just that. No other artistic movement has so emphatically felt itself to be at the end of

one development and the start of another. No other movement in art has so strongly felt that decisions were to be made not only of artistic but of historic and social significance. Heralding apocalypse and rebirth, the Expressionists attempted to deny two hundred years of 'enlightenment,' secularization, science, and technology for the sake of spirit and soul. The Expressionist movement is perhaps the last movement in literature in which the idea of art as a means of salvation and of the artist as a prophet could be discussed seriously. To this complex we must turn in the next chapter.

FOUR

Art and Society

URT MARTENS, in his book *Literatur in Deutschland*, published in 1910 – that is, roughly contemporary with the beginnings of Expressionism – writes: 'es liegt eine Kluft zwischen den jungen deutschen Dichtern und der deutschen Gesellschaft, so schwer zu überbrücken wie nie zuvor' (P246/187). The poet, according to Martens, seems to be a useless member of society, almost its natural enemy, whereas the profession of author is the most despised (184). The author responds in kind, by showing contempt for society. Only superficial optimists and authors willing to compromise are loved. Most writers, however, be they in pursuit of an 'inner world' or in search of beautiful forms, share a turning away from their contemporary world. This situation is dangerous, 'von gleichem Nachteil für die Entwicklung unserer Dichtkunst, die einer steten Befruchtung aus dem unmittelbaren Leben der Gesellschaft bedarf, wie für das Ansehen der Dichter selbst, deren Werke an Resonanz verlieren, wenn sie selbst zu Parias herabsinken' (188). With prophetic insight Martens warns that the inevitable consequence of the rupture between art and bourgeois society will be that artists will embrace the proletarian class, an idea which he obviously finds unnatural and repulsive.

Martens's assessment gives us in a nutshell both the actual contemporary situation from which Expressionism starts and one of the options of which it availed itself in the course of its history. But it must be admitted that Martens reduces the problematic dichotomy between artist and society to a few catchwords; he notes the rupture without explaining its historic roots. For a real understanding of the socio-aesthetic aspects of Expressionism it is essential to grasp the fact that this art movement is not only a beginning but also stands at the end of a development, namely

that of the growing isolation of the artist during the nineteenth century. Around 1900 the relationship between artist and society enters into a crisis stage, which has been described in detail by H.W. Rosenhaupt (S198).

Art in the nineteenth century undergoes a change of function which is the result of a contradictory development. On the one hand, secularization allows art to fill a spiritual and ideological vacuum. Paul Kluckhohn writes: 'Was Menschen früherer Zeiten von den Priestern und Propheten, in zweiter Linie wohl auch von den Philosophen erwartet hatten, das erwartet man nun, nachdem die geistige Säkularisation fast durchgeführt war, von den Dichtern: Lebensdeutung und geistige Führung' (S111). On the other hand, art is clearly perceived as a realm *outside* of social reality and without a true social function – hence Rosenhaupt's contention that Kluckhohn's statement needs further elaboration: 'Vielmehr drückt sich in der Wendung des Bürgers zur Dichtkunst als lebensformender Macht nicht nur die geistige Säkularisation aus, sondern das Bestreben, notwendige Umstellungen dadurch zu erledigen, dass man sie im Reich der Kunst vornimmt, das für die Wirklichkeit nicht verbindlich ist' (S198/12–13). Art as substitute not for religion but for political action, as escapism and the refusal to come to terms with the need to transform society – it is a familiar theme, often considered a typically German phenomenon. But precisely because literature itself is changing, becoming politicized, the attempt to escape into art fails towards the end of the century. Moreover, the artists themselves, in turning to social problems around 1880, discover that they are, and have been for some time, in a state of antagonism towards society: 'Indem der Dichter sich der Wirklichkeit zuwendet, wird ihm der Abgrund zwischen sich und Gesellschaft bewusst und es kommt zu einem Phänomen, das wir hier als Abgelöstheit bezeichnen. In dieser Formulierung drückt sich aus, dass der Dichter im Gegensatz zu anderen Epochen der Literatur seine Isolierung schmerzhaft als Entfernung von seiner Bestimmung auffasst, dass ihm ein innigeres Verhältnis zu einer Gesellschaft vorschwebt, von der er sich entfernt, getrennt, abgelöst empfindet (15).'

Two main points are made by Rosenhaupt: the artist finds himself in a position of isolation, and he feels that this isolation is somehow unnatural. It is a *prise de conscience* to which two possible responses suggest themselves: criticism of society and criticism of one's own position. In both cases there is a question of guilt.

It is typical of the first response that it is not so much the social and economic system which is criticized but the emptiness of bourgeois life.

There is an obvious link here between Naturalism and Expressionism. The norm whereby the *Bürger* (as a product of stagnation) is judged is already available in Naturalism, namely in the concept of *Mensch*. We can see this in certain dramas and some prose writings of Gerhart Hauptmann. Even in the late Hauptmann one may find the conflict between a free and noble human being and the mean and superficial world of the bourgeois. But it is not only because the artist, in contrast to the *Bürger*, still carries within him the standards of a morally and spiritually vital existence that Naturalists and Expressionists argue against existing society; they also argue in favour of the exalted status of art itself within society. Artists who are concerned about their own reintegration into society and the enthronement of art as moral and social force are soon forced to admit that there no longer exists an ethical norm or an organic unity in society but that society is held together merely by accidental relationships of need. But where such organically binding values are absent, art cannot flourish. Art in a society in decay has no function. The crucial importance allotted to the creation of a 'community art,' especially in the form of drama, must be seen against this background. Heinrich Mann's efforts to create a truly 'social' novel also belong in this context. Mann found his inspiration in the French novel because he felt that such an organic social whole existed in France rather than in Germany.

Many authors around the turn of the century approach the problem of isolation from the opposite angle. Not society, or at least not it alone, is considered to be guilty, but rather the artist himself. The frequency with which artist figures occur in literature since 1900 is an indication of how pertinent this theme was. For authors like Thomas Mann, Hugo von Hofmannsthal, Jakob Wassermann, Otto Julius Bierbaum, Carl Hauptmann, Rainer Maria Rilke, Stefan George, and Hermann Hesse the artistic existence had in fact become synonymous with loneliness.

This phenomenon of loneliness is not only an artistic problem but an existential one, related, as Walther Rehm has shown, to the modern sensibility. Rehm points out that antique civilizations did not know loneliness: 'sie ist vielmehr in der Hauptsache eine der vielen fragwürdigen Errungenschaften der neueren Zeit' (S190/7). In its early phases, as in the case of Petrarch, loneliness was often seen as something positive, as a conscious choice and a condition for poetic creation. Gradually, however, loneliness became not so much a matter of choice as of fate. Yet the modern artist who succumbs to loneliness as a kind of masochistic pleasure often makes of necessity a virtue by proclaiming solitude as a condi-

tion for creation. This notion is above all present in Nietzsche's philoso-
phy, where the artist is defined as *the* pathological and the most typical
modern man, indeed as the representative of 'decadent' society. Against
an incontestably greater degree of freedom from family ties, ties of profes-
sion and class, one must weigh especially for artists a certain psychic
instability, which is the price to be paid for this freedom. Georg Simmel,
in his *Philosophie des Geldes* (second edition, 1907) had already spoken
of a purely negative freedom, which individuals experience because capi-
talism allows its participants to unite with others without sacrifice of
personal freedom (P275/373). Phrased more specifically, the artist, as para-
digm of modern man, is freed from attachments but remains isolated and
without specific functions. Under these conditions art has become 'unver-
bindliches Spiel'; the artist himself is often considered to be a swindler.

This whole process is particularly well described in a number of
novellen by Thomas Mann (*Tonio Kröger, Tristan*) and in Heinrich
Mann's *Pipo Spano*, whose hero, the Italian poet Mario Malvolto, sees
poetry as a vice and the artist as a fraud. 'Ich habe es nötig,' Malvolto
states, 'mich in Empfindungen hineinzuschwindeln, damit ich sie dar-
stellen kann ... ich bin ein Komödiant.' He is no longer capable of true
sentiment because he has lost contact with life. Similarly, we can see in
Ehrenstein's *Tubutsch* and in the writings of Georg Heym, Klabund, and
Werfel how a general inability to come to terms with life becomes mani-
fest. No wonder then that artists often indulge in invective against their
own profession, characterizing it as vampirism, voyeurism, and pathology.
Hermann Bahr, for example, writes in the *Dialog vom Marsyas*: 'Nur wer
sich vom Leben abgestossen fühlt, wen es ängstigt, wer keine Macht hat,
es unmittelbar zu gestalten, der versteckt sich vor ihm in der Kunst.' And
he adds: 'Anständige Menschen haben es nicht nötig, begabt zu sein. Sie
brauchen die Kunst nicht, denn sie haben das Leben' (quoted S190/28).

It was against this historical background that the Expressionist writer
attempted once more to bridge the gap between himself and his society.
The beginnings of this movement may be seen in the earliest phase of
Expressionism, in confessions of guilt on the part of certain authors; it
may also be seen at work in some of the activities of the Neue Club.

Of course a number of problems suggest themselves immediately.
Given the almost complete break with bourgeois society, what audience
did the Expressionist wish to address? What kind of art could bridge the
gap between good and bad books, given that there had come about such a
sharp division between high and low art?[1] Given also that Expressionist
art attempted to distinguish itself from previous movements, what ele-

ments of the new art would likely achieve the reintegration of art into society?

One answer to these problems we have already discussed in our study, namely Expressionism's interpretation of art as having a moral and social message. Especially early Expressionism provided a considerable amount of provocation; its anti-authoritarian attitude particularly towards established channels of publication makes clear Expressionism's intention to start a new relationship with the public. Moreover, by at least nominally rejecting the bourgeois audience, Expressionism became committed to addressing itself to the working class, or at least to the progressive elements within it. But here a major problem to be solved was that of accessibility, first in a purely practical sense but then also in an aesthetic sense. In response to the need for accessibility, Expressionists began to stress certain forms and means of communication over others. There were the public readings, first of all, later the journals, which were understood as a means of enlightenment vis-à-vis the ignorance of the general public. Moreover, these specifically Expressionist journals were by their very nature already a form of protest against the commercialism of the bourgeois media, since the profit motive was the least important factor in such enterprises.

Some forms of publication soon involved the Expressionist movement in ambivalence, however. There was for example the revolutionary format of the lyric *Flugblatt*, whose emphatically anti-lyrical style often clashed with increasingly artistic and bibliophile forms of presentation. The same ambivalence characterized the anthologies in which the new literature was collected. Originally intended to demonstrate Expressionist collectivity, they soon took on, at least in the eyes of some adherents of the movement, a bourgeois, even parvenu character: they gave permanence and a certain classicism to positions within a movement whose members saw themselves emphatically in a state of permanent revolution. Less ambivalent was the intention behind the series of modern works in *Der jüngste Tag*: the pocket-book format was meant as a counterweight to the more costly presentations of established publishing houses and, at the same time, as an alternative to those pocket-book editions already in existence, such as the more classics-oriented Reclam Universalbibliothek and the Insel Bücherei.

The running battle of Expressionists with the established bourgeois press is an important aspect of the movement towards a more public type of literature. Many were the complaints about newspapers and magazines as forms of communication. Especially the literary columns were seen as

a means of manipulation, a form of indoctrination rather than enlighten-
ment. The press was overwhelmingly depicted as the enemy; it fell under
absolute ideological suspicion and was accused of cultural conservatism
on the one hand and 'Americanism,' feuilletonism, and an insatiable appe-
tite for sensation on the other. Even those who denied themselves the
privilege of the printed word and turned to cinema found that this rela-
tively new medium had already become part of the larger cultural appara-
tus of a society to which they themselves were basically hostile. One can
hardly deny the correctness of the Expressionist assessment of the bour-
geois press as committed to a vociferous, often vicious denunciation of
the new art, or to an equally destructive silence. Yet once again a basic
ambivalence becomes visible: if the new art rejected the attitude and
content of mass media, these media by themselves were seen as necessary
and highly efficient in the propagation of the new art, and hence were
eagerly exploited. The means of production, distribution, and promotion,
even certain stylistic features of the mass media, influenced Expressionist
art profoundly.

Such ambivalence also affects our assessment of the role of literary
groups, of individuals within such groups, and of the movement as a
whole. Obviously group-building in Expressionism had the intent of cre-
ating a greater resonance for the new art. This took place first of all
within the group itself, which was crucial at a time when isolation had
taken extreme forms. Coming together, listening to the efforts of others,
is a liberating experience. When such groups then enter into public
debate, their emphasis on the achievement of the group over and beyond
the individual is, in the context of normal cultural life, a form of protest,
of iconoclasm. Literary life, in so far as it can be said to play any role
whatsoever in bourgeois life, recognizes only 'great masters,' who are indi-
viduals and cult figures. A literary group (apart from such semi-mystical
brotherhoods as the circle around Stefan George) can only expect a con-
fused and disturbed reaction. Unfortunately, among the Expressionists
this collective phase did not last long. Internal quarrels, soon made public
through publications, destroyed the authority and credibility of these
groups. Aesthetic differences, personality clashes, insistence on personal
viewpoints – all this could hardly be prevented, especially in the case of
artists, and of such young artists. The painful dichotomy of artist versus
bourgeois was therefore most often repeated as a clash between individ-
ual artists and artistic groups.

Yet this group-building had some extremely important consequences.
The literary group as a collective provides a model for the collective of

society in general in that it is a community rather than an accidental grouping. The literary group provides the scheme for an 'organic' model, in which values shared are essential ones. For the Expressionists the group also functioned as a kind of pre-political organizational unit out of which in some cases political standpoints could be formulated. The existence of a literary group facilitated the recruitment of political members, though this was by no means inevitable. The clamour for a larger organization embracing all intellectuals, which surfaced especially during the First World War and the Revolution of 1917–18, shows that groups provided the model here too, though the ideal was clearly unattainable. More successful were the attempts to organize, via these groups, a greater amount of contact with the larger European literary movement. Especially people like Wilhelm Michel and René Schickele should be mentioned here. Above and beyond such immediate successes and failures of literary groups there looms, however, the much larger question as to the importance and nature of any literary movement which advances its claims of leadership with the kind of vehemence and exclusivity as Expressionism did.

Inherent in all literary movements, but especially those which are accompanied by group-building, is the attempt to organize kindred souls, with the intention of realizing common goals *at the expense* of other goals and groups. All groups set up an 'us' against a 'them.' In the case of Expressionism 'they' were in the first place the representatives of the 'old' art, but for many Expressionists other groups also automatically became hostile. Each group considered itself special, and there was something very public about the quarrels between groups. By marking out positions against other movements, Expressionists could of course be said to sin against their own principle, namely that of trying to break down the barriers between themselves and others. Paradoxically, the attempt to find a larger audience was accompanied by an unfortunate tendency to create rigid positions within the movement. This is even more the case in the sizeable body of theory than in the actual works of literature produced. By making their quarrels public and by stressing a 'code' from which others were excluded, Expressionists tended to harden their positions and almost to challenge other writers to dispute their claim of representing the avant-garde. The Expressionist claim of necessity clashed with similar claims by quite different groups and individuals. Expressionists became vulnerable to comparisons with progressive literatures in other countries as well as those within Germany itself. Georg Lukács is not the only critic who finds the claims of the Expressionists

suspect. The place of Expressionism in the larger European context of the avant-garde becomes a matter of interpretation.

That Expressionists saw themselves as belonging to a progressive movement, of this there can be no doubt, and in many respects the claim appears to be valid. Sylvia Schlenstedt has suggested, as appropriate to the definition of the avant-garde at the beginning of the twentieth century, a number of characteristics which would fit the Expressionist movement equally well (S208). First there is the universal calling into question of the role of art in capitalist society; then the building of literary groups; a marked tendency towards internationalization; a mutual influencing of all the arts; and a move towards the applied arts. She lists in addition a clear self-understanding of the avant-garde as involved in a fight against tradition, the destruction of existing forms, and a protest against the social context in which art has functioned hitherto. An important factor for Schlenstedt is also the tendency of the avant-garde to reject all forms and styles which approach decoration, and to refuse the obscuring and harmonizing of social contradictions. She accepts the Expressionist movement as well as Dada as typical of the whole of the avant-garde in Europe. At the same time, however, she emphasizes that the later development of Expressionism shows an unwillingness on the part of its participants to adapt to changed conditions, so that in fact the movement was ultimately superseded by reality, became irrelevant and out of step. Expressionism ended, it would seem, in the same position of isolation as that from which it had originated. Whether it is appropriate to claim a completely revolutionary and progressive attitude in Expressionism is doubtful, therefore, even though Expressionist positions were felt by contemporaries to be provocative, socially subversive, and outrageous. Indeed, much of what Expressionism claims as revolutionary might be more profitably be seen in the light of an attempt to *épater la bourgeoisie*.

This is certainly the impression we get from a manifesto by Rudolf Kurtz (P240), in which a militant attitude towards society is seen as an essential trait of all young poets rather than as resulting from high idealism or moral outrage. Kurtz's list of the characteristics of the ideal young poet remind us of contemporaries' descriptions of Kurt Hiller's Neue Club; they have often been used by later critics to define Expressionism as a whole: 'Er ist spielerisch, boshaft, unverschämt, ungerecht, brutal, brückenlos vom gewagtesten Bluff zu strahlendem Pathos sich schwingend, in einem unirdischen Lärm wie in einer Oriole lebend' (P240 = S8/362). But the attitude described here does not lend itself well to a serious definition of art in general, let alone of the new, socially conscious art. On

the contrary, the absolute aimlessness of such destructive attitudes and gestures brings this type of Expressionism into the vicinity of *Bohème*.

The question of the relationship between *Bohème* and Expressionism is a thorny one. It would certainly not do to follow Georg Lukács in his sweeping equation of Expressionism with *Bohème*, first because attitudes such as Kurtz's are not typical of Expressionism and secondly because there are important differences between the two movements. To be sure, there are, as in the case of the avant-garde, a number of important elements which *Bohème* and Expressionism have in common, particularly the behaviour patterns of individual members. Moreover, these behaviour patterns are not simply adopted for effect but are part of the whole movement's outlook and philosophy. But precisely for that reason a simple equation of Expressionism and *Bohème* would be ill conceived. *Bohème* and Expressionism both distance themselves from society; both feel antagonism; both are to a large extent the result of the inability or unwillingness of artists to adapt to society's dictates. But *Bohème* has in the final analysis a romantic ancestry; its unconventionality provides a certain model for Expressionism, but it cannot claim to be normative for it. *Bohème* existed before Expressionism, from the 1880s on, in roughly the same cities in which Expressionism sprang up. Its 'outrierter Individualismus' (S88/73) was attractive to Expressionism; it shared with the latter a rejection of professional occupations, a tendency towards internationalism, later pacifism, and certainly provided a ready audience for Expressionists. But it did not claim the same kind of political and social leadership as Expressionism, because it could only define itself in terms of opposition, not leadership. Above all, the messianic streak in Expressionism was lacking in *Bohème*. Expressionism was, after all, a movement dedicated not merely to revolt but to spiritual and social renewal.

Precisely in the question of its revolutionary content, however, the Expressionist claim of exclusivity becomes problematic. It is, ironically, in the area in which *Bohème* and Expressionism overlap that the weakness of both becomes obvious – namely, in their ultimate dependency on bourgeois society and its values. This is the opinion, in any case, of Klaus Ziegler, who writes: 'Die oft unklar schillernde und verschwommene Stellung des Expressionismus zwischen Aussenseitertum und Führertum, zwischen Wirklichkeitsdrang und Wirklichkeitsfremdheit, zwischen Lebensgestaltung und Lebensleere findet sich ... in seiner Bindung an die soziologische Widersprüchlichkeit der Bohème eigentlich schon vorweggenommen' (S256/113). This may appear a paradox after all that has been said about the feeling of isolation which authors had expressed since

1880, but the paradox is only a superficial one. The lament about his isolation clearly expresses the author's awareness not only that he has been excluded but also that he experiences this isolation as abnormal and that in the final analysis he is willing perhaps to return to society even if he cannot fully transform it according to his own ideas. Expressionist theory and practice show above all that those categories by which the bourgeoisie defines itself (though this claim is empty) are also normative for Expressionists. In other words, most Expressionists (with the notable exception of those belonging to the *Aktion* group) would accept an *ideal* bourgeois society (one in harmony with its claims) rather than a more radically transformed society, in the form of communism, for example. It is the bourgeoisie which provides, ultimately, the norm to which Expressionist art holds up its mirror. In this respect Expressionism repeats the attitude of *Bohème*. In *Bohème* the anti-bourgeois sentiments of the artist have in fact become a legitimate part of bourgeois society itself, and *Bohème* is absorbed by bourgeois society, just as, we should add, Expressionism is ultimately absorbed. The fact that Expressionism found such a ready audience not only among *Bohème* but among the bourgeoisie itself cannot be explained simply by pointing to the bourgeois family background of its authors, as Kohlschmidt does (S115). Rather, there are profound parallels between the two, especially between Expressionists and the intellectuals within the bourgeoisie, which both believed 'verbalradikal, und ohne sich eigentlich auf die Anforderungen des politischen Alltags einzulassen ... einen "neuen Menschen" frei fantasieren zu können' (S191/167).

Even in its specifically artistic aspects Expressionism betrays, according to Ziegler, its proximity to bourgeois society (S256/111). The reason for this ultimately inescapable identity between Expressionism and bourgeois society, according to Ziegler as well as Helmut Harald Reuter, and before them Georg Lukács, lies in the inability of the Expressionists to break out of their thinking of the bourgeoisie in terms of spiritual and moral values rather than in terms of socio-economic conditions and relationships. We will see how Expressionists depict, in both prose and drama, above all the bourgeois *type*, the philistine. We will also see how writers like Sternheim and Edschmid project their alternatives to bourgeois society once more in terms of individualism, 'eigene Nuance,' heroism, and absolute freedom – values which are incontestably part of the bourgeois value-system, though obscured by prevalent deterministic thought and hypocritical morality. When criticism of the bourgeoisie takes the form of polemic or satire, there are few explicit statements about socio-

economic conditions (Heinrich Mann is an exception). The image of the work-world is less the result of analysis than of emotional and subjective responses, though many Expressionists are quite obviously motivated by genuine social concerns.

One must not forget, of course, that Expressionist intentions do not lie in the area of analysis. Political and social change can be achieved by art alone, Expressionists believe, but (and here is the crucial point at which the assessment of their achievements will differ) only if this art does not sink to the level of party politics and daily concerns. For Lukács, who clearly understands this viewpoint (he calls it 'eine ganz abstrakte Opposition gegen "Bürgerlichkeit"' S139), this effort is doomed. Yet it is built into the metaphysics of the movement, since abstraction and the reduction to essence is the *sine qua non* of the movement. When Reuter notes about Ernst Toller that his 'Weltauffassung eher am Subjekt als am gesellschaftlichen Sein orientiert [ist]' (S191/166), he states something which holds for almost all of Expressionism (in contradistinction to Naturalism). Expressionists see the primary goal as the New Man, not the new society.

The belief in the power of art, especially the power of the word, to change society can be considered a form of arrogance, particularly in light of the recent impotence and isolation of the artist and intellectual. With what right can the Expressionist now advance himself as a leader, as spiritual guide, even as reformer and revolutionary? Only, it would seem, on the basis of the claims against which elsewhere he has so vociferously agitated, when attacking the great masters like Goethe: 'der Intellektuelle begreift sich wie er sich von je her mit Vorzug begriff: als Retter, der die Masse kraft seiner Gedanken zum richtigen Ziel führt' (S191/167).

Many are therefore the paradoxes involved in the Expressionist approach to the public sphere. The wish to go among the people, to work on a larger audience is counteracted, as Michael Stark has pointed out, by a mixture of intellectual arrogance and contempt for the public, and the tendency towards rhetoric, demagogery, and agitation (S8/5–13). The desire to reach a larger audience is in many instances also cancelled out by a complete disregard for criteria, both social and aesthetic, which would be relevant for the audience addressed. One cannot escape the feeling that the avant-garde, esoteric, and provocative literature produced in the book series and periodicals of Expressionism must to a large extent have remained without resonance precisely in those circles in which Expressionists wanted to recruit adherents for their *social* programs. Far from being an art for all, Expressionist art, with its obvious preferences for

complex intellectual content and form, remained an art primarily received by the social class which it attempted to bypass.

The complexities, contradictions, and uncertainties concerning the social position of the writer and the function of his art were perpetuated, even sharpened, by the outbreak of the First World War. Now the rather abstract discussion about the interrelationship of art and society was increasingly reduced and simplified until the question was one of literature and politics, and above all a question of what political role a writer should play, if any. This problem, too, had already been enunciated before the war, in the classic statement of Heinrich Mann in his essay *Geist und Tat* of 1911 (P243 = S8/269-72). In this essay Heinrich Mann advocates the decisive step from a purely aesthetic to a political and revolutionary interpretation of artistic activity. At the same time he foresees the artist breaking out of his intellectual isolation and suggests that the leadership of the artist, lost during the nineteenth century, may be recaptured. He maintains that the artist need not be, indeed is not allowed to be a figure living in an ivory tower, nor a solitary figure living on the periphery of society, nor, worse yet, the servile clerk of established powers. On the contrary, Mann's essay explicitly states that the time has come for Germany to attempt a synthesis of spirit and action. As an example of how intellectuals may influence the course of history and culture he cites France, whose artists and thinkers were always close to political realities, courageous enough to refuse the role of lackeys, and capable of making the transition from thought to action. In Germany by contrast, the cult of the 'great men' has stood in the way of such direct influence by the intellectuals: 'Was es hat an Liebe und allen Ehrgeiz, alles Selbstbewusstsein setzt dies Volk in seine grossen Männer,' Mann laments; 'Hat man je ermessen, was sie dies Volk schon gekostet haben?' (S8/271) Yet the greatest share of the blame Mann attaches not to the people at large but to the intellectual himself. Because of historical conditions in Germany, intellect and power are irreconcilable opposites; the intellectual must of necessity fight against the existing order and the powers that be: 'Der Faustund Autoritätsmensch muss der Feind sein. Ein Intellektueller, der sich an die Herrenkaste heranmacht, begeht Verrat am Geist' (S8/272).

Mann's essay defines the relationship between artist and existing powers as one of hostility and combat. The intellectual's responsibility towards the moral norm obliges him to come out of his isolation and begin the fight for social justice. Mann's essay became a program for

leftist Expressionists, and the vocabulary Mann employs is reflected in the titles of a number of books and other publications of the period: *Die Aktion, Tätiger Geist, Der Poet und der Dichter, Die Tat* – and in the word 'Aktivismus,' which followers of Mann (under the leadership of Kurt Hiller) applied to themselves.[2] The artist as political figure remains, unfortunately, even in those who embraced Mann's program, a vague and ambivalent notion. Ludwig Rubiner, for example, who in a manifesto entitled 'Der Dichter greift in die Politik' (P265 S8/645–52) provided another slogan for the Activist submovement within Expressionism, still does not concern himself with day-to-day politics and social problems but rather more traditionally with a criticism of the lack of spirituality and intellect within the bourgeoisie. For Rubiner the political poet fights against materialism, and both Marxism and the concerns of the proletariat are quite remote to him, as Thomas Anz points out correctly (S8/267).

Nor was Mann's call to arms in the name of politics universally acceptable. Even his brother Thomas reacted negatively to Heinrich's point of view, notably in an essay called 'Der Taugenichts' (P244 = S8/273–83). Thomas praises Eichendorff's book as a specifically German work exactly because it represents a point of view indicative of 'politischer Unschuld und Ruchlosigkeit' (S8/273). He wishes his defence of the *Taugenichts* to be understood explicitly as a counter-revolutionary gesture, 'in einem Augenblick, wo literarische Aktivistentugendhaftigkeit ihre rhetorisch geschulte Stimme mit den Stimmen jener Exzedenten der Staatsfrömmigkeit vereinigt, welche kategorisch dafür halten, dass das Menschliche dazu da sei, organisiert, *restlos* organisiert und sozialisiert zu werden und im Staatlichgesellschaftliche unbedingt aufzugehen' (S8/273). He refuses to accept the idea of a thoroughgoing politicization of the German nation, though he qualifies his objections carefully. He fears the complete transformation of the nation into state and republic, which to him would mean 'Nivellierung, Verengung, Verarmung dieses nationalen Geistes' (280). Mann's defence of the nation versus the state, his fear of politics permeating all social life, clearly bring him into conflict with his brother, and the conflict is sharpened by the different opinions the two held about internationalism and cosmopolitanism, as well as by their different attitudes towards France.

Kurt Hiller, who considered himself a follower of Heinrich Mann, felt called upon to answer Thomas Mann's essay on *Taugenichts* by elaborating upon the definition of Activism that Mann had used in his essay. Hiller attacks Mann for using Nietzsche as a source of his anti-Heinrich views, and he criticizes Mann's idea of art as independent of politics.

Hiller's definition is concerned with spirit or intellect, whose task it is to create a utopian dimension in art. Activism is indeed a political attitude, but art itself remains crucial. He stresses once more: 'Der Aktivist ist kein Feind der Kunst; er weist ihr im Gesamtbau der Kultur sogar einen viel höheren Rang zu als das l'art pour l'art-Volk der verflossenen Ära' (285). Hiller's Activism stems directly from the ethical component of Expressionism but becomes, under the impact of war and revolution, increasingly militant. After 1916 Hiller published a series of *Ziel* yearbooks in which he attempted to define the relationship between spirit and action not as antagonism but as synthesis. Similiar viewpoints are expressed by Alfred Wolfenstein in his yearbooks *Die Erhebung* of 1919 and 1920.

Not only Thomas Mann criticized the synthesis of art and politics: Franz Werfel, in 1913, published a little book in the series *Der jüngste Tag* with the title *Die Versuchung. Ein Gespräch des Dichters mit dem Erzengel und Luzifer* (P289). The essay begins with the well-known complaint about the inherent ambivalence of the poet's mission. As a mediator between man and God he is fascinated by the world, especially by mankind, but he understands this fascination as danger, for it distracts him from his vocation. Lucifer's options – fame as a poet or reputation as a citizen – are rejected by the poet. A third, more insidious temptation, however, is not so easily dismissed: that of becoming a political poet. Why is this option presented as a temptation? Werfel cannot accept this function because for him poetic existence means an unpolemical attitude. Poetry which is political is self-indulgence and does not act upon the external world. Moreover, since for Werfel politics is worthless, the political poet is himself in danger of becoming worthless: 'Wer in der kleinen Misere Leid der Ewigkeit spürt, singt, aber kämpft nicht' (S56/10). The artist depicts the world; he cannot succumb to the temptation of becoming a party member.

Werfel represents a small but extremely important segment of Expressionist thought. In spite of the desperate wish to bridge the gap between himself and society, the poet as Werfel sees him cannot and will not abandon the high opinion he holds of himself and his vocation. In the case of Werfel this refusal to 'dirty his hands' is strengthened by his fatalistic acceptance of suffering as man's fate and man's dignity. This belief we will encounter also in the story 'Blasphemie eines Irren,' to be discussed later. The reformer is a blasphemer because he arrogantly undertakes to rectify a world whose purpose he cannot even fathom. And yet another idea about politics informs Werfel's thinking, namely the idea that the

artist, if he widens his horizon, will shift from the depiction of the 'kleine Misere' to a political standpoint which tries to deal with the largest possible context. Werfel's belief coincides with that of Rudolf Leonhard, who in 1915 wrote: 'unter Politik ist im ersten, tiefen, umfassenden Sinne eine Energie, eine Dichtung, eine Gesinnung zu verstehen, dann erst ein Handeln und ein Beruf. Und in diesem Sinne sind die Dichter wahrhaft politisch' (P241 = S8/363). Werfel himself formulated this idea in even more absolute terms in his fictitious 'Brief an einen Staatsmann' of 1916. 'Das Wahrhaftige,' he writes there, 'ist ihm [the poet] nur das menschliche Ich an sich, das fern von Gemeinschaft – und Menschheitspathos – sich dem anderen Ich nicht eigentlich verbindet, sondern wesensgemäss fremd bleibt' (quoted S56/13). The politician, Werfel claims, forgets the purely human dimension; he thinks in abstractions, or worse, politics becomes a form of theatre for him. Thus Werfel abides by his pessimistic, deterministic view of mankind and must therefore reject efforts to overlook man's earthbound nature in favour of utopian flights of fancy.

Even in its extremist formulation Werfel's standpoint is not unique. It is obviously in agreement with his views on the nature of the work of art when Carl Einstein characterizes writing as an activity which does not force the writer into political positions – hence his essay 'Unverbindliches Schreiben' (P364). Outside of the Expressionist camp such an attitude we already saw in Thomas Mann. Of Rilke's attempts to become a 'useful' member of society, Rosenhaupt writes that these were not the result of a youthful weakness but sprang from a true social impulse, yet they failed, and it became clear to Rilke that he was not a revolutionary (S198/60).

The debate about the relationship between literature and politics is part of a larger debate about the differences (real or imagined) between poet and *littérateur*, between *Dichter* and *Literat*, or, in Rosenhaupt's terminology, between 'Dichter' and 'Geistiger.'[3] Rosenhaupt defines as follows: 'Spezifisch dichterisch würden wir diejenige Haltung nennen, der es in erster Linie auf die Hervorbringung in sich geschlossener Gebilde ankommt, wobei die Beziehung dieser Gebilde zur Wirklichkeit – ihre Realität oder Idealität – eine Frage zweiter Ordnung wäre. Spezifisch geistig würden wir diejenige Haltung nennen, der es in erster Linie um die Konfrontation eines Ideals mit der vorgefundenen Wirklichkeit geht, die sie in dieser oder jener Richtung zu formen beabsichtigt' (S198/205). The latter attitude seems in many ways typical of writers like Heinrich Mann, yet the impulse to confront reality with the ideal is in a very broad sense evident even in the pathos-filled works of Georg Heym, Oskar Loerke,

Paul Zech, Albert Ehrenstein, and Alfred Lichtenstein. That their attempts often remain fragmentary as well as lacking in final clarity, that they are usually, in other words, not 'geschlossene Gebilde,' seems reason to see them as products of 'Geistige' rather than of 'Dichter,' and yet such classification is obviously dangerous, and the case of Alfred Wolfenstein will show to what extent the neat division into Expressionism and Activism, which Wolfgang Paulsen undertook particularly for the drama, often enough collapses in the face of concrete evidence, particularly in prose (S165). Prose was in any case seen by contemporaries as capable of uniting life and art into a synthesis; hence the constantly repeated longing for the Expressionist novel, in which this synthesis would be achieved.

The same objections can also be levelled against Adolf Klarmann, who distinguishes between 'Dichtung' and 'politische Sendung.' It is doubtful whether one can, in any work which is legitimately a work of *art*, distinguish between the intention to present a message and the intention 'so markant und überzeugend wie möglich den Leser zur Verwirklichung eines politischen Planes anzuspornen, ohne besondere Skrupel, wie die politische Aussage als Literatur wirken mag' (S108/158). In the latter case we are clearly not speaking of art any more, but of political bias, of pamphlet, manifesto, or tract. Most Expressionists would not, or could not decide about their ultimate intentions along such crude lines of demarcation. Nor can it be said, however, that they ultimately solved the dichotomy between art and politics in an unambivalent way. We are in any case tempted to agree with Eykman when he writes: 'Das Verhältnis des expressionistischen Schrifstellers zur Politik ist nicht auf eine einfache Formel zurückzubringen. Die Vielfalt einander zum Teil direkt widersprechenden Haltungen schliesst sich nicht zum einheitlichen Bild zusammen' (S56/26).

In the discussions about war and revolution no agreement could be reached about the role of the author either, given such opposing views before the war. We have seen how even the interpretation of war itself was by no means unified and unequivocal. Even by the time most authors belonging to the Expressionist movement had become pacifists and the war was unanimously condemned as catastrophic and immoral, the consequences it would have were not obvious. To be sure, war and revolution had brought the era of aestheticism and unpolitical art to an end (S8/357), and the Activist belief that the intellectual ought to play his role in Germany also (P214 = S8/357) had more resonance now than when it was first formulated by Heinrich Mann in 1910. But precisely the experience

of war and revolution meant for others more than ever a complete rejection of politics and a political role for the author. If anything, the lines of battle were drawn even more clearly. Thomas Mann's apology for war, in *Gedanken im Krieg* (1914), which found some sympathetic response even within the Expressionist camp, was seen by Hugo Ball as the most blatant example of the compromising position in which intellectuals found themselves (P161). Many Expressionist and non-Expressionist artists and writers had been pro-war, or had tacitly accepted it (Kokoschka, Rudolf Leonhard, Franz Marc, Ernst Toller, Reinhard Sorge, Alfred Kerr, Robert Musil, Alfred Döblin, Frank Wedekind, Gerhart Hauptmann). War was for many the integration into a new community, the proof of vitality and the end of aestheticism. Lined up against them were those for whom war was almost immediately perceived as catastrophic: Wilhelm Herzog, Heinrich Mann, Franz Pfemfert, Karl Krauss, Arthur Schnitzler, Ricarda Huch, Annette Kolb, Johannes R. Becher, Walter Hasenclever, Leonhard Frank, and many others. By 1915 the shift towards pacifism was complete; war and art were now seen as enemies, in direct opposition to Thomas Mann's earlier contentions. Expressionists had become pacifists, partly because of the incredible losses within their own ranks, partly because of the disillusionment over heroism and individual courage. Particularly striking conversions were those of Bertolt Brecht, Klabund, Fritz von Unruh, and Ernst Toller. Paradoxically, the commitment to pacifism at first only had the effect of continuing the isolation of the artist. Once again Expressionist writers constituted a fringe, a minority opinion. Only gradually could the movement's pacifist stance take hold, particularly in the face of censorship and accusations of unpatriotic behaviour. The commitment to internationalism similarly endangered the position of the movement as a bridge between intellectuals and the population at large.

Internationalism was particularly promoted by *Die Aktion* and by *Die weissen Blätter*, though the two journals otherwise developed quite a different strategy during the war. Texts from Russia, France, England, Belgium, Italy, and Bohemia were printed in *Die Aktion* to demonstrate the humanity of the enemy (S15/229). Similarly, the connection of *Die weissen Blätter* with other countries, especially France (made more emphatic because René Schickele, the editor, was an Alsatian), was apparent in the publication of French pacifists such as Georges Duhamel, André Suarès, and Henri Barbusse and the publications of texts, in French, of Henry van de Velde and Marcel Martinet, as well as the publication of poets from Belgium, Denmark, England, Czechoslovakia, the United States, and Hungary. Yet the differences between the two periodicals

begin to surface soon. The anti-bourgeois bias of *Die Aktion* appears first of all in the debate over Heinrich Mann. Once the spiritual leader, Mann is now seen as a traitor for being associated with 'ethical socialism' and the idea of a bourgeois republic as a transitional form of government. Heinrich Mann's submissions to *Die Aktion* are rejected; the list of contributors shrinks. Those sinning against the intellect are excommunicated. From 1916 on, the lyric texts published by *Die Aktion* become increasingly aggressive about the coming of the New Man; by 1917 Pfemfert rejects most lyric poetry as ineffective. Where shortly before the typical representatives of high Expressionism had been given space (Franz Werfel, Alfred Wolfenstein, Albert Ehrenstein, Karl Otten, Ivan Goll), lyric poetry now disappears almost completely, since it is considered outmoded. 'Wenn ich es doch endlich allen Ahnungslosen einhämmern könnte, dass es mir nicht um Literatur, jüngste oder älteste Dichtung geht,' sighs Pfemfert in 1918 (*Die Aktion*, 1918, column 172). Later, in 1924, he writes: 'Die Aktion ist an Lyrik heute absolut uninteressiert ... die Zeiten der Lyrik in der Literatur überhaupt sind für diese Gesellschaftsordnung unwiederbringlich dahin' (column 717). Consequently, after the war *Die Aktion*, politically radicalized and deprived of an artistic component, ceases to be a literary periodical. Pfemfert had drawn one possible conclusion about the effectiveness and desirability of uniting art with politics.

René Schickele went a different road. During the last phase of the war he published, as we saw in the previous chapter, a series of essays by Svend Borberg, stressing the link between war and technology. Fraternity and soul are two of the key words which appear repeatedly in these essays, showing that Schickele and his friends had not abandoned this vocabulary. The opposition against the war was fed by the very same sentiments which had fired the criticism of the bourgeois world: the idea of the brotherhood of man, of compassion, of international co-operation, and the rejection of power structures such as those existing in the capitalist world. Typical of the continuation of the arguments in *Die weissen Blätter* is also the renewed support for Heinrich Mann, for Romain Rolland and the pro-French attitude – most clearly in the publication of Heinrich Mann's essay on Zola in 1915 (in *Die weissen Blatter*, 2 [1915]/ 1312–82). Crucial also is the increasing scepticism with which Schickele approached the viewpoints expressed in *Die Aktion*. Above all, Pfemfert's and Hardekopf's anti-German sentiments disturbed Schickele. Under such circumstances international socialism could hardly establish itself, Schickele feared. He and Pfemfert parted openly, in the end, over the issue

of Bolshevism and the dictatorship of the proletariat, which Pfemfert proclaimed with such fervour.

Even the war, therefore, did not put an end to the debate about the role of the author; it became on the contrary much more focused. This can be seen in the polemical exchange between Franz Werfel and Kurt Hiller in 1918. The occasion was Hiller's attack on Werfel's epilogue to his adaptation of *Die Troerinnen*, which the former turned into a pacifist-religious manifesto. Werfel in turn answered in 'Die christliche Sendung,' in which he once more defended the position discussed earlier (P288). Ernst Toller, too, attempted to define what he understood by the term 'political poet' in his 'Bemerkungen zu meinem Drama "Die Wandlung"': 'Voraussetzung des politischen Dichters (der stets irgendwie religöser Dichter ist): ein Mensch, der sich verantwortlich fühlt für sich und für jeden Bruder menschheitlicher Gemeinschaft' (P282 = S8/372). In the utopian formulations which became increasingly frequent towards the end of the war and even more so during the revolution, terms such as 'Christian brotherhood' and 'community' provided a stark contrast to the pro-Russian models of Pfemfert or the anarchistic, anti-authoritarian models of Rubiner. For most Expressionists, violence in the name of whatever cause was of course unacceptable. Here the dividing lines remained drawn: 'Gewalt ist seit je Mittel und Garant der Dauer für Revolution gewesen,' Adolf Klarmann has written; 'Der parteitreue Dichter ... unterwirft sich wenigstens äusserlich protestlos diesem Diktum. Der echte Expressionist, wenn er auch Politiker ist ... wird nicht im Stande sein, so weitgreifende Kompromisse mit seinem Gewissen, seiner Hingabe an den Menschen zu machen' (S109/173).

The issue of literature and politics, more than any other, accelerated the decline of Expressionism. When in January 1919 the armed conflict in Berlin ended in the defeat of the Spartakusbund and the murder of Karl Liebknecht and Rosa Luxemburg, and in the same year the Munich Soviet Republic was brought to a violent end by troops under a Social Democrat government, politics, at least for the time being, seemed to have precious little to do with the programs enunciated and the hopes expressed during the revolution. A profound sense of disillusionment can be felt in the writings of the 1920s – writings in which Expressionism itself is constantly declared dead.

Later critics have made much of the failure of Expressionism to change society in a dramatic way. Many excuses have also been advanced: the lack of political experience, the arrogance and disregard of the intellectuals for the masses, the writers' stubborn insistence on playing the role of

leader, the lack of viable plans, the exaggerations and exalted attitudes – all of these have been attributed to the fact that Expressionists were still part of the society from which they hoped and claimed to have liberated themselves. Their isolation and their reaction to it, the aggressive way in which they tried to wrest back their lost supremacy, have been seen as grounds for their inability to communicate with the masses. Profound dualisms are part of Expressionism, and in politics as in other domains they cannot be covered up. Perhaps there is something intrinsically para-doxical about the poet as political man, or perhaps even as a regular member of society, at least in the Germany of the early twentieth cen-tury. Where art is considered per se critical of society, as Heinrich Mann claimed it must be, integration is neither possible nor desirable, for it involves a servile attitude towards the 'great men' whom Mann so abhorred. Ultimately, of course, even our time has not solved the problem: some humility on the part of the successors to the Expressionist move-ment seems called for.

PART TWO: THEMES OF EXPRESSIONIST PROSE

Ecce Homo

'THE PROBLEM that faces the Expressionist is twofold; he must not merely define the true nature of life as infinite, but he must also find the means of expressing it in finite terms. The duality which we find inherent in the theoretical formulations of Expressionism, namely of "Transcendence" and "Immanence," gives to Expressionist art a special task; it must resolve this implicit duality' (S204/23).

What Richard Samuel and R. Hinton Thomas say here about the duality of immanence and transcendence in Expressionism has, in the thinking of that movement, the force of dogma. But the degree of intensity with which this duality is experienced may differ considerably. Moreover, the impulse to transcend is accepted as innate by such tragic writers as Heym and Zech, but given no hope of success. In Albert Ehrenstein's work this impulse is first described, then rendered absurd; Oskar Loerke, on the other hand, castigates metaphysics as 'Chimäre.' What is shared by these writers is a profoundly pessimistic view of reality – a world-view in which man is pitifully inadequate.

If Expressionist art has the task of illuminating the human condition and of describing man's unequal conflict with overwhelming odds, most authors see a first step towards such illumination in the expression of a personal feeling about reality: an account of the inner life and the encounter with the larger world. They further believe that such personal experiences can be made paradigmatic. From intuition and from intellectual reflection there emerges a world-view which has validity not only for the individual but for the human condition in general. The urge to reveal oneself, which in Expressionism sometimes takes extreme forms, is in this scheme of things not a form of exhibitionism (though this ought not to be ruled out) but is rather to be seen as associated with the conviction

that such confessions will create a community of kindred spirits who, having left behind their sterile isolation and having discarded the false sense of security of the self-satisfied bourgeoisie, may find each other in community and in the brotherhood of man, still suffering perhaps, but no longer each for himself. This is not to say that all Expressionists see the road to one's fellow man through the power of pathos; other forms and modes also serve this purpose. But there can be no doubt that in the description of the human condition as one filled with pathos, Expressionism found one of its most effective tools to express its existential crisis.

Pathos is an emotional rather than an intellectual category, according to Emil Staiger. It is 'eine unmittelbare Bewegung, die sich selbst in ihrer Herkunft und Richtung nicht zu verstehen braucht ... aber sie [hat] eine Herkunft und ein Ziel. Der pathetische Mensch ... ist bewegt von dem, was sein soll; und seine Bewegung ist gerichtet wider das Bestehende' (S223/84). Staiger also stresses the energetic quality with which pathos answers the challenge of the discrepancy: 'Das Pathos setzt den Widerstand der Trägheit voraus und versucht, ihn mit Nachdruck zu brechen' (80). Emphasis, both in language and in the pathetic gesture, is used as a means to achieve understanding, compassion, and participation on the part of the one to whom the pathetic situation is revealed. Even in those cases where the pathetic outcry cannot hope to achieve change, it still demands recognition: 'Das Pathos des Schmerzes scheint ohmächtig. Doch was hier sein soll, ist die Anerkennung des ungeheuren Leids, im Helden und allen, die ihm nahen, die Höhe des Bewusstseins, das den Schmerz erfassen muss' (84). Three moments are therefore recognizable in the creation of pathos: the situation itself is pathetic, in that it reveals the discrepancy between man's aspirations towards the ideal and his limitation in reality; man expresses awareness of the pathetic nature of the situation in emphatic language and in gesture; man solicits in the observer recognition, a 'Höhe des Bewusstseins,' as the pathetic nature of the situation is grasped.

A peculiar difficulty presents itself when we try to apply the notion of pathos to narrative prose, however. The traditional view of prose holds that distance is inherent in it. Emil Ermatinger emphasizes the freedom and sovereignty of the epic narrator and the free play between the writer and that which he writes about (S55/338). A certain 'cosiness' in narration, and the reference to a narrative 'Ursituation' (someone telling an audience an episode out of the past), seem to rule out any proximity to the matter narrated – the pre-condition for pathos. That this temporal distance is in practice a mere convention, as Käte Hamburger has pointed

out in *Die Logik der Dichtung*, would at least suggest that involvement is not altogether impossible. More important than such technical questions is the *origo*, the standpoint of the narrator himself. Pathos is characterized by an extreme emotional involvement of the author with his work. This involvement allows the reader to identify the fictional world-view with that held by the author. A text using pathos appeals to the reader emotionally, and ultimately demands a response from him. Although we would be ill advised to accept Egbert Krispyn's dictum that the *exclusive* mode of Expressionism is pathos (S123/7), pathos is nevertheless an extremely important aspect of Expressionism, as an examination of the prose of Georg Heym, Oskar Loerke, and Paul Zech may show.

In Georg Heym's 'Die Sektion' we have a typical example of the extreme situation from which pathos may spring. Heym describes here the merciless destruction of a human body, from which simultaneously a dream of great beauty and happiness emerges. The stark opening section immediately reveals the essence of the pathetic situation: 'Der Tote lag allein und nackt auf einem weissen Tisch in dem grossen Saal, in dem bedrückenden Weiss, der grausamen Nüchternheit des Operationssaales, in dem noch die Schreie unendlicher Qualen zu zittern schienen' (P69 = P372/35). This opening presents the protagonist reduced to a minimum of human characteristics, as 'der Tote,' nameless, alone, naked, devoid of all marks of identification, of mask or pretence, but also of a place in the order of things. This reduction (reminiscent of existentialist philosophy) is then continued in the mention of the largeness of the room, implying the smallness of the body. The reference to previous suffering to which the room has been witness completes the situtation.

Instead of objective description, Heym involves the reader by means of interpretations. This is carried out in a variety of ways: through commentary, through choice of words, through insistence on the perceptions of the individual rather than on 'objectively' existing reality. From the start the stylistic features are associated with the emotional involvement of the narrator: from the very first paragraph on, Heym depicts man as prey to hostile forces, to suffering against the background of indifferent fate. And yet, for a brief moment Heym seems to leave the possibility open for some kind of reconciliation between man and the cosmos. In the second section of the story nature itself momentarily transforms ugliness into beauty: the sun 'zauberte aus seinem nackten Bauch ein helles Grün'; but this beauty is then immediately destroyed (in a typical 'fall from grace') by the phrase 'und blähte ihn auf wie einen grossen Wassersack' (35). Exactly the same surge upwards and precipitous drop occurs in the next section –

'Prächtige rote und blaue Farben wuchsen an seinen Lenden entlang' – but the bursting wound emits a terrible stench.

This juxtaposition of putridness, decay, and death with the explosion of colour (also typical of Heym's poetry) only reinforces the contrast between human wish and cosmic determination. Here Heym already prepares us for the destruction of the body and the escape of the soul in the second part of the story by manipulating two vocabularies, one pertaining to the world as limit and one aspiring to transcendence. The world as limit is impressively rendered by Heym's obsessive insistence on the concreteness of details: 'Sie nahmen aus den weissen Schranken ihr Sezierzeug heraus, weisse Kästen voll von Hämmern, Knochensägen mit starken Zähnen, Feilen, grässliche Batterien voll von Pinzetten, kleine Bestecke voll riesiger Nadeln, die wie krumme Geierschnäbel ewig nach Fleisch zu schreien schienen' (35). The descriptive method of the opening section is maintained; the modifiers of the nouns are full of emotion; personification and demonizing are used to achieve the desired shift from observation to vision. We are told that the doctors are friendly men, but at the same time it is hinted that their interests do not extend to the patient himself; they look upon him 'mit Interesse, unter wissenschaftlichen Gesprächen.' The indifference of the inanimate world is now repeated on the human level, and even intensified when the doctors start their work, called 'ihr grässliches Handwerk.' No further pretense of objectivity is made by Heym. 'Sie glichen furchtbaren Folterknechten' (35). With intolerable insistence Heym creates vividness through an appeal to the senses. The intestines are 'grüngelbe Schlangen,' 'Der kalte Harn ... stank scharf und beizend wie Salmiak,' and the body excretes 'eine warme, faulige Flüssigkeit' (35–6). The description of the dead man takes on a dehumanizing aspect, not because of derogatory comments or degrading similes but because of Heym's fascination with the purely physical, with the body as the biological and chemical object it ultimately is.

And yet, out of this totally materialistic, mechanistic, and deterministic frame of reference Heym suddenly breaks into the spiritual: 'Während die Schläge der Hämmer auf seinem Kopfe dröhnten, wachte ein Traum, ein Rest von Liebe in ihm auf, wie eine Fackel, die hinein in seine Nacht leuchtete' (36). About midway into the story the word 'love' is introduced, a word which implies communication, caring, and sharing. Starting with a view out of the window, the vision of the dead man takes him out of the confines of the room into an infinite space, filled with light. And while this vision is at first presented as a counterpoint to the continuing destruction of the body, the vision gradually gains dominance, until the

perspective changes from the outside 'er schien zu lächeln' to the inside 'er träumte.' We finally enter into the consciousness of the dreamer himself, as he addresses his beloved directly: 'Wie ich dich liebe' (37).

With the attainment of a 'du' the narration's shift into the idyll is complete. Heym's idyll is one filled with images of light and colour: the girl is 'eine duftende Mohnflamme,' her dress 'eine Welle von Feuer in der untergehenden Sonne'; her head is bent in the light, her hair 'brannte' and 'flammte.' The scene is inspired by an experience in the dreamer's past, but it is also projected into the future: 'Ich werde dich morgen wiedersehen ... wir werden uns nie verlassen' (37). At the height of this vision, as the dead man trembles 'vor Seligkeit,' both the destruction of the body and the vision of happiness are brought to a sudden close.

I have analysed this prose text in rather great detail because it gives in a nutshell the essential technique of Heym's prose. It is typical of Heym in that it presents an action which is extremely concentrated in time and space. But it is a moment of great intensity, an existential moment crying out for expression. Though it is a concrete situation, we feel there is an attempt to achieve meaning beyond the clinical and morbid presentation of facts. The cry at the height of suffering and delight points to an existential situation for which Expressionist prose seems to be an eminently suitable medium. At least in this story Heym avoids the danger of imbalance between the story's aesthetic aspects and a content which overwhelms the reader. The language of pathos allows Heym to explode the concrete situation by opening into a radically different perspective. Typical of the language and style associated with the world as limit are the short-winded, clipped sentences and the many parallel constructions of paragraphs. Sentences appear like erratic blocks, isolated from one another and merely describing a series of observations, later a number of events in chronological order, without any attempt at logical and causal connection. It is a hard, rough style, concentrating on essentials; parataxis and parallel syntactical structures, typical not only of Heym but of many other Expressionist prose writers, prevail. The syntactical arrangement – subject, verb, rest of the sentence – is, for example, also typical of Döblin. Great emphasis is placed on the verb, since it indicates both the mechanical character of human beings and the demonizing powers of objects. Similar tensions are achieved in the presentation of beauty and putridness in the same object, or benevolence of appearance combined with barbaric acts. Language and things signified by it are in constant contrast. This is most obvious in the use of metaphors and similes; often the beautiful is described in terms of decay, the ugly in aesthetically pleasing

terms: 'Sein Leib glich einem riesigen schillernden Blumenkelch, einer geheimnisvollen Pflanze aus indischen Urwäldern,' or 'Sie stachen die Blase auf, der kalte Harn schimmerte darin wie ein gelber Wein' (35).

With the introduction of comparisons which become dynamic, and which take on a life of their own, the door to the grotesque is opened. When Heym likens the medical instruments to 'Geierschnabel' he goes one step beyond the dynamic metaphor: the borderline between a subjective, emotionally charged language and the language of the grotesque is crossed. A similar process takes place in Heym's description of the doctors: conceived as the representatives of society, they are shown indifferent to human suffering, then made to symbolize statistics-oriented science, abstraction, even hostility towards life.

The contrast between the terrifying and the absurd is synthesized in the concept of the grotesque, as Wolfgang Kayser suggests (S105); the contrast between the empirical world and the ecstasy of the subjective is synthesized in the concept of pathos. About halfway through the story we enter the realm of the ideal. An entirely different vocabulary is introduced and one of the main themes of Expressionism is sounded – that of *Erlösung*. Here it is situated in the world beyond, however, not in this world. It is a private utopia, accessible only through death. There is no guarantee of the permanence of the vision either, though the beauty of nature seems to be introduced to underpin it. If the body is the gateway to *Erlösung*, perhaps the ultimate destruction of the body also means the limits of this *Erlösung*.

The extreme, existential situation can easily be recognized as a constant in Heym's prose. In the story 'Jonathan,' which describes the illness and death of a machinist, again a concrete situation is taken as a starting-point for pathos. Like 'Die Sektion,' this story also has a relatively simple structure. It incorporates a flashback but is narrated by the protagonist without interruption to the chronology. The opening section serves once again as exposition of the situation; once again the emotional proximity of the narrator to his subject is revealed:

Der kleine Jonathan lag schon den dritten Tag in der entsetzlichen Einsamkeit seiner Krankenstube. Schon den dritten Tag, und die Stunden liefen immer langsamer und langsamer. Wenn er die Augen zumachte, hörte er sie langsam an den Wänden herabsickern wie einen ewigen Fall langsamer Tropfen in einem dunklen Kellerloch. Da ihm beide Beine in dicken Schienen lagen, so konnte er sich kaum rühren, und wenn die Schmerzen aus seinen gebrochenen Knien langsam an ihm

heraufkrochen, hatte er niemand, an dem er sich festhalten konnte, keine Hand, keinen Trost, kein zärtliches Wort. Wenn er nach der Schwester klingelte, kam sie herein, mürrisch, langsam, verdrossen. Als sie ihn über seine Schmerzen klagen hörte, verbat sie sich diese unnütze Nörgelei. Dann könnte sie jede Stunde tausendmal rennen, sagte sie, und sie schlug die Tür hinter sich zu. Und er war wieder allein, wieder verlassen, wieder seinen Qualen ausgeliefert, ein verlorener Posten, über den von allen Seiten, von unten, von oben, von den Wänden die Schmerzen ihre langen weissen, zitternden Finger ausstreckten. (P68 = P372/38)

The same stylistic features as in 'Die Sektion' are at once recognizable: emotionally charged adjectives, repetition for emphasis and intensification, demonizing metaphors and similes. In accordance with Heym's view of the universe, Jonathan's extreme suffering is once more answered with complete indifference. His loneliness, pain, darkness are unrelieved; even the inanimate world takes on an air of danger, and abstract categories of time and space come to life as demons. Reality is interpreted as Hell: 'sein Bett schien mit ihm auf einem höllischen Strome herunterzuschwimmen, dessen ewige Kälte in die ewige Starre einer verlorenen Wüste endlos zu laufen schien' (38). Even the crucifix suspended over Jonathan's bed has become a source of pain, for as proof of Christ's inability to perform miracles it seems to emanate a 'furchtbare Ohnmacht' (40). Far more terrible than pain itself is the loneliness, more terrible than death is the impersonal kind of dying in this environment: 'Ach, warum hier sterben,' Jonathan exclaims, 'hier wo man den Tod an jedem Bette stehen sah, hier, wo man dem Tode ausgeliefert war wie eine Nummer, mit sehenden Augen, hier, wo jeder Gedanke vom Tode infiziert war' (39).[1] Under these circumstances the mere exchange of a greeting, with a young girl in a room next to him, must appear to Jonathan as comfort and hope, and as the first sign of the possibility of re-entry into life.

In an exchange between these two patients, Jonathan tells the girl of his recovery from a previous illness, in a hospital in Monrovia. This episode, seemingly superfluous, introduces on the contrary a very important theme, that of community: 'Ach, was er da zu dulden gehabt hatte in der fürchterlichen Julihitze, die die Adern der Kranken verbrannte, wo das Feuer bis in ihr Hirn wie ein eiserner Hammer schlug. Aber es war trotz des Schmutzes, des Negergestankes, der Hitze, trotz des Fiebers immer noch besser gewesen als hier. Denn da wären sie nie allein gewesen, da hätten sie immer Unterhaltung gehabt' (41).

On the one hand, the vitalistic sphere, exemplified in this exotic context, is allowed to create a counterweight to the death-and-decay atmosphere of the hospital; on the other, the reader's notions about the superiority of modern science and 'civilization' are called into question when illness and loneliness become concomitants of our impersonally efficient way of dealing with the individual. This episode, then, like the idyll in 'Die Sektion,' becomes a kind of counter-project to the universe as it is presented in the opening section, a contrast to the 'Nüchternheit' of the present. To underline the significance of this flashback, Heym momentarily shifts perspective to the girl, 'alle diese seltsamen Bilder erfüllten das Herz seiner Zuhörerin mit Bewunderung und entrückten den Kranken da drüben in eine fremdartige Atmosphäre, den kleinen Maschinisten in dem elenden Bette eines nüchternen hamburgischen Krankenhauses' (42). The apparent narrative inconsistency has the double function of elevating Jonathan to the level of a human being and of emphasizing the importance of human communication.

As in 'Die Sektion,' the idyll itself is also present in this story, as the result of Jonathan's growing love for the girl. It is very similar to the vision of the dead man in 'Die Sektion': '[Seine Liebe] zeigte ihm eine weite Wiese in einem goldenen Wald, sie zeigte ihm einen Sommertag, einen langsamen Sommertag, einen seligen Mittag, wo sie beide Hand in Hand durch das Korn gingen, das ihre Liebesworte mit seinem leisen Rauschen umhüllte' (44). But the vision is brutally interrupted by the nurse's closing of the door between Jonathan and the girl. The immedate result is a relapse into illness, described in great detail, until Jonathan's animal-like cry causes havoc in the hospital, evoked by Heym through the use of the grotesque.

At this point another important aspect of Heym's prose becomes apparent: his tendency towards allegory. Already in the opening lines of the story we noted Heym's description of Jonathan's pains as 'Schmerzen [die] ihre langen,weissen, zitternden Finger ausstreckten' (38). Now, in the scenes describing the bedlam of the hospital, death itself enters as a person: 'Jetzt stand er hoch oben auf dem Dache, und unter seinen riesigen knöchernen Füssen sassen in ihren Betten ... die Kranken auf in ihren weissen Hemden' (46). Allegory takes the form primarily of dynamizing metaphors: 'und das Entsetzen flog wie ein riesiger weisser Vogel durch die Treppen und die Säle' (46; note also the repeated use of the colour white, the hospital colour). Further on, Heym speaks of the 'Sabbath des Todes' and of the doctors and nurses as 'Ministranten eines seltsamen Gottesdienstes' (47).

In an important chapter discussing Heym's stories, Helmut Liede borrows from the idea of Kurt Mautz, who defines allegory as the metamorphosis of living reality (usually nature) into a *Sinnbild* (symbol), creating thereby a kind of *Ruine* when compared with the living landscape of nature or the world itself. The idea of a 'frozen' nature (world), of a transformation from a living thing into a symbol (and an impotent one at that), seems quite apt in the case of religion. The crucifix in 'Jonathan' indicates that religion has become a spiritual ruin, that its dynamism is lost. In 'Der Irre' Heym uses certain passages from Lutheran chorales to create a grotesque contrast with the madman's killing of two young children; in 'Der Dieb' there are quotations from St John the Baptist accompanying the elaborate planning of a theft. For Liede these instances show Heym's longing for religion: 'Heym zeigt sich gerade in der brutalen Negation christlicher Glaubenssätze der ungestillten Sehnsucht nach neuer religiöser Bindung ausgeliefert' (S132/178). This is at least superfically confirmed by Heym's plans for a new religion, as formulated in his *Versuch einer neuen Religion* (1909). But we must take note of the fact that in both 'Die Sektion' and 'Jonathan' religious salvation is absent and that redemption lies in a secular context of nature and the idyll.

Liede's suggestions don't work quite so well when we look at the allegories of a purely secular nature. The hardening of ideas into figures (for example, the birds of death, the fingers of pain, death as a skeleton) are more like rhetorical devices. A similar device is space itself. This is not to deny that Heym himself might have understood these figures as having more universal meanings (and indeed the use of infinite space returns in the work of Leonhard Frank and Kasimir Edschmid). Unfortunately, these 'symbols' have already other, often more persuasive contexts. Heym's personal use does not supersede those previous usages. Precisely because we are dealing with extreme characters in extreme situations, universality becomes more difficult, though as we have seen, Expressionists do not see a problem here. Nor can it be denied that Heym's language is at times inappropriate. This is especially the case where happiness is to be portrayed. Both Liede and Fritz Martini have noted Heym's proximity to Jugendstil, and both use the term pejoratively.[2] The idylls of 'Die Sektion' and 'Jonathan' rely on nature as guarantor of happiness, but unfortunately the language describing this nature touches on kitsch. Liede especially criticizes these visions, which he argues are made up of dead fragments, and points to Heym's 'Ohnmacht, das Entseelte wieder zu heiler Gestalt zu erwecken' (S132/178).

The conclusion of 'Jonathan' is a good example of both the weaknesses

and the strengths of Heym's prose. It is once again a vision: 'Plötzlich schien es ihm, als wenn sich die Tapeten des Zimmers an einigen Stellen bewegten. Sie schienen leise hin und her zu zittern ... Und siehe da, mit einem Male zerrissen die Tapeten unten am Fussboden' (49). Suddenly, Jonathan finds himself lying in a large room. But Heym quickly widens the horizon even further: 'Er lag allein und nackt in einem grossen Felde auf einer Art Bahre' (50). The final two figures represent life and death: Jonathan cannot follow the figure of life (who resembles the girl in the next room), and he progresses 'Immer weiter durch Dunkel, durch schreckliches Dunkel' (51).

Can we speak of transcendence here? In 'Die Sektion' love represented a transcendental value; can we see something similar in 'Jonathan'? Love fails to draw the protagonist back into life; since religion has already been shown insufficient to conquer death, what is there which goes beyond death?

An even more problematic ending is provided in the story 'Das Schiff' (P70). The story also shows more clearly the dangers of Heym's 'lyrical' style. The subject matter is trivial: a landing party from a freighter contracts, in a mysterious way, the plague which has killed the inhabitants of the tropical island. When the crew returns to the ship, a long drawn-out agony and death await them. Whereas the first part of the story is told in a fairly straightforward way, the second section is highly subjective and hallucinatory. A spooky atmosphere is created (here Edgar Allan Poe's *Arthur Gordon Pym* or Coleridge's 'Rhyme of the Ancient Mariner' may have been the model): 'Und die bleierne Atmosphäre einer tropischen Nacht, voll von schweren Nebeln und stickigen Dünsten, senkte sich auf das Schiff und hüllte es ein, düster und trostlos.' (55). The agony of illness and death is accompanied by visions and nightmares; the reader enters into the consciousness of each crew member in turn. The final scenes introduce another allegorical figure, a black woman, first seen on the island as 'eine kleine schwarze Gestalt wie eine Frau in einem Trauerkleid' (53). One by one the crew members fall prey to this figure, until she grows to gigantic proportions: 'in dem Feuerschein schien sie zu wachsen, und ihr Haupt erhob sich langsam über die Masten, während sie ihre gewaltigen Arme im Kreis herumschwang gleich einem Kranich gegen den Wind' (64). Finally, space is opened up once more: 'Ein fahles Loch tat sich auf in den Wolken. Und das Schiff fuhr geradenwegs hinein in die schreckliche Helle' (64).

Striking though Heym's language is in the description of the gradual decline of the crew and in the creation of an atmosphere of terror, there is

a real danger that the sheer weight of the narrative material might destroy the aesthetic unity of the story. The paraphernalia of exoticism and the obvious delight with which Heym dwells on the nightmarish and the terrifying bring the story close to trivial literature. No movement which breaks out of this hellish sphere can be perceived, since the focus is on external action only. The meaning and purpose of the allegorical figures and of the symbol of 'schreckliche Helle' are for the same reasons ultimately lost in the wealth of optical elements.

Inge Jens has claimed that *Handlung* (the fable) is the most important aspect of Heym's prose. Indeed, dramatic high points are inevitably external phenomena in a Heym story: illness, madness, an accident, death. The crisis is never the result of a psychological change or a moral act. It is doubtful whether we can in most cases even speak of morality, or moral decision-making, since so often the weight of circumstance is too strong, rendering the individual helpless. Nor can it be said that Heym's stories climax in an idea, for too often the allegorical figures are not true ideas but embodiments of external actions – in 'Das Schiff' the plague, in 'Jonathan' pain – none of these being particularly profound.

Certainly a peculiar lack of concern for the principles of narrative prose can be seen in Heym's stories. At times this is an advantage, for in the lyrical, image-laden passages he achieves moments of great power and striking beauty of expression. At other times there are the dangers of kitsch, trivia, exoticism, and sensationalism. For Heym, it would seem, aesthetic considerations are subordinate to his obsessive urge to express man's situation of pathos. Neither universality (the result of sufficient intellectual depth and aesthetic abstraction) nor purity of novelistic forms can outweigh his prime goal: the expression of the human condition.

Pathos, conceived of as the conflict between necessity and freedom, is a major theme also in the prose of Oskar Loerke, but with two major differences. Loerke shifts the emphasis from the outside events which fascinated Heym so much to inner limitations, those within man himself; and he emphasizes as ontological premise that truth and reality are unknowable. The individual cannot transcend the here and now; if he attempts this, he falls a victim to illusion.

Loerke, too, is primarily a lyric poet. This explains the similarities of language and imagery with Heym. But Loerke has a greater aesthetic control over his material; he is more inventive, a greater experimenter with the forms of prose. A good example of the boldness of Loerke's

narrative technique is the novelle 'Das Goldbergwerk.' Its opening is highly dramatic, starting *in medias res*, without the introduction of a speaker or situation. An impassioned speech, rich in rhetorical devices, metaphors and similes, outlines the extreme suffering of a colony of condemned Egyptian slaves, who are dying from lack of water in a distant desert goldmine. The speech is addressed, it turns out, to Pharaoh, to spur him to take action and alleviate the suffering of his subjects: 'Dem Sonnengott selber dürstete in der endlosen Wüste, und er kam in unser Bergwerk trinken. Durch den Gürtel leeren kochenden Dampfes beugte er jeden Morgen aus seiner Höhe das glühende Angesicht, und er trank und trank aus unsern vier Quellen, bis sie matt und erbärmlich wurden, und ihr Widerhallen in den Felsen nur noch röchelte und dann hinsank' (P93 = P391/3). Neither escape into the desert nor rebellion can provide an alternative: without water both are futile. Loerke's language, like his creation of an existential situation, reminds us of Heym: we recognize such typical features as the parallel structure, the repetition, the devaluing verbs that bring man down to the level of animals, and the dynamic metaphors.

With the arrival of Pharaoh Apaanchu and his queen Zait the story shifts from the struggle for survival of a whole community to a more personal plight, and a new situation of pathos: the slave Hesi's passion for Queen Zait. Loerke's handling of narrative is highly inventive. From the initial meeting between Hesi and Zait until the ultimate conflict between these two protagonists in the presence of Pharaoh, Loerke uses a parallel structure; each of the two parts of the narrative has its own perspective. The two groups (Hesi-Zait and Apaanchu-Zait) are only brought together again in the final catastrophe. In the first section of this double narrative we are acquainted with Hesi's past, first through a dialogue with Zait, then through a narrative intrusion. We learn of Hesi's crimes: because rich and beautiful women were unattainable for him, he turned into a 'Leichenräuber und Leichenschänder,' as well as a rebel against the existing order. His past passions surface in an even more heightened form in his love for Zait. Since life does not hold out any hope that he may realize his desires, he rejects life; his frantic search for water obscures the fact that he has already abandoned all hope; his emotional outburst against Pharaoh is similarly not a last desperate act of rebellion but an act of hatred against the queen as unattainable object of his aspirations. This is revealed in Hesi's game, in which he takes on the role of the queen in order that the slaves might use him as their object of hate.

The most important phase of Hesi's transformation from frustration to

resignation is not shown in detail by Loerke.[3] The hiatus is effectively bridged by Loerke in a dialogue between Zait and Apaanchu. This latter exchange hinges on the value of life. The Vitalist philosophy of early Expressionism sees life as an absolute good; Loerke's heroine seems to subscribe to this idea, for so strong is her feeling of being part of the life-process that she claims immortality and calls upon nature to be the guarantor of this immortality: 'Ich bin wie der Wind und ich bin wie der Mond ... Ich bin wie der Süden, ich bin wie der Nil, und du sprichst zu mir: lisch doch aus! Wie bist du fremd!' (20) Her identification with nature makes her exclaim: 'Ich sage doch: Ich! Und das ist, als sagte ich: ewig' (20). If she were to die, her past life and loves would become meaningless, the universe absurd. Apaanchu, who has accepted death, must become a stranger to her, since in the face of death the I-Thou relationship is shown to be an illusion. Yet when Hesi confronts Zait for the second time, a remarkable transformation takes place. Zait, it appears, is the perfect partner for the second game Hesi plays, that of evoking the realm of the idyll, a domain in which their union might be possible. Zait feels compelled, despite herself, to enter into this game: 'Ich hasse ihn ja,' she says, 'mir graut vor ihm, aber es lockt mich, es liegt so weit wie Ägypten und ist so lügenhaft' (25-6). Though she claims 'Es ist nur ein Spiel,' she becomes involved in a radical break with her past: since the idyll cannot be part of her life, she too, like Hesi, must reject life. At the precise moment in which she is ready to die because the fairy-tale is superior to reality, Apaanchu kills her in a jealous rage. Apaanchu's dependence on external circumstances has denied him the inner freedom which the other two players have achieved in their game – to accept death as their destiny.

'Das Goldbergwerk' is important for the understanding of Loerke's writings. In contrast to Heym's stories, the situation of pathos is here almost completely interiorized; the emphasis is on character and motivation, and there is a much greater degree of psychological subtlety. The figures are less allegorical, though their representative functions remain clear. Loerke also shows a greater balance between dialogue and narration; the action is concentrated, but the high point is an intellectual dilemma, not an external event.

An attitude of passivity prevails in 'Das Goldbergwerk.' Loerke considers the acceptance of one's fate as desirable, though at the same time his characters arrive at a degree of freedom only through struggle. The greatest impediment to inner freedom lies in one's attachment to life and the rejection of death. This refusal is caused by the absence of a metaphysical

dimension. Loerke's view of reality is immanent; if there is a God, we cannot know him, and any attempt to cross the boundaries between reality and metaphysics is bound to end in disaster. Zait's original attachment to life is typical of many of Loerke's heroes. For them, death is an abomination because it is the passage from individuation (to which they cling) to anonymity. Since they see the ego as the guarantor of life, loss of the self means loss of life. Moreover, there exists a very close relationship between the ego and nature. In the dialogue between Zait and Apaanchu nature sustains life as well as the individual. The proximity between the two is underlined by means of metaphors; yet one of the reasons Zait is able to accept Hesi's dream as desirable is that it seems to guarantee the continuation of this relationship beyond death, in Loerke's own eyes an illusion.

The inability of man to enter into contact with the metaphysical is also dramatized in 'Die beiden Götter.' This too is an exotic story, situated in the Egypt of five thousand years ago. The choice of Egypt is of course not arbitrary, since a preoccupation with the metaphysical was an integral part of that society. The story tells of Pharaoh Menes, the human manifestation of God, and his counterpart in the animal kindom, a crocodile in the Nile, the god Sobk. The story is told in a straightforward style, without comment by the narrator, a style well suited to the story , which is something like a parable. This time the pathos is not of an emotional but an intellectual kind. The characters and the reader go through a learning process.

Two illusions are discussed. In their blind need for an all-embracing myth, the Egyptians constantly find ways to prove Menes's divinity, and that of the crocodile. Menes's very large eyes, large 'weil sein Hirn von einer schleichenden, zersetzenden Krankheit befallen war'(P92 = P391/48), are to the Egyptians messengers of great things to come; the longevity of the crocodile, on the other hand (a simple fact of nature) is interpreted as a sign of divine power. Having accepted a man as a manifestation of God, the Egyptians are then logically led to demand a dialogue between the two gods. In his growing isolation, the originally sceptical Menes is finally convinced of the desirability of such an encounter.

As we approach the intellectual nexus of the story, Loerke takes great care to explode beforehand the myth of the crocodile's divinity by stressing its animal appearance and character. The crocodile's smell and movements warn the reader that a catastrophe is inevitable, and indeed, the young Menes is swallowed up. At first there are attempts to translate the terrible event into yet another myth. One spectator claims 'Die beiden

Götter haben sich vereinigt' (50), but this meets with no response. The Egyptians' belief is shattered: 'viele gerieten in religiöse Verzückung und wältzten sich in Krämpfen,' the narrator reports (50). Only a few realists possess the clarity of mind and the courage to kill the crocodile in turn. Ironically, however, the mythmakers have the last word: they execute those who killed the crocodile as 'heretics.'

Menes's transformation from scepticism to belief is attacked by Loerke as illusion. Man cannot know God; he can attain freedom from necessity only within the human context. Whereas the Egyptians interpret nature as miracle, the events depicted are eminently real. In the contrast between ideas and action lies the tension of the story. But it must also be admitted that the detached attitude of the narrator opens the way to a certain amount of irony. The distance created through a quasi-objective type of reporting and through the wisdom of hindsight provided by five thousand years of history prevents the conflict from becoming too oppressive. But more up-to-date mythmaking (whose disastrous powers were soon to be demonstrated in war and revolution) ought to have warned Loerke's readers not to be too smug about their superiority. Mythmaking in any form is dangerous, as Loerke demonstrates in a further number of stories, to be discussed in chapter 8.

Man's mental and physical insufficiency vis-à-vis a cruel reality is a central theme in the works of Paul Zech, especially in his collection of novellen *Der schwarze Baal*. These novellen illustrate to a high degree what most critics understand to be typically Expressionist writing, not only because of their language but also because of the tendency to interpret social and economic factors in terms of myth and fate.

The title story especially is a good example of the latter quality. It describes the futile efforts of the widow Antje to save her illegitimate son from his death in the coal-mines, a death predicted by the community. Neither the concrete dangers of the miner's life nor the carelessness of the authorities about safety standards are seen as posing a threat to the boy; the threat comes from the mine itself, transformed into the mythical monster Baal. The workers themselves are responsible for obscuring the facts about their existence; they rationalize accidents as coincidences in order not to have to face the truth and in order to continue to work in the 'verfluchte[n] Berzirke[n]' (P156 = P418/11).

At first Antje's son, the appointed victim of Baal, seems to be able to dodge his fate; ultimately, however, he dies in fulfilment of the prophecy that has for so long been suspended over him. The fulfilment of a proph-

ecy is one of the recurring patterns found in folk-tale (see S230), and thus a rather primitive device, but in *Der schwarze Baal* a number of such folk- and fairy-tale features are introduced to create a contrast between a magi- cal-mystical and a brutally real world. Antje's son escapes twice from an accident, but he is killed the third time, in the familiar pattern of three. The dead father is identified with a star, and this star is invisible on the night of the accident. The boy is considered to have been 'called' by his father, who died in the mine on the day of the boy's birth. In such constel- lations we ought not to see a form of escapism on the part of Zech but a formulating of man's condition in terms at once poeticized and made universal. Zech defines the pathetic situation as the struggle of man against a mythical monster; he reinforces the magical-mystical aspects by leitmotifs: the predictions of the old women, the threefold calling by the father, the mysterious attraction of Antje's son for the slagheap, and the father-son motif. Myth is certainly intended if we consider the boy's role as that of a scapegoat for the community, as a sacrifice to appease an angry god. As an outsider, a fatherless son, the boy seems eminently suited to play this role.[4] Zech himself suggests this interpretation in the final scene, when the villagers come to view the corpse of the victim: 'Und sie wussten alle, dass einer fort musste von der Welt. Einer, dessen Tag nun gekommen war, wie sie es vorausgesagt hatten mit lästerlichen, kalten, trostlosen Worten. Sie suchten triumphierend Antje. Ihre Blicke glühten wie in der Ekstase des Rausches. Es war ein Blutrausch. Der Rausch nach dem Opfer' (P418/23).

The fulfilled prophecy also provides the structure for Zech's story 'Das Vorgesicht.' The title refers to a dream of the miner Jean, in which a mining disaster is announced, though it is in fact a human action which causes the disaster. Jean's friend, Severin Roubaud, having taken the place of the foreman in the mineshaft, sees an opportunity to prove himself worthy of promotion by driving the men very hard, until through exces- sive speed and carelessness the mineshaft collapses. Zech's language is more Expressionistic here than in the previous story. In short, nervous sentences the catastrophe is evoked: 'Und da ... da ... da ... wie von unten mit riesigem Nacken wütend emporgedrückt, brach die ganze Arbeit zusammen. Splitterte. Riss. Knallte und rollte empor. Die Kolbenwuchten steilten sich wie Dämme. Berg und Gehölz verschwanden in Rauch und Steinhagel. Ein Geheul wie nicht mehr aus menschlichen Kehlen don- nerte auf' (P158 = P418/55). The darkness and chaos which follow the collapse of the mineshaft set the stage for a terrible vision in Severin's mind: the hand of his friend becomes the hand of Satan himself. Conflict

between the two men breaks out when Jean suspects Severin of abandoning him in the shaft, and in the ensuing battle he kills Severin. As Jean reaches the lift, however, it is sent shooting down. Once again, fate is shown to be inescapable.

Guilt is a central theme in 'Die Gruft von Valero' (P154). The miner Jonsen feels responsible for his actions, which have allowed the reopening of a shaft in which several miners have found their death and in which his friend Piet is now forced to work. When a second disaster occurs, this time claiming Piet's life, the news reaches Jonsen via his landlord. When Jonsen is subjected first to the landlord's total lack of emotion, then to his sarcastic remarks, he kills him in a rage.

Coincidence as fate – this seems to be Zech's message. The idea is pushed to the extreme in 'Nervil Munta' (P155), in which a miner released after a prison sentence for taking part in a strike is forced to work under the supervision of the brother-in-law of the man he caused to be killed during the strike. The outcome of this particular constellation of circumstances is at once predictable and tragic: the foreman so persecutes Munta that an accident occurs in which the latter dies. The story is one of two in the collection in which the social and economic conditions of the mines is treated in greater detail, though the notion of fate still dominates. Some progression seems nevertheless to be indicated in the collection, from blind fate in 'Der schwarze Baal' to a greater degree of human responsibility in the creation of the tragedy. The social comment also becomes gradually stronger. Yet the structural pattern of 'Nervil Munta' is not so very different from the other stories in this collection. They all reveal the iron law of fate and show Zech's world-view as being determined by a tendency towards mythicizing. The concrete situations which Zech knew from his own experience in the Belgian Borinage are less important for their own sake than as illustration of the futility of man's struggle against fate. Zech's work is equally far removed from the Naturalist works of Zola (Germinal) and from the biting comments of a Brecht inspired by a belief in the possibility of change. Man is a pawn of demonic forces rather than of socio-economic ones, and time and time again Zech uses cosmic irony to bring about the final catastrophe.

Zech presents a bleak world, deliberately limited in scope, in which work is little more than slavery. But Zech's pessimism results in pathos rather than in social indignation because his primary interest seems to lie not in the social but in the philosophical realm. Only one story in the collection, 'Der Anarchist,' is, as we shall see in chapter 10, more specifically social in content.

The most illuminating example of Zech's art is the opening story of the collection, 'Die Birke' (P153). This time Zech anthropomorphizes a birch tree to create a feeling of pathos. The birch tree is the last reminder of nature in a world committed to industrialization. The obvious contrast between the black slag-heaps of the mines and the white of the birch tree is fully developed. There is no real action in the story; it is rather a poem in prose, summing up Zech's pessimistic view of man. The ultimate death of the tree is described in human terms, intended to solicit indignation on the part of the reader. Unfortunately, Zech's pathos turns into bathos here, even becomes involuntarily funny: 'Die Erde tat sich auf. Und aus dem klaffenden Spalt schwebte langsam, von hundert weissen Fittichen getragen, die arme Seele der Birke empor' (P418/8).

This particular example is not unique. Zech's weaknesses often come close to destroying the artistic integrity of his work, especially whenever the contrasting realms of idyll and reality come into play. Sentimentality mars the opening sections of 'Das Pferdejuppchen' and the relationship between Antje and her son in 'Der schwarze Baal.' Zech is at his best when he describes the concrete world of the mines. But since his vocabulary is one of pathos, it entails a certain amount of insistence and over-emphasis, which he cannot easily transpose into the domains of childhood, motherhood, or the idyll without sliding into the sentimental. Georg Heym avoids this particular danger by introducing the grotesque, and Oskar Loerke retains a certain distance between himself and the fiction he creates; Zech, who employs neither, often falls prey to excessive emotionalism. Nor does Zech revolutionize form; his is essentially a traditional style of narration. His stories give the sense of a closed world, owing to his restriction of motifs, the concentration on few characters, and the atmosphere of the work-world. It is only the highly emotionally charged language which prevents us from seeing these stories as true novellen.

Like Heym and Loerke, Zech provides an example of the Expressionist claim that out of individual consciousness alone there no longer results in the work of art a world as a totality, only a fragmented and closed world. The narrator perceives the world from a particular angle, through a limited number of windows. Some critics have argued that this consistent limitation gives Expressionist prose a lyrical quality. Epic breadth has gone; the distance which the past tense supposedly creates has disappeared, and the scene is here and now. Much of this results, I believe, from the use of pathos as a mode of presentation. But Expressionist prose is also an excellent vehicle for the depiction of the transcendence of pathos

through an existential leap of faith, as two stories by Alfred Wolfenstein may demonstrate.

If in Georg Heym we have, as Inge Jens has argued, examples of characters in extreme situations, the same may be said for the characters in Wolfenstein's 'Die Ohnmacht' and 'Der Lebendige.' Death itself constitutes the limit to man's aspirations. But whereas Heym shifts from the empirical world to vision and idyll, Wolfenstein obstinately retains the perspective of the here and now and reasserts the possibility of an earthly utopia. To believe in such a utopia requires considerable faith. Unable to draw certainty from existing society, from history as a teleological process, even from God, Wolfenstein creates his vision of a better world out of a sheer effort of will. 'Der Lebendige' (P147 = P417) illustrates this process. In its two-part structure with a definite *Wendepunkt*, this story is a true novelle, though its language is anything but classical. In the two parts, life and death are starkly contrasted: somewhere in the middle lies the hero's transformation from an exponent of the death-wish to a man committed to the glorification of life. How this transformation takes place, however, must be extrapolated, since it remains rather obscure.[5]

In the first part of the story death rules supreme. A procession of mourners follows the coffin of the hero's mother: 'Um ihn war es tot' (P417/7). Yet there are at the same time powerful forces at work drawing the son back into life: 'Teuflische Krallen scharrten an seinen Türen – Engel pochten er solle öffnen – Wer wusste was es in Wahrheit sei?' (8). Lacking certainty about his course of action, the son implores his mother to aid him in making a decision for or against life. The mother does in fact intervene, first in a vision, then as if in reality. During the vision/dream the son has remained in the cemetery after the mourners have gone, having lost all sense of time. Now, during the dream, certain time-markers in the text indicate important changes in the hero's mind. 'Es schien hell auf den Platz, abendlich tief' (10), marks the beginning of evening. As in many poems by Georg Trakl, it is a time when man looks back over the past day. The next marker, 'Die Sonne war untergegangen' (11), accompanies the son's decision to remain in the graveyard. The total darkness which follows marks the crisis stage: 'Plötzlich fiel er stolpernd hin, und als er aufstand, sah er das Licht nicht mehr' (12). Losing direction, the son begins to crawl on all fours, reduced to an animal-like existence. Panic is expressed by the quickening of the pace; the language becomes hectic. But the frantic movement has a deeper meaning, for it is already part of life again: 'Und schon war dieses Rasen nicht mehr traurig und sinnlos' (12). The dynamism of the search for orientation is an indication that on a

purely physical level the transformation has already been accomplished.

Without explicit comment Wolfenstein bridges the contrasting parts of the novelle. In a vision, skeletons appear, indicating to the son that in searching for his mother he was in fact striving for a grotesque fusion with the dead of all mankind. But this vision is already part of the past; now his intellect has also awakened him to the realization that redemption lies in life itself. Just as the empirical world is created out of darkness by the light of the sun, so the will creates the world of the individual: 'Die Schöpfung war wieder zu schaffen von dem, der lebte' (14). Action awaits the young man, and with a feeling of 'ozeanischer Frische' he opens the gate of the cemetery, the gate to the world, and disappears in the morning light.

How are we to interpret this suddenly gained faith in life and utopia? What is the nature of this utopia? Only an act of faith can explain the burst of enthusiasm with which the story closes. But the creative energy shown in the story is not, at least not in an obvious way, given a target, nor is it shown acting upon the world in a concrete way. Utopias, personal or social, are frequent in Expressionism, but they mostly remain literature. They are evocations, rather than blueprints. It has often been noted that Expressionism believed in the power of the word itself to transform reality. When utopia is evoked in this way, death can indeed not hold power over man, but the exact nature of utopia, its sheer possibility, remain also outside the discussion, having been made dependent only on an act of faith.

Wolfenstein is willing to go even further, by postulating that death can in itself be a liberation and a form of personal utopia. Freely accepted suicide as an act of revolt against the limitations of the world is the theme of 'Ohnmacht' (P148 = P417). The young girl Dika recognizes that the best way she could challenge repressive parental and social authority would be to emulate her boyfriend Friedrich, who has killed his father. But she realizes that this kind of violence is not open to her. Whereas men can achieve identity through action, women are 'hilflos, unvollendet'; they either lack intellect or their thoughts 'schmelzen ... allzu dicht, charakterlos ineinander' (P417/31). Her impotence is revealed to Dika in a stormy argument with her mother. She soon feels that a woman must find a different solution for the problem of authority, and it dawns on her that it is precisely through her weakness, through her female, vulnerable body, that she might achieve revenge. Thus Dika goes in search of her death at the hands of a sex murderer.

Wolfenstein's writing in this story illustrates the possibilities of

Expressionist prose admirably in that it is able to mirror perfectly the haphazard, directionless wanderings of the girl in search of her killer. As Dika's search becomes more desperate, the language becomes increasingly disconnected; the pace of the whole section is quickened by the use of dynamic verbs, by adjectives and adverbs modifying usually static objects. There is in this passage an absolute identity between language and object described. At times the sequence takes on dream-like qualities; both Dika and the narrator himself lose control of their intellectual faculties. But it is really the wish to triumph over reality which gives a subconscious direction to Dika's quest, and this becomes obvious in her sudden decision to visit Friedrich in prison. For now she wants to have a child by him in order to assure that he will live on through her: 'Aus seinem Schoss Leben – Heimat – und steigende Ewigkeit' (36). When he then refuses to grant her wish, her last hopes are dashed, and there remains only one way open to her: to make sure that she dies before her lover: 'Noch atmet er mit ihr, und sie kann machen, dass sein Leben, so schnell er auch stirbt, noch länger dauern wird als ihres' (37). This decision to commit suicide is already foreshadowed in the dream with which the novelle opens. With its obsessive concern with clocks and time, the dream anticipates the urgency of the last section of the novelle, Dika's desperate attempt to stop time, her wish to 'cheat' time in order to die before her lover. The solution was present from the start; it gives the story the structure of a labyrinth with only one exit. There is also a paradoxical timelessness involved, despite the hectic pace of events and narration.

In theme, motifs, and language Wolfenstein's 'Die Ohnmacht' is a typical example of Expressionist prose as commonly defined. Its fragmentary, non-causal, discontinuous narration, designed to achieve maximum intensity and a near complete unity of narration and subject narrated, point to a high degree of involvement both emotional and aesthetic by the author. In a profound sense this type of writing is *non*-narrative prose; it does not invent crisis situations; it relives them. What is narrated here in the guise of an existential situation is but the reworking of personal experiences and their consequent transformation into *Lebensgefühl*. Especially when pathos is present, we may assume an extremely close connection between the fictional world-view and the author's.[6]

Identity between fictional and authorial world-view is of course most nearly complete in those writings which we could characterize as forms of confession or disguised autobiography. This is the case above all with Albert Ehrenstein, whose work has been called by Fritz Martini 'Aussprache, Bekenntnis, Selbstdarstellung eines Ichs' (S147/690). Ehrenstein

himself invites the reader to see his fiction as confession. In his 'Lebens-bericht' he writes: 'Was ich erlebte an Schönem und Traurigem, mit Wesen und in ihrer Natur, meine wirkliche, inner-seelische Biographie steht ... in meinen Erzählungen und Aufsätzen, geschrieben zwischen 1900 und 1931' (P360/162). The 'Lebensbericht' is itself of considerable help in establishing the connection between work and life. Ehrenstein's early retreat from his environment, for example, is well documented there. The reference to his stories, on the other hand, aids in interpreting these as aspects of the gradual process of revulsion and rejection of his particular petty-bourgeois environment. Family and school in particular are two aspects of childhood which bring out Ehrenstein's vituperation with particular force.

The story 'Begräbnis' (P39 = P358) focuses on the banal and trivial events surrounding the funeral of an aunt. Satirical intent is obvious from the deliberations about the cost of the funeral, certain arrangements to be made, and the proper behaviour to be adopted. But the humour is clearly subordinate to the attempt to characterize the tensions existing within this social class.

An important segment of the story is taken up by a seemingly arbi-trary discussion of literature. For our understanding of Ehrenstein, how-ever, this section is crucial, for the attacks on literary critics as well as on writers point to a constant motif in Ehrenstein's work: his questioning attitude towards his own chosen profession and, more specifically, his self-denigrating attitude, which is related to a constant feeling of guilt and inadequacy. In 'Begräbnis' this feeling of guilt is over-compensated for by a radical gesture: the young author's refusal to cry over his aunt's death and to imitate the hypocritical behaviour of the other family members. Like literature, the author claims, most conventional behaviour at funer-als is 'humbug': 'Nein, Blut war in diesem Weinen nicht ... es kam aus dem Kehlkopf' (P358/371). When the narrator then digresses into a dis-cussion on women which is clearly designed to shock his audience, what has appeared to be ruthless honesty quickly turns into cynicism of a particularly offensive type: 'Die sogenannten anständigen Frauen machen viel zuviel Geschichten, eh sie endlich die Beine auseinandergeben. Und präsentieren dann als Offenbarung ein verstunkenes Stück Fleisch. Das ist die ganze Seligkeit' (374–5). These passages reveal an undercurrent of aggressiveness hardly justified by the matter under discussion. But pre-cisely because cynicism, sarcasm, and aggressiveness surface primarily in matters of love, faith, and death, one has cause to believe that the cyni-cism is a way of covering up real fear or that the cynicism is there to avoid

sentimentality and pathos. This is the opinion of Gabriel Beck, who notes that Ehrenstein's targets of attack are singularly inappropriate and that Ehrenstein's wit is a peculiar device, running counter to the sentimentality and pathos with which his work is also replete (S18/92–104).

It is no doubt Ehrenstein's violent attitude towards love, faith, and death which made Max Brod call him 'ein aus tiefstem Seelengrunde geschmacklosen Witzbold und Wortverderber' (P343/36–7). Beck also finds Ehrenstein's jokes about death offensive. But perhaps we ought to consider Ehrenstein's macabre humour in the light of the bitter comment Lessing once made on the death of his son, whom he considered clever for having left this vale of tears so quickly. Thomas Mann, who quotes Lessing's 'joke,' comments: 'Dabei gibt dieser Brief zu bemerken, was es mit seinem Witze auf sich hat: es steht im ganzen nicht spassig darum. Wer witzig ist an der Bahre seines Kindes, witzig vor Schmerz, für den muss der Witz etwas sehr Ernsthaft-Natürliches sein: es ist seine Art, auf die Härte und Traurigkeit des Lebens zu reagieren' (P399, vol. 1/353).

The feeling of inadequacy which lies behind the wit and humour of 'Begräbnis' surfaces openly in 'Der Weg ins Freie' (P39 = P358). The author, having gone for a walk to escape from the misery of the city, finds no relief among the appallingly poor in the country. He feels a growing unease because his better clothes make him into a suspect character. A note of pathos is struck in the description of two little girls who, playing 'telephone' through a sewer pipe, ask each other for strawberries: 'Beide konnten ihr Ideal – denn es gibt kein tieferes Symbol für den Begriff "Ideal" und alles Streben der Menschheit, ihrer Wirklichkeit zu entrinnen, als reine Sehnsucht nach Erdbeeren in ein Kanalgitter hinabzurufen ... beide konnten ihren Wunsch nicht erfüllt sehn' (345). Seen in the light of such powerful symbols of longing and deprivation, the narrator's wish to transcend reality seems futile in the extreme. But Ehrenstein rejects the recourse to a general law and any attempt to make *it* responsible for the impossibility of happiness. He feels personal guilt: 'Hilflos! Auch ich habe dieser Welt nicht geholfen. Niemandem!' (346) This is the other side of Ehrenstein, a vulnerability inspired by self-criticism when confronted by suffering. But can we speak of a genuine compassion for his fellow man? It has been suggested that Ehrenstein's social conscience is motivated primarily by his fears of becoming a victim himself and that social criticism and self-pity coincide in such a fashion that the term altruism would not fit. Alfred Beigel writes: 'Es wäre falsch, bei Ehrenstein von einem echten sozialen Mitleid zu sprechen: es handelt sich letzten Endes bei ihm immer um die eigene Person; weil das eigene Ich keine Verbindung zwischen sich

und der Menschenwelt herstellen kann, wird diese in Bausch und Bogen verurteilt' (S19/24). None of this would of course be surprising in an Expressionist writer.

The story 'Zigeuner' (P49 = P358) takes things one step further. This time the narrator is not simply a helpless bystander but an active (if unintentionally so) cause of suffering. Because of his writing talent, the boy's uncle had ordered him to write to the emperor to ask for a new fire-engine for the village. When the engine arrives, the firemen, in search of a suitable practice target, set fire to the camp inhabited by gypsies. The most vulnerable and defenceless creatures of society become the objects of destruction. The boy, having indirectly caused the destruction of property, can no longer blame others: 'Ich bin schuld,' states the opening line of the story. But this time personal guilt is seen in context of universal human guilt: 'Ich hab gerad noch Kraft "Waat! Waat!" zu schreien und so die Schlechtigkeit der Welt blosszulegen' (342). Like the previous story, 'Zigeuner' shows how Ehrenstein moves from subjective experience to his view of the world, and how his feelings of guilt derive from his belief that to act makes one guilty (even though one might have the best of intentions) but not to act is equally problematic. It is also particularly revealing once again that it is the boy's talent as a writer which makes him guilty – another reflection on Ehrenstein's own profession.

Guilt is again the subject of 'Kaninchen' (P40 = P358). The narrator once more describes his boyhood experiences, his growing isolation, and his final escape into illness. But this retreat into illness as a way to avoid responsibility makes him guilty nevertheless. Having abandoned the care of his rabbits during his illness, he finds one of them being served up at the dinner-table one day. This trivial incident is now universalized: 'Wir martern, zerbrechen, morden, essen schwache Tiere, Kinder, Menschen. Gerechtigkeit ist. So muss dereinst rächend ein Höherer, Stärkerer: ein Gewaltriese, ein Leuteschlächter kommen und wird zur Strafe für unsere Menschenschinderei, Tierquälerei mich und uns alle zerbrechen, zu Tode martern, morden, vernichten!' (340)

Animals may often be interpreted in Ehrenstein's writings as substitutes for the author himself, and as such they often become substitute targets of his self-aggression. This is the case in 'Der Selbstmord eines Katers' (P44 = P358), in which a young boy, in a fit of rage, kicks his cat and thereby gives the farmhand Janku the idea to kill it. The moral implication is that Janku 'gehorchte einem Weltgesetz: wen der Herr tritt, erschlägt der Knecht' (334). Hence the almost Goethean motto of the story:

O Mensch, sei lieb
Nicht nur zu dir!
Was stiess und trieb
Das arme Tier,
Den kleinen, schwarzen Kater fort?
Im Leben hilft nur selige Tat,
Zu spät wird Reue Wort. (323).

It is the 'impotence of the heart' (as Jakob Wassermann subtitles his book on Caspar Hauser) towards another orphan of our unfeeling world which causes the failure of the narrator. At the same time there are ample indications that the failure is one which implicates the self also: 'Wie Tubutsch ist auch der Kater das zweite Ich Ehrensteins,' writes Alfred Beigel (S19/62). Many parallels exist between the narrator and the animal. Like the cat, he has cut himself off from society yet still longs for contact and affection. Both seek love and erotic experiences; both fail. In having murdered the cat (by implication), the author has quite literally committed 'Selbstmord.' To atone for his guilt, he gives himself up to the police, after first having killed the female cat who had spurned the tomcat's advances.

Existence on the margin of humanity is interpreted by Ehrenstein as evil. Much as K. in Kafka's novels is accused of being incapable of love, and just as Kafka himself considered he was guilty of an inability to love and had come to be accused by fate, so Ehrenstein sees in the peripheral existence a cardinal sin. This is a theme which also appears in the works of Ernst Weiss, who of course had personal contacts with both Kafka and Ehrenstein. Both the Viennese and Prague variants of Expressionism present the theme of the outsider and detached artist as a major one.

Ehrenstein's two most important stories, 'Wudandermeer' (P48 = P358) and Tubutsch (P47) take up this theme and lead it to its logical conclusion. The name Wudandermeer does not refer to the first-person narrator (Wodianer) but to a fantastic cosmic creature, an alter ego of the hero. The cosmic fantasy is one of Ehrenstein's favourite devices to signify the escape from the monotony of life. There are other fantastic creatures throughout Ehrenstein's work, such as the talking bootjack in Tubutsch; frequently objects are given names ('Sirius' and 'Rasiries' are Wodianer's whiskers). These devices are proper to the Groteske. In 'Wudandermeer' Ehrenstein describes the death of a nova, whose light reaches earth only after centuries; this description is used to illustrate the absurdity of man's presumptuous claims, 'Gott könne den masslos schäbigen, kleinen

Sonnenirrtum 'Erde' so blutig ernst genommen haben, ihnen – diesen unverbesserlichen Mördern seinen einzigen Sohn zur Kreuzigung und ihnen beliebigen Läuterung ihrer Seelen anzuvertrauen' (381). In *Tubutsch* the disproportion is reversed: two roosters are fighting over the 'Weltherrschaft' (284), and two flies, drowned in the writer's inkwell, become the symbol of man's spiritual aspirations.

Ehrenstein achieves absurdity above all by mixing the spiritual and the material. A window displaying umbrellas, herrings, and books shows how futile man's spiritual aspirations are. The narrator in *Tubutsch* no longer writes with ink, therefore, but with pencil. Poetry is an illusory, transitory act; genius is humbug, as can be seen from the fact that both Schopenhauer and Byron wrote their greatest works under the influence of alcohol. Tubutsch suffers from the 'Monotonie des Daseins'; like Büchner's Danton, Ehrenstein's heroes are driven to distraction by the rituals and gestures of the everyday. They attempt desperately to escape time and place, but travel is useless: 'wir gehen ja mit' (286). In both 'Wudandermeer' and *Tubutsch* Ehrenstein alludes to Nietzsche's idea of the eternal return of the same, and he shows how archaeology backs up this idea: there existed a kind of Christ cult in ancient Peru. There is no point, under these circumstances, in pursuing sex or love, for the end is already contained in the beginning, and the sex act is grotesque precisely because of its repetitive character, though it does, admittedly, kill time. In 'Wudandermeer' the narrator confesses: 'Rhythmische Senkungen und Hebungen einem Mädchenleib gegenüber, ja selbst die freiesten, wildesten, feurigsten Rhythmen exekutiert an solchem Objekt, helfen über repertoirlose Augenblicke hinweg. Liebe? Niemals fühl ich mich zutiefst verkettet. Ich fühl es nie' (385). Such is the narrator's opinion about women that he considers it his mission 'möglichst vielen dieser lebensschwangern Tierchen die nächste Wiedergeburt abzutreiben' (393). Tubutsch, for his part, cynically compares the various sounds women make during copulation: one woman makes love 'wie sie sich einen Riegel Brot abschnitt' (295). Worst of all, Tubutsch has the unhappy talent of seeing, even in the most beloved woman, the skeleton. Love and death are neighbours in the obscene and grotesque universe inhabited by Ehrenstein's creatures.

Ehrenstein's pessimistic view of life is coloured by the impossibility of ever realizing the ideal. Even the religious dimension is negated, as is art, as a 'Nichts.' Yet there is always, in the background, the ideal, the never-achieved state of harmony. Wodianer confesses that he had always had 'Sehnsucht nach dem Anderen, Nichtvorhandenen.' Often the only way

left open to Ehrenstein's characters to create some excitement is to give in to unbridled fantasy. Both Tubutsch and Wodianer lead many imaginary lives; but they both fear that only death might bring release from monotony.

And yet, Ehrenstein's attitude towards death remains ambivalent. He is a blasphemer, but blasphemy is only worthwhile if there is such a thing as God. Similarly, he frequently invokes death, yet fears it with mortal fear. With his beloved cat Kerouen dead, Wodianer wonders when it will be his turn; Tubutsch, contemplating the loss of his dog Schnudi, anticipates with trepidation a similar end. To be sure, Tubutsch reflects 'Das Leben. Was für ein grosses Wort! Ich stell mir das Leben als eine Kellnerin vor, die mich fragt, was ich zu den Würsteln dazu wolle, Senf, Kren oder Gurken' (306). Yet death is in no way welcome.

Ehrenstein is a rather exceptional and extreme case. His pessimism is, unlike that of many later Expressionists, unrelieved. Since his autobiographical and fictional writings show no essential difference,[7] since, moreover, most of the stories are monologues and hardly present narrative sequences – which makes them even more autobiographical and also makes them appear the appropriate vehicle for an extremely isolated individual – we can abstract from them (despite the grotesque and phantasmagorical dimensions) a world-view which is one of absolute opposition to the world as it is constituted. There are indeed many Expressionists who show a much greater degree of objectivity, a much more ironic distance and less aggression. But what we have seen in Ehrenstein's work occurs in varying degrees in much of early Expressionist prose. To cite just one more example, H.D. Balser has shown how Benn's attacks on his milieu spring from an aggressively hostile attitude towards the world which is very similar to Ehrenstein's. Moreover, the 'von tiefem Ekel provozierte Vernichtungswille richtet sich nicht nur gegen den Mitmenschen ... sondern auch gegen das eigene Ich als den traditionsbestimmten Persönlichkeitswert des Menschen' (S13/49). Balser also points out Benn's cynical view of sex, and his Baroque-like insistence on the theme of *Vanitas*. Like Ehrenstein's destructive cosmic fantasies, Benn's writings testify to his 'programmatisch-aggressiver Nihilismus allgemeinen Vernichtenwollens' (50). Both authors also extend and universalize highly personal preoccupations into a world-view which then holds not only for the author but for reality in general. Ehrenstein's cynical assessment of family life, for example, is proclaimed, sometimes in obscene language, as valid for all families. The fictitious heroes (behind whom always looms the author himself) become guilty not because they happen to be weak

characters but because man is a sinning creature. By the same mental process Benn's protagonist Rönne discovers a fact not merely about himself – namely, that his psychology is discontinuous – but about reality in general. Marion Adams writes therefore: 'Psychology is always subordinated in Benn's writings to larger interests. Rönne's discontinuous psychology matters not only for the interest of nuances and perceptions, but because it seems to reflect the discontinuous if rhythmical character of reality' (S1/41).

The examination of Ehrenstein's work has shown that the subjective viewpoint tends to create a kind of autistic world, in which the isolated self, lacking the corrective of an objective viewpoint and the mitigating force of distance which could create irony, is thrown upon itself not as a free agent but as an absurd, highly vulnerable entity. Under these circumstances every reference to the outside world becomes a source of uncertainty. Loss of self is intensified by the loss of external reality. In this situation the danger exists of becoming self-pitying, sentimental, and maudlin, and Ehrenstein certainly does not escape this danger. At the same time, the gestures and rituals of revolt, the blasphemies and obscenities, remain futile and without issue, since a higher power has a priori been denied. Transcendence is not possible in Ehrenstein's view; but deriving a meaning from immanence appears an equally impossible task.

SIX

Problems of Integration

The writer whose attitude towards reality is determined by the feeling that it can never attain the lofty ideals which he carries within himself must of necessity reject the world of man, that is, the social world. There are three areas in particular which Expressionist authors see as leading to conflict situations and which they treat as conducive to the formulation of the specifically Expressionist world-view: family, school, and work-world.

The family is a particularly sensitive area of exchange between the individual and his environment. Here the individual first defines and must often assert himself against authority in its most elemental form – hence the frequent conflicts between father and son in literature of this period. From a purely psychological point of view this conflict is an eternal one, reaching back into the realm of myth. But the conflict of generations has also a sociological aspect, which in the period after the turn of the century sharpens the traditional conflict. To some extent the writings of Sigmund Freud can be held responsible for the more theoretical and more broadly cultural approach to this problem. With the founding of the periodical *Imago* in 1912 Freud created a forum for theories having wide implications, going well beyond mere psychology and psychiatry. The larger works, containing the synthesis of his thinking about civilization and culture, were created rather later, to be sure: *Das Unbehagen in der Kultur* dates from 1930 and *Das Ich und das Es* belongs roughly to that same period. Nevertheless, the early writings of Freud certainly helped to bring into focus the conflict of generations. Roy Pascal claims that from about 1900 on there is a certain urgency about this conflict, which climaxes in a series of articles on the Oedipus complex in *Die Aktion* and a whole series of provocative, almost hysterical dramas deal-

ing with the theme, among them Reinhard Sorge's *Der Bettler*, Walter Hasenclever's *Der Sohn*, and Arnolt Bronnen's *Der Vatermord*. On the periphery of Expressionism, Franz Kafka's 'Die Verwandlung' and 'Das Urteil' belong here, and one of the central novellen of Expressionism, Franz Werfel's 'Nicht der Mörder, der Ermordete ist schuldig,' is devoted to it. Expressionists themselves recognize certain antecedents for the theme in the movement of Storm and Stress and Das Junge Deutschland, but they emphasize at the same time that the present situation has intensified the conflict. Certain basic changes in the structure of the family unit in the industrial age make this claim a plausible one.

'The monogamous patriarchal family acquired in the middle classes its highest social and moral credit,' writes Roy Pascal. 'Recognized by law and Christian morality as the sole legitimization of sexual union, its stability was reinforced by the laws governing inheritance and by a material affluence usually not so great as to weaken mutual family dependence' (S164/ 198). The father, usually the sole bread-winner, acquires his prestige from society at large; his ambitions and aspirations to obtain an appropriate level of income, a suitable rank in the bureaucracy or the military, define the horizon of prestige of the whole family. This dependency of the other members of the family, including the sons, on the father causes tensions which, at the beginning of the twentieth century, are aggravated by the abandonment and outright rejection of the fathers' ambitions by the younger generation. At the same time, however, the refusal to follow in the footsteps of the older generation does not entail full liberation from parental authority. Here lies one of the most important reasons for the growing acuteness of the conflict. It is because of the secure financial position of the fathers that the sons can pursue intellectual and artistic activities and hence attain a measure of freedom. The ties with their fathers nevertheless remain close, which explains at least partially the hysteria expressed in the revolt and the often futile and excessive gestures of rejection which strike the modern reader and spectator as rather ludicrous. It must be added that the sons' alleged pursuit of *Geist* to the detriment of social and material prestige often deteriorates into a revolt for its own sake and an irrational urge to destroy all and everything associated with the old. This results in a considerable number of younger people living on the margin of society, caught in the trap of either snobbishness and/or political anarchy. If the older generation can be accused of opportunism, the younger generation may sometimes be dismissed as *Bohème*.[1]

Revolt is characteristic of the young. In more flexible times the revolt

is fruitful, since it leads to liberation and to necessary changes in the fabric of society. But in an age such as that in which Expressionism flourished, an age of transition, the revolt becomes ambiguous, not only because alternatives are not easily formulated but also because the objects of attack are not brought into focus clearly enough. In fact Expressionists formulate the conflict in terms that are no longer appropriate. Even in the middle classes the effects of industrialization and education had begun to undermine the family ethos: 'The father's authority, still emphatically proclaimed, was no longer commensurate with his social function' (S164/195). The fathers themselves, we now realize, had feet of clay, and the greater their authority seemed to grow at home, the more it was undermined by factors outside their control – by world events, by economic and social, political and scientific factors. The ultimate collapse of the world of the fathers after 1918 was followed by the collapse of the economic system in the great crisis of the twenties and thirties, and the collapse of a stable political environment in the turmoil of the Weimar Republic.

It was the privilege of Franz Werfel to be able to comment on the larger implications of the father-son conflict from a vantage point in time. His famous novelle 'Nicht der Mörder, der Ermordete ist schuldig' was written in 1920, after the apparently unshakeable world of the fathers had collapsed in war and revolution. An analysis of Werfel's story can be of special interest when combined with a discussion of a novelle dealing with the same theme but written by an author still in the fullness of the conflict, Max Herrmann-Neisse's 'Himmelfahrt zu Gott vaterlos.' A reading of both stories suggests that the move away from the personal, subjective world-view to a more universal level is explored consciously by Werfel, with the intention of finding a way out of the conflict.

Werfel's story has considerable psychological subtlety and motivation. HIs attempt to achieve a kind of totality, a 'world,' contrasts sharply with Herrmann-Neisse's approach, which rejects psychology and instead uses *chiffres*, gestures, and allusions. The style of Herrmann-Neisse's story is revealing also of the distance which Expressionism had travelled by Werfel's time. There are no discursive passages; the action progresses by leaps and bounds and relies heavily on external, seemingly trivial yet revealing incidents, concentrated in an extremely short time-span. Only through a certain amount of reconstruction and extrapolation can the reader understand the young boy Anno's attacks on his mother, his hatred for his father, and his ultimate suicide. The banality of family life, exemplified by a series of senseless conversations, and the father's presence as a bar-

rier to Anno's freedom are contrasted with the boy's longing to escape into the green oasis of the forest, and his reminiscences of his nightly walks. His feeling of being unwanted, of being an accident in creation, not only accounts for Anno's feelings of hostility; it explains his ultimate resolve to revenge himself against his father by suicide: 'Muss der Jäger nicht, wenn das Wild vor ihm sich freiwillig in den Abgrund stürzt, sich erdrosseln gleich unentrinnbar vor sich selbst entblösst?' (P63/8) Through his voluntary death, Anno feels, he will achieve 'Ausgeglichenheit äonenlang'; free from his father he will be with God, who is also fatherless (8).

Herrmann-Neisse's story is typical of an extreme type of Expressionist prose. Its high degree of concentration makes a quasi-analytical reading necessary and lets no 'world' appear. Yet the emotional involvement of the narrator-author is almost excessive and, one is forced to confess, rather tearful.

Werfel's treatment of the Oedipal theme is quite different. He attempts to write a history of his hero's youth, a kind of *Bildungsroman* with the father-son conflict as the dominant interest. Like the *Bildungsroman* this story works towards a synthesis. At this relatively late stage of Expressionism Werfel attempts to transcend his theme, first by exploring it fully, then exploding it as (perhaps) a 'fruchtbarer Irrweg.' The novelle reformulates the typical Expressionist theme by showing an awareness that the dualistic view, of which the father-son is but a symptom, is in need of an alternative. This alternative appears at the end of the story in the hero's leaving for America and the announcement of the imminent birth of his son. The conflict is solved not in the fashion of the Herrmann-Neisse story and that of most dramas, by murder, suicide, or revolution, but by the conflict's being shown to be in essence non-existent.

Werfel uses a complex structure of psychological reflections, leitmotifs, symbols, and dreams. From the beginning he creates a certain amount of tension between the negative and positive aspects of the father-son relationship, which prepares for the peaceful denouement, though at first the tyrannical older Duschek, an officer, is presented primarily as the typical father apt to antagonize the younger generation. His social ambitions and moral rigidity poison the life of his submissive wife and overshadow the boy's accomplishments. The extent of the boy's resentment against his father is made clear in the central episode, the incident in the amusement park. The boy's failure to hit the mechanical figures of a shooting booth, later correctly analysed as substitute figures of authority, is a good example of the kind of symbolism Werfel employs. A Freudian interpretation of this novelle would undoubtedly be possible, but though

the rivalry has the earmarks of a classic case, the story does not exhibit the hysteria that mars so many dramatic treatments of the theme.

The young boy displays the typical inability to cope with life that we have come to expect from our reading of Ehrenstein; but here it is unequivocally linked to the father: 'Fünfzehn Jahre Einschüchterung und Angst hatten meine Seele gebrochen' (P143 = P416/23). His father's cold, detached treatment plunges Karl into despair, until he blames the very sterility of his own life on him. Though the rupture between the two men, which follows suspicions about Karl's involvement in a scandal, seemingly affords a measure of freedom for Karl, the episode in which he becomes mixed up with anarchists reveals once again a persistence in his fixation to oppose authority in all forms resembling that of 'the fathers'; ultimately it leads to his decision to kill the 'Plagegeist meiner Knabenjahre' (35).

Unlike Herrmann-Neisse, Werfel introduces the reader to certain characteristics of Karl's father which allow him to feel some sympathy for the character. Karl in fact reaches out to his father on several occasions, when the latter's guard is down. Duschek's civilian clothes are suddenly seen to reveal his 'Engbrüstigkeit' and 'Schäbigkeit' (13), but they also show Duschek as more human. During his involvement in scandal, Karl's ready acceptance of guilt indicates that he is motivated by what his dreams anticipate as reconciliation and grace (30). His participation in revolutionary acts and the insulting of an officer only superficially hide Karl's desire for dialogue, which he shows openly when, upon being arrested, he calls out 'Vater.' In fact Karl's awareness of the complexity of his relationship with his father is evident as early as the moment he receives news of his father's illness: 'stehen wir beide vor einem unbegreiflichen Gesetz, uns in der *Ferne suchen,* und in der *Nähe hassen* zu müssen?' he asks (57). As yet he rejects the 'gefährliche[n] Gedanke[n]'; nevertheless, the realization of a 'mystery' prepares him for the final rejection of murder. When he sees before him 'ein[en] nackte[n] Greis,' for whom he feels only pity (90), and particularly when he thinks of a possible future son of his own, he throws away the murder weapon, and with it the 'Krankheit der Kindheit' (90). Out of an act of revolt he makes a turning-point, the start of a new life. Karl says farewell to his childhood when he finally sees in his deep-seated love of his father the 'stärkste Trieb meiner Seele' (105). The end of childhood also means farewell to the Old World, which exemplifies the frustrations of his youth. Werfel even implies that the Expressionist theme itself has been superseded, that it has lost its actuality because the conflict of generations only exists in the eyes of the immature. From this

point on Werfel develops the larger implications: Karl's case becomes the paradigm of a whole generation.

During the sequence in which Karl is involved with the anarchists, Werfel has already begun to phrase the theory of the father-son conflict in more universal terms. All social institutions are condemned by the anarchists, he suggests, because this semi-mystical brotherhood considers them forms of patriarchal organization. Religion, state, the army, even industry are interpreted as distortions and corruptions of a supposedly perfect primitive democracy which had no father-figure: 'Die patria potestas, die Autorität, ist eine Unnatur, das verderbliche Prinzip an sich' (43). Anarchism is thus seen by Werfel as a more universal manifestation of the same father-son conflict. The condemnation of the one entails therefore that of the other, and there is evidence that anarchistic streams within Expressionism itself are implicated in this condemnation. This is brought out by Werfel when he introduces into the story a newspaper article which discusses the parallels between the 'new literature' and the murders at Sarajevo. 'Eine lasterhafte Jugend is herangewachsen, die alle Gesetze, alles was der Väter Mühsal geschaffen und erworben hat, mit Füssen tritt,' claims the article (94). Moreover, by recounting the parallel story of a certain August Kalender, Werfel is able to demonstrate the consequence of anarchist thinking, since the latter's case *does* end in murder. There seems again symbolism involved here: what Julius Kalender (July, the older generation) built, August Kalender destroys.

The conflict of generations is explained, in a letter to Kalender's lawyer, as a struggle for authority as old as Greek mythology. The extenuating circumstances of Karl's own case – the fact that his father is a military man, trained to kill – may at first seem to justify Karl's revolt. But Werfel's hero finally rejects both the personal and the anarchist revolt. Despite his admiration for the purity of their principles, despite the fact also that within this group he has found love for the first time, the anarchists and their aims now appear deluded to Karl, and the whole episode like a dream inspired by opium. Anarchism and Expressionism are considered movements of youth, to be left behind in maturity. Nevertheless, even in this late formulation an important fact about the conflict of generations is revealed. In Werfel's analysis the subjective view and the most personal experience lead, as in the cases of Ehrenstein, Heym, and Benn, to the most universal world-view. Karl's hatred for his father not only colours his view of himself; it leads him to embrace a political cause which has world-wide implications. But in Werfel's story the distortions, exaggera-

tions, and frustrations are shown to be dangerous: a departure from dualistic thinking is considered necessary.

Roy Pascal claims that 'in literature generally, the "conflict of generations" turns out to be, not the true principle and source of social revolution, but one specific and typical form of the social tension and dynamism of the period' (S164/228). It is true that, although there are implications in Werfel's story which show that the personal revolt may lead to political and social revolution (here anarchism), the failure of the anarchists to come up with viable alternatives, their ineffectiveness and inability to abstract from personal motivations could be seen as typical of the general failure of the revolt of the younger generation. That the revolt is more personal than social and that the presence or absence of the father-son conflict in an author's work is indeed mostly determined by personal experience can also be seen from Max Brod's confession: 'Ich habe meinen Vater immer sehr geliebt. Er war sanft und bescheiden, immer etwas an die Wand gedrückt ... durchaus nicht die Vaterfigur aus den Werken von Freud, die "Imago," vor der man sich fürchtet und die man im Geheimen hasst ... Daher vielleicht meine einsame, isolierte Stellung innerhalb der expressionistischen Literatur, die vom Ödipuskomplex des unterdrückten Sohnes lebte' (P343/45).

Ladislao Mittner concurs with Pascal, perhaps having such personal motivations in mind, when he writes 'im übrigen wird [der Vatermord] mehr aus persönlichen Motiven vollzogen oder wenigstens geplant, als aus eigentlichen sozialen' (S154/409).[2] But this goes against the opinion of Walter Hinck, who maintains 'Es ist der Wille zur radikalen Welterneuerung, der sich in der Erhebung der Söhne offenbart – das Verlangen nach einer von Autoritäten befreiten Gesellschaft von Brüdern und Freunden' (S85/350). To be fair, it is certainly Hinck's opinion which seems to conform most closely to the intentions of the Expressionists themselves, both in their theoretical and creative writing. A case in point is the medical doctor Otto Gross, who, basing his statements squarely on the 'Freudsche Methode und deren wesentlichen Ergebnisse' (P206 = S8/149), sees in the father-son conflict a conflict between individual freedom and the oppressive forces of authority. Moreover, the relations between the sexes are equally determined by the social patterns existing within the family: 'Man kann jetzt erst erkennen, dass in der Familie der Herd aller Autorität liegt,' he claims (S8/150). A liberation of mankind can only be achieved by destroying the authoritarian patterns of the family, since external authority has entered into the inner psyche of the individual via

the family: 'Der Revolutionär von heute, der mit Hilfe der Psychologie des Unbewussten die Beziehungen der Geschlechter in einer freien und glückverheissenden Zukunft sieht, kämpft gegen Vergewaltigung in ursprünglichster Form, gegen den Vater und gegen das Vaterrecht' (S8/150).

Ironically, Gross's proclamations gained a sudden and dramatic audience when he himself was interned in a psychiatric institution by his father. The *Wiecker Bote* (a periodical in the proximity of *Die Aktion*) provided the background to the case and demanded the release of Gross. The article was carried by a number of Expressionist periodicals and in fact did lead to Gross's release. Fittingly, the case became a symbol for the whole Expressionist generation: 'Die ganze Jugend wird in dem Geschick unseres Kameraden Otto Gross ihren eigenen Kampf, ihre grösste Gefahr sehen,' wrote the *Wiecker Bote*. 'Deshalb ist es gut, dass durch die Genialität eines Sohnes, der sich der durch staatliche und familiäre Sanktionierung gestützten Kraft des Vaters nicht beugte, die Katastrophe herbeigezwungen wurde. Hier liegt der Freiheit Kampfplatz' (P255 = S8/153).

Paul Federn also sees patterns of authority and power which exist in society being mirrored in the family circle. The revolt against the fathers is also the revolt against authority of the state and against the suppression of individuals within it. For Federn the 'allgemeine Ehrfurchtsverpflichtung gegenüber dem Obrigkeitsstaate' is rooted in 'ein leidenschaftliches, unbewusstes, kindlich intensives Verlangen nach vaterähnlicher Autorität,' which must spring up everywhere, 'wo in einem patriarchalisch aufgebauten Staate normale Kinder unter mütterlicher Pflege und väterlichem Familienhaupte aufwachsen ... Die allgemeine Vatereinstellung war schuld, dass die soziale Ordnung sich so lange erhalten konnte' (P193 = S8/166). With the fall of the emperor, who now could no longer offer security, the way was cleared for a society without the father. Such a society is also the only one in which 'Bruderschaftsbewegungen' (S8/167) can truly come about. Children, so plead both Gross and Federn, ought in effect to be educated according to matriarchal rights. A similar shift from a patriarchal to a matriarchal society was also suggested by Hermann Hesse in *Demian*. Such views seem to oppose Pascal's interpretation of a merely 'internal' conflict. There are, in fact, time and again references to larger dimensions going well beyond the specifically individual sphere. For Erich Mühsam the youth movement is called upon to realize 'das höchste anarchistische Ideal, die Selbstbesinnung des Menschen ... Zum erstenmale organisiert sich die Jugend gegen Autorität und Zwang, gegen Tradition und Erziehung, gegen Schule und Eltern' (P254 = S8/147). Mühsam claims for the younger generation all those characteristics and quali-

ties which the older generation has lost: 'In schönem Radikalismus streben sie nach den grössten Dingen: nach Wahrheit in Empfangen und Geben, nach Freiheit in Leben und Lernen, nach Raum zum Atmen und Werden ... Mögen Lehrer, Pfaffen und Eltern vor Entsetzen bersten, mögen sie sich mit Maulkörben bewaffnen und die Polizei herbeirufen, um das freie Wort im Munde der Jungen zu verstopfen, – er nützt nichts mehr' (S8/147).

Old and new morality are sharply contrasted in Heinrich Mann's novelle 'Der Gläubiger.' Its young hero, Wölfchen, is a creditor in the double sense of the word: concretely because with his coming of age he is able to claim his inheritance, and in a symbolic sense because he claims from the older generation a moral inheritance in lieu of one which has taught him only hypocrisy: 'Hätte ich nicht mein leichtes Herz, wo bliebe ich ... Ihr habt das Menschenmögliche besorgt, um von der Geschichte weggefegt zu werden ... Nur wir halten eure sogenannte Ordnung noch aufrecht. Ihr wart schon zu neunzig Prozent mit ihr fertig '(P99 = P393/25). In contrast to the preoccupations of his mother and her clandestine lover (who is also Wölfchen's guardian) with 'reputation' and convention, Wölfchen proclaims his own ambitions and those of the young, whose spokesman he sees himself as, with an almost cruel honesty: 'Wir heucheln weniger als ihr. Wir nennen, was wir tun, beim richtigen Namen, und manches tun wir nicht. Nach Geld heiraten. Einander betrügen. Verbotenen Lebenswandel führen: wir haben das alles nicht nötig. Wir sind sowieso fertig, dank eurem Wirken. Unsere Mentalität ist gradliniger als eure, daher unsere restlos ablehnende Einstellung zu eurem Treiben' (26). Wölfchen's honesty is echoed by that of the girl Inge, who confesses to her father that Wölfchen is her lover. Her father's objection, 'Ich weiss, ihr habt eine andere Einstellung als wir sie hatten,' she answers bitterly with 'Ihr habt lieber geheuchelt' (20). We are reminded of Erich Mühsam's 'Idealistisches Manifest,' in which he writes: 'Was haben die Alten nicht getan, um ihre Macht über die Jungen zu konservieren! Sie haben verboten und gestraft, geprügelt und gelogen, sie haben das Geheimnis der Menschwerdung vor den Kindern gehütet, als ob alles Seelenheil in Gefahr wäre, wenn der Junge weiss, wie das Mädel beschaffen ist' (P254 = S8/148).

According to Paul Federn, the 'Vatereinstellung,' which is so dangerous for the family and the individuals within it, is continued in the school: 'die Schule ist darin so erfolgreich, weil sie der Vatereinstellung entgegenkommt. Darum lassen die Menschen leicht das Wissen der Schule hinter

sich, aber nicht den Geist' (P193 = S8/166). In 'Nicht der Mörder, der Ermordete ist schuldig,' the military academy which Karl attends is made at least partially responsible for the hostility by which Karl feels himself surrounded. To the Expressionists school is often a source of pain and frustration. Far from incorporating the old *Bildungsideal*, the school is a theatre in which authoritarian, stultifying teachers terrorize and humiliate abjectly submissive and passive students. The spirit which reigned in the school system around the turn of the century is well described in *Education and Society in Modern Germany* by Richard Samuel and R. Hinton Thomas. Literature from the period between 1900 and 1910 is also rich in descriptions of the stifling and oppressive atmosphere pervading most of these schools. Another motif important for Expressionism also occurs in the novels and stories of this period: a pupil's suicide as the only means of escape from the pressures of school. Suicide occurs in Emil Strauss's *Freund Hein* (1902), in Stilgebauer's *Bilder der Jugend* (1900), (probably) in Hesse's *Unterm Rad* (1906), and in the plays *Der junge Mensch* (1919) by Hanns Johst and Wedekind's *Frühlings Erwachen* (1891). All of these feature 'the schoolboy suicide, the grotesque figures of hateful and hated schoolmasters and the attack on Christian sexual morality' (S164/222).

When Expressionist prose takes up this theme, something happens to it which should not surprise us. Its treatment quickly moves away from the realistic to the bizarre and grotesque. Distortion and exaggeration serve to reformulate the problem in ever more extreme forms, true to Nina Pawlowa's contention: 'Der Expressionist ist ausserstande, die Dinge besonnen, objektiv zu betrachten: Künstler und Werk, Autor und Gestalt lebten in der gleichen Ekstase, in der gleichen Welt der stürmischen Katastrophen, der unerklärlichen Diskrepanzen, der tragischen Zusammenstösse' (S167/142).

In one of the sketches making up the semi-autobiographical collection *Klagen eines Knaben* by Carl Ehrenstein (a brother of Albert), a parallel is drawn between the boredom and absurdity of life and that of school; the young boy asks himself why he must participate 'im Trauerspiel "Schule," dessen Dauer ohne erlösendes Ende zu sein scheint,' and 'weshalb das Stück überhaupt aufgeführt wird' (P363/10). The equation school = world is important to remember when we turn to Alfred Lichtenstein's *Groteske*, 'Der Selbstmord des Zöglings Müller,' for if the school equals the world, then the world equals a madhouse.

The confessions of the pupil Müller, addressed to his teacher Lenzlicht, instructor in an institute for psychopathological children, express

the typical *Lebensgefühl* of the early Expressionists. But Müller's justification for his fatalistic views on life, and especially his decision to commit suicide, are seen to be without proper authority, since the boy is living within the context of a madhouse. Suicide as revolt against the pains of existence will have no validity when carried out by a 'mad' little boy: 'Man wird mich für überspannt erklären. Und das medizinisch begründen. Um sich zu beruhigen; denn wenn jeder so dächte, gäbe es bald ein allgemeines Protestieren gegen das Dasein. Das Leben würde boykottiert. Das darf nicht geschehen. Wenn man fragt: warum nicht? – wird man ein Sophist gescholten. Die Leute sterben nicht gern, das heisst Lebensenergie. Sie helfen sich mit Göttern und heiterer Weltanschauung. Wenn einem der Jammer doch zu grell wird, fährt er in ein besseres Irrenheim' (P90 = P389/31).

In typical Expressionist fashion, the statement moves immediately away from the personal and the unique case to the condition of mankind in general. Lichtenstein explores here a theme dear to twentieth-century literature, that of the lucid madman. At the same time the objective norm of the outside world is also undercut, for the teacher Lenzlicht, who figures as an interpolated reader, is also relativized. The characterization of Lenzlicht is such that we have great doubts about his ability to understand the outpourings of Müller. He does in effect parry Müller's disturbing views by shifting into psychology, not surprising from a man who is 'bartlos, wie ein Schauspieler' and who wears a 'strenge, scharfe Maske' (P389/25). Lenzlicht escapes into psychology because it is supposedly scientific; in reality, of course, Expressionists would argue that it allows for the inhumane treatment of humans. In fact the whole problem of psychology and psychiatry, and of madness, is opened up in this story. It may suffice here to note that Lichtenstein does not allow the reader to avoid having to face both Müller's madness and the madness of the world in general. The story itself does not resort to psychology to explain everything away. There are plenty of grotesque elements in the story: the events take place in a children's insane asylum; the writer Müller is eight years old but works on an essay on 'art and genius' (while being locked in the bathroom); this essay is intended for the periodical *Das andere A*, an oblique reference to *Die Aktion*, and so on. All this tends to relativize Müller's plight and the statements associated with it, whereas the reader Lenzlicht is shown to react to Müller's confessions in such a way that he is equally grotesque: 'Der letzte Aufsatz des Heftes schien ihn mehr zu interessieren. Die Augen weit, sie klammerten sich an die Schriftzeichen. Auch hielt er das Papier wie ein Kurzsichtiger; und mit beiden Händen.

Manchmal sprach er etwas Undeutliches. Oder er lachte, ohne es zu wissen. Oder lachte, wie einer Donnerwetter sagt. Oder er liess die Zunge aus dem Mund hängen' (26).

Of course Lichtenstein uses Lenzlicht to emphasize Müller's isolation and to bring out the essential correctness of the latter's assessment of the world. He carries this even further by letting the woman who might have saved him, Dr Mondmilch, adopt an equally 'official' attitude: 'Wenn ich einmal versuche, ihr meine Leiden und Schönheiten in ernster Unterhaltung verständlich zu machen ... ist sie fremd, macht Notizen' (27). The possibility of redemption through sex, a theme we shall encounter often in Expressionist prose, is denied Müller. This is catastrophic, since it reinforces Müller's loneliness and strengthens his opinion about the sorry state of the world. The grotesque shows itself capable of genuine tragedy. Fritz Martini, writing about another of Lichtenstein's *Grotesken*, claims: 'Die Schwermut flüchtet in eine Selbstironie, die in das Groteske und Absurde überspringt. Die Groteske bestätigt und distanziert die Nihilität; sie ist deren Anerkennung und gleichwohl ... ein Spiel mit ihr' (S149/45-6).

Tragedy is certainly involved in the conflict between the schoolboys Max Mechenmal[3] and Kuno Kohn – a conflict which Lichtenstein uses as yet more evidence of the imperfect state of the world. Whereas irony and self-irony are constantly breaking down the mood of pathos in Müller's narration of his own sufferings, pathos is consistent in the scenes in which he recounts the persecution and death of his fellow pupil Kohn. The figure of Kohn, which appears frequently in Lichtenstein's prose, is a foil for Lichtenstein himself; as Fritz Martini suggests (S149/45-6), in this character Lichtenstein allows himself at the same time a playful and a self-pitying attitude.[4] As he recounts the fate of Kohn, the vocabulary of pathos predominates, despite the grotesque context. We would be tempted to speak of a break in style were it not that the whole idea of the grotesque is this shift from one mood to the other. A sense of personal suffering begins to permeate the language from the moment the schoolboys' torturing of Kohn is described: 'Da wurde ich durch das langsame, seelenvolle Geschrei des blinden, kleinen Kohn ... erschreckt ... der kleine Kohn war bleicher. In seiner Hilflosigkeit. Er hielt den Rücken gegen eine Wand. Die dünnen leidenden Hände tasteten in der Luft ... Ich habe niemals so viel konzentrierten Schmerz gesehen, wie auf den verstorbenen Augen des kleinen Kohn lag' (P389/28). The martyrdom and death of Kohn in fact trigger Müller's own decision to commit suicide. His 'Grübeleien' (31), which take on cosmic dimensions, threaten his very

existence; in the fate of Kohn he recognizes his own, and even that of all mankind. A profound discontent with his own being, as well as with the world, forces him to make an end. In suicide lies a way at least to a private death and freedom. Moreover, suicide means revolt: it signifies the refusal to accept given conditions; it means Müller's breakaway from the hell of school, symbol of an imperfect reality.

By using the topos of the madhouse as world, Lichtenstein indicates that the world is experienced primarily as pain. In the clash between the ideal and the real, the real is felt to be shabby: 'Ich möchte in einem mutigen, ehrlichen, reinen Jungen sein,' Müller complains; 'Mein Mensch ist unwahr, unästhetisch, plump' (31). A veritable conflict within the self is experienced by Müller, though it is a moral, not a psychological one (schizophrenia, for example) :'ich bin mir ernsthaft unsympathisch. Ich kann zufällig nicht aushalten, über ein ganzes Leben bei mir zu bleiben. Ich kenne mich zu genau. Ich habe häufig geweint, dass ich von mir nicht loskommen kann' (31). From such a division of the self only death can save Müller; the central concern of the whole sketch turns out to be in effect the problem of death. Klaus Kanzog suggests as a possible source of this story a quote from Carl Einstein's *Bebuquin*: 'Man muss den Mut zu seinem privaten Irrsinn haben, seinen Tod zu besitzen und zu voll-strecken' (P389/115, 141). Obviously, Lichtenstein's grotesque story is a complex one, going far beyond the criticism of the institution of school. It contains an indictment against all reality and the human condition.

Prose writings dealing with the entrance of the individual into the larger world, the world of work in particular, demonstrate the tendencies already outlined so far. Because of the extreme importance attached to *Geist*, we could hardly expect the work-world and the larger social world to be discussed in objective terms. The Bohemian attitude of many Expression-ists is itself a clear indication of a negative stance towards the work ethic. In the tendency towards group-building as an alternative to patterns prev-alent in bourgeois society, as well as in the cult of the genius and the life-style of the dandy, we may see further evidence that confrontations with society are usually decided in favour of the individual and that disen-chantment and retreat are frequent. Two stories, Max Brod's 'Notwehr' and Alfred Wolfenstein's 'Über allen Zaubern,' may illustrate two atti-tudes towards the larger world.

Brod's hero Victor experiences his first contact with the work world as an abrupt break with his former existence: 'Ein scharfer Strich ... war unter seine Jugend gezogen, etwas Neues, nie Geahntes hatte er

begonnen' (P16 = P335/121). But the break with the past is not a release; rather it is a limitation. The work is a source of boredom, primarily because the larger context in which the work supposedly fits escapes him completely: 'Zu Hause auf dem Lande war er gewohnt gewesen, dass jede Tätigkeit, mit der er sich befasste, in sich rund und abgeschlossen, mit dem deutlichen Siegel ihres Nutzens versehen war. Hier reichten ihm unsichtbare Hände aus unsichtbaren Etagen des grossen Gebäudes herauf Schrifstücke, deren Bedeutung er nicht fasste, und die er ... wieder weitergab, an andere' (122). Even time taken away from work appears meaningless: 'Die freie Zeit war offenbar nur so bemessen, dass man sich abends ein wenig erholen konnte, um am nächsten Tage wieder frisch zu sein. Und dazu lebte man?' (126) Brod is describing a phenomenon which Marx calls alienation from the work process. It results in a total lack of identification with it. Interesting is also the echo of the passage by Benn: 'Früher in meinem Dorfe ...' The loss of a middle and of meaning can manifest itself, it seems, in an existential situation, as in Benn's case, as well as in a social one, as in Brod's story.

The insignificance of work and the monotony of private life cause in Victor a profound longing for change. But Victor is not the type to revolt against the status quo. Except for a brief interlude his life is characterized by resignation and passiveness. An early submission to authority as fate has made him incapable of decisions. Victor is not an Expressionist hero but a coward whose one act of revolt, the killing of a robber in self-defence, remains without issue.

Wolfenstein's unnamed hero in 'Über allen Zaubern,' by contrast, does achieve a transformation, though for him too the confrontation with the larger world is at first painful and disturbing. The great city with which the young man (like Victor from the country) is confronted presents itself as an image of power and is intuited as hostile: 'Das war die Stadt der Gewalt, die menschenschlingenden Türme besetzt mit Gesetzen, das war die Stadt, in die er noch nicht eingedrungen war' (P149 = P417/42). The hero's sheltered life has not prepared him for the true character of the city. He must, like Victor, abandon completely his childhood and his innocence if he is to conquer this city. But in Wolfenstein's case, society is not met on *its* terms. The abandoning of the previous life is not undertaken to make a complete integration possible, nor is it the hero's longing to achieve the identification of world and ego. On the contrary, this hero goes beyond the society he finds and towards the realization of a utopia based on the doctrine of love.

In both stories just discussed the first confrontation with the larger

world is cataclysmic. It determines the hero's view of the world and his subsequent behaviour. In both cases we are also dealing with a confrontation with the city as a symbol for society, just as school was a symbol of the world. Family, school, and adult world provide us with an insight into the mechanisms by which Expressionist authors formulate their view of society. In at least one case, Werfel's, we also noted that the author himself is aware of the degree of subjectivity involved in the formulation of the world-view. In Werfel's case this entailed a moving away from subjectivity. Werfel realized that in 1920 the time had come to break with a movement which maintained 'das Subjekt ist nur seiner selbst gewiss, während alles Objektive den Charakter des Fremden, ja Feindlichen angenommen hat' (S88/95).

Measured against their implicit or stated norms, the social world as the Expressionists see it seems to cry out for both polemics and satire. In the description of the bourgeois and of his society, the distance between values proclaimed and values held, between behaviour recommended and behaviour indicated, is perceived as greater than at any other time since the triumph of the middle classes in the French Revolution. All of nineteenth-century literature, it seems, concerns itself with the problem of appearance and reality, with *Sein* and *Schein*. The Expressionist author continues the social criticism which started especially in Naturalism, but his criticism argues from different premises. Ernst Alker, using Wilhelm Worringer's terms of 'Abstraktion' and 'Einfühlung,' describes the difference as follows: 'Einfühlung ist das pantheistische Vertraulichkeitsverhältnis zwischen dem Menschen und den Aussenwelterscheinungen; dieser Vertraulichkeitsdrang lässt den Naturalismus das "Glück" des Organisch-Lebendigen, nicht das des Lebenswahren erstreben. Abstraktion (Anfang jeder Kunst) ist die Konsequenz der Beunruhigung des Menschen durch die Aussenwelt, hat transzendentalen Akzent' (S3/262). This is the crucial difference between Naturalism and Expressionism. Whereas Naturalism believes that reform will allow happiness of the individual and a reconciliation between man and nature as well as between man and fellow man, Expressionism has lost this faith: it sees the objectionable human condition as a metaphysical problem, incapable of adequate description in terms of merely material or social factors but entailing a vision of the totality of creation and requiring a leap of faith. To the Expressionist the relationship between man and reality and between fellow men does not admit of a gradual, progressive, historic improvement but demands a sudden and complete transformation, a *Wandlung*. Expres-

sionists accuse Naturalism of staying on the surface, of dealing only with externals; it does not nor can it deal with the essential dichotomy of man and world. For this, the Naturalist tools are inadequate.

Of course the actual prose written during the period under discussion cannot be so neatly dissected into components. On the contrary: there is a continuous spectrum from more or less Naturalist criticism of society to the abstract, almost completely intellectual analysis of society in drama (for example, Georg Kaiser's *Denkspiele*) or to the pathos-filled visions of a cataclysmic *Weltende,* followed (in some cases) by a convulsive birth of a new world. We shall do well to proceed from the specific to the more general, from the more realistic to the larger and speculative descriptions of the world. Ultimately, however, the social dimensions of Expressionism are part of other concerns of a transcendental nature, without whose investigation in later chapters the social concerns dealt with here must of necessity remain incidental and to some extent devoid of content, since they are divorced from their context.

Expressionism is still very much in the tradition of Realism and Naturalism in its criticism of the bourgeois as a specific type. This form of representation of a society through a type works particularly well in the theatre, of course, and has a long tradition there. In Expressionist prose the criticism of the bourgeoisie takes the form of a catalogue of characteristics associated with this figure. That the bourgeois is almost universally and exclusively made responsible for the evils of society is in itself an indication that the society which Expressionists criticize is a bourgeois society. When criticism moves away from the type to a larger context, and thus concerns itself with the direction of society under the impact of industry, capitalism, technologies, and ideologies, we must therefore not anticipate a difference in the kind of criticism expresssed but merely in its scope.

'Die negative Darstellung der "bürgerlichen" Welt steht im Zentrum der Gesellschaftskritik der expressionistischen Prosa und vor allem Dramatik,' writes Thomas Anz (S8/168). Not only do Expressionist authors draw the image of the bourgeois world on the basis of their own experiences; they note with great interest contemporary philosophical and sociological works which define the bourgeois. Max Scheler, for example, reacted with a long article in *Die weissen Blätter* of 1913–14 to Werner Sombart's book *Der Bourgeois. Zur Geistesgeschichte des modernen Wirtschaftsmenschen* (Munich 1913). Thomas Mann's attempt to define his own problematic identification with the bourgeoisie in 'Bürgerlichkeit,' a chapter in his *Betrachtungen eines Unpolitischen* (1918), resulted

in a predictably violent reaction by the Expressionists. Both in Mann's use of the term and in that of the Expressionists, however, it is clear that a socio-analytical notion of the bourgeoisie is far less important than a certain moral idea about the bourgeoisie. Sociological and economic factors are mostly obscured by ideological and behavioural constants which are ascribed to the bourgeois.

Perhaps the most viciously worded attack on the bourgeoisie was undertaken by Walther Rilla (later a citizen of the GDR), in *Die Erde*: 'Kann man ihn definieren,' he asks, 'seine obstinate Verbohrtheit ins Gegebene, die Mediocrität seines um den eigenen Nabel spiralig sich drehenden Vegetierens?' And he answers: 'Man wird' (P263 = S8/172). Rilla attempts to paint a portrait of the bourgeois in the light of the latter's behaviour during the First World War and the following revolution. He attacks the bourgeois press for not protesting against the arrest of a leading Spartakist, Leviné-Nissen, and for rationalizing the invasion of Belgium and the sinking of the *Lusitania*. Especially Thomas Mann is attacked, as a prominent figure, for having those characteristics Rilla most violently rejects. Yet Rilla's definition of the bourgeois as 'ordnungsliebend,' servile, power-worshipping, and gullible, to which he comes after examining political bourgeois behaviour, is not so different from that of authors who attempt to define the bourgeois in moral terms. P.U. Hohendahl writes, after an analysis of Carl Sternheim's play *Die Kassette* (1912): 'Die literarische Moralkritik, die die Technik der Entlarvung anwendet, fördert zutage, dass das Bürgertum das Sittliche für seine Interessen benutzt. Sie entdeckt, dass seine Moral, bildhaft gesprochen, nur äusserlich ist. Sie will zeigen, dass die Bourgeoisie, wenn sie von dem Guten spricht, im Grunde das Geschäft, die Macht oder sonst etwas anderes, aber eben nicht das sittlich Gute meint' (S88/161).

All such criticism would remain suspended in mid-air, however, were it not for the presence, explicit or implicit, of a norm by which bourgeois behaviour can be measured. For the Expressionist generation this norm is subsumed under the dichotomy of the old and the new man on the one hand and the soulless *Bürger* and the spiritual *Mensch* on the other. Given the dualistic thinking which underlies all of Expresssionism, it is no wonder that definitions of the bourgeois frequently resort to such contrasts. Thus Th. Haubach sees the opposition between *Bürger* and *Mensch* in the following terms: 'Bürger, d.i. kümmerlicher Mensch mit vermoosten Horizonten, enger begrenzter Nörgler am Leben, Sattzufriedener oder hämisch Besserer (hierher alle Reformer), ein Blutloser, Ordnungssüchtiger ... nie ganz Reiner, nie ganz Böser' (quoted S8/168). These

negative characteristics, typically not sociological, are then contrasted with the norm: 'Doch Mensch: Ungebärdig und nie ohne Chaos, Teufel und Gott, Tendenzloser, Sehsüchtiger nach Abenteuer und Rätsel, voll tropischer und polarer Stürme in den Wettern der Seele, oft Tier, oft Engel, Aufbäumender zum gestirnten Himmel.' Clearly, this particular contrast is based on a vision of the new man heavily inspired by Worringer's theory of a 'Gothic' or 'Northern' man: oceanic, metaphysical, religious. By these standards the bourgeois is a cripple, a product of a stagnant, levelling civilization, a restrictive code, and a thing-oriented materialistic and deterministic culture. And yet, precisely because he incorporates all the vices and limitations from which the true *Mensch* must liberate himself, the bourgeois has an important function. Wilhelm Michel explains: 'Es gibt eine gewisse Summe Feigheit und Dummheit in der Welt, die durchaus gefeigt und gedummt werden muss. Diese Arbeit nimmt uns der Kamerad Bürger fast vollständig ab. Er ist Knecht, damit wir frei sein können ... Er ist unser Widerstand, unsere Bestätigung, unser Opferlamm, unser Komplement' (P248 = S8/170–1). The bourgeois, as counter-image of the norm *Mensch*, makes the definition of the latter possible and inevitable.

The contrast *Bürger-Mensch* is not conceived of only in terms of blind obedience and freedom to decide issues (Rilla) or in terms of mediocrity and transcendental longing (Haubach) but also especially in terms of vitality and stagnation. This opposition belongs to the sphere of influence of the *Lebensphilosophie* which Günter Martens has shown to be an integral part of the world-view of many Expressionist authors (S145). In the wake of Friedrich Nietzsche's and Henri Bergson's philosophical writings, 'life' as an absolute good is celebrated by Expressionists in both theoretical writings and in literature. From these philosophers and from Georg Simmel's sociological writings of the period 1908–18 (for example, *Lebensanschauung*, Munich 1918) yet another set of contrasts is obtained which describe the bourgeois as representative of the old measured against the ideal of the new: 'erstarrt' versus 'bewegt,' 'geordnet' versus 'unruhig' or 'chaotisch,' 'unproduktiv' versus 'schöpferisch,' 'kontinuierlich' versus 'sprunghaft,' 'begrenzt' versus 'unendlich,' and so on. Simmel, whose lectures were attended by some members of the Neue Club, saw in Expressionism the revolt of life against decay and stagnation, and Expressionists themselves stressed their opposition to the rigidity and predictability of bourgeois behaviour patterns.

The bourgeois has at his disposal only a limited range of responses to a given situation. He acts according to a code rather than to his feelings and

emotions. Spontaneity is interpreted as dangerous; it opens the door to chaos. The bourgeois is therefore apt to wear a mask (see Lenzlicht in Lichtenstein's story) and always resorts to the called-for, appropriate word or gesture, which is recognized by others as having this specific meaning. Communication is reduced to easily interpreted stock responses. Albert Ehrenstein's acid comments on the behaviour of the funeral guests in 'Begräbnis' were based on the narrator's certainty that the grief displayed was feigned.

Gustav Sack has made a rather thorough study of these adopted behaviour patterns, specifically as they refer to eroticism. His writings revolve around the notion of kitsch. In 'Das Duell' he shows how the exalted behaviour of one of the main characters results from his belief that a lover deceived must seek revenge.[5] In 'Capriccio' and 'Reigen' Sack attacks the Impressionist and Neo-Romantic notions about love and reveals them as a morbid play with convention, and as mutual dishonesty. The problem of what Sartre was to call authenticity is in Sack's work couched in terms which appear at first un-Expressionistic. Sack plays a subtle game, far from the more pathetic outbursts of his contemporaries, whose cries for man to become 'wesentlich' are heard loud and clear in the marketplace. Yet in his own way, and with a much greater degree of control, Sack poses the very same questions. This at least was the opinion of his contemporary Max Krell, who wrote: 'Sack war, wie keiner in dieser Zeit, wesentlich' (P236/1195).

The bourgeois recourse to codified instead of authentic responses ultimately betrays his lack of soul. In our analysis of 'Der Selbstmord des Zöglings Müller' by Lichtenstein we noted the mechanical reaction which both Lenzlicht and Mondmilch adopted, and their flight into psychology, which takes for granted the constancy of certain phenomena. Reliance on constant values allows the bourgeois to operate in this world. His search for security in a financial and material sense is paralleled by his search for a stable ideology. For the bourgeois, knowledge is possession; he disposes of it the way he uses his capital. He secures access to education and amasses within his own four walls the cultural heritage of his nation. For his own protection he accumulates a number of classical precepts and formulates a type of wisdom carefully assembled from accepted authority. This effectively blocks him from being exposed to chaos; it also encourages him to resist the new with uncompromising ardour. The Expressionist, on the other hand, prides himself on being able to reveal the fragility of such structures, since he maintains an extra-social position, not by birth but by choice.

One classic example of the breakdown of the fragile barriers thrown up against the chaotic is the case of one Herr Michael Fischer, in Alfred Döblin's 'Die Ermordung einer Butterblume,' one of the most famous of all Expressionist stories. The novelle has often been interpreted as a *Bürgersatire*, and on one level this is appropriate. The events which follow the sudden intrusion of a reality so far never acknowledged, and which cause Fischer to feel a profound sense of guilt about the seemingly innocent enough gesture of destroying a buttercup, are presented by Döblin in the form of a pathological case history, but there are social implications also. The vision which imposes itself on Fischer, of a gigantic anthropomorphized bleeding body of a flower, creates a situation with which Fischer cannot cope, precisely because of his usual security. Several attempts to stop the slide into madness, by gestures, admonitions to himself to show 'Selbstbeherrschung' (P22 = P348/44), even by jokes, all fail. The cliché'd behaviour which has saved Fischer so far seems to collapse, and the terms borrowed from business life, from trade and commerce, and from bourgeois virtues are of no avail. The truth is that Fischer does not have a centre: once stripped of the attributes which usually allow him to treat reality head-on and without fears, he has nothing to fall back on as an essence, as the Expressionists would say. Like most bourgeois, Fischer has relied for his contact with nature, on the idea of domination, on the interpretation of nature as a tool for humanity (an idea found in the Bible), as something over which man holds sway in an absolute sense: 'Es war sein Recht, Blumen zu töten, und er fühlte sich nicht verpflichtet, das näher zu begründen. Soviel Blumen er wollte, konnte er umbringen, im Umkreise von tausend Meilen, nach Norden, Süden, Westen, Osten' (P348/48). It is with this same matter-of-factness that Fischer kills flies in his office. When this sense of security, based on fixed beliefs, is destroyed through an 'unerhörte Begebenheit' (the story is a true novelle!) madness results. By criticizing Fischer as a man without essence, Döblin implicitly refers to a vitalist and Futurist concept of man. At the same time the story becomes a satirical weapon, for if Fischer is correctly analysed as a pathological case, then his madness is the madness of his social class.

This is also the point of Martin Beradt's novelle 'Die Nummer am Haus' (P12), in which a strange play of fate destroys a marriage of convenience between the bourgeois Fünfhausen and his wife Marie. An anonymous letter, which is in the end revealed as a practical joke, sets the plot in motion. It casts suspicions on Marie's fidelity, but works beyond this as an intrusive demonic message out of the realm of the unknown. The gradual alienation between the couple which follows the first doubts

about Marie's infidelity causes the latter's mental instability. She begins to identify with a prostitute, and her own house reminds her of a brothel in Paris. When in her mind the house is indeed transformed into a brothel (the lines of demarcation between dream and reality disappear completely at this point), fate leads a secret admirer (one who believes in Marie's innocence and purity) to commit suicide under the lantern in front of the house. A similar intrusion of the demonic can be seen, finally, in Herrmann-Neisse's story 'Das Experiment' (P62), in which the demonic Menge, by initiating the bourgeois Zander into the pleasures of erotic art, so upsets Zander's delicate balance of acquired sexual behaviour that he destroys the latter's (conventional enough) marriage.

The obsessive search for security and stability on the part of the bourgeois betrays his lack of vitality. The bourgeois is spiritually and physically dead. His unwillingness to break out of his self-imposed deterministic philosophies, which according to Sternheim he has adopted in the course of the nineteenth century, his fanatical belief in facts only – all this sharpens the antagonistic feelings Expressionists have towards the bourgeois. But the particularly strident tone in Expressionist declarations, the aggressiveness and hysteria, can be explained only by the urge these young authors have to break with what in effect is their own environment. Such hysteria may lead to writings like Heinrich Schäffer's 'Aus den Memoiren eines Unbekannten' (P120), in which amorality is glorified, the criminal cast as a hero, and the sexually promiscuous proclaimed as natural being. In such stories we may see the same attitude of revolt at work as in the Expressionist drama: 'Der Protest gegen die uniformierenden Tendenzen der sozialen Welt begnügt sich nicht mehr mit der Absonderung an sich, sondern geht zur Zerstörung der Ordnung über,' writes Hohendahl (S88/225).

One striking indication of this destructive tendency is the presence of a number of criminals who are interpreted positively because they break out of a world in itself already perceived as criminal. Once the morality of the bourgeoisie is revealed as a system of exploitation maintained by violence and oppression, crimes against this society may take on the character of the heroic. This is, for example, Peter Pfaff's view of Edschmid's writings: 'Mit grausigen Episoden in seinen Geschichten provoziert Edschmid ... Begütigung und schwächliche Felonie seiner Zeit' (S173/708). No wonder that ambivalent figures such as the poet François Villon or tyrants like Tamerlane fascinated Edschmid. Yet even when hostility towards bourgeois society turns into violence and revolt, the attacks on the moral order are not in the first place aimed at any specific laws as

much as at the obvious gap between morality preached and morality practised. In the tradition of Naturalism, Expressionism takes over the Nietzschean criticism of the abyss between appearance and reality; many of Frank Wedekind's characters are also more preoccupied with reputation than with virtue.

Heinrich Mann and Max Brod especially provide striking examples of the immoral morality which they see as determining bourgeois society. Mann's novelle 'Der Vater' (P102) illustrates how survival in an economic sense may also lead to senseless and ruthless persecution of one's fellow man in a psychological and moral sense. The father's obsession with the acquisition of wealth and the maintenance of his status in the 'jungle' of the business world cause him to adopt a hard attitude towards a younger competitor. Too late he realizes that the young man whom he has hounded to death had merely fallen in love with his daughter. It is shown that the morality of the business world (that is, the law of the jungle) can in the long run not be kept separate from the private sphere. Morality is in fact generally closely tied to the world of status, production, and consumption; virtue is profitable. In 'Kobes' Heinrich Mann has his hero declare: 'Kobes schlemmt nicht, Kobes säuft nicht, Kobes tanzt nicht, Kobes hurt nicht. Kobes arbeitet zwanzig Stunden am Tag' (P100 = P393/313). On a much more elaborate scale Mann demonstrates in the satiric panorama of *Der Untertan* how religion, patriotism, and devotion to the emperor produce material rewards.

Love and marriage, too, are tied to economic considerations. The institution of marriage is reinforced by state and church because the family is not only the basic molecule in both structures but also the basic economic unit – with the result that marriage is largely a practical affair. In Heinrich Mann's 'Gretchen' marriage is arranged by mother and daughter because of the fiancé's financial desirability. The lieutenant's own decision to marry the girl is at least partly motivated by her frugality. There is no love involved in the courtship, and though she briefly goes through an infatuation with a second-rate actor, Gretchen never really questions her future marriage. In 'Passion' Ehrenstein, too, looks rather critically at the motiviation behind his beloved's rejection of him for someone else. Commenting on the wedding to which he is invited as a guest, the narrator writes: 'Nach einer von rhetorischen Schönheiten gewiss strotzenden Rede ging die Dame meines Herzens in den Besitz [!] eines Nadelfabrikanten über' (P42 = P358/349). The same condition prevails in Heinrich Mann's 'Der Gläubiger.' The novelle opens immediately with the description of a marriage of convenience: 'Emmy Blasius konnte ihren einzigen

Geliebten nicht heiraten, denn Assessor Liban hatte nicht genug. Die jungen Leute blieben einig gegen die Eltern, aber wo waren die Stärkeren? Die ganze, stark befestigte Ordnung der Dinge in jenen friedlichen Zeiten sprach für die Eltern. Die Jungen konnten nur machtlos protestieren '(P99 = P393). Moreover, in their own behaviour these young people end up demonstrating the same mentality as their parents. Emmy does not seem too upset by her subsequent marriage to a Doktor Schatz, 'ein alternder Afrikaner, der Geld hatte' (7), and Liban follows the 'herrschende Vorschrift, Geld zu haben,' and marries a rich woman (9).

Besides being determined by economic considerations, marriage is also regarded as the only licensed outlet for sex. Here the moral ambiguities of the bourgeoisie come even more blatantly to the surface, since there is an almost universal acceptance of prostitution and sexual relations between middle-class men and working-class girls – relations which are explored, for example, in the writings of Arthur Schnitzler and Max Brod. Since in Expressionism the emphasis shifts from the Naturalist idea of the prostitute as a basically good and natural person to that of a primitive life-force embodied in her ('das Weib,' as Frank Wedekind portrays her in his Lulu dramas), we may assume that this fascination with the 'bad' woman points to the unsatisfactory nature of most marriages of the type considered earlier. Much of the preoccupation with sex in Expressionism might well stem from the family background of many of these writers, in which only the illusion of marriage was upheld.

It is one of the unstated but universally assumed truths in middle-class thinking that virtue and vice separate according to rationally explicable, teachable, and traditionally fixed precepts. The bourgeois relies on a rational system of vice and virtue, and morality is the result of logic and argument. There are constants which cover any moral situation, though in truth they often reveal themselves as obscuring a deep-seated egotistical impulse from which the moral act springs. In Max Brod's 'Notwehr' we have an interesting example of the illusory nature of this 'rational' morality. Victor Kanturek, despite the obvious hatred for the work he is doing, defends with courage against a robber a large sum of money which he has to deliver for the bank. The courage is revealed to be inspired not by a sense of duty, however, but by a suppressed antagonism against all of society. Brod carefully describes Victor's ambivalent motives for the killing of the thief. Victor realizes with sudden clarity 'dass er ja (glücklicherweise) würgen müsse' (P16 = P335/132). He is in fact taking revenge against a society which has cast him in the role of underdog all his life. Suddenly he is himself the law: his function is to exercise justice, now

that someone has been delivered to him 'dem er das Äusserste, was Menschen einander antun können, den Tod, mit Fug und Recht antun durfte und musste.' Law and privilege coincide for one ecstatic moment of 'Befreiungswohlbehagen' (133). Society even congratulates Victor for his courage, 'Notwehr' being the bourgeois term under which this 'ungeheure Lust' to kill can become a heroic stance. But Victor himself soon realizes the truth of his action, and a 'heimliches ... sich steigerndes Grauen' (138) prevents him from using his act of revolt as a new start in life.

Victor is unable to live with the truth of his moral act. In Carl Sternheim's work, by contrast, egoism, which is latent in bourgeois society but veiled because of certain metaphors, is elevated to the status of a virtue – in fact, to the basic doctrine of all moral behaviour. For Sternheim, as we shall see in the next chapter, natural morality entails the glorious affirmation of the self and an absolute acceptance of the consequences of ruthless egoism. Genuineness in morality depends not on given categories but on the proximity of the moral act to the nature of the moral agent himself. Something similar is suggested by Kasimir Edschmid.

Revolt against hypocrisy through the insistence on a self-centred morality, as in Sternheim and Edschmid, is one of the basic possibilities which at least some Expresssionists condone as alternatives to the illusory and hypocritical morality of the bourgeoisie. But it is a possibility which is condoned reluctantly, and with many reservations. Much more often Expresssionists propose a totally different solution: an out-and-out altruism in the brotherhood of all men. The true moral act, Expressionists argue, is unreflected, emotional, dynamic, inspired by feeling only. The purity of the moral act thus depends not on any system, for morality cannot be captured once and for all in any set of rules, but must come immediately from the heart as an impulse. Morality is therefore conceived of as a series of spontaneous acts which involve the sacrifice of the self to the larger ideal of common humanity. The problematic nature of such an emotional morality is of course revealed in the many instances in which the moral agent cannot fulfil his responsibilities. Walther Hinck writes: 'Im Namen einer nicht formulierten, sondern durch das Gefühl nur ahnungsvoll beschworenen, im Namen also einer unkontrollierbaren neuen Ethik macht sich das Ich zur letzten Gewissensinstanz' (S85/353). To overcome this problem of a purely subjective basis for morality, and to avoid the problem of sustaining the impulses of non-connected moral acts, the Expressionist proposes a change in the social structure itself – the creation of a utopia, the framework in which morality could work automatically and become the natural way of life. This in turn is often

connected with a tendency towards regression into the simple life, the opposite of the complex relationships existing in the modern world.

Bourgeois society of the period 1910–25, measured against the standard of a desirable *conditio humana*, makes an ideal target for satire, since this mode is exploited by the lucid author to show the discrepancies between appearance and reality in the moral sphere. Obvious targets of satire are the 'frozen' institutions which continue to operate as if façade and content were identical; the ideologies which have changed from faith to dogma; and concepts such as honour and valour, which have lost their meaning in a purely materialistic society. And of course the mechanical and rigid aspects of social behaviour and of thought – seen by Henri Bergson in *Le rire* as the source of all comedy – make of the bourgeois a favourite target of ridicule. The relative paucity of true satire in Expressionist prose seems strange, therefore. It could be explained by two facts of which we have already become aware in the course of our study. I have suggested that in many writers the reference to the implied norm to which satire must refer had become a quasi-unattainable and therefore pain-causing ideal. Associated with this first reason is the second, aesthetic one, rooted in the poetic practice of Expressionism itself. To understand the first we must look at Schiller's concept of satire. For the second reason we must go back to considerations which also apply to pathos.

In his essay *Über naive und sentimentalische Dichtung* Schiller defines satire as follows: 'In der Satire wird die Wirklichkeit als Mangel dem Ideal als der höchsten Realität gegenübergestellt' (S207, vol. 5/722). This definition unites two opposites which also appear in the concept of pathos: the ideal and the real. In satire as in pathos the real is by definition imperfect and to be rejected: 'Die Wirklichkeit ist also hier ein notwendiges Objekt der Abneigung' (722). Ever since the 'death of the gods' man has lived in the painful awareness of a discrepancy between two levels of being. The 'sentimental' poet, in the Schillerian sense, 'hat es immer mit zwei streitenden Vorstellungen und Empfindungen, mit der Wirklichkeit als Grenze und mit seiner Idee als dem Unendlichen zu tun' (720). Should he decide to treat the discrepancy 'ernsthaft und mit Affekt,' he will produce a feeling of pathos. Should he decide, however, to present the imperfect state of undisplaced reality 'scherzhaft und mit Heiterkeit,' he would then decide for satire (721). Pathos and satire are therefore not incompatible; they do not differ in quality but in degree, in the degree with which the discrepancy is experienced as pain. But Expressionists seem to have little faith in the 'scherzhafte' treatment of the imperfec-

tions of the world; they tend to opt for pathos rather than for satire. Even when the belief in a progression of society towards utopia is postulated, as in Activism, this is done by means of polemics; the fictional component is then often sacrificed for the sake of demonstration and argumentation. The ecstatic component of Expressionism, by contrast, prefers to proclaim its utopian ideals not through argument but by means of a sudden and miraculous *Wandlung*, which must overcome such an overwhelming inertia that satire once again seems inappropriate. The ecstatic believer acts out of a feeling of pathos and must therefore employ the *Schrei* rather than the cool, intellectual mode of satire.

The second reason why satire flourished less in Expressionism than might be expected has to do with the poetic practice based on the prevailing social stance of this movement. Satire must be close to life, since it criticizes specific ills with the aim of improving society. Expressionists, however, frequently move away from social life: they retreat into their private sphere; they are interested rather more in the inner self, and when they approach society, they do so in the hope of establishing communications on their terms rather than society's. Few Expressionists know society well enough to satirize it; fewer still are able to make the jump from a too painful reality to a too distant ideal.

Schiller stresses as an important condition for true satire that it must be inspired by a genuine awareness of the ideal. If the poet is merely motivated by personal dissatisfactions, he cannot hope to aspire to greatness. Such latter satire Schiller considers 'der Dichtkunst unwürdig,' and he labels it 'materielles Interesse.' This idea is also an important one for our discussion, for is it not personal discomfort rather than genuine concern for the ideal state of affairs which inspires so many of these authors? To be sure, the very fact that they go about making their views public in such a hopelessly unrealistic and impractical fashion seems, ironically, to provide some guarantee of their basic honesty and idealism. But it must be admitted that for many Expressionists a change in society implies a change not towards an objective ideal but one that will accord with very personal and subjective wishes. We are reminded of Wolfgang Paulsen's comment on Alfred Lichtenstein: 'Der Satiriker ist im wesentlichen ein extravertierter Beobachter, während Lichtenstein ... letzten Endes doch ein introvertierter war. Die ihm in die Aussenwelt abgeschnittenen Wege führten ihn immer wieder auf sich selbst zurück' (S165/596). Even where the Expressionists were able to go beyond their own phantasmagorias and dreams and where they postulated a changed society, in the utopia, they did not find satire a suitable vehicle for their ideas but preferred to use

rhetorical traditions and what one could call rhetorical pathos. By contrast, where the utopia comes about *ex negativo*, as in Ehrenstein's writings, for example, it appears in such a way that resentment is turned into ridicule, vituperation, and cosmic aggressiveness. There is little middle ground in Expressionism; perhaps only in the relatively 'low' type of satire, 'als die idealisierte Form einer Vergangenheit oder als das Muster einer besser organisierten Gegenwart' (S217/35), as Schiller defines this type, can satire exist at all in Expressionism.

Of this latter type Heinrich Mann has given some typical examples. Mann's desire to reveal the gap between illusion and reality inspired him, in 'Sterny' (P101 = P392, vol. 9), to attack the opportunism of the period after 1918. In the figure of Rackow, Mann satirizes a preoccupation with social status and honour which is not only out of step with the times but is also little more than pretence. Rackow's prompt sacrifice of both in the face of new-found post-war money, which an irony of fate has bestowed upon him, clearly reveals his code to be little more than opportunism. The formerly suppressed Sterny, by contrast, is allowed to take revenge, not because of a new and just society redressing his grievances but through the irony of history. Because of moral and social collapse in post-war Germany, the ordinary soldier, completely without honour, can now exploit his former superior. Only a quirk of fate robs Sterny of his final triumph. The woman in between, Lissi Lerchen, is a typical product of a corrupt society; she is an amoral woman in an immoral world of 'business.'

Honour, as the title indicates, is also the main concern of the novelle 'Ehrenhandel' (P98 = P396), in which the adopted code of a group of bourgeois friends is revealed as sham. The outcome of the conflict between two friends locked in a situation involving the defence of their honour is a reversal of fortune not unlike that in 'Sterny.' However, the victor of a duel is here not robbed of his triumph because of a quirk of fate but because of a clever ruse of his intended victim. Both stories illustrate well the amusement that satire may provide, but the tone is light, and the question of what social change or utopia is suggested seems irrelevant.

Satire directed at the bourgeois in the private sphere usually coincides with satire of the philistine. Criticism of the philistine has a long history, going back at least as far as Goethe's *Werther*. The philistine lives in harmony with his social context, generally in 'kleinen Verhältnissen': his life is restricted in scope; often it is characterized by monotony. What the philistine lacks in insight or spiritual values, he makes up for by conformity, complete acceptance of his social status and of any social status as the only meaningful criterion of worth. Many prose writers in Expression-

ism offer examples of this type. The bourgeois is in fact much more in evidence than the powerful capitalist.[6] Naturally, the bourgeois' vulgarity, his lack of culture, of intellectual independence, and his laughable gullibility make of him an excellent target for satire. Notably Heinrich Mann again, but also Herrmann-Neisse, have given some striking examples of satirical portraits of the bourgeois.

Herrmann-Neisse's stories usually are situated in one or another 'gottverlorenes Provinznest' like that of 'Die Begegnung' (P61 = P371). This latter story develops the frequent hostility of the petty bourgeoisie to anything smacking of art. Worbs, a tradesman, is shown to be a man at once submissive towards his superiors and brutal towards his underlings. Money and status are his main concerns. He is worried about his son, who reads too much. He even feels the need to defend himself against his son's aspirations, as well as the cultural pretences of his wife, by pointing to the fact that he is the provider of the family. Yet he too had once, in his youth, a kind of epiphany, when a beautiful girl greeted him from her carriage. All his life Worbs has treasured this moment as something rare and beautiful, as a kind of 'call' from another world, though of course it in fact seems to hint rather at a tendency in Worbs to sentimentalize the trivial, perhaps out of a need to cast a transfiguring light on his rather banal existence.[7] Worbs's meeting with the artist Karst, a figure from a totally different world, is thus his second encounter with the non-bourgeois world. But Worbs is not aware of Karst's profession. Urged on by an obscure need to have his own feelings clarified, Worbs asks Karst to interpret for him the 'poetic' incident with the girl. Karst is even invited to visit Worbs. For Karst this incident becomes something of a revelation, but Worbs himself soon forgets it. The possibility of changing his life never enters his mind, and when one day he finds out that Karst is an artist, his reaction is violent: 'Nach der Aufklärung, die er nun über den Fremden empfangen hatte, war ihm der ganze Mann verdächtig, die Begegnung mit ihm entweiht, und alles, was er sich damals daraus gefolgert hatte, hinfällig' (P371/41). Not the man, but the profession is suspect, the friend suddenly revealed as enemy. Worbs's revulsions about his son's readings and his wife's cultural aspirations now climax in his revulsion against the artist as the source of all evil. Ironically, however, the incident is later nevertheless absorbed into bourgeois life, for when Worbs has a 'Theaterdezernat' bestowed upon him, the incident appears to fit neatly into his life, and 'wann er mit den Schauspielern zusammenkommt, verfehlt er nicht zu erwähnen, dass er mit dem grossen Dramatiker Herrmann Karst befreundet sei' (43).

Herrmann-Neisse's story is directed at the educated philistine. Nietzsche writes: 'Der Bildungsphilister ... unterscheidet sich von der allgemeinen Idee der Gattung "Philister" durch einen Aberglauben: er wähnt selber Musensohn und Kulturmensch zu sein' (quoted S88/107). This type of philistine is of course particularly dear to literary people, as we can also see in Herrmann-Neisse's 'Das Experiment' (P62) and in Klabund's short sketch 'Der Literaturverein' (P79), which parodies the efforts of the local merchants of a small town to set up a worthy society for the promotion of the arts. Klabund is particularly skilful in using language itself to create comedy, through the introduction of inappropriate vocabulary (transposition of terminology from commerce to art) and by the introduction of slogans and clichés. This same procedure leads to more serious results in 'Der Kriegsberichterstatter' (P78), for here the humorous but cynical use of metaphorical language for the purpose of glorifying the military amounts to a virtual collaboration with the oppressive system.

The military is one of the frozen institutions popular in satire. Ehrenstein's 'Der Tod eines Seebären' (P45) interprets the military as hiding behind elaborate ritual and grotesque logic. Another institution, religion, is the target of attack in Alfred Döblin's 'Astralia' (P20) and in 'Der dämonische Otto' by Klabund (P77), not so much because of its intrinsic merit or demerit but because of the fashionable and even grotesque uses people make of it. The cynicism of Western civilization vis-à-vis the naïve and pure religious man from the East is demonstrated in Klabund's 'Die 99. Wiederkehr des Buddha' (P80).

Expressionism satirizes not only the immobility of the bourgeoisie but also those who attempt to achieve change from dubious premises. Both Ludwig Strauss's novelle 'Das verpasste Verbrechen' (P135) and Max Brod's novelle 'August Nachreiters Attentat' (P14) poke fun at the dubious rebel, the bourgeois or Kleinbürger trying to live up to the ideals of the Expressionist movement. In both stories the heroes are grossly inadequate and badly equipped to fulfil their self-imposed mission to liberate themselves through a 'pure act.' Particularly in Brod's novelle, the phantasmagoria of the mousy little bookkeeper who is supposed to become the leader of a movement bringing about utopia – a utopia in which lonely individuals like Nachreiter himself can at last partake of the finer things in life – is debunked as an incredible amalgam of kitsch, sentimentality, and latent eroticism. The idiosyncratic hero, extreme in his emotionalism as well as in his stunted social and cultural background, obviously cannot function as model for a desirable transformation and revolt. His ultimate escape

into the arts, a domain which serves as a substitute for real life, is typical of the 'educated philistine,' perhaps, but, it must be admitted, also of many artists themselves.

Satire in Expressionism seldom reaches a level from which we may grasp the hidden utopia. The proclamation of a better society and a better fate for man remains reserved for utopian writing, in which the human condition is revealed as in an epiphany. This complex will be dealt with in chapter 10. Our immediate concern is to show the obverse of what this chapter has discussed: from problems of integration we shall turn next to problems of autonomy, and to two of the most controversial figures of Expressionism, Kasimir Edschmid and Carl Sternheim.

SEVEN

Problems of Autonomy

THE EXPRESSIONIST PREOCCUPATION with the self, and the attempt to derive from the individual and subjective standpoint a norm by which to measure the value of moral and social acts, may be seen as a form of protest against the threat posed by the collective. Where the oppressive character of that collective becomes too great, there are but three solutions: surrender, which means giving in to depersonalization; escape into an 'inner world' or into myth; or egocentricity, the reaffirmation of the exclusive claims of the self. The latter goal is pursued by Kasimir Edschmid and Carl Sternheim. Against society, against the human condition itself as expressed in the works of such writers as Heym, Loerke, and Zech, they assert man's dominance over fate, reality, and circumstance. Neither author proposes a new collective or a new society; both formulate a doctrine of the self which denies all social determinants and all restraints of morality. Their solution to the conflict between the individual and society is the elimination of the latter as an obstacle. When they adopt the standpoint of absolute and consistent subjectivism and egoism, however, their solutions prove to be highly problematic. Ultimately, as we shall see, the dichotomy of man and world is reaffirmed rather than solved. Moreover, in both content and style the works of these authors reveal grave shortcomings.

Kasimir Edschmid's novellen *Die sechs Mündungen* appeared in Leipzig in 1915 amid a flurry of critical approval.[1] Much has been made subsequently of the revolutionary prose which these novellen have been supposed to introduce into the literary world. In his introductory remarks to the prose anthology *Die Entfaltung: Novellen an die Zeit* (1921) Max Krell wrote of Edschmid's first work: 'Diese Novellen bedeuten sichtbar den völligen Bruch mit allem Uberkommenen: sie sind der entschiedene

Vorstoss einer Entwicklung. Die Dinge werden neu gesehen und gesagt' (P326/viii). Here, Krell argued, was the kind of prose that corresponded to the poetry and drama being written by the avant-garde, which for Krell as for most other members of the younger generation meant Expressionism. Here was something truly new and innovative, possessing, moreover, the advantage of having come about spontaneously, as works of genius are supposed to do. 'Edschmid bekennt sich zu keiner Theorie,' Krell wrote,' seine Dichtung geschieht rein eruptiv.' Of course, in choosing this last qualification Krell was referring to an essential trait of Expressionism in general, and since for Edschmid's contemporaries 'feeling' and 'significance' largely coincide, Edschmid's emotionally charged prose quickly earned itself the epithet 'cosmic.'[2] Edschmid, so it seemed, could claim to be one of the creators of Expressionist prose.

Krell, an enthusiastic but uncritical promotor and anthologist of Expressionism, did not himself originate the claim of a 'spontaneous creation' of Expressionist prose by Edschmid. In his much-read and highly admired article 'Über den dichterischen Expressionismus,' Edschmid wrote in 1917: 'Als ich vor drei Jahren, wenig bekümmert um künstlerische Dinge, mein erstes Buch schrieb, las ich erstaunt, hier seien erstmals expressionistische Novellen. Wort und Sinn waren mir damals neu und taub. Aber nur die Unproduktiven eilen mit Theorie der Sache voraus' (P350/31). The history of Edschmid's claims, and the subsequent rise and fall of Edschmid's standing as an originator of Expressionist prose, have been discussed with some degree of elaboration by Armin Arnold (S10). Less interest has, strangely enough, been accorded the philosophical and moral message of these novellen; yet *Die sechs Mündungen*, and much of Edschmid's subsequent prose, advocate a manner of life that breaks with tradition much as their style breaks with established norms of narrative prose.

The first novelle, 'Der Lazo' (P34 = P356), in fact contains all of Edschmid's 'program' and exemplifies his style. It is the story of Raoul Perten, a young German bourgeois, who after a crisis of conscience decides to break with his oppressively conventional environment and leave for America. Perten's voyage to the land of the future is punctuated by episodes showing the transformation of a rather fastidious bourgeois with a feeling of guilt about his former privileged status to a self-assured young male, rather too eager to gain the respect of others by resorting to his fists. America itself, unfortunately, turns out be be corrupt, and it is only in the far west, as a cowboy, that Perten goes through his final transformation of character. Here he rejects out of hand the temptation to adopt the form of

'Verkrachtsein' which is embodied by the German von Kladern, a former nobleman. A more insidious temptation, to settle down with the rancher's daughter Helen, is not so easily dismissed. The pull exerted by the values of culture on the one hand and freedom on the other is exemplified by the episode of the lasso, from which the story derives its title. In the end, after Perten has fought a duel with von Kladern in defence of Helen's honour, he decides not to claim his reward, Helen's submission, but to leave the ranch in search of new adventures.

Freedom and the absolute superiority of change over stability are the two main themes of 'Der Lazo'; they turn the rather banal cowboy story into a demonstration of Edschmid's theory. For there is indeed a theory. Edschmid advocates a doctrine of individualism and 'essentiality.' According to this doctrine, good is that which opposes traditional values. Undoubtedly influenced by Nietzsche's criticism of nineteenth-century Germany, Edschmid seeks the solution to the problem of *Vermassung* as well as sloth in the quest for individuality and heroism at all cost. He concentrates on pulling down social and cultural conventions, which he interprets as restrictions rather than as achievements. Criticism of civilization is of course rampant in Expressionism. Edschmid belongs to a fairly large group of authors who protest against the monotony and uniformity of social existence (Ehrenstein, Brod, Heym, for example) and against the excesses of order and convention. The constant *ennui* which Perten experiences, and his revulsions against the 'schamlose ... Verbrauchtheit' of conventional gestures are the result of a sense of the eternal return of the same, explored by Nietzsche and rendered visible in 'Der Lazo' by the symbol of the snake biting its own tail.

The answer which Edschmid provides is neither unusual for nor limited to Expressionism. It involves, in practical terms, leaving home and starting on a journey in the hope of experiencing something new. This is a familiar enough motif, going back to the very beginnings of literature; but its specific sociological thrust is only felt if the setting-out for adventure involves protest or criticism against the society left behind. This is undoubtedly what Edschmid intended, even though the sociological, Expressionist intention is at first not made clear. The decision to leave Germany is explicitly *not* the result of deliberate reflection but of a subconscious process. But even though the absence of theoretical underpinnings makes it difficult to distinguish between Edschmid and, say, Karl May, who after all also has his heroes embark upon adventure, we can safely say that such a theoretical position in fact exists in the story. For what Edschmid attempts to do in this as in the other novellen of the

collection is to reinstate travel and adventure as a way of proving one's mettle, a strategem which by the time of Daniel Defoe's *Robinson Crusoe* had already become questionable in the eyes of those staying behind (S231).

Edschmid's heroes do not seek adventure merely because of a longing for far-away places, but set off on a road leading away from society and towards the self. Not only the alleviation of boredom but the glorification of the self is the object of the initial departure. This becomes clear from the alternative which Edschmid proposes to Perten's previous existence, for this alternative is 'zivilisationsfeindlich' to the extreme. Specifically what results is an asocial or antisocial power-cult.[3] In the fist-fights, first on the ship, later with the cowhands and von Kladern on the ranch, physical acts are made to appear valuable in themselves, and the cowboy existence is interpreted as 'natural,' obviously out of a kind of misguided romanticism, for which Karl May may well have provided the model. Karl May may also have inspired Edschmid's faith in another notion which repeatedly makes its appearance in his stories and novels, that of America as the land of authenticity. By contrast, European cultural achievements are usually relegated to the *Rumpelkammer*. In 'Der Lazo' mere striving, so unqualified as to be meaningless, is presented as the summum bonum. This 'Sturm und Drang... dessen Sinn sich in der Demonstration unrücksichtiger Lebenskraft, heldischen Mannesmuts und in der sklavischen Einhaltung eines an solchen Massstäben orientierten Ehrenkodex erschöpft' (S236/335) has, however, inherent paradoxes and tragic tensions which the grandiose conclusion of 'Der Lazo' does not succeed in hiding. The attempt to prolong the kind of ecstasy which horse-riding, fist-fighting, or the taming of wild horses or women might bring fails completely in the realm of human relations. Love and friendship, both based on constancy and duration, are impossible for Edschmid's heroes.

Human and humane considerations have indeed little place in Edschmid's doctrine. His fear of bourgeois life prevents him from seeing in marriage an acceptable mode of human experience. All permanent and committed forms of love and sexuality spell restriction of the self. Time and again the female appears in Edschmid's works as temptation, to be overcome in what usually is a battle of the sexes. Love-hate relationships abound: sexual rivalry functions mostly as a stimulant to eroticism and prevents the relationship from becoming habitual. Moreover, sexual rivalry fits the image of the independent, self-assertive male, who periodically tests his supremacy by creating a situation of confrontation. The desire for perpetual change appears even more flawed when we consider

that it might be associated not with a sense of freedom but with the slavish following of a blind passion (in Spinoza's sense of the word) or with the submission to a blind will (in the sense Schopenhauer uses the word)[4] which originiates outside of the individual. Here is yet another paradox of Edschmid's theory. Heroism built on eternal change is not accomplished by exerting pure will but results from a World Will manifesting itself: 'Es ist heute kaum noch zu begreifen,' write Silvio Vietta and Hans-Georg Kemper, 'mit welchem geradezu messianisch-euphorischen Impetus diese Lebensläufe gestaltet sind, ohne Rücksicht auf das im Grunde Verzwei-felt-Schicksalhafte für die unentrinnbare Ananke, die diesen Vitalismus determiniert und immerhin für Schopenhauer der Grund für das Postulat einer Verneinung des Willens zum Leben war' (S236/339).

There are other dimensions to this *Aufbruch* which ought to be mentioned at this point. For the Expressionists, bourgeois existence often implies inauthenticity, the relinquishing of potential qualities for the compromise of conformity. It has been stated that the bourgeois can only exploit his latent talents vicariously, through day-dreaming, for example, but above all through art. The paradox of bourgeois art, however, is that it often ends up producing images that merely reflect the objectionable environment in which the bourgeois lives – in effect, kitsch. Gert Ueding writes: 'Der Kitsch konserviert die überlebten bürgerlichen Existenzfor-men – vor allem die der Familie und der heimatlichen Welt' (S231/35). In rejecting the bourgeois world Edschmid also correctly rejects the world of kitsch and those institutions which it reflects: family and home. This explains the vehemence with which Perten rejects Helen's initial advances. It also explains the involuntarily comical insistence on the 'natural' values exemplified by Longfellow's *Hiawatha*, which Perten happens to be reading. The introduction of such references shows only too clearly the origin of these writings, for the impulse to break away from society is itself of course determined by culture and civilization. Hostility towards civilization is understandable only at a certain level of civilization, and protest against what is perceived as kitsch requires a keen sense of what kitsch cannot be: 'Wer kein Organ für Kunst hat, kann auch keinen Kitsch erkennen' (S231/19). It may well be asked whether a product of so much 'culture' as Perten (and Edschmid himself) can simply revert to nature in the naïve sense or whether his actions will not be forever tied to a form of protest. In any case, I believe that Vietta and Kemper make a serious mistake when they find Perten's *Aufbruch* 'eigentümlich zeitlos' (S236/336). Considered within the theoretical framework of all of *Die sechs Mündungen*, which is in fact not a simple framework but an essen-

tial point of reference, Perten's *Aufbruch* is the result of a specific protest against Western civilization. We are therefore not dealing with 'anthropologisch-psychologische Grundkategorien' but with a very personal, very idiosyncratic response of one man to the challenge of a specific social environment.

What has been said here about 'Der Lazo' applies, with minor modifications, to all of the novellen of *Die sechs Mündungen*. Precisely because of the extreme urgency of his culturally determined revolt against the status quo, Edschmid feels he has to work with blatant dichotomies which blur any problematic aspect of his heroic philosophy. Thus, to the opposition between the self and the collective, between man and woman, amorality and morality, freedom and loyalty, he adds, in 'Der aussätzige Wald' (P28 = P356), that of beauty versus ugliness, represented respectively by the hero and the herd. Like Perten, Jehan Bodel, a medieval troubadour, is cast in the heroic mold. He is set apart from others by his extreme courage, which he demonstrates when plague victims attack him in the forest. This attack represents the sudden intrusion of the ugly upon a life devoted to the exclusive pursuit of beauty. So great is Bodel's disgust with the plague victims in fact that he offers a reward for their extermination. The contrast between Bodel's almost pathological concern with the beautiful, his disdainful aristocratic fastidiousness, and the ugliness of the real world is from this point on emphasized throughout the novelle. The *Wendepunkt*, a conventional element in Edschmid's novellen, comes with Bodel's discovery that he himself has the plague. Since nobody comes forward to kill him and claim the reward, Bodel decides to meet his death in the forest. He walks away proudly, leaving behind all his earthly possessions, 'da sein Geist schon ganz eingerichtet war auf den neuen Sinn seines Lebens' (P356/65). This novelle too ends with an apotheosis: 'Seine Haltung war stark und königlich. Mit einer ungeheuer schlichten Gebärde ging er auf den Wald zu, der ihm entgegenkam' (67).

A more excessive character is depicted in 'Yousouf' (P37 = P356). The hero of this story, the Spanish nobleman Las Casas, amply demonstrates those qualities which Edschmid seems to admire. Even for a Spanish grandee the larger-than-life Las Casas merely feels contempt. The scales are tipped still further than in the previous stories in favour of self-worship, and fastidiousness and contempt are even more closely wedded to cruelty, as is shown in the extraordinary scene at the beginning of the story in which Las Casas kills the king's pet weasel. That this insult goes unpunished is one more indication of the superiority of the hero. Edschmid's world is one of bold males who must constantly prove their prow-

ess in order to set themselves apart from the mob, and in which the defence of one's honour takes precedence over any other consideration. 'Yousouf' is concerned with Las Casas's attempts to capture the pirate Yousouf, who has destroyed the nobleman's family, but above all it illustrates once again that the exaltation of the hero entails, for Edschmid, the reduction of all other human beings to the undifferentiated elements of a mob. The crew with which Las Casas sails plays the same role as that of the plague victims in 'Der aussätzige Wald.' When Las Casas promises his men unlimited richness if they should capture Yousouf, their behaviour is elemental and barbaric, culminating in their abject submission to the will of their commander: 'Viele knieten hin und brüllten mit den geketteten Armen zu ihm winkend oder den Kopf auf den Steg legend, dass er darauf trete' (P356/144). If we let ourselves be guided by the notion of an unbridgeable gap between hero and herd, we might understand why, during the several voyages which Las Casas undertakes, cruelty reaches hysterical levels. The crew members figure merely as human machines, destined to be used by a supreme will. Edschmid's definition of the hero does not preclude his defeat or demise, however. On the contrary: the idea of tragedy is inherent in this definition, and thus, as in 'Der aussätzige Wald,' 'Yousouf' ends in a dramatic reversal of fortunes. In a precise counterpoint to the abject humility displayed previously, the crew, the moment it becomes apparent that Las Casas has lost his nerve, kills him with cannibalistic cruelty. Again, the intrusion of the ugly herd upon the heroic and the beautiful is exemplified.

Parallels exist also in the depiction of the females in the two stories 'Der aussätzige Wald' and 'Yousouf.' Beautrix, Bodel's mistress and slave, is beautiful, aristocratic despite her slavery, and, like Bodel, driven by an aversion to the mean and ugly. She also shows no scruples about condoning Bodel's cruelty towards a rival, and accepts it as a token of his boundless love, albeit with a deliciously amoral *frisson* (P356/51). The two lovers live out an idyll which Edschmid describes as being of great intensity and beauty. But the conclusion of the novelle contains another battle of the sexes, for when Beautrix refuses to give up her love for Bodel, he can only free himself from her by calling her a slave. 'Yousouf' contains a similar battle of the sexes. When during one of his voyages the thought of his mistress Juana interferes with his powers of concentration, Las Casas sacrifices her in effigy, by throwing a strand of precious pearls, intended as a gift for her, into the sea (147). In heroic stature as well as in ruthlessness, Juana resembles the hero of the novelle. It is not surprising that on hearing of her lover's death she chooses his rival Quijada as her new lover.

At the end of the novelle Edschmid describes her gesture of submission: Juana 'schritt auf Luis Quijada zu und legte ihren Kopf an seine Brust' (199). Quijada, at first shocked, finally accepts her, and the story ends with another striking gesture.

Edschmid, for reasons to be explained later, is very fond of such gestures. The most pointed use of gesture occurs in the novelle 'Maintonis Hochzeit' (P35 = P356). In fact the story seems to have been written exclusively with the *pointe* in mind. Maintoni, a seventeen-year-old girl, enraged by the killing of her fiancé Rodriguez by a burglar, sees, when the thief in turn is killed, her chance to repay Rodriguez for once saving her from drowning: 'sie trat dem Sterbenden mit dem Fuss breit ins Gesicht; sein Kopf rollte schwerfällig zurück' (97). The extraordinary behaviour of the girl is called 'grösser und furchtbarer wie alles was Rodriguez gab, als er sie von der Klippe rettete.' In Edschmid's view intense feeling cannot be restrained by propriety; the cruel act, as the central event of the novelle, shows how conventional morality is inoperative. 'Natural' man appears in all his ambiguity. The story anticipates such later works by Edschmid as 'Die Herzogin' (P33), dealing with the career of the poet François Villon, seen as a kind of Brechtian Baal, and 'Der Bezwinger,' which traces the bloody career of the Asian tyrant Tamerlane.

Only one story, 'Yup Scottens' (P38 = P256), seems to leave some doubt about the values discussed so far. The cowboy Yup Scottens, for a bet, rides a train undetected for twenty-four hours. A friend, witnessing the attempt, is accidentally killed, and Yup's girl Laura, believing Yup dead because his papers are found on the witness, goes mad and finally kills herself. In a key passage Yup expresses his fear that he has become guilty because of selfishness. But he also provides the justification for his acts: 'Yup dachte ... dass er es wegen Laura vielleicht nicht hätte tun dürfen (darüber war er sich allerdings nicht ganz klar, denn Laura hatte ihn immer angehalten, den Instinkten seiner Kraft nachzugehen, wohl weil sie fühlte, dass ein Versagen ihn dumpf auf die Dauer und ungleichmässig ihr gegenüber machen würde)' (216). Laura's ideas are of course in harmony with Edschmid's. One must give in to instincts, for the restrictions of bourgeois life make one 'dumpf' and incapable of authenticity. Yup is absolved of guilt because he remains true to himself and innocent of the greatest vice of all, sloth. Any attempt to reach a stable point, to halt 'das rasende Leben,' as a later collection of novellen is called, is the capital sin.

Das rasende Leben, which appeared in 1916 (P352) and consists of only two novellen, in fact celebrates the variety and richness of life in quasi-hymnic tones. In the first novelle, 'Das beschämende Zimmer,' the host

who receives the narrator explains to him his attempt to capture the past and retain it by means of a kind of magic formula: a gallery of paintings which relate some of the important incidents of his life. Already in the frame of the novelle, a conversation between the two men, there is an atmosphere of exoticism; famous people and distant places are mentioned casually, setting the stage for the main body of the novelle, the host's stories connected with the paintings: 'Es ist keines darunter, in dem nicht ein Erlebnis wühlte. Es ist eine Laune oder ein Experiment. Ich muss es abwarten. Ich habe sie hier aufgehängt ohne Auswahl, ohne Ordnung ... Es liegen Jahre in manchen eingeschlossen und strömen sie aus' (P352/6). The paintings, in other words, are meant to bring the past back to life.

The capsule stories themselves are pure Edschmid. In most of them there is only a skeleton of a plot; they are impressions in which mood and atmosphere play the most important role. There is for example the picture of the lady on a swing, and the story which goes with it, 'ein Erlebnis wie ein Pastell' (7). Goyas, old Dutch silver-point drawings, scenes with 'geballte[r] Atmosphäre' (10), depicting northern landscapes, mingle with paintings which capture episodes close to kitsch: 'Am reizvollsten war sie, wenn sie auf einem Fell abends neben meinen Füssen lag. Sie trug ein langes weisses Hemd, träumte und färbte die Nägel ihrer Zehen ... Germaines Glieder lagen auf den schweren roten Decken wie Achat' (14). The attempt to come to terms with the past fails, however, when the host suddenly confesses: 'Diese Geschichte ist ganz anders ... Ich habe geglaubt, sie von mir abtun zu können, wenn ich sie erzählte, aber ich konnte sie nicht erzählen. Da phantasierte ich sie. Aber das war noch schlimmer, zu sehen wie etwas hätte werden können' (21). The living museum is in reality a spiritual ruin; the important thing is life itself: 'Man soll keine Erinnerungen haben. Niemals. Nein! ... Man soll die Dinge von sich werfen. Weit' (22). This message clearly reiterates that of 'Der Lazo.'

The importance of 'Tosendes ... rasendes Leben' (22) is stated even more explicitly in the second novelle, 'Der tödliche Mai.' In his struggle against death, an idea comes to the wounded soldier which is subsumed under the word 'Bäume' and which apparently is potent enough to allow the young officer's recovery. For weeks the officer had been apathetic, had lost contact with life, and was 'ohne Schwung' (26). Three stages are to be travelled through before he can establish a new zest for life. From the landscape he receives no support, since its endlessness becomes a mirror of his own spiritual emptiness, but after a visit to a nearby castle he returns in a thoughtful mood. A visit to the city sets something free in

him, but he is still not ready, and in his confusion he breaks a lamp and some dishes. In the elephant which comes with a travelling circus he recognizes yet another image of life and vitality. A final image of life is presented in a smooth stone which the young man touches: 'Er empfand, wie die Angst vor der plötzlichen Leere um ihn herum schwinde und wie das Gesicht des realen Steins ihn wieder an das natürliche Leben und die geliebte Erde (prometheisch) zurückriss' (33). The feeling of the stone liberates him for the experience of the trees, which finally allow him to recover. Edschmid plays with the neo-Romantic idea that beauty may represent death. But it is significant that the beauty which Edschmid envisages is of an impressionistic kind. There is a good deal of kitsch involved in it, particularly in the depiction of virginal girls dancing on the lawn in Greek tunics under blossoming apple trees. The young man, however, is almost driven to madness by this beauty: he has come to realize 'dass Schönheit tausendfach mehr tötet als Hass und Wut' (27). To avert the danger of drowning in beauty, he buries his face in cow dung, in another typical gesture loaded with 'significance.' Ugliness is closer to life; it is vital and therefore the necessary counterweight to the deadly attraction of beauty. Like 'Der Lazo' the story is a manifesto, full of generalizations and quasi-philosophical reflections. Life is presented as the greatest good, no matter how that life is filled with toil and suffering; sloth is denounced as the greatest enemy of fulfilment. Great tensions are necessary for a well-lived life. 'Das Ungeheure' and 'das Süsse' mix in life, and create its infinite variety.

Edschmid does not deviate significantly from these premises in his later works. To combat sloth and indulgence he preaches activity, sacrifice, asceticism and resignation, virtues which lead to heroism. Only absolute egocentricity provides an adequate answer to the claims of the mob. At the same time, the message contained in these works is clothed in a form which is in itself an expression of the ideas Edschmid is propagating. This is already evident in 'Der Lazo,' in which Edschmid makes the break with traditional narrative techniques a topic of the story itself. The conventional inner monologue with which the story opens is suddenly interrupted by Perten's decision to leave Germany. The narrator stresses that this decision is not based on any conscious psychological struggle. The rejection of psychology, at least as traditionally defined, is but one aspect of the rejection of all outworn bourgeois values and ways of thinking. Psychology, Edschmid argues, is only capable of analysis: 'mit dem Fortfall des psychologischen Apparats fällt der ganze Décadencerummel,

die letzten Fragen können erhascht, grosse Probleme des Lebens direkt attackiert werden' (P183/36).

Of course this iconoclastic narrative attitude works conveniently together with Edschmid's emotional side, and both are pressed into the service of constantly reiterating the message of superiority of action over reflection and intellect. Only the former is used to express development; the progression of the protagonist is shown in a series of events separated by what amounts to blank space, to be filled by the reader. Actually, the absence of reflection and the emphasis on external action contribute as much to the impression of speed and hectic movement as such stylistic features as parataxis, ellipsis, and the preference for verbs over nouns. The Expressionist character of Edschmid's work also results largely from gestures and the 'gestic' method of characterization; descriptive passages are absent. Gestures convey emotions, but they are also used sometimes as devices carrying the central message, as in 'Maintonis Hochzeit,' 'Yousouf,' and 'Der aussätzige Wald.' Unfortunately, the gestic method has serious flaws, which become visible above all in 'Yousouf' and 'Der aussätzige Wald.' In the former story Edschmid surely wanted to convey a sense of pathos in describing Las Casas's brutal end. But pathos is founded on the reader's sympathy for the hero; Edschmid's heroes too often have an unresolved inner ambiguity which forbids sympathy. In any case, they stand in stark contrast to the altruistic, often almost messianic figures in most other Expressionist writings and show clearly their origin in the 'Wille zur Macht.' In 'Der aussätzige Wald,' specifically, the gestic method also fails to differentiate between genuine resignation in the face of overwhelming odds of fate (in the form of the plague) and the self-imposed disdainful renunciation displayed in 'Yousouf' and by Bodel himself.

Yet another problem is posed by the settings of these stories. Vietta and Kemper have suggested that Edschmid's stories play in far-off lands and long-past times 'um so die expressionistische Antwort als die eigentliche, zu allen Zeiten und allen Orten gültige zu erweisen' (S236/335). This appears to me to be a rather charitable way of explaining away one of the more blatant elements of colportage in Edschmid's work. It may be argued more unkindly, but also more accurately, that there are two main reasons for this exoticism. The one is the tradition in which Edschmid writes: that of the adventure novel à la Karl May. The second, more important reason, the one which ultimately helps to decide Edschmid's relevance to the problems posed by Expressionism, has to do with the original impulse of protest which he registers at the beginning of the collection. The

almost metaphysical space in which these so-called masters of their destiny operate betrays, I believe, a flight from reality which closely resembles that of Gottfried Benn in his novellen *Gehirne*. The shift from civilized Europe to 'natural' America and the regression from contemporary to medieval times and the sixteenth century have the function of circumventing a genuine solution to the problem of individuality versus the collective. The removal of his heroes to other contexts makes the reduction to essence easier, to be sure, but it also appears to indicate Edschmid's despair about the possibility of achieving essentiality within the context in which he lives. The exotic context becomes a prerequisite for the development of the protagonists; it alone guarantees authenticity. Because setting functions in this fashion, space must become private space, made for heroism; the world is one's individual phantasmagoria in which a hectic life is played out by two-dimensional characters incapable of true development. Sequences follow each other quickly; the novellen are like mosaics, picture galleries, collections of snapshots capturing fleeting moments of ecstasy in a chain of random actions. Epic breadth is largely replaced by spacial breadth. The search is for an elusive totality, for allegorical and universal qualities, but what results is reality fragmented like a broken mirror, and the idealized picture emulates, moreover, those images created by the much-despised decadent and aestheticizing movements which immediately precede Expressionism.

This brings us to yet another paradox in Edschmid's work. The initial refusal to accept the bourgeois world of kitsch leads Edschmid to exploit the genre of colportage.[5] At the same time, however, kitsch enters by the back door once again. The ending of 'Der Lazo' is a good example. Perten has just been debating whether he should accept Helen's love and settle down on her ranch. Now he has made his decision – 'das Leben würde nichts mehr zum Steigern für ihn haben' – and thus he turns north, away from Helen (P256/29). His decision is punctuated by another typically 'significant' – that is, symbolic – gesture: 'Raoul Perten ritt nach Norden zu. Und ritt und warf plötzlich die Arme hoch, dass sie hingereckt aufwärts standen als fasse er, sich eingliedernd, in den Schwung eines masslosen Trapezes und liess den Lazo in mächtig sich vollendenden Ellipsen um seine Hände fahren' (31). And now all of nature is recruited to underline the importance and correctness of Perten's choice: 'und ritt auf ein Stück Himmel zu, das sich wie ein blaues Dreieck zwischen zwei Hügel hineinbohrte und über dem ein Horizont aufbrach, ungeheuer, voll Ewigkeit und in flimmernden Rotunden kreisend wie ein von Rätseln durchstochener Schild' (31). This passage not only abounds in bombast ('mass-

los,' 'mächtig,' 'voll Ewigkeit'); it also blatantly aims to achieve 'pro-fundity.' But in doing so it solicits stock responses from the reader, a characteristic of kitsch. To that end, nature itself – and a highly aestheticized nature at that – must do what the rather banal cowboy story itself cannot achieve.[6]

Both 'Der Lazo' and 'Yup Scottens' feed on the myth of the cowboy idyll, with a celebration of all its trappings, whereas 'Yousouf' resorts to an almost caricature depiction of what Edschmid considers to be the qualities of a Spanish grandee, a depiction which would have delighted Karl May. Exoticism and beauty are consistently used to glorify the heroes and to underscore the importance of the message conveyed. 'Der aussätzige Wald,' finally, demonstrates an almost obsessive preoccupation with beauty as a quality pertaining to the heroic. But the result is the depiction of a collection of exotic and medieval bric-à-brac and paraphernalia which calls to mind certain paintings of Jugendstil. Here, for example, is a description of Beautrix: 'Sie schlang den blauen und gelben Turban um die Haare und steckte sieben Dolche hinein und band an den ersten einen weissen Schleier, führte ihn unter das Kinn, dass er schwebte, und hakte ihn wieder an dem siebenten ein. Dann schloss sie um ihre kleinen Brüste einen weissen Mieder, der dünne gerötete Zwicken hatte an den Achseln, welche in die Arme liefen mit engen Ärmeln aus reinem Gold-brokat und zwischen denen die weisse Seide des Rockes hinunterströmte zu den gekreuzten Schnüren aus Hermelin und dem Passepoil mit roten und lila Augen.' There is always a certain ambivalence in Edschmid's attitude towards beauty. Often it is seen as a threat to life (as in 'Der tödliche Mai'), but the alleged fear of beauty has a false ring to it, not only because Edschmid so obviously delights in describing it but also because the beauty referred to is so often precisely the kind that borders on kitsch. Such narrative elements are not only important from an aesthetic point of view, however, but also from an ethical one. When settings, striking images, and significant gestures deteriorate into kitsch, it is time to re-examine content also.

Armin Arnold has criticized some of the more objectionable narrative and stylistic elements of 'Der Lazo' and concludes that Edschmid is not always felicitous in his choice of symbols or telling details (S10). But such easily perceived blunders as Arnold identifies are insignificant when compared with the implications of Edschmid's doctrine which come to light upon closer examination. Here Arnold's comments miss the mark, for what lies at the end of Edschmid's literary development is not merely a private fantasy-world, a world of wish-fulfilment, but a reign of terror. The

point is not that later works of Edschmid became cliché-ridden and man-neristic but that Edschmid's myth, when transposed to the political arena of the real world, would propose the doctrine that 'might is right,' and that in these early stories this doctrine is already enunciated. These novellen have come to be considered by some the finest examples of Expressionist prose writing. However, given their glaring weaknesses and the brutality which lurks beneath the stylistic trappings, uncritical admiration seems hardly appropriate in our day.

There remains the important question of whether they are typical of Expressionism. I believe this question can be answered by looking closely at the function these stories had in 1915. Why did at least some contem-porary readers consider Edschmid a leader?

It would seem that Edschmid supplied his audience with precisely those devices which combine a sense of the familiar with the promise of novelty. Building on certain elements of turn-of-the-century amorality of the Nietzschean variety and heroism à la Karl May, Edschmid was able to construct a kind of literature that seemed new. To be sure, certain critics have seen in the colportage novel itself a revolutionary intention.[7] Undoubtedly Edschmid's contemporaries sought and found a revolution-ary impulse in his work. The irony of his case is that the value system which the author so vehemently rejects as intolerable returns in many and varied ways in his own writings. The anti-feudalistic criticism of many a colportage novel is blunted in Edschmid's case by his preference for aristocratic characters, whereas bourgeois values are replaced by feu-dal qualities. Edschmid's heroes resemble nothing so much as medieval warriors insisting on their point of honour. Similarly ironic is the fact that these so-called absolutely unique heroes quickly turn into cardboard characters, because of repetition, stereotype, and exaggeration. Edschmid's protagonists do not have a true personality, and they are doomed to a life removed from the social reality in which their intended uniqueness would mean anything at all. The real world disappears, and these writings stand exposed as pseudo-solutions.

Edschmid's much admired anti-psychological method, fashionable and delightfully iconoclastic in the eyes of his contemporaries and a source of annoyance among the critics, may originally also have been adopted with a revolutionary intent. But we have seen that the cruder forms of Ed-schmid's characterization lead to obscurity of motivation and even to an extremely unartistic presentation of the 'inner life' by gesture. Even his language (the one achievement which even the most hardened critics hesitate to criticize openly), presumably invented and designed to express

naturalness, originality, and authenticity, gradually turns to fetish, cliché, and mannerism. No longer a language capable of expressing an individual's unique point of view, it indiscriminately turns up in the mouths of whores, adventurers, and saints.

But whatever else Edschmid's contemporaries saw in his writings, there can be no doubt that the most exciting, the most striking element of his work was the strident message of individualism with which he infused his largely eclectic prose. What contemporaries overlooked was the fact that Edschmid's work does not lead to a true alternative. The hero in Edschmid's work does not live *in* society but outside of it. He does not attempt to change the world; he escapes from it: he solves the tragic opposition between individual and society by denying the validity of the collective. Early Expressionism by and large shows precisely these same tendencies, and it is therefore by no means wrong to claim Edschmid for Expressionist prose. What distinguishes him from the Activists, who at least attempted to find a *modus vivendi* within the real social and political world, and those who simply despaired is his view that those tendencies in modern bourgeois society which are most reprehensible are in fact things to glorify and exalt. The very lack of social cohesion and the all-pervading rule of the hard-hearted become, in Edschmid's theory, the ideals of the New Man. Charity, empathy, and love are dismissed; barbarism triumphs. Edschmid demonstrates the inability of the individual to avoid moral ambiguity, even absolute evil, once he has lost touch with reality, and with what Hofmannsthal calls 'das Soziale.'

At first sight, Sternheim's approach to the problem of the self versus society appears less philosophical than Edschmid's. Sternheim formulates the problem of autonomy specifically in relation to the bourgeois society of his own period. Thus the conflict is reduced to a sociological one. In comparison with Edschmid's treatment of the problem of autonomy, Sternheim's is simpler, but also clearer, and more sharply focused. Whereas Edschmid often disregards contemporary society completely and adopts a kind of parabolic narration, Sternheim admits that the need to glorify the self is inspired by his rejection of his own time and society. It has been suggested that Sternheim's ideas about autonomy are to be understood less as a consistent philosophy than as an attempt to rationalize his own inherent aversion to the society in which he lived. Nevertheless, from the implications of this social conflict we may abstract something approaching a doctrine. In a series of theoretical writings, chiefly the essays *Berlin oder juste Milieu* and 'Das Arbeiter ABC,' Sternheim

attempted to state the problem facing modern man in an increasingly industrialized and burocratic society, in which the individual, rather than being given the freedom to pursue his own development and allowed to search for happiness, is forced, mostly by subtle and devious pressures, to conform to ideals held by the collective.

Basic to Sternheim's philosophy is his idea that man maintains relationships with the outside world in two distinct ways: through 'Denkinhalte,' which relate him to the immutable laws of nature, and through 'Beziehungsinhalte,' which relate him to his social environment. Freedom is possible only in the latter realm, where man is not only an object but also a subject and where he can realize his 'vision' and aspire to a personality. In the realm of 'Beziehungsinhalte' man is open for the 'possible.'[8] Bourgeois society of the last two hundred years has, according to Sternheim, gradually eroded the freedom to realize the individual's 'eigene Nuance.' In particular, the acceptance of such notions as Kant's categorical imperative, Hegel's doctrine of historical inevitability, Marx's economic determinism, and Darwin's theory of natural selection have set more and more severe limits to man's freedom. They were eagerly adopted by the bourgeoisie and fused into a world-view which permitted the exploitation of other social classes by means of a morality of 'juste milieu' – that is, of mediocrity, conventionality, and normalcy. By confusing the two types of relationships, Sternheim maintains, the bourgeoisie accepts restrictions of a mostly moral kind, whereas in theory man has absolute freedom in this domain. Conformity ('Anpassung') becomes the highest good, and the individual sacrifices his freedom for the maintenance of the collective. Since the ethic of the 'juste milieu' pervades all of German society, only someone willing to abandon bourgeois modes of life can reassert his individuality. Only by following exclusively the doctrine of one's own nature can one hope to realize the 'eigene Nuance.' Anarchistic though this doctrine seems, Sternheim believed that the confrontation between individual and society would not necessarily lead to violent conflict, since man is endowed with a 'natürlicher Sozialismus,' which would maintain a certain equilibrium. In fact, a true utopia would come about, in which all men would respect each other's wishes.

In 'Das Arbeiter ABC' (P278) Sternheim blames the French Revolution and the attendant rise of the bourgeoisie in particular for the reversal of the trend towards individualism in Western civilization. A peculiarly bourgeois idea, that of self-sacrifice to further the aims of the community, took hold at that time, and a consolidation of the bourgeois position was

further achieved through a devious manipulation of language: the true, empiric nature of objects was neglected in favour of the relationships that objects allegedly maintain with a 'higher' reality. The truth was distorted by means of language, to allow the bourgeoisie to triumph. Art itself now has become part of the conspiracy of the bourgeoisie to foist its philosophy upon the whole of society. From this point Sternheim develops his theory of art and the artist.

According to Sternheim, the dominion of the bourgeoisie over society can only be broken by a revolution in language and literature. Since the bourgeoisie has a tendency to describe reality in terms not of its actual being but in terms of metaphor – that is, in relation to a realm of ideas – this metaphorical language must be revealed as illusory and detrimental to life.[9] The distortion of the truth which the procedure entails must be combated by a return to the use of language as an instrument of revelation and cognition. In ethics in particular the bourgeoisie uses metaphors to obscure its brutality in the struggle for survival. Man's imperfections as well as his higher purpose are used to sanction his ruthless ambition. Deluding himself into believing that the system thus erected can make him free, he is in fact caught between the irreconcilables of utilitarianism and idealism. True freedom lies, according to Sternheim, only in a freely admitted ruthlessness, namely that of following one's own individuality. Art's role is to demonstrate how this can be realized. To Sternheim, art is educative and illustrative. The artist must not satirize, must not mythicize: 'Sichtbar Vorhandenes soll sie [die Kunst] nur am rechten Ende packen, krüde, dass nichts Wesentliches fehlt, und es zu Formen verdichten, die der Epoche Essentielles späteren Geschlechtern festhalten' (P411, vol. VI/37-8). Sternheim demands 'einfache Spiegelung des irgendwie Hervorragenden ohne die Spur bewusster sittlicher Predigt' (482). A true, objective picture should result, and all metaphors will be eliminated. But the reference to 'Wesentliches' also indicates that this depicted reality must have representative character, that it must be significant and lay bare the fundamental aspects of society rather than the changing and superficial realities of a historical epoch. The artist is a realist who clarifies reality and assists man in realizing his individuality: he is a chronicler, as the title of Sternheim's collection of novellen indicates.

The theory of the 'eigene Nuance' has major consequences for the kinds of characters Sternheim depicts. Since the individual must find his essence regardless of the norms of society, we must be prepared to be confronted by amoral characters, heroes who cannot be grasped in terms

of conventional values and standards. Wolfgang Wendler writes about this aspect of Sternheim's work:

Wer mit konventionellen moralischen Massstäben misst, in der Vorstellung, Sternheim lege die gleichen Massstäbe an seine Helden, muss glauben, Sternheim beabsichtige Angriff und Satire. Denn seine Helden verstossen ständig gegen die üblichen Moralbegriffe. Tatsächlich aber will Sternheim seine Helden gerade als von allen überkommenen moralischen und gesellschaftlichen Zwängen befreite und unabhängige Menschen zeigen. Für ihn gibt es kein 'Laster', er billigt jede Handlung, wenn sie nur der wirkliche Ausdruck der Person ist. Er appelliert an die 'Privatkurage,' fordert jeden auf, seine 'eigene Nuance' zu sein. (S247/45)

The denial of the existence of an absolute good and evil, which the doctrine entails, prevents the evaluation of Sternheim's writings as satirical. Satire only exists where the ideal can be created *ex negativo*. Sternheim's omni-directional attacks on society, coupled with his all-embracing praise of the very same vices when practised by individuals, give rise to a total relativism. Sternheim himself, therefore, denied his works a value as satire: 'Nicht Ironie und Satire also, die meine Absicht der Reporter lügnerisch festgestellt hatte und Menge nachschwatzte, doch vor allgemeiner Tat aus meinen Schriften schon die Lehre: dass Kraft sich nicht verliert, muss der Mensch auf keinen überkommenen Rundgesang doch seinen frischen Einzelton hören, ganz unbesorgt darum, wie Bürgersinn seine manchmal brutale Nuance nennt' (P411, vol. 1/24).

The absence of a clear norm, admitted by Sternheim himself, would lead, it seems to me, to a loss of meaning. Sternheim can take no real position except to glorify the status quo under certain circumstances, and to rationalize irrational acts. The drastic representation of uncontrolled lust for power, sexual drive, unscrupulous manipulation of others, and the pursuit of wealth against all laws has indeed led many critics to see in Sternheim a violent attacker of vice in bourgeois society. Helmut Liede's thesis of 1960, for example, still sees Sternheim's main aim as satire. Only since the work of Wilhelm Emrich and Wolfgang Wendler can we speak of a return to an interpretation which takes into account the ideas expressed in Sternheim's theoretical program, though even nowadays the debate about Sternheim's aims rages on, as the relevant sections in Wilhelm Krull's *Forschungsbericht* illustrate (S124).

Sternheim wrote his nineteen short stories (he called them novellen) between 1912 and 1923. Fourteen of these were collected in 1918 under the title *Chronik von des zwanzigsten Jahrhunderts Beginn*. The stories

are linked by the common theme of the struggle of the individual (with a few exceptions also the title hero or heroine) towards fulfilment in a society which attempts to thwart this effort. Without using the breadth of the novel, Sternheim nevertheless attempts to give a total picture of his heroes, often in fact a biography from birth to death. The biography is the basic model of the Sternheim novelle, achieving both a kind of realism and an aesthetic unity. Within the novellen there is, however, a clear tendency towards concentration on essentials. This reminds us of the demands of the nineteenth-century novelle, and could almost be called a classical aspect of Sternheim's work.

Two things interest Sternheim about his heroes: their character and their inner development – conceived as a reaction and reflection of an outside development such as war or a change in social and economic conditions. This inner development ultimately leads to a high point, which is the finding of the 'eigene Nuance.' This finding oneself could be characterized as anti-Goethean, and especially anti-Kellerian, since it does not mean finding one's place in society as a useful member, but an unscrupulous realization of the individual impulses, usually *against society*. The inner development is accompanied by external changes, though they are less important than the inner ones; they reveal, however, the underlying structure of the novellen. Structure aids in understanding the Sternheim novelle; by contrast, language tends to confuse the uninitiated reader.[10] Whereas the external development of the story is usually clear and straightforward (chronological), Sternheim's language gives us few clues about the parallel inner development of the hero. Despite such complications, however, a basic pattern can be discerned and, once recognized, is revealed to be giving each novelle something of the character of an exemplary tale.

In 'Die Poularde' (P130) Sternheim has perhaps given us the clearest model of the development of a hero towards the finding-oneself. The 'eigene Nuance' has been reduced to a simple formula: the title of the novelle is meant to be a character description of the heroine, Stefanie. As in most of his novellen, Sternheim situates his protagonist clearly in a socio-economic milieu, a trait which makes him distinct from most other Expressionists. Milieu is part of the constitution of the hero, and Stefanie's poverty determines her character. The opening of the story also introduces a second motif: eroticism plays a crucial role in Stefanie's life. There is a hint of incest in her relations with her father, and she accepts sex with her employer. Accused of stealing, Stefanie is imprisoned, and for the first time she has occasion to reflect on herself. She discovers her own

beauty during an episode of narcissistic self-contemplation and discovery of the pleasures of Eros, and sees in it a way to advance in the world.

Stefanie accepts a position in a bourgeois household, later in a 'fürstlicher Haushalt' (P411/318), where she is initiated into the ways of female charm, until she becomes a politician's mistress and settles down to a life of indolence and ease. In this situation of 'Beharren' she acquires Rubens-like qualities, but a feeling of being the mere property of her lover does not leave her. Her exceeding loyalty is finally threatened by a valet, Wenger, an enigmatic character whose male pride and 'Leidenschaft hinter der Grimasse' (325) upset Stefanie, all the more since her chambermaid Sophie already maintains an erotic relationship with him. Confusion about Wenger brings an end to Stefanie's stability. The force of 'Elementares' (326) leads her one night to bury her face in Wenger's bedclothes, and she steals his underwear, which she then wears herself. The motif of fetishism is coupled with that of voyeurism when Stefanie observes Wenger and Sophie embracing, at the same time making fun of Stefanie in her absence. Still, her fascination is so great that Stefanie is irresistibly drawn to Wenger. At this point Sternheim introduces Dr Rank, an author, who tries to warn Stefanie against her impulses. He argues that her desires are not the expression of her true self but the product of her former experiences and background: 'Hätte man Ihnen als Kind durch Ihres Geistes Entwicklung an Hand reichlich ausgebreiteten Materials Gelegenheit gegeben, die in Sie gesenkte Kraft gemächlich auszubreiten ... wären Sie aus Verhältnissen nicht stets Besitz, nie die Besitzende gewesen, hätte der Kern, der Sie ausmacht, nicht so verdichtet, riesige Sprengkraft zusammengedrängt werden können, die jetzt entladen will' (330). Rank suggests that to compensate for the feeling of being owned by others Stefanie should live a great passion, and he proposes spiritual ecstasy combined with sensual pleasure, 'Steigerung ... über das Sinnliche hinaus' (332); this will give her the pleasure of discovering her 'eigene Form' and her own 'besondere Person' (333). He indeed manages to alienate Stefanie from Wenger, and to substitute himself for him. Ultimately Stefanie settles down to marry Rank, and at the end of the novelle the latter sums up the message which Stefanie's development demonstrates: 'Sie sind, liebe Freundin, endlich am rechten Ort. Nicht Steigen stand Ihnen und steiler Aufschwung. Lässliche Ruhe, Verharren kleidet Sie sehr. Und nicht mit der kletternden Lerche soll Sie Ihr künftiger Dichter messen, Ihr Gleichnis wäre – "Die Poularde," sagte Stefanie' (335).

No other story except 'Die Laus' (P126) states the 'eigene Nuance' quite so simply. Usually it cannot be given in a formula; but generally a certain

mode of life is postulated as most suitable for a certain character. 'Die Poularde' is also an exception in its relative absence of drama. Very often the will to assert oneself clashes violently with the wishes of others. Stefanie's 'Beharren' is non-violent, and leads to a kind of stability which does not cause her to come into conflict with others.

For Meta, the protagonist of the story with the same title (P127), this kind of 'Beharren' is not suitable; it is not her true nature. It is rather Meta's task in life to be 'dienender Geist.' Meta must go through many experiences, as must Stefanie, before she finally finds herself. She, like most of Sternheim's figures, seeks refuge in typical bourgeois myths and clichés. Particularly her initiation into the erotic makes her the victim of this tendency. In her day-dreams and fantasies Meta seeks a fulfilment inappropriate to her character, and the relation she maintains with a local telegraph boy continues this error. Sternheim tries to show this 'Irrweg' by a blasphemous manipulation of the symbolism associated with the Virgin Mary: 'Engel war für die Angeschwärmte das mindeste Gleichnis. Er gab ihr Krone, Kelch und Dorn, alle Vollkommenheit voraus ... Wort aus ihrem Mund war Allegorie, Silbe Botschaft. An ihrer Seite ging er Andacht und Glaube' (P411/83). Meta, by contrast, is at home in a more mundane sphere: 'Schwäche sass in den Schenkeln, von der Küche sah sie zum Hof auf die Tiere, die sich berochen' (81). Yet other errors draw Meta away from her 'eigene Nuance.' Franz's absence during the war inspires a rash of metaphors in Meta's life. She anticipates an idyllic existence upon his return, and a total immersion into the values of bourgeois society; she dreams of 'Mutterglück' (91). When Franz dies in battle, there is a sudden end to these dreams, and Meta is thrown back on her own resources. Now begins a strange episode, difficult to interpret, in which Meta pursues a veritable cult with the dead Franz. Through her own body she conjures up his presence and has intercourse with him nightly. Only her physical and mental exhaustion force her to abandon finally the continued state of ecstasy induced by masturbation and to return to society, but 'unter veränderten Begriffen' (98).

Meta makes her greatest mistake in becoming, through a ruthless exploitation of her employers, the one to be served rather than the servant. In her new position she is an object of constant care and attention, but this stage of her life also marks the point at which she is the furthest removed from her true nature. Because of her self-indulgence, she is finally forced out of the household and, now realizing her mistakes, finishes her life by taking care of old women, whom she shows the beauty of their own being. The final section reiterates the message of the 'eigene

Nuance'; Meta does not regret the life she has led: 'Nie habe sie sich gegen den Höchsten vergangen, hätte sie, ein menschliches Weib und nach den Worten der Schrift ein Abbild, das Recht auf die eigene Person, volle Verantwortung für sich vom ersten Lebenstag gefordert' (110). The doctrine remains the guiding principle till the end: 'Schönste irdische Wirklichkeit bin ich mir selbst, und auch vor meinen Herrn muss ich einst so treten, dass er mich als das Höchstpersönliche erkennt, welches er, von aller Menschheit unterschieden, schuf, und das er "Meta" nannte' (112).

'Meta' therefore operates very much with the ideologies we encountered in 'Die Poularde.' What makes this story far more problematic, however, is Sternheim's style. It is a difficulty which runs through most of Sternheim's novellen, and has to do with the function which Sternheim assigns to language. Franz's adoration of Meta and Meta's attempt to live up to this excessive adoration are described in a language which clearly departs from Sternheim's idea of himself as a chronicler. We cannot dismiss a feeling that a form of satire is at work here, despite Sternheim's claims to the contrary. We cannot possibly read these equations of Meta with the Virgin Mary as being seriously intended. Moreover, most of these comments originate through explicit narrative manipulation; not *erlebte Rede* is used, or reported dialogue, but a straightforward narrative voice. Sternheim therefore seems to satirize – by means of the distance he creates and by simply contrasting the two modes of love – the romantic and the sensual. Meta's longing for carnal love is postulated as genuine; romantic love is a form of kitsch. But such manipulations fly in the face of Sternheim's professed neutrality as a mere chronicler. A similar incongruity between theory and practice exists in the passages in which Sternheim describes Meta's ecstatic mode of existence under the sign of the erotic. Helmut Liede, in speaking of these and similar passages in 'Busekow' and 'Ulrike,' interprets them as a criticism of the ecstasy of the self. Liede sees Meta's cult with the dead Franz as a cult with her proper body, which becomes a tool for fulfilment. To be sure, the erotic seems in Sternheim's work to represent self-indulgence and narcissism. Of 'Meta' in particular it is however also appropriate to mention Wolfgang Wendler's suggestion that in Sternheim's theoretical writings there is evidence that his concept of reality allowed for the possibility of a 'vision,' which means that Meta would be able to conjure up Franz's presence out of sheer willpower (S247/160). In either case, as euphemism for masturbation or as 'vision,' Meta's ecstasy is seen in a positive light. The question poses itself now of why this particular type of love should be interpreted as positive and romantic love as negative, since there is no indication in the vocabu-

lary to presume a qualitative difference. Both types of love are described in the same exalted language, and again the *origo* of these descriptive passages lies not with an internal character but with the narrator, hence outside.

This points to one of the great disadvantages of Sternheim's use of language. The difficulty is that language does not, contrary to his stated intentions, fulfil its function as a cognitive instrument. A complete *identification* with the object it describes allows language no critical *evaluation* of what is being described. The total 'objectivity' of Sternheim is therefore a fallacy; in striving to find 'appropriate' language, Sternheim in fact falls into a total dependence on the thing described. To the reader the ecstatic language of Romanticism and Meta's presumably genuine outpourings are the same. That we are at all able to interpret Meta's feelings is the result of the narrator's direct comments, such as that Meta's soul-searching ends in her becoming a 'neuer Mensch.' But such narrative intrusions, lying outside the scope of consciousness of the internal characters, constitute a break in style. Sternheim's claim that he has abandoned the role of the interpreter of fiction is therefore hollow: theory and practice are unquestionably diverging.

The Novelle 'Schuhlin' (P131) is linked in two ways with 'Meta.' The central character, a musician who, by exploiting his talent, manages to subordinate both his wife and his pupil, to the point where they do his bidding without question, establishes himself in much the same way as Meta did in her bourgeois household. Like Meta, Schuhlin is a proletarian, with an obsessive ambition to be successful. A cold, calculating man who uses art for his own benefit, he quickly rises in status. For Schuhlin the audience is both his victim and the mirror for his inflated ego. His marriage to Klara, her subjugation, and that of his pupil Neander allow him to enjoy the relationship of mirror and self not only in public but also in his private life. But as in 'Meta' Schuhlin's settling down poses a threat, narrowly averted when a rivalry springs up between his two fanatical followers (Klara and Neander), which ends in murder. For Schuhlin it is only the end of an episode, which frees him for other victims: 'Sanfte Trauer hindert ihn nicht, unverzüglich neue Verbindungen zu suchen, die ihm die Mittel zu jenem Leben, das er als ihm gemäss und seiner Bedeutung zukommend, ein für allemal erkannt hatte, sichern sollen' (P411/76). Schuhlin manages so well in life because he exploits the myth of the genius which the bourgeoisie holds so dear. He is a figure closer to those of Sternheim's comedies than most other characters in these novellen, who usually opt for retreat rather than for exploitation of the bourgeoisie.

Perhaps the best example of such a retreat from social life is the novelle 'Ulrike' (P132), in which the heroine's disillusionment over the collapse of her adopted values forces her to embrace the philosophy of chaos. 'Ulrike' illustrates a form of ecstasy which results from the loss of will; yet even this loss of will, and the end of individuation, is by a veritable *salto mortale* made to represent a genuine expression of the 'eigene Nuance.' The catalyst for Ulrike's transformation, as for Meta, is the First World War. The role of the war is crucial in these novellen because, rather than being an economic or political phenomenon, war is for Sternheim a particular form of bourgeois myth.[11] Like any other myth in bourgeois thinking, war places society over the individual and hampers thereby the full development of the 'eigene Nuance.' In 'Meta' Sternheim writes: 'Überall stand Allgemeinmenschliches für Besonderes' (88). War is a kind of collective ecstasy; in its own way it illustrates the 'metaphorical' character of society: 'Vom eigenen Schicksal war täglich weniger die Rede' (89). In 'Meta' the symbolism of war is shown to be stronger even than the symbolism of love; it brings to an abrupt end Meta's status as a semi-divine being. In the decision of Franz to go to war the male principle triumphs over the female dominion.[12] In 'Ulrike' the war destroys the clichés by which Ulrike, the daughter of an impoverished Prussian nobleman, has lived so far. Though at first as a nurse at the front she might consider her moral principles vindicated because her adopted role as Christian, virgin, and martyr succeeds remarkably well, confrontations with several problematic men in her life gradually erode her class-determined philosophy; 'Ulrike sah ihr Leben in Schläuchen, die nicht mehr dicht waren, sickern' (152), Sternheim comments.

The madness of war, the self-destructive implications of the bourgeois myth, cause Ulrike to waver: 'Sie ging geköpft durch tolle Zeit. Und als in Reden und Schriften der Unsinn krass wurde, groteske Ereignisse lärmender prasselten, rettete sie sich vor der Not in äussere Zerstreuung. Fand Licht vor europäischer Nacht bei exotischen Kinobildern' (153). To defend herself against the madness of her times she replaces reality with a reality once removed, the cinema, until her meeting with Posinsky, a 'männliche Bestie' (155), causes the house of cards of her world-view to crumble permanently. Ulrike is converted to a philosophy of chaos and primitivism. Posinsky's experiences in Africa, his love for Negro art, and his outlook on life are emulated without examination by Ulrike. She literally becomes his slave; in their apartment they build a *kraal* in which Ulrike lives like a primitive Negro woman, tattooed and dressed in animal skins, obedient to Posinsky's whip. Ulrike has abstracted herself from

her past, from the 'culture' of Europe, from life itself, and has escaped into the world of exoticism and ecstasy of a primitive paradise. No longer anything but 'berücktes Fleisch,' the former duchess dies giving birth to a child with negroid features. Posinsky's last picture of her, with the child, entitled 'Nevermore,' provides a *pointe* to the whole episode.[13]

As in 'Meta' we are once again struck by the problematic nature of the doctrine of the 'eigene Nuance,' especially where it involves ecstasy. Ulrike escapes into a world of her own making, a world of 'Rausch,' in which the self may seem to express itself uncontrolledly and in utter freedom. But it is necessary to emphasize the crucial role of war in this process, since it is primarily the war which causes Ulrike's loss of self-confidence and trust in her original convictions. This implies, however, that the *specific* nature of the 'eigene Nuance' is to a certain extent determined by the nature of the oppression under which the individual suffers. Just as in Meta's case we noted that sexual longing combined with a mystical tendency forced her into masturbatory cults with her dead lover, so for Ulrike the failure of culture and civilization triggers her escape into primitivism.. There seems, then, to exist a system of opposites between which the characters oscillate – a fact which limits considerably the choice of the 'eigene Nuance.' Sternheim sets up a dualistic system, each novelle exploring contrasts rather than a multitude of possibilities. This is of course a grave objection to the idea of individual unfolding. Any kind of dependency on empirical, external, especially social circumstances reintroduces the determinism and 'metaphorical' bourgeois thinking which Sternheim opposes so violently. In 'Ulrike' the war clearly functions as such a determinant in the heroine's final choice of the 'eigene Nuance.' Moreover, her choice entails a destruction of the self rather than a development of it. The loss of her past is in fact the loss of that which constitutes the unity of the self. Without memory there is no individuality, no centre of being, and certainly no 'Nuance' at all. The doctrine therefore seems to be in contradiction to itself. As in 'Meta,' Sternheim's narrative technique also endangers the reader's understanding of the novelle. This is particularly the case with the description of war as 'Rausch.' Although he obviously rejects war as collective madness, Sternheim later glorifies the ecstatic life of Ulrike and Posinsky, 'starker behaarter Affe und die berauschte Äffin' (158), as means of achieving the true self. Liede, interpreting the war and Ulrike's thirst for primitivism as parallel cases of ecstasy, must come to the conclusion that a criticism of both is concerned,[14] though of course Sternheim's theory admits a positive evaluation of certain attitudes which in others are seen as negative.

What we are to understand is that individual ecstasy is a manifestation of the 'eigene Nuance'; collective ecstasy, by contrast – and this includes war – is to be condemned. Nevertheless, the obvious difficulty associated with the absolutely subjective basis of Sternheim's doctrine becomes visible.

The novelle 'Posinsky' (P129) continues the fate of the painter after Ulrike's death. Posinsky has adopted a 'cult of the body' and fanatically pursues his search for food and drink, made infinitely more difficult because of the war. Against a background of extreme suffering Posinsky practises a form of materialism which has grotesque overtones. In his hoarding of supplies, his rejection of culture, of spirituality, and humanistic values he is revealed as a figure striving to reach, in a *reductio ad absurdum*, the essentials of mere physical man. Posinsky maintains the priority of the body over all spiritual values with such unrelenting fanaticism that when he discovers a young couple next door rehearsing a Schiller play, he interprets it as a personal insult. Schiller's drama, with its metaphors, aesthetic clichés, and philosophical pretensions, stands in extreme opposition to the cult of eating, digesting, and survival. Even when Schiller's play turns out to have certain parallels with real life, Posinsky cannot accept its validity: the very life of the young couple appears to him to be nothing more than a series of clichés. There is no truth in it when compared to the pursuit of the 'eigene Nuance.' Even the young girl's death agony is mere theatre: 'Der Kleinen letzter Seufzer war Klischee nach Shakespeare' (P411/239). But the greatest challenge comes to Posinsky when the young actor returns one day to express his grief over the death of his beloved: 'Hier bäumte nicht minder begeisterter Wille wider den Seinen. Nun musste er für Überzeugung lebendiges Zeugnis ablegen. Erweisen sollte sich, wie der Gutgespeiste den Schlechtergenährten bei Glaubens gleicher Inbrunst leicht vernichtet' (241). To bear witness to the strength of his own convictions, Posinsky shoots the young man, and is, as we learn in the novelle 'Der Anschluss' (P122), arrested and brought to an insane asylum.

Sternheim formulates the doctrine of the 'eigene Nuance' in ever more extreme terms, but the function of external circumstances (the war) as determinant for bringing out the particular 'Nuance' is reinforced also, for it is only through the specific pressures exerted by the war that response results in this particular fashion: Posinsky's cult of the body is the result of hunger. That individual and unique responses to external circumstances can nevertheless remain possible is illustrated in the novelle 'Heidenstam.' This successful investor's career we had occasion to trace in chapter 3; though the war initially causes considerable difficulties for

Heidenstam, he eventually triumphs as a speculator and retires from public life to devote himself exclusively to a new way of life which he has adopted in view of the excitement sparked by war. 'Das Ganze gab sich bunt und grell' (176), for the spectacle of war seems to externalize the boundless inner excitement and feverish energy which has taken hold of Heidenstam himself: 'Europa schien ihm zu seinem Vergnügen moussie-rend gequirlt' (P411/178). The new outlook on life is conveniently chan-nelled into the ecstasy of war: 'Bis in die Nacht liess er den Phonographen die Nationalhymne spielen, trank Punsch dazu' (179). Unfortunately, Heidenstam is making the mistake of confusing his private madness with the madness of the external world. Even though he praises the war as 'Erwecker zu tätigem Leben' (177) and idolizes even the greatest excesses, he still places himself beyond society, because his notion of war does not entail patriotism but self-indulgence. In bourgeois society violence is strictly reserved for collective goals. Heidenstam's career also ends, like Posinsky's, in a madhouse. Nevertheless, individual madness triumphs over collective madness in the end, for Heidenstam now rules over a reality of his own making. This solution, though it might appear strange to the reader, is again intended seriously. Madness overcomes the obsta-cles of reality, and Heidenstam is prefectly correct in considering himself a New Man, at last able to direct his own destiny. The subjective view-point is all that matters, even though this extreme form poses problems of intelligibility and evaluation from a critical point of view.

The distance between individual viewpoint and conventional social wisdom is elaborated in 'Der Anschluss,' in the discussions between the interned Posinsky and Heidenstam. Judging unpremeditated behaviour as a true expression of the self, Heidenstam pleads with Posinsky to insist during his trial that the murder he has committed was the result of a moment of non-rational impulse. Reason and logic imprison man within the value system of the bourgeoisie, whereas crimes like Posinsky's sup-posedly make man free. By accepting this argument, Posinsky finds the connection to himself. The awareness of his own worth in fact raises him to the heights of ecstasy, though for the doctors these ecstasic outbursts of course only prove Posinsky's madness.

Despite the fact that 'Der Anschluss' does not deal with the erotic, it contains again references to ecstasy. As we realize by now, ecstasy plays a central role in Sternheim's work. Though it presents itself in many guises, certain interrelationships can none the less be established. There is first of all sexual ecstasy. Sternheim focuses sharply on the role of the erotic in the development of the individual. Meta and Stephanie learn about sex at

an early age; both willingly submit to the advances of their employers and do not even shy away from incest. The erotic is an impulse which particularly drives the female characters: Stefanie is a born mistress; Meta is fascinated by carnal love; Ulrike ends up as a primitive 'Äffin.' There is also a high frequency of narcissism and voyeurism in Sternheim's stories. All these qualities are related to the doctrine of fulfilment. Masturbation, the ecstasy of copulation, voyeurism, and narcissism are counterparts of the lust for power in Schuhlin, the ruthless exploitation of others by Yvette, the food fixation of Posinsky. To be sure, voyeurism seems rather to point to a sense of impotence and isolation, but in its tendency to treat people as mere objects voyeurism may be explained as yet another source of sexual gratification and of self-indulgence. Paradoxically, even the chaos which opens up through the *loss* of the self, in the sex act, may be a road to *finding* oneself: Ulrike discovers her 'eigene Nuance' in the ecstasy of sex because the chaos it symbolizes happens to be *her* appropriate philosophy. The ecstasy of sex is therefore related to the ecstasy of the self. This comes out clearly in the motifs of the mirror (narcissism) and the materialistic preoccupation with the body (as external manifestation of the self). Sternheim seems to have considered the cult of the self and indulgence in the sex act as the highest forms of protest against society's collectivism; hence it is not only the highest form of gratification, but also the anarchistic gesture *par excellence*. The doctrine of hedonism as a form of social protest goes back at least to Sade and Heine, what Sternheim adds is the rejection of collective types of ecstasy such as war. This does not mean that collective and private ecstasy may not on occasion coincide. But when it is recognized that not collective but private myth prevails, the subject will suffer the consequences for his transgression.

The latter fact points to one of the major difficulties of Sternheim's doctrine. Both when the hero lives in contrast to or removed from society and when he uses the conventions of his society as a mask to achieve his personal ends (as in most of his comedies), the hero in fact usually displays the same vices as those for which society is attacked. The hero's 'opposition' to his environment in fact frequently amounts to a virtual identification with it. Hence, instead of providing alternatives to society, instead of functioning as a kind of 'Gegengift,' as Emrich calls it (P411, vol. 1/13), the hero rather becomes an exponent and a representative of that society. Consequently, the norm by which society is judged is absent.

The novelle 'Busekow' (P123) may illustrate this once more. The Protes-

tant policeman Busekow, unhappy in his routine job and in his marriage, finds release in his relationship with Gesine, a Catholic prostitute. Their liaison climaxes in a synthesis of erotic and religious ecstasy. But the use of religion in this story is problematic and ambiguous. In the case of Gesine we are dealing with a true, albeit exalted faith, in the case of Busekow with a conventional type of Christianity. The religious motif appears in many forms: Luther's portrait hangs over Busekow's bed, but it is shown that the Busekows are unable to respond to Luther's 'ausladende Gebärde.' Biblical reminiscences are frequent: they are intended to criticize a church in which erotic and ecstatic love have no place. It is the great achievement of Busekow that in his experience with Gesine he *does* reach erotic ecstasy while at the same time finding a satisfactory relation to religion. Problematic, here as in 'Meta,' however, is Sternheim's language, which again does not distinguish between genuine faith and 'falsche Frömmigkeit.' Again, we need narrative intrusions to enlighten us.

Another motif, Busekow's loyalty to the emperor, plays an equally important and problematic role in the novelle. It, too, appears at the climax of the sexual encounter between Busekow and Gesine, in Busekow's singing of the hymn 'Heil dir im Siegeskranz.' Religion and 'Königstreue' are two characteristics of Busekow's 'eigene Nuance' – supposedly two modes of expression of his inner life. But in this capacity they merely repeat the characteristics of countless bourgeois of the Wilhelmian period. What makes these characteristics different in Busekow's case is merely the consistency with which they are pursued. What desirable quality the experiences of ecstasy, religion, and patriotism have in the order of things, however, does not become clear. The spurious rejection of conventional religion because it is not an expression of the true self, and the proclamation of 'Königstreue' (equally conventional) as virtue and indicative of 'eigene Nuance,' demonstrate the lack of objective standards in Sternheim's hierarchy of values. More generally speaking, ecstasy as an intensely subjective experience, by nature alien to society, ought to be considered an even more problematic aspect of Sternheim's work. A general pursuit of ecstasy would lead, presumably, to a disintegration of society rather than to reform.

Finally, the analysis of 'Busekow' and other novellen shows that the 'eigene Nuance' may very well be identical with the values of society. If the characters display the typical philosophy of self-interest which characterizes the bourgeoisie itself, and if instead of real liberation from the oppressive nature of society we are made aware of the limitations which

society continues to set on the development of the individual, so that several stories end on a negative note, to what extent can we then claim that Sternheim offers a solution to the problem of autonomy? Heidenstam and Posinsky end up in a madhouse, discussing the principle of freedom; Busekow dies in a moment of ecstasy which has such overtones of parody that Liede could not believe it was meant as a final triumph; and Ulrike dies after having come down to the level of bestiality in a 'Rausch' which denies culture and civilization. In all these cases the objectionable excesses of society as collectivity are glorified as individual virtue. Above all, the acceptance, even the glorification of violence (most obvious in the discussions between Posinsky and Heidenstam) constitutes an insurmountable barrier to a ready acceptance of the doctrine.

Both Sternheim's theory and the prose which it inspired are replete with paradoxes and contradictions. The subjective doctrine which places the truth of man's behaviour completely within the sphere of the individual and which refuses an objective norm as point of reference makes ethical acts an arbitrary matter – a conclusion which Sternheim tried to escape by referring to our 'natural socialism.' An investigation into his prose reveals, however, that no such condition prevails. Examples of callousness, sadism, cruelty, and inhumanity abound. Only 'Napoleon' (P128) shows an attempt to shift into a more peaceable existence. The hero, after changing direction from a utilitarian preoccupation with life, and having been forced to detach himself from it because of great social and political upheavals, comes to realize that only the cult of the self may lead to harmony and peace; but he at least achieves this, by returning to his native village, where he lives out the remainder of his days, 'gut und fromm' (P411/56). Elsewhere the idyll can only be established in a retreat from society, such as in the madhouse, the *kraal*, or the bedroom. When the affirmation of the self reaches its highest intensity and when at the same time it can go unchecked by all reality, the doctrine shows its true face as escape or madness.

Equally grave objections to Sternheim's work may be made with regard to the discrepancies between style and content and between the stated aims of the work of art and the factual procedure within the opus. A close reading of Sternheim's major novellen shows to what degree the formal aspects colour the statements made. Sternheim could well serve as a test case of the problematic relationship between content and form in all Expressionism, since so much of what is being said is transformed by how it is said. Sternheim's stated aim of chronicling objectively the society in which he lived – not to create *Dichtung* or *Tendenz* – is of course a

paradox, as Liede points out: 'Insofern sie mit Recht für Dichtungen gelten, sind auch Sternheims Werke ihrem Wesen nach metaphorisch, nämlich wirklichkeitsenthoben, scheinhaft' (S132/105). Moreover, though the theory stresses the untendentious nature of Sternheim's writing, all his fiction is written with an eye on effect: the 'rhetoric' of Sternheim's fiction lifts it out of the realm of mere chronicle. Sternheim creates a closed world in which certain principles, particularly that of bi-polarity, operate. The language too reinforces the hermetic quality of the prose, so that the 'realism' he aspired to does not fully realize itself. Liede mentions the high degree of abstraction in Sternheim's work, and the tendency towards a kind of 'classicism' directed at a specific audience. This is of course especially obvious in the discursive, almost programmatic parts of 'Posinsky' and 'Der Anschluss.' An almost anachronistic preoccupation with form, associated with the cult of the artist and with a didactic tendency, betrays the fact that Sternheim's work remains oriented towards a specific, educated, and ultimately bourgeois audience.

The inescapability of Sternheim's own bourgeois background is further confirmed by his use of language. The attacks launched by Sternheim against metaphorical language are carried out largely by stylistic methods similar to those employed by his opponents.[15] The descriptive method used to characterize his heroes is not so very different from that used to characterize the much-despised bourgeoisie. Ultimately, the identification of art and the artist with reality 'as it is' leads Sternheim to an acceptance of the world on its own terms, or, by contrast, to the total destruction of all reality. Winfried G. Sebald has written: 'Wie Posinsky Ulrike, so misshandelt Sternheim in seinen eigenen Werken die Wirklichkeit, indem er die Zynismen einer Gesellschaft enthüllt und sie im selben Atemzug als den höchsten Sinn des Wirklichen proklamiert, als dessen "eigene Nuance"' (S217/34). The hypostatization of reality as a given condition, even when it is modified by its location in an individual, implies the acceptance of evil as part of the human condition. But this in turn implies precisely the kind of metaphorical thinking of which Sternheim accuses his opponents.

Sebald has suggested sociological and psychological reasons for the obvious contradictions and unorthodox tendencies in Sternheim's work. His attacks on the bourgeoisie are said to be based on his incomplete assimilation. Sternheim's aggressive attitude towards the milieu to which he really wanted to belong could then be seen to be rooted in his Jewish origins. His pseudo-conservatism, the celebration of all things Germanic, is then an obsessive wish to find acceptance; his anti-Semitism, his cult of

'Blut und Boden,' an indication of his being torn between hating and longing. Such conclusions are neither strictly scientific nor quite relevant for our purpose. However, in one respect Sebald's argument seems enlightening. The motif of voyeurism, which we noted on several occasions, would be explicable in terms of a neurosis. More importantly, the striking frequency of such a motif cannot be explained within the context of the work alone, precisely because it contradicts in its unselective occurrence its pertaining to anyone's 'eigene Nuance.' Here as in his 'nivellierende Sprache' Sternheim contradicts both the doctrine of individualism and his theory of art. From a philosophical point of view as well as from a formal, aesthetic one the glorification of the self by Sternheim results, as in the case of Edschmid, in severe contradictions, and ultimately in failure.

EIGHT

Autistic Worlds

IN ONE OF HIS EARLIEST prose works, 'Heinrich Mann. Ein Unter-
gang,' Gottfried Benn wrote: 'Jahre waren es, die lebte ich nur im Echo
meiner Schreie, hungernd und auf den Klippen des Nichts. Jenseits
von Gut und Böse – dummes Literatenwort. Jenseits von Krebs und
Syphilis und Herzschlag und Ersticken – das ganze grauenvolle Leben der
Götter war es, ehe sie ihre Erde schufen' (P7 = P399/1181). Benn describes
here a feeling of total despair, for which the critics have quickly found the
term nihilism.[1] The reference to Nietzsche, the phrase 'Klippen des
Nichts,' indeed identify the source of despair as the knowledge that 'alles
Geschehen sinnlos und umsonstig ist' (S13/5), that metaphysics is an
arbitrary projection of man, that 'alle Theogonien, Götterwelten und Reli-
gionen der Menschheitsgeschichte' are but 'Flucht in eine nur erträumte
Gelogenheit' (S12/30), and that man's own endeavours, his science and
philosophy, his social and cultural achievements are without issue.[2]

In the same novelle, Benn explains why he arrives at such a devastat-
ingly negative image of man's achievements: it is the awareness, which he
shares with many of his contemporaries, that all man's activities take
place 'gegen einen versinkenden Hintergrund' (575). For though man
prides himself on his ever-increasing knowledge of the empirical
world, in reality every modern man is, like Benn's fictional mask, the
physician Werf Rönne in the collection *Gehirne*, a 'Flagellant der Einzel-
dinge' (1896). However far we extend our knowledge of the universe,
through gathering of data, drawing up of laws, and ceaseless experimenta-
tion, we are confronted by the loss of an overriding order, a binding
principle which gives the mass of information an ultimate meaning. Benn
cannot accept the scientific world-view in which spirit and matter are
ultimately identical, because it must lead necessarily to a philosophy of

determinism and a rigidly mechanistic view of the universe. Rönne, and with him Benn, 'Kind des zwanzigsten Jahrhunderts und als solches Empörer gegen das neunzehnte, gegen dies naturwissenschaftlich gerichtete eitle Jahrhundert, das aufging in Einzeluntersuchungen, Statistiken, Beschreibungen des Formalen und lächerliche Versuche mit Menschen und Tieren' (S219/820), revolts because he has the 'Urerfahrung eines metaphysischen Ichs, die die auf Verstand, Logik, Kausalität aufgebaute Welt zertrümmert' (S219/821). At the same time, however, the new-found realization that there is a dichotomy between the self and the world leads to an equally problematic situation and becomes itself a source of suffering. For in the moment in which the subject grasps itself as thinking, the bond between man and nature is ruptured: the fixed objective principles which had hitherto determined the life of the subject are destroyed. Perception of the mental process *as* mental process leads to the realization 'es geht nirgends etwas vor; es geschieht alles nur in meinem Gehirn. Da fingen die Dinge an zu schwanken, wurden verächtlich und kaum des Ansehens wert' (P339/1181).

The self as the theatre of all reality: this is the extreme subjectivism of whose danger many Expressionists were aware. Does a world in fact exist? For if the self is the exclusive place 'wo etwas vorgeht,' how can we grasp an objective reality? And how can we avoid questioning all efforts of man, including his philosophical and metaphysical explanations of the cosmos? What grounds do we have for believing that our ideas 'cover' a thing or event which we signify by our ideas of it? Hans-Dieter Balser writes: 'Als ... das Denken seinen absoluten Bezugspunkt verlor und damit auf eine fragwürdige Weise autonom wurde, begannen "Ding" und "Begriff" auseinanderzutreten ... das Denken, das Gehirn, geriet in eine völlig isolierte Autonomie' (S13/41). This is the 'Seuche der Erkenntnis,' the destructive tendency of *ratio*. According to Benn, *ratio* is responsible for man's separation from nature. It is a theory dating, as we have seen, from at least as far back as Schiller's essay *Über naive und sentimentalische Dichtung*, but in Benn's case the doctrine is more likely to have come through such contemporaries as Ludwig Klages, Edgar Dacqué, and Lucien Lévy-Bruhl. Klages's famous book *Der Geist als Widersacher der Seele* postulates *Geist* as the rupture of harmony between man and nature, which man used to experience through the soul. Lévy-Bruhl believed in a change from a collective consciousness to an individual one at some point in human history, and Dacqué located this change within the brain itself, an idea which obviously held considerable fascination for Benn, as the title 'Gehirne' shows. Benn worked out his own theories in

this direction in a series of essays in which he also quotes these sources extensively, as in 'Zur Problematik des Dichterischen,' 'Das moderne Ich,' 'Der Aufbau der Persönlichkeit,' and others. Crucial to all these writings is the idea that there was a golden age of harmony, which man's intellectual development destroyed. Being an Expressionist, Benn would of course be tempted to postulate as ideal, perhaps as possibility, at least a temporary return to this original state of perfection. That this return, if it is to be interpreted as the transcendence of nihilism, would have to be a return to the primal, pre-logical, pre-conscious state is clear. If transcendence is at all possible, it must be 'tierisch'; hence Benn's conviction that 'wenn es noch irgendwo eine Verankerung im Überindividuellen gibt ... [es] nur im Organischen sein [kann].' The solution lies, for Benn, not in an even greater extension of science and technology, but in what he calls, with a reference to a statement of Thomas Mann (!), 'tierische Transzendenz' (995).[3]

Benn sought a utopia well removed from politics – if we are charitable enough to dismiss his brief flirtation with the Nazi doctrine. As a poet and mythmaker he found his utopia in myth itself and in the language associated with it. This idea, however, only gradually reveals itself in his work. Benn's longing to re-establish a mode of existence similar to primitive man and in accordance with primitive thought, which as Marion Adams writes Benn believed was 'intuitive, collective and a-priori, and enabled man to live for hundreds of thousands of years without the modern torment of self-consciousness' (S1/104) – this longing is not immediately satisfied. In the beginning we have despair, particularly because the results of man's intellect are revealed in such a devastating fashion.

If the brain is an 'Irrweg,' then the results of the original deviation are of course all the more damnable, especially since modern developments have carried the imbalance of intellect over emotion and vitality to such an extreme that the clash between the two spheres, the 'begriffliche Ich' and the vitalist self, have caused intolerable suffering in the individual. In 'Die Insel' (P80 = P339) Benn develops this idea fully. His investigation of the self in relation to reality leads him to the notion of a certain 'Denkmodell,' in which the extreme intellectuality of modern man leads to a *loss* of self. Rönne, Benn's mask, traces the history of ideas about the thinking process from an initial 'Umgestaltung der Bewegung zu einer Handlung unter Vorwegnahme des Zieles' (1212) (which he situates 'Im Unentschleierbaren, wo der Mensch begann' [1212-13]), by way of a crisis stage somewhere in the North (when 'zwischen Hunger und Liebe' there comes 'der dritte Trieb ... die Erkenntnis' [1213]), all the way to modern

times. Science has now so far advanced that the actual location of the thought-processes has been discovered, not as Descartes believed in the pineal gland, but in the brain. Psychology, the bane of all Expressionists, has systematized thought, and panpsychism has even interrelated all thought-processes and subsumed them under the common denominator of the 'promotion of the perpetuation of the species.' But this eminently 'intellectual' system now seriously poses the question of what is left in all this to be called 'the self.' Benn asks in his essay 'Lebensweg eines Intellektualisten' (commenting on his novelle 'Die Reise'): 'Was bedeutet eigentlich das Ich? Bedarf es einer Reise nach Antwerpen ... ist es auf solche Eindrücke angewiesen ... bedarf es des Einzelfalls?' (1898–9)

The scientific 'Denkmodell' does away with the borderline between the self and the world. Between phenomena which present challenge and others which present responses there is the self: but how is it defined? 'Aus Ereignissen des täglichen Daseins und Rennberichten spielt der psychische Komplex sich ab' (1214), a phenomenon 'bietet ... Anknüpfungen zu Bewegungsvorgängen an Mitmenschen, sozusagen einem Geschehnis zwischen Individualitäten' (1215), but: 'Wo bin ich nicht?' asks Rönne, and 'Wo tritt das Ereignis nicht in das Gegebene?' (1214) The tendency to reduce phenomena, ideas, and individuals to manageable quantities in fact reduces individuals themselves to thinking entities which function as 'motorische Konkurrenzen'; man becomes part of a large stream of already existing and describable correlations. As Rönne says: 'Der Knabe spricht, aber der psychische Komplex ist vorhanden, auch ohne ihn' (1215). Wellershoff correctly analyses this 'stream' as similar to Heidegger's 'das Man'; 'Der kategoriale Raum ist die Welt des Geredes,' he writes, and quotes Heidegger's definition: 'Das Man, das kein bestimmtes ist und das Alle, obzwar nicht als Summe, sind' (S244/24).

A double collapse is therefore at work. Because thought is the only mode of existence of reality, there is no longer an objective reality, only a system, a structure of categories which catches reality as in a net. At the same time, the self, reduced to its thinking functions only, has become unknown as far as its essence is concerned. Rönne, 'der eine kontinuierliche Psychologie nicht mehr in sich trägt' (P339/1902), is the sum of his mental categories only. He is in fact reality as it is thought and, in the words of Wellershof, 'so ist er vor das Erlebnis von der tiefen, schrankenlosen, mythenalten Fremdheit zwischen dem Menschen und der Welt gestellt' (S244/26). Benn summarizes, in 'Die Insel': 'Wir überwanden unser letztes Organ' (P339/1215).

Rönne sees himself as a product of the historical process which led to

these ideas about man and reality. He identifies emphatically with the scientific world-view; 'er stand am Ausgang eines Jahrtausends ... er schuldete seine Entwicklung einer Epoche, die das System erschaffen hatte, und was auch kommen mochte, dies war er!' (1219) The identification with the system reveals itself also in the language, especially of the last paragraph: 'und siehe, es blaute das Hyazinthenwesen unter Duftkurven reiner Formeln, einheitlicher Geschlossenheiten, in den Gartenraum; und eine versickernde Streichholzvettel ran teigig über die Stufen eines Anstaltsgebäudes unter Glutwerk berechenbarer Lichtstrahlen einer untergehenden Sonne senkrecht in die Erde' (1219). Rönne consciously avoids seeing the pitfalls of the closed system just elaborated. The seemingly efficient way in which conceptions are transformed from 'das Unerklärte,' 'das Abweichende,' or even 'das Widersprechende' into 'Versöhnung' (1214), the aim of all science, obscures the fact that the arbitrary multiplicity cannot be forced into a system without loss of meaning: no fundamental truths about the world can be gained in this fashion. But that the apparent order of the universe is a fallacy, of this Rönne will finally become aware through an 'Urerlebnis,' which is of the same shattering impact as the original one, in which it was realized 'die ganze sogenannte wirkliche Welt ... ist nicht die eigentliche Welt' (S219/ 820). This time the 'Urerlebnis' is one of language, the 'Auseinandersetzung innerhalb seiner Selbst' (P339/1213). It takes place precisely in that novelle in which an aggressively scientific vocabulary predominates, namely in 'Die Insel.' From here on begins the road towards an escape from the seemingly inevitable conclusions to which the scientific approach forced him (and Benn). The individual stories in the collection *Gehirne* can therefore be seen as 'approaches' to a solution. They are sometimes dead ends, because they carry the protagonist only part of the way. The whole cycle is something of a kaleidoscope, showing various stages of consciousness, various models of behaviour and action, which are tried and rejected. Only in their totality do they achieve a transformation. They reach their goal only when the main character abandons himself totally to what Albert Soergel has called a 'dunkler Strom' (S219/820).[4]

In 'Die Insel' there is the first hint that Rönne will eventually have to leave the positivistic age behind. That hint lies in the fact that he can think two realities at once: that of the actual island on which he lives, and an imaginary one in the Pacific Ocean. There are therefore apparent rifts in the scientific world-view, rifts which Rönne attempts to prevent from coming to the surface. He does this by seeking proof of the validity of the order in which he has been raised (like Herr Fischer in Döblin's 'Die

Ermordung einer Butterblume'). Problematic aspects of reality are either negated completely or channelled into already existing categories, and for the moment the doubts which assail Rönne are conquered, as they are with varying success throughout the novellen. The doctor's efforts in 'Die Eroberung' (P3 = P339) demonstrate how this is done. In order to achieve a feeling of security Rönne must first establish himself. To this end he begins by observing his surroundings. A painting on the wall, of a cow, is his starting-point. The cow has four legs, 'das lässt sich gar nicht leugnen.' Numbers have solidity; they are 'rundherum gleich unantastbar, sie starren von Unangreifbarkeit, ganz unzweideutig sind sie' (1194). Gradually Rönne moves from simple observations of single phenomena to more subtle, larger truths. He concludes: 'Man muss nur an alles, was man sieht, etwas anzuknüpfen vermögen' (1196). In other words, one must have a system.

The same movement is depicted in 'Die Reise' (P10 = P339). During a walk, a sense of chaos begins to invade Rönne. To overcome it he employs his analytic ability: 'Er blätterte das Entgegenkommende behutsam auseinander' (1204). By playing on his ability to absorb and incorporate reality, he hopes to discard his fear. He begins to name things, for in naming them he 'tames' them. In 'Die Insel' nature itself, in the form of natural laws as well as scientific concepts, had similarly been invoked to provide order and form. Even moral laws, and the structures inherent in society, are called upon to provide proof that the world is in place, that it is an ordered world.

But not all efforts at finding security and balance are crowned with success. The title novelle, 'Gehirne' (P5 = P339), describes the mental and physical disintegration of a man for whom the contradictions between the systematic world-view and the threat of chaos have become intolerable. Rönne's state of exhaustion after having operated on approximately two thousand brains manifests itself not only in the non-connected observations he makes during his train ride to the clinic but also in the passivity he shows once he arrives there and in the apparent independence of the hand he has used during his operations. Yet he has faith in two things: in life and in science. Unfortunately, science proves to be a deceptive guide. The moment Rönne's imagination anticipates the results of certain movements, the borderline between the scientifically measurable and definable brain and the non-definable personality of the individual undergoing the operation becomes problematic. True, the physical properties of the brain are known, but they come together in a way that is outside Rönne's control. Brains live by laws that are outside the jurisdiction of science,

and their fate is 'so fremd wie das eines Flusses, auf dem wir fahren' (1189). The disturbing thought comes to Rönne 'Wenn die Geburtszange hier ein bisschen tiefer in die Schläfe gedrückt hätte ... Wenn man mich immer über eine bestimmte Stelle des Kopfes geschlagen hätte' (1190-1). Since soul is at least partially equated with brain, it is biologically determined. So disruptive does this thought become that Rönne is obsessed by it. If the hand, his own hand, can become alienated from the self, can the brain (and with it the soul) not also become independent?

In 'Diesterweg' (P2 = P339), which is thematically related to the Rönne cycle, the initial situation is similar to that of 'Die Reise.' The doctor (the name Rönne is not used, but we may safely supply it) has apparently achieved some measure of security through integration into a group of doctors, though at times he is still reminded of 'das andere Leben,' especially through the sense of smell.[5] Whenever the doctors meet, Rönne experiences the thrill of common goals; social intercourse proves the ordered nature of human life. Again the vocabulary ('das Abgegrenzte,' 'die Sicherheit des Geformten,' 'Gültigkeiten,' 'Erfüllung') is indicative of Rönne's search for stability and form. But insecurity manages to reassert itself nevertheless, and the doctor is forced once again to seek a definition of himself. This time Rönne follows a different path from that of 'Die Eroberung' or 'Die Reise.' He rebuilds himself after the model of a certain Matzke, a man of whom it is said 'er hatte was an sich' (1237). Rönne even takes a different name, Diesterweg, and he adopts a tic by which he can be identified. A borrowed sense of strength even allows him to attack his colleagues' definition of reality. But in the later part of the novelle two realities clash. Inside the room there is the security of a fixed world; outside, however, there is chaos: 'vor dem Fenster aber, schien es Diesterweg, stand das Weisse eines Auges, der heisse Strich eines Pfiffes scholl ums Haus – das ist der Dämon, schrie Diesterweg, der holt alles heim, das er einst geschieden, in Wasser und in Feste' (1241). The clash of spheres so upsets the delicate balance previously established that the others consider Diesterweg mentally ill. He is sent back to Berlin, where 'das Diesterwegsche' gradually disappears, and he becomes nameless.

Several of the novellen suggest that one might strengthen one's feeling of self through others. In 'Gehirne' Rönne notes: 'Wenn ich durch die Liegehallen gehe – in je zwei Augen falle ich, werde wahrgenommen und bedacht ... vielleicht nimmt ein Haus mich auf' (1187). In 'Die Eroberung' Rönne is concerned with the possibility of finding a community of souls through such activities as drinking, dancing, and singing. Since Rönne attempts to assert himself in bourgeois circles, 'Die Reise' and 'Die Erobe-

rung' have the quality of satire. 'Die Reise' bears an ironic title, since the intended journey never takes place. Rönne fears the reaction of the 'others' to his plan to travel. Moreover, he doubts his own ability to 'experience' the journey and to report on it later. He therefore abandons the plan and turns up at the dinner table, bent on asserting himself there. As he enters, his attitude is one of abject humility: 'Durch Verbeugung in der Tür anerkannte er die Individualitäten ... Still nahm er Platz. Gross wuchteten die Herren' (1201). The self-assured bourgeois express themselves freely and acquire thereby substance and identity. With the courage born of despair, Rönne joins in the discussion. On the edge of the abyss he awaits the verdict: does he in fact exist? His interpolation is well received, and he is established as both doctor – that is, man of science – and as 'Herr': 'Voll kostete Rönne seinen Triumph. Er erlebte tief, wie aus jedem der Mitesser ihm der Titel eines Herrn zustieg, der nach der Mahlzeit einen kleinen Schnaps nicht verschmähte und ihn mit einem bescheidenen Witzwort zu sich nimmt' (1203). Benn's satiric intent is clear, especially when words like 'Ermunterung,' ' Behaglichkeit,' and 'schlichtes Eintreten für die eigene Überzeugungen' are introduced. But for Rönne these qualities are ideals to emulate, for they represent 'form.'

The most important attempt to establish himself through others, namely through an erotic experience, seems at first impossible for Rönne. In many of Benn's novellen the loneliness of the main character is striking. In his very first story, 'Nocturno' (P9 – P339), this loneliness is already associated with the separation from the vitalistic sphere. The protagonist is caught, in the words of Friedrich Wodtke, in the sterility 'sinnlicher und geistiger Inversion' (S252/17). In the 'Denkmodell' to which Rönne subscribes there is no room for human relations, since the collapse of the self implies the collapse of the Thou. Rönne therefore works on a syntax that would do away with the Thou relationship, since it has become 'mythical' (1212). At other times, however, it is precisely the sexual relationship which seems to hold out promise of the greatest degree of integration. As the cycle of novellen develops, woman comes to play an ever more important role: she gradually functions as an indicator of Rönne's progression or regression.[6] In 'Die Reise' two prostitutes offer themselves to Rönne, but he dismisses them with cynicism because as a doctor he has become indifferent to their charms. More importantly, they are in Rönne's view mere tools for male assertion. Rönne claims to aspire to a different goal, not of self-assertion but of self-loss: 'Ich will Formen suchen und mich hinterlassen' (1204). In reality, of course, he is afraid of women

because they pose a threat to his scientific world-view; woman is suggestive of chaos.

'Die Insel' illustrates this very well. At first Rönne approaches woman like any other phenomenon: 'warum sollte er sie nicht kennen lernen: einen Haufen sekundärer Geschlechtsmerkmale, anthropoid gruppiert' (1216). Woman is simply an object of study. But at the same time woman appears to be the opposite of intellect and form, which explains why Rönne quickly attempts to 'tame' her, to integrate her into his system (Benn calls this 'beformeln'). Woman is a riddle, at once dangerous and fascinating. Predictably, Rönne tries to apply sociological terminology to her and to understand woman under some overriding scientific principle. But woman resists the 'Denkmodell': every woman is a Lulu figure. Faced with the imminent destruction of his rationally constructed universe, Rönne exclaims: 'Was aber wurde aus ihm, dem Arzt, gebannt in das Quantitative, dem beruflichen Bejaher der Erfahrung?' (1218) The decision he takes for the moment is to reject the entrance into the chaotic world represented by the female, in favour of science and 'form.' In 'Die Eroberung,' by contrast, Rönne finally finds contact with the vital sphere and experiences sexual release. From the very opening of this novelle the fascination of woman is felt. The atmosphere of the café into which Rönne has drifted in search of human contact is charged with eroticism: 'Eine Blonde wogte beim Atmen eine Rose hin und her. Die roch nun mit Blut der Brunst zusammen irgendeinem Manne zu' (1193). 'Blut' is for Benn 'eines der Schlüsselworte für den Bereich von Traum und Rausch' (S13/58), and signals that the realm of the intellect, of 'Gehirn' is being abandoned in favour of 'psychological primitivism' (S1/96). The novelle develops this motif elaborately: 'Da tanzte eine hinter Schleiern, die Brüste gebunden ... Zwei wehten mit ihren Händen an ihren Leibern vorbei und trieben Geruch und Lust den Männern zu ... und plötzlich stand vor ihm die Schwangere: breites, schweres Fleisch, triefend von Säften aus Brust und Leib' (1198). The pregnant woman is a personification of the life-force, and Benn emphasizes this by giving the woman 'ein[en] mager[en], verarmt[en] Schädel' and by associating her with the most primitive level of existence. She is 'Landschaft aus Blut ... Schwellungen aus tierischen Geweben' (1190). Thus eroticism sets the stage for a regression that removes Rönne further and further from his existence as 'brain.' It ends with his reaching a vegetative level of being, next morning: 'Er wühlte sich in das Moos: am Schaft, wasserernährt, meine Stirn, handbreit, und dann beginnt es' (1199).

What begins is the *Südkomplex*, first hinted at briefly in 'Die Insel,' in a moment of epiphany, in which a woman fleetingly appears in an idyllic landscape: 'in sein Auge fuhr ein Bild; klares Land, schwingend in Bläue und Glut und zerklüftet von den Rosen, in der Ferne eine Säule, umwuchert am Fuss, darin er und die Frau, tierisch verloren, still vergiessend Säfte und Hauch' (1219). At that point, however, it is rejected because Rönne knows full well that acceptance would destroy his closed view of the world: 'Aber wo führte das hin? '

Benn explains in his 'Schöpferische Konfession' what the *Südkomplex* and the *Südwort* mean to him: 'da ich nie Personen sehe, sondern immer nur das Ich, und nie Geschehnisse, sondern immer nur das Dasein, da ich keine Kunst kenne und keinen Glauben, keine Wissenschaft und keine Mythe, sondern immer nur die Bewusstheit, ewig sinnlos, ewig qualbestürmt –, so ist es im Grunde diese, gegen die ich mich wehre, mit der südlichen Zermalmung, und sie, die ich abzuleiten trachte in ligurische Komplexe bis zur Überhöhung oder bis zum Verlöschen im Aussersich des Rausches oder des Vergehens' (vol. 7/1645). The *Südkomplex*, therefore, is a complex of associations which allows the subject to regress into a primitive, pre-logical existence, free from intellectual doubts and inquiry. It makes its first appearance in prose in Benn's first novelle, 'Nocturno,' in a summary vision of the East: 'Ägypten lag ihm sehr am Herzen. Asien dämmerte auf. Häfen, Möwen, braune Kutter waren da; weisser Oleander die Ufer hoch' (1180). In 'Heinrich Mann. Ein Untergang' the function of this complex is already much clearer. Mann is cited not only as an author who has learned to live with the absurdity of life, but also because, in Benn's mind, he is associated with the Mediterranean world, and especially with Italy, which in this novelle represents an escape from northern sterility. But the Mediterranean world is only the first hint of what comes to represent the vitalistic world. Soon Benn seeks a more primitive landscape, in the South Seas ('Die Insel') and still later in pre-history ('Diesterweg' and 'Die Eroberung'). But only in 'Der Geburtstag' does he present the complete submission to the 'ligurischen Komplex.'

'Der Geburtstag' (P4 = P339) is a summary of all the preceding novellen. All the themes reappear, and the movement from consciousness, intellectual sterility, and nihilism to the vital, primitive, irrational sphere, with its stream of elaborate hallucinations, is completed. Once again Benn develops the theme of the discontinuous personality, the failure of science, logic, and belief, but now a radical alternative is presented. For the first time the primitive vision (again initiated by the temptation of a

woman) is not a brief epiphany but a sustained and ever deepening experience, finally achieving the 'recovering of an original undifferentiated totality' (S1/84). For the first time also Benn finds an appropriate language for his experience. Benn's language is a product of the destruction of a continuous personality and is therefore also discontinuous in its rendition of reality. But this does not mean that it is not dynamic. The situation of crisis and the nihilistic world-view inspire a language of despair that is characterized by extreme aggressiveness and emotionality. Neither thought nor artistic canon determine this language. But with the reliance on science to stem the dangers of chaos and the irrational rifts insinuating themselves into the fixed and structured world-view, the language itself also becomes technical, scientific, and abstract, and tinged with the same radicalism as that of earlier Expressionist language. Horst Fritz calls it a 'fast klinisch-wissenschaftliche Terminologie des Zerebralen' (S67/401). This clinical language works through a static image of reality, through an abundance of nouns, especially abstract nouns; there is also a strange mixture of non-poetic language, from medicine, from foreign languages – even clichés, especially in the theoretical passages on the brain in 'Die Insel.' While retaining its monologic character, Benn's language at intervals moves away from this arid, theory-generated language to the Dionysian and ecstatic language through which the South is conjured up. In such passages the language is evocative, filled with colour and movement; the sentence structure is elaborate, the tone emotive. These passages are crucial because they betray Benn's fascination with language as mythical dimension and as one more rift in the scientific world-view. 'True' language is like that which Rönne attempts to create in describing poppies in 'Die Insel': '"Mohn, pralle Form des Sommers," rief er, "Nabelhafter: Gruppierend Bauchiges, Dynamit des Dualismus: Hier steht der Farbenblinde, die Röte-Nacht. Ha, wie du hinklirrst! Ins Feld gestürzt, du Ausgezackter, Reiz-Felsen, ins Kraut geschwemmt, – und alle süssen Mittage, da mein Auge auf dir schlief letzte stille Schlafe, treue Stunden"' (1213–14).

Such attempts become increasingly important with the greater proximity to the irrational sphere of the *Südkomplex*, until it reaches its climax in 'Der Geburtstag.' At this point woman becomes a test-case. Rönne knows women, in the scientific sense of the word, but now he wants to love one. For this to come about the context must be transformed, and this involves a more complete absorption into the hallucinatory world: 'Er konnte in diesem Land nicht bleiben – Südlichkeiten' (1225). And now the vocabulary evokes a luxurious, exotic setting in Egypt. But the regression

must be taken much further, all the way to the domain of vegetation: 'Es zog ihn nieder, auf den Rasen zog es ihn, leichthingemäht' (1226), where a union takes place that wipes out consciousness. 'Im Garten wurde Vermischung ... Erloschen war Richtung und Gefälle.' Rönne 's rigid world-view disintegrates; 'es entsank fleischlich sein Ich ... Im Rasen lag ein Leib' (1227).

But there remains the challenge of the 'Morellenviertel,' a *chiffre* intended to pose a serious threat to the purified palace air in which the erotic experience with the transfigured courtisan Edmée has just been celebrated.[7] Can the newly found *Südkomplex* stand up against the crude reality of this plebeian quarter of the town? Rönne reaches a crisis here: 'Wo war sein Süden hin? Der Efeufelsen? Der Eukalyptos wo am Meer? ... Hilfe, schrie er, Überhöhung!' (1229) But for the second time the southern complex saves him. Key words such as 'Hafenkomplex' and 'Venedig' keep the experience alive.

Benn attached considerable importance to this passage, because in it he shows how in fact the complex *intrudes* upon the subject. In 'Schöpferische Konfession' he writes: 'Ich finde nämlich in mir selber keine Kunst, sondern nur in der gleichen biologisch gebundenen Gegenständlichkeit wie Schlaf oder Ekel die Auseinandersetzung mit dem einzigen Problem, vor dem ich stehe, es ist das Problem des *südlichen* Worts. Wie ich es einmal versucht habe darzustellen in der Novelle "Der Geburtstag" (Gehirne); da schrieb ich "da geschah ihm die Olive," nicht: da stand vor ihm die Olive, nicht: da fiel sein Blick auf eine Olive, sondern: da geschah sie ihm, wobei allerdings der Artikel noch besser unterbliebe' (1644). From what happens in 'Der Geburtstag' it becomes clear that experiences associated with the *Südkomplex* are both rare and impossible to predict. They do not occur as long as the will and the intellect are active. There is a kind of vacuum required, possible only when the grasping attitude towards reality characteristic of modern man is abandoned. Only then can we experience simultaneity of reality and dream: 'Manchmal eine Stunde, da bist du, der Rest ist Geschehen. Manchmal die beiden Fluten schlagen hoch zu einem Traum. Manchmal rauscht es: wenn du zerbrochen bist' (1231). Yet the vitalistic solution reached in 'Der Geburtstag' is an ambivalent one. In flux there is danger, a danger of formlessness and chaos. As an artist and as an intellectual Benn himself often shows that he experienced formlessness as threat. On several occasions Rönne sees the dissolution of form and the advent of irrationalism as crisis, and 'Diesterweg,' written later than the Rönne novellen, reintroduces this theme of chaos as danger. It is therefore with some justification that

Balser maintains that the *Südkomplex* does not solve the problem posed by the discovery: 'es geht nirgends etwas vor.'[8]

Benn's dilemma can be illustrated by an assessment of the role of language in these novellen. Despite the elimination of the self in dream, primitivism, and undifferentiated totality of being, the description of this process of loss of self is rendered in highly cerebral language. Here the contradiction between Benn's 'message,' his 'tierische Transzendenz,' and the highly intellectual form in which this primitivism is couched becomes visible. Language remains the product of the brain; even undifferentiated totality can only be made tangible by means of language, and the development from an aridly scientific and rationalist vocabulary, such as that of 'Die Insel,' to the ecstatic and visionary vocabulary of 'Der Geburtstag' takes place within language itself. Thus *Gehirne*'s antinomy of primitivism and science leads to two major vocabularies and syntaxes. It is in fact the clash between these two vocabularies which constitutes the tension in these novellen. They otherwise have little narrative quality, although, as I have tried to show, a certain progression can be discerned.

Most Expressionists are aware of the danger of relying exclusively on the self as norm. As we have seen, Franz Werfel's 'Nicht der Mörder, der Ermordete ist schuldig' warns against too subjective a basis for action and morality and sees in Expressionism itself a manifestation of this excessive subjectivism. Rudolf Kayser urges writers to escape 'aus der Analyse innerer und äusserer Erfahrungen in eine hellere Idealität' (P227/302); and in 'Kinderland' he calls it the goal of Expressionism 'den Geist aus Ruhe und Abseitigkeit zu lösen, ihn tätig zu machen in diesseitiger Welt' (P225/283). The dichotomy between man and world cannot be solved simply by abstracting one side of the conflict – all the more so since the self has itself become a questionable entity. For this reason Oskar Pander finds it necessary to sound a cautious note which counterbalances some of the panegyric utterances of other Expressionists when they praise the new art for its subjection of reality to the reality of the mind; the true achievement of Expressionism is not its subjectivism, according to Pander, but its humanism: 'Expressionismus ist nicht wilder Ausbruch des Ich. Expressionismus drückt der Welt das Gesicht des Menschen auf' (P256/147). The reason for this toning-down of subjectivism we have analysed earlier; it is the realization that the freedom to 'create' reality comes from the loss of an objective norm with which to grasp this same reality. It is this which accounts for the sense of bewilderment of Expressionists and for

their often frantic efforts to re-establish some kind of order. Of prime importance is necessarily the establishment of a stable subject itself, of a tangible and continuous identity. Whereas in Cartesian philosophy the self is confidently called upon to guarantee certitude and hence can play the role of interpreter, arbiter, and giver of meaning, the self as seen by Expressionists often collapses, especially when forced into contact with the world. Disturbances often occur at the point of friction, and various forms of disintegration are the result, many of these being documented in the biographies of Expressionist authors and in their fictional writings. A certain number of psychological mechanisms by means of which the endangered self attempts to protect itself also become visible; they range from the refusal to admit that there is a problem all the way to madness and suicide. What happens in such cases is subject to the author's own interpretation – that is, the mechanism may be evaluated positively or negatively, subject to the author's personal convictions, as can be seen in a few striking examples which I would like to discuss here.

Perhaps the classic Expressionist statement about the relationship between the self and the non-self is made in Alfred Wolfenstein's 'Fragment eines Daseins' (P145 = P327). In this story a crisis occurs when the hero realizes how insignificant he is when compared with the cosmic forces symbolized by the sun. If control over nature is impossible, the hero asks, is control over the self possible? This problem of will versus circumstance leads the hero to seek temporary tranquillity in the abandonment of all responsibility (the realm of the will) and the pursuit of pleasure. But the uneasiness persists, and one night he wakes up, 'ohne zu wissen, ob er es war . . . der aufwachte' (359). A complete loss of identity appears to have taken place, even though the protagonist's image in the mirror seems to assure his actual existence. Unfortunately, the mirror only allows the affirmation of the self *by* the self, and thus the hero goes in search of other 'mirrors,' that is, people. But this involves him in yet another trap, for when he hears his name called and when others react to his words, he cannot escape the question of whether what he is observing is in fact not initiated exclusively by himself. From this dilemma there is no escape. If the outside world is only a reflection of the self, the existence of the world as such cannot be demonstrated adequately. And even if the world exists, its nature is intangible, and the boundaries between the self and the world become vague.

In 'Der Sprung aus dem Fenster' (P107 = P327) Karl Otten describes a similar confrontation between reality and the self. The hero of this story lives in constant fear of being a mediocre writer. His ambition is to

become a great poet, because for him being a genius is synonymous with existence itself. A painful dichotomy exists between the hero's banal life and his overwhelming ambitions – a dichotomy which gradually leads to near madness and suicide. One day, in his flat high above the crowds, the hero feels an impulse to throw himself down. In anticipation of his fall he realizes, however, 'ein Nichts war abgestürzt' (117). To this discovery he reacts with 'unfassbare[m] Leid' because he must now face the truth about his own insignificance. But he quickly overcomes this feeling by telling himself that only the body can die; the spirit can soar because it is immortal. The idea of immortality now guarantees the hero the possibility of overcoming the limitations set by reality. The opposition between spirit and body is used by the protagonist to underpin his illusions of personal greatness. This particular test ends happily because illusions are allowed to continue without obstacle.

In Oskar Loerke's prose such resorting to illusion is always considered objectionable. People pursuing illusions and unrealistic goals are 'Chimärenreiter.' Two stories from the collection of that name may illustrate the problematic nature of the attempt to live by rules arrived at from personal criteria only.

On the surface, 'Zimbehl in den Wolken' (P97 = P390) is the story of suspected adultery and a subsequent breakdown of trust in a marriage. But the fairly trivial problem is given an interesting treatment by the addition of an almost Kleistian dimension. As he works on a bridge high above a river, between heaven and earth, the protagonist Franz Zimbehl is tortured by his suspicions about his wife Marianne's illicit feelings for his brother Joseph, who is living with the couple.[9] Zimbehl is already somewhat vulnerable to speculations because of his pietist background. His state of being suspended above the world is clearly intended by Loerke to mean an even more dangerous proximity to metaphysics and illusion. When his wife brings him food, Zimbehl refuses to come to her, so she must walk the narrow planks to reach him. In this dangerous situation Zimbehl suddenly asks Marianne about her relations with Joseph. Loerke changes the perspective to Zimbehl's wife: 'Marianne erschrak, weil sie geglaubt hatte, Franz leide daran, dass sie und Joseph sich lieb hatten, aber nicht an dem Verdacht ihrer Untreue' (42). To make clear the woman's innocence Loerke not only changes perspective; he goes so far as to establish an 'objective' proof of innocence by inventing a miracle. As Marianne steps back in astonishment over Zimbehl's suspicions, she falls in the river, but her skirts keep her afloat momentarily. Zimbehl remains blind to this sign, however, and makes the saving of his wife's life depen-

dent on her confession of guilt. The latter miserably cries out 'yes' – 'denn als Marianne Franz da oben wie einen Irren stehen sah, wusste sie, dass er den Strick ihr nicht zuwerfen würde, wenn sie nein sagte' (42). Zimbehl saves her, but in despair over the validity of the 'truth' he has obtained in this fashion, he plunges to his own death.

In the novelle 'Die Puppe' (P95 = P390) the problem of illusion and reality is taken one step further, in that the truth is made dependent on a trivial fantasy. The story's hero, Friedrich Schedel, suffers from his individuation. Only in moments of quasi-ecstasy, in which his being is fused with the cosmos, does he find relief from a sense of separation, from the feeling 'Die Erde gehört niemand' (10). At other times he is forced to question not only his own place in the universe but also the innate goodness of creation itself, as it originates in God. Ultimately Schedel looks for God's goodness and the goodness of men, which the rare moments of epiphany insinuate, in a childish fantasy. If there is indeed a yellow doll inside the suitcase that he has found lying in an abandoned field, Schedel will have received proof of God's goodness. But the moment Schedel realizes that this fantasy has become the focal point of his very existence ('Sein Lebensgrund war aufgeregt' [16]), terrible doubts begin to assail him. He wanders aimlessly through the city, avoiding the possible revelation of a life-long illusion. Gradually he enters the realm of phantasmagoria as in his dreams he hears music accompanying a vison of a yellow doll dressed as goddess and 'goldene Dame' (18). When two schoolboys finally climb over the fence to fetch the suitcase, Schedel panics and runs away. Recognizing that his panic indicates a loss of faith, he attempts to commit suicide by throwing himself in front of a streetcar, but jumps out of the way at the last minute. 'Vorübergehende richteten ihn auf und führten ihn eine kleine Strecke,' the story concludes, perhaps ironically indicating that goodness does exist (20). The tragicomical novelle has unmistakable overtones of satire, directed, as Fritz Martini has suggested, at Expressionism itself (P335/42). Like Schedel, Expressionists like to manipulate large notions such as 'Menschheit,' 'Friede,' and 'Bruder,' but they fear to test these notions against reality. Expressionists themselves, Loerke seems to argue, are often 'Chimärenreiter.'

In the stories just discussed the endangered self chooses to eliminate one pole of the opposition between self and world. The result of the most severe case of confrontation between the self and the world may lead to a solution of a somewhat different kind. In madness the self establishes a reality completely outside the empirical world, but it does so only at the

cost of the destruction of the self. Expressionist authors are quite ambivalent about their assessment of madness. Wolfgang Rothe has suggested that madness and religion are intimately linked in the view of Expressionists (S199), but even secular assessments of madness can turn out to be quite positive. Some of the more striking examples might suffice to show the range of possibilities.

In Oskar Loerke's novelle 'Kaiser' (P94 = P390) the protagonist achieves an escape out of the given reality through the loss of his own identity and the adoption of a new one. The story is set in Paris, a city that epitomizes man's indifference to man. Julian first experiences this indifference socially, in the contrast between the splendours of Notre Dame Cathedral and the beggars installed on its steps. In more personal terms he receives an instructive instance of the questionable charity of Christianity when he is ejected from a brothel. This experience is so traumatic for him that his mind becomes unsettled. In an effort to escape a reality which has now become extremely painful, Julian adopts a different identity, that of the Roman emperor Julian the Apostate. This identity is suggested not only by the surroundings in which the 'conversion' takes place (the ruins of the Roman baths) or Julian's original character of petty demagogue but also because he revolts against Christianity. But the leap into the 'Gegenwelt' (S137/26) is not achieved easily. Julian's former identity intrudes continually upon his new-found one, and the conflict between the two is felt as physical illness. During an erratic journey through Paris, climaxing in a kind of *katabasis* in the Métro,[10] surreal visions haunt the hero, and when he emerges from the underground, he is constrained to steady himself against a feeling of nausea. He finds support in an animal statue, and here Loerke openly refers to the title of his collection of novellen: 'Es war eine der steinernen Chimären, die im Clunysquare stehen, anzusehen wie ein riesiger Vogel und zugleich wie ein geflügelter magerer Löwen und auch wie ein hungernder geflügelter Hund' (P390/9). This statue, symbolic in its lack of true identity, is mounted by Julian as he imagines himself leading his armies into battle. Loerke breaks off the account of the visions now welling up in Julian's brains by laconically stating that someone pulled him down and that a car came to take him away. The objective reference, as in 'Die Puppe,' relativizes the hero's presumptions to the point where we feel comfortable in labelling him mad.

By relativizing and ironizing the 'Chimärenreiter' Loerke not only achieves a 'sane' perspective; he also uses madness as an instrument of criticism. In Expressionism Loerke is by no means unique in using the theme of madness to illustrate larger thought-complexes. As we have

seen, Carl Sternheim uses madness to indicate the unbridgeable gap between the pursuit of the 'eigene Nuance' and the demands of the bourgeoisie. In Sternheim's interpretation we get a hint of subjectivism's function as a defence mechanism. In fact subjectivism is often a kind of 'last stand' in the thinking of this movement. Helmut Liede writes: 'Expressionismus bezeichnet eine Endphase der bürgerlichen Literatur, in der das Individuum, das während des 18. und 19. Jahrhunderts in Deutschland seine Autonomie versäumt hat, nun – angesichts der Übermacht kollektiver Gewalten – den letzten, verzweifelten Versuch unternimmt, sich auf die seinem eignen Begriffe nach verbürgte Selbständigkeit zu besinnen' (S132/iii). Faced with the dangers of anonymity and an oppressive collectivity created by technology, large-scale industrialization, and the rise of large cities, with their danger of *Vermassung*, the artist tries to defend his uniqueness by retiring into himself. Frequently he launches a violent protest against societal forces; but quite often also the protest is not formulated in terms of society at all but in terms of nature, seen as disharmonious, even demonic.

In the context of our discussion Heym's story 'Der Irre' (P67 = P372) is of particular interest. A comparison of this novelle with that other famous story of madness, Döblin's 'Die Ermordung einer Butterblume' (P22 = P348), to which I had occasion to refer earlier in a different context, can help explain the Expressionists' fascination with madness from different points of view. The differences of technique and intention revealed in a comparison of these two stories show that even though they are inspired by a similar aesthetic challenge, Döblin and Heym are very far apart in their interpretation of the meaning of madness.

Döblin's story was written, like most of the stories in the collection of the same name, during his years as a medical student. Most stories present characters in opposition to their environment. Deformation of the psyche, even its destruction is quite common. Often the characters show a tendency to create a certain distance between themselves and their emotions and thoughts, to treat them as independent entities. Violence and seemingly unreflective action, for which Döblin himself refuses to give motivations, are typical of the protagonists. Behaviour is intended to be expressive of inner feelings, but the interpretation of such behaviour is often extremely hazardous. All these characteristics apply to 'Die Ermordung einer Butterblume' itself. The accidental catching of Fischer's walking stick in some buttercups sets in motion a process of deterioration which finally results in Fischer's complete madness. The process is carefully analysed, from the initial lashing out at the flowers with characteris-

tic abruptness to the imposition of a reality which is completely unrelated to the empirical world. Subtle changes are indicated. Visions, at first recognized as such, gradually become for Fischer reality itself. Attempts to erect barriers against chaos, by drawing upon his stable bourgeois background, fail utterly.

Throughout this process Döblin avoids comment on what takes place. Instead, images, hallucinations, obsessive gestures, and disruptive chronology are used, with the remarkable result that the very 'objectivity' of the presentation creates in the reader an awareness that he is dealing with a pathological case. Even occasional ironies aid in conveying the fact that Fischer is going mad. The *erlebte Rede* of the second half of the novelle does not mean a departure from this objectivity, for the reader is now aware that he is inside the madman's consciousness. Again, though in the end Fischer seems to achieve some kind of freedom from the sense of guilt he has come to accept for the 'murder' of the buttercup, anthropomorphized into the girl Ellen, this freedom exists only in his own distorted mind. To be sure, he feels exonerated when the flower, which he had taken home and nursed there, meets an accidental 'death,' but Fischer's comment, 'Er konnte morden, so viel er wollte,' indicates that he continues to think in terms of his neurosis. This is also borne out by the final image of the story, Fischer's running into the forest to pursue his destructive treatment of nature. Fischer's illusions no longer find obstacles in reality itself.

Pathology was of interest to Döblin first of all as a clinical phenomenon. Madness is a mystery to traditional psychology, of which Döblin was an enemy. It cannot be grasped by the usual methods of classification and categorization. Madness therefore deserves a privileged position in Döblin's world-view. But there are additional reasons for Döblin's interest. Madness also challenges an author's abilities because, just as traditional psychology cannot cope with madness, so traditional narrative techniques cannot deal effectively with the process of going mad. Döblin the scientist and Döblin the author feel equally challenged by the problem of madness, and Döblin's objective method of narration is his answer to the aesthetic aspects of madness, just as his deliberate refusal to 'explain' is the answer to the medical problem. Though satiric intent is clear, as I have argued earlier, this satire is subordinate to the theme of madness and its aesthetic repercussions.

Heym's 'Der Irre' does not have the clinical interest of Döblin's story. For one thing, Döblin's detachment, which allows accurate observations, is lacking. In Heym's story we are consistently inside the hero. Here as in

the second half of Döblin's story, *erlebte Rede* is the appropriate vehicle for narration, but in Heym's case we are never given an alternate view. Unlike Döblin also, Heym does not describe a *process* of disintegration; he is depicting the *condition* of madness. Parallels exist, however: there is a tendency towards violence, which leads the madman to kill two children and an adult as well as to destroy parts of nature. Violence is always just lying beneath the surface, and many changes in mood occur without apparent motivation. As in 'Die Ermordung' visions are accepted as reality; thus the noise of the grass under his feet makes the madman think of himself as walking on the skulls of a crowd of people. There is also a persistent tendency of the madman to identify himself with animals. This complex is first introduced in a simile: the madman swings his arms 'wie ein grosser Vogel.' But soon the comparison changes to identification, an indication of the loss of control over the self. The loss of will is also indicated by the madman's willingness to abandon himself to outside circumstances, which explains why his journey home acquires the character of a series of chance encounters. This feeling of haphazardness is strengthened further by Heym's narrative technique. Though the story procedes chronologically, the different events are not linked logically. The story's structure reveals not intentionality and sequence but movement by leaps and bounds. Between individual events there exist gaps which are frequently bridged by monotonous devices such as the use of the adverb 'plötzlich' or the repetition of syntactical features such as the sequence subject-verb-rest. Time itself is seen as a series of unrelated moments, one following the other without flowing *from* it. It has been said of Heym that he does not have a true narrative talent. His prose has often been called lyrical, which even when used as a term of praise implies a certain inappropriateness. But the flaw may well be a virtue in this particular instance, because the technique adopted by Heym is singularly effective. Like Döblin, Heym has devised a suitable technique to meet the aesthetic challenge posed by the theme of madness.

An article by Wieland Herzfelde in *Die Aktion* of 1914 (P213 = P333) gives us a good summary of the aesthetic interest of Expressionism in madness. Herzfelde's focus is not on people who are physically ill and suffer mentally as a result but on people who show a complete psychic disorientation. Hölderlin and Nietzsche are quoted as examples of the latter category. Such people are 'seelisch, ethisch entrückt' (P333/42), but they have characteristics which appear to the Expressionist as great gifts. 'Der Geisteskranke ist künstlerisch begabt' (40); he is fortunate in possessing a different perspective, but also in having the ability to express

this perspective in language. The madman's language is 'seelischer Ausdruck': he has a feeling for the essence of things (40). The distortions to which his language is given are not indicative of inability but are 'künstlerische Initiative: Erfindungskraft, Freude am Willkürlichen' (41). The madman's language is the expression of a freedom from oppressive laws and conventions, precisely those qualities the Expressionist author seeks to incorporate into his work.

We can see the link here with both Döblin and Heym, and their fascination with the possibilities and limitations posed by the choice of a madman as the centre of consciousness for a novelle. Certainly Heym's description of the barbaric murder of two innocent children, accompanied by the madman's singing of a Lutheran chorale. pushes to the limit that which is aesthetically possible. The novelle takes on the character of an act of revolt, like Gottfried Benn's 'Morgue' poems. But it is clear also that in the case of Heym aesthetic innovation is not pursued only as a form of protest against literary or even societal conventions. The quest for aesthetic freedom is subordinate to the quest for a more fundamental freedom, namely that from objective reality in general. It is here that we come to the real reason for Heym's use of the madman and his interest in madness. Again Herzfelde's article helps to give us the necessary perspective. The truly enviable quality of the madman, according to Herzfelde, is his capacity for happiness: 'Der Geisteskranke ist sicher fähig, glücklicher zu sein, als wir es vermögen: denn er ist natürlicher und menschlicher als wir. Ihn treibt Gefühl zum Handeln, nicht Logik. Sein Tun ist machtvoll, unmittelbar,' and later on: 'Der Geisteskranke ist immer Held, immer Persönlichkeit, nicht nur im Traum. Er ist König, wenn er will' (41). The laws of nature no longer apply to the madman; he is capable of attaining a permanent, idyllic existence. For Heym madness is a form of *Erlösung*. Only in this way can we understand the conclusion of 'Der Irre.' The undeniable beauty of the madman's visions accompanying the murder of a woman is rendered in a language which truly transcends the subject matter. The agony of yet another murder and the ecstasy of the visions accompanying it achieve a paradoxical unity. In the final image of the madman soaring like a bird, high above reality, we may see the symbol of utter freedom. And even when he is shot down and killed, the madman is not conquered, ironized, or relativized. In Heym's story he achieves tranquillity and an end to individuation: 'Eine ewige Musik stieg von unten herauf und sein sterbendes Herz tat sich auf, zitternd in einer unermesslichen Seligkeit' (P372/34). The madman enters utopia, though even he can only achieve it in death. We are very far removed indeed from

the ironizing attitude of Loerke, or even the clinical distance of Döblin. Though Heym's aesthetic interest in the theme unites him with these authors, the sense of pathos which inspires the novelle puts him squarely in the tradition of subjectivism as a last possible escape from an intolerable reality.

Our survey has shown that subjectivism binds two seemingly opposite tendencies of Expressionism together. In the optimistic view of men like Rudolf Kayser, subjectivism is the result of man's realization that he is free of the laws of necessity and that he himself in fact creates laws. The more pessimistic view, on the other hand, sees subjectivism as a defence mechanism against a world which has essentially become uninterpretable because there are no longer objective laws to guide man. The aesthetic freedom gained by the subject leads to a wealth of new forms, styles, and expressions; but the bewilderment of the self vis-à-vis an incomprehensible reality often leads to the depiction of conflict, opposition, and mental disturbance, usually followed by the creation of an autistic world in which the empirical world no longer has any relevance. Paradoxically, the most severe consequence of this turning in upon oneself, madness, can suddenly gain the quality of salvation, as in Heym, because it is the springboard to escape. The personal utopia becomes a possibility.

NINE

Eros in Extremis

I N HIS *Prosa des Expressionismus*, Armin Arnold, referring to a statement by Hermann Hesse, writes: 'Über die 'Vatermord' Literatur ist viel gesagt worden, über die Erotik in der expressionistischen Literatur wenig' (S10/136). This is indeed all the more remarkable since Expressionist prose is in fact so preoccupied with sexual relationships of all kinds that we may almost speak of an obsession. Both when seen in relation to the frequently expressed desire for release from the pain of individuation *and* as a social and moral phenomenon, the Expressionist fascination with sexuality is indicative of the ideological situation of contemporary society; as Roy Pascal writes: 'No literary work can treat sex in isolation' (S164/254).

Most of the young authors of 1910 to 1925 had been raised in families in which the rules of the nineteenth century were still largely in force: 'Diese Regeln umzustossen war eines der Ziele der Expressionisten' (S10/136). Revolt against the hypocritical morality of the bourgeoisie is of course one of the prime impulses. The proclamation of sexual freedom, to which writers like Curt Corrinth, Alfred Döblin, and Hans von Flesch-Brunningen subscribe, contains in the first place a revolutionary impulse, an 'anarchistic' element which fits the ecstatic, emotionally charged early phase of Expressionism. A more philosophical view of the role of sexuality later sees its connection with the demand for happiness as a specific moment in the theory of hedonism, which because of the nature of bourgeois society would, as Herbert Marcuse has shown, quite naturally come into conflict with the greater demands placed on the individual by his environment (S142). We might in this context remember the role which sexual ecstasy plays in the novellen of Carl Sternheim, where it is always considered a thoroughly valid *personal* mode of being but a vice if prac-

tised by the collective. We also had occasion to point back to Heine and his attempt to 'abolish' sin, at least the sins of the flesh. It should not be forgotten that in bourgeois society sex and morality are intimately interwoven – hence the predominance of appearance over reality also in sexual matters.

In bourgeois society sex fits into the prevailing patterns of domination and submission. Sex is a struggle for power; it is a yardstick of status. In sexual role-playing is repeated the same hierarchy which prevails in other domains. Marriage, sanctioned by the state and sanctified by the church, appears to the Expressionists a bastion of hypocrisy and an institution devoid of meaning; attacks on marriage denote attacks on the bourgeoisie at large. Similarly, virginity, regardless of the doubtful auspices it may appear under in the 'metaphorical' language of the bourgeoisie, is to the Expressionist author an object of barter, a fetish primarily associated with property rights and intimately linked with the prerogatives, henceforth vehemently rejected, of the bourgeois male. By contrast, the prostitute, who has escaped from the clutches of society and who has discarded its hypocritical standards, albeit at the price of now living on the margin of society as an outcast, is seen as a 'natural' creature, as a sinner who finds grace with God. Under these circumstances it is not surprising that we see Expressionists using their writings about sex as a most efficient device to dislodge *all* conventional notions about society and its morality.

Sexuality is an elemental force, both psychologically and biologically. Expressionists discuss sex openly, as did Naturalists. 'Der Sexualtrieb ist für die expressionistischen Autoren ein brutum factum der Irdischkeit' (S201/322), writes Wolfgang Rothe, and as such it is not to be legislated by state, church, or collective. It is an instinct like any other, and to be satisfied without reference to conventional morality. But the mere realism of Naturalism no longer suffices for the Expressionist when he discusses sex and Eros. He adds to its descriptive arsenal a number of elements which often bring Expressionist treatment into the vicinity of the grotesque. Partly this may be explained by a heightening of tension and frustration, by the overwhelming pressures exerted by society on the individual, which do not allow the realization of an 'eigene Nuance' even in the most intimate sphere. This forces the Expressionist to fight back with the typical means at his disposal: with polemics, satire, exaggeration, rhetoric, even blasphemy.

What amounts to an often exaggerated preoccupation with Eros must also be seen of course in connection with a new sensuality which springs up under the influence of Vitalism. Evidence of this new emphasis on the

senses can be gathered from articles in *Die Aktion* and from Hermann Schüller's essay 'Naivität und Gemeinschaft' in *Die Erhebung*. There is a certain reaction to excessive cerebralism; much of Sternheim's output is concerned, as J.M. Ritchie has pointed out, with the 'anti-brain' (S196/16), and the same might be said of Gottfried Benn. The latter's stress on the sensual, the emotive, and intuitive is related specifically to Vitalist philosophy, as Otto Flake claims (P333, vol. 2/185-6). Bourgeois sex, it is felt, is unnatural, since it destroys spontaneity; sex is channelled, legitimized, and subject to extra-erotic considerations.

Of prime importance for a freer, more explicit treatment of sex (though not necessarily an unproblematic one) is of course also the pioneering work of Sigmund Freud. Though it is not usually possible to establish direct influences of Freud on Expressionist authors (an exception is Ernst Weiss), we can be sure that Freud's writings were instrumental in promoting a more open and frank discussion of sexual matters and their social and moral ramifications.

Finally, we might already discern in Naturalism and in the art of the Jugendstil the longing for a more natural and spontaneous unfolding of sexuality. With the removal of the stigma attached to sexuality *without* metaphorical and idealized transfiguration, sexuality enters into literature as a serious and valid topic. Even homo-erotic or incestuous relationships are now presented frequently, first mainly to 'épater le bourgeois' but in later phases also as an attempt to make possible the exploration and redefinition of this domain, so crucial for the overwhelming question of autonomy and integration.

Characteristically, however, the demands for greater freedom in the depiction (and ultimately in the experiencing) of sex cannot obscure the fact that sex emerges from Expressionist prose writings as a disturbing, thoroughly frustrating, and confused/confusing topic. Setting the sexual instinct free does not mean that Expressionists unanimously glorify sex. Sex rarely appears as a good in itself; rather, sexuality constitutes a limit in Expresssionism. It is of the same nature as other physical and natural limitations imposed on man's aspirations in a spiritual sense. Particularly in early Expressionism sex is not a means of transcendence but an obstacle to it. Sex is fate, and as such more often than not a source of suffering and a source of pathos. Though it is true that on rare occasions it may lead to ecstasy, release, and even redemption, such 'altered states' tend to be brief, transitory, and often illusory. Even where such states are promulgated with a certain strident insistence, as in Sternheim and Edschmid, Eros does not manifest itself as a fusion of two egos, but more likely as an

extreme form of self-indulgence and self-enjoyment: the partner is often seen as a mere instrument for the attainment of this end.

The oscillation between attraction and repulsion, between the desire for extinction of the self and the fear of loss of the self pervades all of erotic Expressionist prose. And though the 'parfümierte "Laster" bürger-lich-literarischer Ersatzbefriedigung' may no longer be of interest (S201/222), what is substituted is at least as complex, chaotic, and demonic as the last fitful manifestations of Romanticism in Baudelaire or Lautréa-mont. The eccentricities and excesses which one encounters in the prose of this movement point to a tremendous insecurity and indecision in sexual matters. Many of these writings suggest a deep-seated sexual maladjustment. The extreme youth of most of the authors concerned may well explain much of this frustration. Social strictures obviously play a role, as do physical and intellectual isolation and *Weltfremdheit*. These liabilities are compensated for by an overheated imagination and a destructive and anarchistic tendency. From the confessions of impotence to the cosmic orgasm, there is revealed a sense of crisis for which answers are urgently sought.

Of the problem of isolation and lack of contact we have previously seen a striking example in the writings of Albert Ehrenstein. The motif of emotional impotence was of course not invented by Expressionism; we encounter it at least as far back as Stifter's 'Kalkstein' and Grillparzer's *Der arme Spielmann*. But the inability to love is often associated in Expressionism with a more general maladjustment to life which is not caused by merely psychological factors, as in Stifter or Grillparzer, but by philosophical and metaphysical doubts.

This may be demonstrated in the short sketch 'Der wohlhabende junge Mann' (P83 = P382) by Klabund. The story is also of interest because it contains an indictment of Impressionism as a possible way of life. The *ennui* encountered in this story is related to that of Ehrenstein's *Tubutsch*, brought on by the feeling that the world revolves under the curse of an eternal return of the same. The narrator of this sketch sees himself suspended in nothingness; he lives 'zwischen den Zeiten,' devoid of future, excused from acting. His whole life is reduced to a passive reception of impressions: 'Und ist uns denn ein anderes Glück gegeben, als Worte und Bilder zu sammeln?' (P382/39) Klabund's protagonist is an impressionist, a cripple who finds the appropriate symbol for himself in a twisted pine tree, for which he feels a kind of elective affinity: 'Ich habe ihre rauhe braune Rinde gestreichelt, sie umarmt und mir von ihr die Stirn wund reissen lassen. Als wäre ich ihr Blutsfreund' (39).

Perhaps fighting for a cause would have solved this hero's dilemma, 'Aber ich habe Plattfussanlage, Krampfadern, Herzerweiterung (mein Herz ist so weit, dass die Welt wie eine runzelige Nuss darin verschwindet) Lungendefekte und einen doppelseitigen Bruch' (41). Such bitter, ironic comments and grotesque exaggerations are familiar to us from Ehrenstein. A person like this, we remember from 'Passion' and 'Der Selbstmord eines Katers,' cannot love – certainly not an ordinary, vital girl who smells 'nach wollener Unterwäsche und ungelüfteter Stube' (41). Such a creature is too close to reality for the *Ästhetentum* à la Hofmannsthal of the narrator. Though the girl loves him, he cannot reciprocate: 'Ich liebe sie nicht. Ich will nur, dass meine Freunde mich um das schöne Mädchen beneiden' (41).

Klabund introduces the connection between the inability to love and a general inability to commit oneself to a particular cause. In Gustav Sack's novelle 'Aus dem Tagebuch eines Refraktärs' (P108 = P406) this connection is also crucial, though here the inability to fight in a nationalistic war is revealed as cowardice. Though the writer of this fictitious diary at first couches his refusal in sophistries, it becomes clear, after he has deserted and left his homeland, that his idealism cannot be maintained: his individualism is a lie. The proof for this is the fact that he must seek the companionship of a woman; erotic needs show him to be dependent: 'Meiner harten Einsamkeit ward ich müde, und meine Reinheit und mein Stolz flatterten über die Berge davon, und kopfüber purzele ich in einen Abgrund von Sammet und Blut' (P406/343). The erotic dependency, seen as 'Strudel' and 'Brunst,' is an escape from the 'Furcht vor der Einsamkeit.' Ironically, the woman cannot love a man whose actions are inspired by cowardice.

The impressionistic atmosphere of Klabund's sketch 'Der wohlhabende junge Mann' also pervades Max Brod's novelle 'Die Stadt der Mittellosen' (P17 = P342), which again deals with the problem of passivity and commitment. In tone it resembles the writings of Arthur Schnitzler. The story relates how two young people live out their *Liebelei* during the summer months, when Prague is deserted by the well-to-do bourgeoisie, so that the 'little people' may enjoy some of the pleasures otherwise unavailable to them. The young man is keenly aware of his role as a mere 'deputy' of the more exciting, elegant, and sophisticated youths of Prague, but Ruschenka, a type of Schnitzlerian *süsses Mädel*, takes the love affair seriously. So strong is her love that she feels the courage to fight for it. Since both lovers are dependent on others, they must defend their right to happiness against the pressures of those who employ them. Unfortu-

nately, the young man is a thorough conformist, unable to respond to Ruschenka's call. The girl's suicide shows how the fear of change can destroy even close relationships.

In Edschmid's 'Fifis herbstliche Passion' (P30 = 356), such change poses an overwhelming challenge. The novelle's male protagonist, Franz, is fascinated by Fifi, a not very successful dancer in a variety show. Feeling both pity and admiration for the fragile dancer, he believes 'dass er Inhalte in sich trüge, die in ihrem Wesen auf dieses Kind abgestimmt seien, und die Schwere dieses Bewusstseins nahm ihm den Mut zur Leichtigkeit' (P356/112). He does not approach Fifi, as men are wont, in the fashion of Fifi's artist colleagues, one of whom, a Mexican, maintains an undefined relationship with her. The novelle enters a crisis stage when Franz rallies to Fifi's defence against the attack of a circus artist. As usual, Edschmid builds up the scene until a significant gesture marks the climax. Fifi stands between Franz and the Mexican; she takes one step towards Franz, then hesitates: 'Sie war ganz verändert. Ihr Gesicht war wie ein weisser Fels, über den in zuckhaft raschen Stössen rote Wallungen strömten. Blitzhaft wechselten Hell und Rot und drohten, den Hals zu sprengen. Und während sie wieder auf Franz zuging, als trüge sie alles gegen ihn, zitterte ein Klang, rauh, gegenströmend, in ihrer Kehle auf, und wie alle Glieder zu ihm drängten, hielt sie ein Schluchzen zurück; sie warf den Kopf zur Seite, gewaltige Erschütterungen lösten sich aus, und gleich einer Verurteilten liess sie sich gegen den Mexikaner fallen' (116).

Later, in a prayer, Fifi explains her decision. In a flashback she reviews her life with the artists, her revulsion against the obscenities which surround her. At first the decision in favour of the Mexican appears incomprehensible to her; she cannot understand why she abandoned Franz, 'gleich einer begnadeten Heimat, die man verlässt für immer' (112). Finally she realizes 'dass es Aufbäumen gewesen sei aus der allzugrossen Tiefe dieses vergangenen Lebens vor der plötzlich viel zu strahlend aufgereckten Perspektive jener höchsten Erfüllungen.' In a final dance, 'gross, vorwurfsvoll, in Tragik und Schmerz vertieft und einem brennenden Feuer zugebracht' (124), she attempts to explain her action to Franz, 'dass es zuviel gewesen sei für sie damals, dass sie ängstlich, trotzig vor dem Schicksal gewesen sei' (123). But Franz does not understand the ritual of the dance, and no metamorphosis takes place. Fifi dies dancing 'wie ein seltsames gutes Licht' (127); the ecstatic movement of the dance, symbolic of the sex ritual, cannot bridge the distance separating the two people.

For Edschmid the theme of love is of course related to that of the heroic existence. Fifi's renunciation is but one of the many instances in which

love appears coupled with this heroic quality. Perten, in 'Der Lazo,' rejects Helen's love because it means a limitation to his unquenchable thirst for the active life; Las Casas, in 'Yousouf,' gives up his love for Juana because of a greater passion, that for revenge; Scottens ('Yup Scottens') sacrifices his beloved for the proof of his courage, and Jehan de Bodel ('Der aussätzige Wald') abandons his beloved Beautrix to meet his destiny in the forest of the plague victims. In each case the purity of the self takes precedence over the impulse towards others. The male principle overrides the female; even where the female is the main character, the heroic principle is not abandoned, for Fifi's renunciation and Maintoni's act of revenge are demonstrations of it. The erotic nowhere finds true fulfilment, since the desire is not allowed to reach a stable point; this would go against the ideal of the heroic and ever-moving life.

Carl Sternheim's attitude towards sex is similarly determined by the main idea which inspires his prose. The erotic impulse is linked to the individual's striving to reach the 'eigene Nuance.' Meta, Ulrike, Busekow, and many others show an extraordinary capacity to experience sex in all its forms; in each case the sexual drive is linked to other traits of a similar dimension. In 'Yvette,' however, there is an example of the *inability* to love.

Yvette's sexual demands are connected with her status of fabulously wealthy heiress. She satisfies her sexual urges as a matter of course and as her birthright. Her superior financial and social position prevents her from even acknowledging her sexual partner's identity: 'Sie merkte nur das besondere Vergnügen, nicht Name und Art des Stifters' (P134 = P411/ 301). True to her nature, she rejects marriage, yet the preoccupation with financial empire-building does not completely satisfy her, and to prove her extraordinary abilities in sexual matters also she exploits her (platonic) relationship with the lyric poet René Maria Bland by having him compose 'vollkommene Metapher' (308) about their sexual encounters for her. Bland's mythmaking abilities are used by Yvette to prove her own sexual prowess; in volumes of correspondence Bland exalts Yvette's capacity for love: 'Sie prostituierte seine Scham und buchte als Effekt: schwört er mit tausend Eiden später meine Unzulänglichkeit, hier habe ich, heilig von ihm beteuert, kommenden Geschlechtern meine Bedeutung bewiesen' (309). Thus her actual inability to love is temporarily obscured by Bland's proofs to the contrary. But the novelle ends with an ironic twist, a typical Sternheimian scene of voyeurism. During a holiday in Baden-Baden Yvette becomes the reluctant witness to scenes of obvious sexual pleasure between a couple in the room next to hers. Contrary to

her cynical assessment of sex – 'des Vorganges Mechanik sei schlecht in seinem Abschluss balanciert. Höhe Abgrund Jubel Gähnkrampf lägen zu nah beieinander' (310) – the couple seem inexhaustible. Yvette's confidence in herself is undermined: she begins 'ihres Lebens gemachte Erfahrung in Frage zu stellen' (311). Her discovery that the man next door is Bland spurs her on to seek for herself experiences of the same ecstasy. But Bland warns her: 'die Frau, die ich liebe, bleibt das Allerseltenste auf Erden ... Wo ich sie fasse, ist sie Strom, der mich mit Feuer aus Aufspeicherungen lädt. Immer ist sie kraftvoller Beginn, und hinterher noch scheint ihr Geschlecht das Allernatürlichste ... stets entsteigt ihr das Ursprüngliche, von dem Gebären und Frucht, Yvette, kommt!' (312) The woman he loves is 'Lebensquell,' whereas Yvette is an intellectual like himself; 'gewählte Geistigkeit' is her 'Nuance,' and attempts to break away from it are futile. Yvette can never aspire to greatness in love, since she lacks the qualities necessary for it.

Like Klabund's 'wohlhabender junge Mann,' Felix, the hero of Ernst Weiss's 'Marengo' (P139 = P415) is a lonely, introverted individual with a profoundly dualistic nature: 'Er war weibisch von Herzen, männlich von Gehirn' (187). In typical psychoanalytic fashion Weiss associates the female aspect of his hero's character with a pull away from the conscious ego, the male aspect, characterized by its spiritual and mental faculties and its impulse to control. Felix is 'hungrig nach Illusion,' but his male brain does not allow him to follow his inclinations. His deepest longing, in fact, is to annihilate consciousness, and once, during a boat trip, he had reached this ideal momentarily: '[er] lag da wie ein Stein und löschte seine andere Existenz aus' (190). It is part of his divided personality that at the office he is efficient and practical, and by no means a *Sonderling*, yet precisely because of this he feels himself at thirty 'wie eine juristische Person' (195).

Weiss finds an appropriate symbol for Felix's existence in the shape of a woodlouse which the latter discovers during a voyage to the Alps. The woodlouse's perfect stillness during a violent thunderstorm suggests Felix's own way of life: 'Unbekümmert um Licht und Finsternis, gleichgültig gegen das Gewitter draussen und gegen die Donnerschläge, unter denen das leichte Holzdach des Sommerhotels bebte. Wie es schien lebte sie in diesem Augenblick verlassen von Wesen gleicher Art ... War sie wie Felix wieder an den gewohntesten Ort zurückgekehrt, weil sie nur da, wie er in seinem Unternehmen und Beruf, Halt hatte? ... War sie wunschlos, mit der Weltordnung versöhnt? Wollte sie sich mit ihresgleichen verbinden?' (203)

The discovery of the woodlouse is a turning point in Felix's life. Upon returning home, acting under an obscure impulse, he invites his secretary Margot to an outing by boat, thereby setting the stage for the kind of 'cosmic' experience he had had once before. Within the realm of nature the couple appears transformed. The conscious will seems to have been silenced, and a blind force pushes Felix to seduce Margot. The sex act itself takes place on an unconscious level; the couple makes love 'ohne zu wissen warum' (218). An inescapable fate seems to have led Felix from the contemplation of the woodlouse to the experience of sex. But with the moment of 'Auslöschung' over, a disquietening alienation sets in: 'Je näher die Natur ihm kam, desto fremder wurde ihm der Mensch' (220). The moment of ecstasy leads directly to deception – 'Das Innigste war vorbei, das Glühendste dahin' – and the old bachelor in him surfaces once more. Margot seems to have fulfilled her function as provider of sexual release, but no new relationship establishes itself between the two. Felix remains tied to his environment and to his past: 'Hatte er mit dreissig Jahren sein Teil dahin?' he asks himself. 'Konnte man etwas Neues beginnen? Allein? Mit anderen?' (228) The moment of liberation in orgasm, which might have led to a true transformation, remains without issue. The problem of how to prolong ecstasy, familiar from Edschmid and Sternheim, leads in this story to capitulation before the power of the past.[1]

Sexual orgasm sometimes takes on an almost mystical quality in Weiss's work. It is the thing to which Felix aspires under a blind compulsion. In 'Franta Zlin' (P137 = P415) the inability to reach orgasm forms the central theme of the novelle, and orgasm seems for Weiss an appropriate symbol for the annihilation of the conscious self, for which many of his heroes strive.

The inability to love is exaggerated into the grotesque, finally, in a novelle by Alfred Lichtenstein, 'Die Jungfrau' (P89 = P389). The title itself is significant, for the associations it suggests are grotesquely contradicted by the story. The novelle centres upon the encounter between two extremely unlikely characters and climaxes in their attempted sexual intercourse. The female character, Maria [!] Mondmilch, seems to be designed to shock the reader, while at the same time, in typical Expressionist confusion of purpose, the story seems to proclaim the need for a more frank and liberal treatment of sexuality. The result of this confusion, and the very wealth of detail supplied about the sexual exploits of the heroine, add up to grotesqueness. Maria's incest with her father at the age of eight, her sexual relations with her uncle and guardian, the correspondence which she maintains with the latter, 'voll ausschweifender

Liebessehnsucht und abenteuerlicher Hoffnungen' (P389/67), the accusations of 'allerhand Schweinereien' in a *Gymnasium* for girls, her involvement with a professor (leading to accusations of 'Sittlichkeitsverbrechen'), her posing for obscene photographs, and finally her decision to study medicine 'aus erotischen Bedürfnissen' (68) – all this tends, because of the very accumulation, to become absurd.[2]

The same criteria apply to Maria's male counterpart, the actor Schwertschwanz (again a 'significant' name). He is 'ein intelligent und verludert aussehender Mensch' (68), with 'von Schminke und Hoffnungslosigkeit, von unmässigen Hurereien oder Onanien ringsum zerrissenen und inwendig fast verfaulten treuherzigen blauen Augen' (69). His favourite topic of conversation is syphilis: 'Fräulein Mondmilch erzählte entsetzliche Fälle. Herr Schwertschwanz hörte erschrocken und begeistert zu' (68-9). The mutual attraction of these two results in a tête-à-tête in Maria's room: 'Sie wollten einander ihre Leiden von klein auf entgegenschluchzen' (69). Schwertschwanz's confession of syphilis, accompanied by tears, is consciously theatrical, designed to seduce the hysterical woman, who, holding her hands before her face, 'retaliates,' 'Theatralisch wie er' (70), by confessing that she is a virgin. The confession turns out to have unpredictable results, in that it at once repulses and attracts Schwertschwanz. The couple attempts to have sex, and Maria sings her 'Werbelied' (70), a resumé of her sexual promiscuity. She hints, however: 'Die meisten sind weggegangen, als wäre nichts vorgefallen. Nichts ist vorgefallen.' Promiscuity is coupled with frigidity in Maria, causing impotence in her male partners. Schwertschwanz too becomes the victim of this union of opposites, and his attempt ends in disaster: 'Da rief Maria Mondmilch in dem Untergehen: "Schwertschwänzchen, liebst du mich – " und schon ertrunken: "Er liebt mich nicht –" ' (71). The story ends on a note of pathos nevertheless, for, left alone, 'vor Begierde zitternd, eine geeignete Hure,' Maria ponders over a diagram of a nude man, 'Und heulte wie ein Hund am Meer' (71).

With its clashes in thematic and stylistic elements, its constant shifts between seriousness and parody, its oscillation between pathos and the grotesque, the story uses a potentially pathetic situation – impotence, the inability to communicate – and loads it with such exaggeration and highspirited nonsense that the initial situation is buried. Nevertheless, we may see in this novelle the same message as in the previous stories. Moreover, from here to the view of sex and of woman as chaos, as demonic and threatening agents, is but a small step.

In erotic matters the Expressionist writer is torn between two powerful

impulses: to seek release from isolation in the merger with another human being (in extreme cases an obliteration of his individuality and an end to individuation in the moment of ecstasy); and an impulse to reject sex because of the danger it presents to that same individuality. The confidence which Goethe demonstrated, in 'Seelige Sehnsucht,' in the reconciliation between the self-loss in sexual union and the self-capture on a higher level, is lacking in Expressionism. To the Expressionist there is a real danger of destruction of the self (already in a state of vulnerability). The tension between these two impulses inspires a whole series of novellen in Expressionism.

Often the inability to love is the starting point for more problematic relationships between sexual partners. The protagonist of Alfred Wolfenstein's 'Die künstliche Liebe' (P146 = P417), for example, represents the typical passive lover; his motivation for marriage is to provide himself with a context in which he may discover how others experience and enjoy sex. Felix makes the fatal mistake of not taking into account the mutuality of sex, of course, and to make matters worse, his wife turns out to be extremely creative in sex, forcing him into the role of a mere spectator, a voyeur. Resenting his wife's prowess, Felix resorts to a new technique. His perversion consists in imagining his wife to be another woman. The process also involves the invention of an exotic, fantastic context. Though the experiment is superficially successful, it is of course self-contradictory and self-defeating. Felix cannot now experience the enjoyment his wife feels – which was the whole point of his marriage. Paradoxically, he has become the giving partner, and has transformed himself into an artist. Felix's early death is explained as the result of the terrible loneliness the process involves. The attempt to experience sex 'through the head' is a perversion of which only a decadent is capable.

Unwillingness to accept the partner's individuality out of fear that one's own may be enveloped by it is often the root of sexual conflicts. Gustav Sack's 'Der Teufelszwirn' (P119 = P406) is a story which works through a double symbol for the clash of egos. Once again a man develops a talent for metamorphosis, though this time not to retaliate against his partner but to satisfy her. The man's ironic coldness even during the 'Momenten der weissen Seligkeit' (P406/319) causes the woman to question the man's love for her. The man tells her a story about a plant with sucking cups which crawls over the ground 'bis er seine Beute gefasst hat und in ihr grünes Fett seine Zähne schlägt.' The woman rejects the image of what she takes to be herself as a 'kitschiges Symbolum.' The woman's interpretation is wrong, however, and the man tells her another story,

about a man in love with a mermaid. The point of both images is not that the victims feel victimized, or that they resent the loss of their freedom, but that they lose their identity. Thus, the man argues, he himself has been forced to change: 'Ich habe mich dir prostituiert ... ich ward aus Wahnsinn und Liebe zu dir ein Protheus an seelischer Wandlungfähigkeit' (321). In order to please his lover he has had to act as if he moved between 'blauer Idealismus' and black despair, between cynicism and romantic exaltation. Even the 'ironische Kälte' (319) about which she has complained is part of his repertoire. Having now reached the last of his transformations, he finds that there is nothing left for him to do but to commit suicide in the river. But Sack closes his story with an ironic twist. In the last segment of the tale, narrated objectively, it is revealed how great an impression the man's speech has made on the woman. Her face is 'von jäher Liebe zu der müden Schönheit dieses Mannes bezwungen' (322), so that, Sack writes coyly, the man could leave the house only half an hour later than planned. The threat of suicide was yet another mask designed to fascinate the woman.

If 'Der Teufelszwirn' is concerned with the danger of losing one's identity in order to please one's partner, 'Die Dirne' (P111 = P406) deals with the problem of an abundance of love on the part of one partner, which could pose a threat to the other. The saying 'Eher lieben wir noch die, die uns hassen, als die, die uns mehr lieben als wir wollen' is, by means of an anecdote that a father tells his son, shown to be a dangerous cliché. Acting upon the conviction that the saying is true, the man tells his beloved: 'Diese ewige Anhänglichkeit, diese hemmungslose Hingabe, dies entsetzliche mich Bewundern, mich entzückend Finden, dieses Hungern nach einem freundlichen Wort, dieses stündliche, dieses bedingungslose sich an mich Schmiegen, dieses hündische Dulden, das ist ja entsetzlich' (P406/319). After finally abandoning his beloved, the man has a momentous encounter with a prostitute, whose beauty ('Ihr Leib war gepflegt wie einer der besten ihres Handwerks und war doch heiss und schien unverbraucht' [318]) is nevertheless not sufficient to overcome the man's revulsion, since no true communication is possible between them. When she answers his attempts to talk to her with a non-comprehending smile, he revolts: 'Da presste ich den Mund zusammen, wenn sie mich küsste, und stiess abwehrend den Atem durch die Nase, wenn sie näherrückte und Liebesworte flüsterte' (318). Spiritual love is part of the total concept of love. Moreover, it is shown that an abundance of love is a guarantee of happiness, and that clichés are dangerous since they result from thinking in fixed categories. Sack defends the complete involvement of the

partners over any 'logical' or 'rational' ideas held by common wisdom.

In a somewhat lighter vein, Max Brod shows how confusion may result from the fixed ideas his male protagonist has about the role of women. At the same time, 'Das Ballettmädchen' (P15 = P342) is also the description of a clash between a bourgeois and an artistic woman. To Wlasta the ballet girl appears as a 'natural' and elemental creature, an incomprehensible, animal-like being from an exotic realm. For her, it seems to him, planning and work are unimportant, whereas he lives for his work and his routine. In reality, Wlasta's admiration for the ballet girl is based on his secret fear of women, who appear as mysterious and unpredictable to him as natural forces. But the highly subjective picture which Wlasta has drawn of his partner is suddenly destroyed when an accident causes him the loss of the use of his legs. He expects the girl to react with unconcern, with a childlike, even slightly amoral lack of feeling. But the girl shows concern and maturity, and Wlasta is forced to abandon his illusions about her. He is disappointed to such an extent that he now treats her brutally; she has lost her aura of mystery, but this, ironically, also makes sex between them possible.

Lichtenstein's story 'Die Jungfrau' gave us an indication that one major difficulty in assessing sexual relationships in Expressionism has to do with the impossibility of knowing woman's nature truly. In that story virginity and prostitution are linked so closely together that our final impression is one of bewilderment. Often the difficulty lies with the man, whose pre-conceived notions stand in the way of his understanding his partner on her own terms. Sometimes the woman herself hides behind a mask, however, and at yet other times the confusion results clearly from the author's deliberate intention to intrigue, shock, and jolt the reader. The shudder which accompanies the feeling of the grotesque in Lichtenstein's 'Die Jungfrau' is caused by the union of extreme opposites in the same figure. Conventional thinking holds the notions of innocence and depravity, virginity and prostitution far apart. Yet this theme has a most prominent place in Expressionism (Döblin's story 'Der Dritte' [P21] is also concerned with it) and has an illustrious ancestor in Frank Wedekind's plays *Die Büchse der Pandora* and *Erdgeist*. In the figure of Lulu, the elemental, amoral force of love and sexual drive, Expressionists found a model to emulate and even to surpass.

In many ways Carl Einstein's 'Die Mädchen auf dem Dorfe' (P52 = P364) resembles Lichtenstein's story. Nina, the daughter of the mathematics professor Aurier (a bourgeois with an outrageously utilitarian morality) is a figure like Maria Mondmilch. At age twelve she seduces or is seduced

by a pupil of Aurier and earns from her father the name 'Saustrang' (327). The incident also serves to make her father realize how beautiful Nina is. He promptly decides to commit incest with her. Aurier's advances are not met with much protest: 'Nina hatte im Dunkeln die Hose heruntergezerrt: er warf sich über sie und leistete die männliche Pflicht' (329). While Aurier cynically reflects 'Es muss doch enge Beziehungen zwischen der Familie geben,' Nina's acceptance of the new relationship is complete. Her boyfriend's revelation that her father visits the brothels of Marseille hurts her because she feels rejected. Meanwhile, she happily accepts gifts from her father, and 'Aurier und Nina verkehrten jetzt, wann es beliebte, wie Mann und Frau' (331). Elaborating on an already sufficiently gross and grotesque situation, Einstein now even sets up a rivalry between father and son over Nina's favours (an interesting variant of the father-son conflict!). When Nina subsequently escapes to Paris, Einstein indulges in outrageous satire. Aurier's letters to Nina are tearful and pathetic; they deplore Nina's promiscuity and claim that at home she was always 'von liebevoller Gesittung umgeben' (335). But Nina only returns home after her father's death.

From this point on the story splits into several narrative strands. As in a kaleidoscope, Nina's character is broken up into different aspects, each having its source and meaning in another, different character. To each of these people Nina means something different, but the totality of the image is a portrait very much like that of Maria Mondmilch. To Nina's mother, for example, she is a rival: 'Alle rennen auf dich, du läufige Hündin,' she complains, 'als sei ich nichts, ich muss auch noch leben' (345). And when Nina seduces an old farmer, she complains, 'Selbst die alten nahm sie ihr weg' (347).

Nina's career is as chequered as that of Maria Mondmilch. She seduces a school principal who pays her five hundred francs; a doctor, crippled during the war, watches her do nude callisthenics and offers himself as 'jemand zuverlässig' (344); an old spinster is initiated by Nina in the art of sex; a young peasant kills his father over her; a priest idolizes her as the Virgin Mary returned to earth, but at the same time calls her 'Die Hure von Babylon' (348) (the theme of the novelle stated in a nutshell!); and the mayor allows a charge of the community to be procured for Nina's brother and silently accepts the founding of a brothel in his town. The whole absurd story ends with the community setting fire to Nina's house; Nina herself escapes. With an oblique reference to Wedekind's Lulu plays, the novelle ends with Nina's decline as a prostitute in Paris: 'Mit zwei Franken stieg sie die fünf Treppen herunter, wo sie sechs Menschen

223 Eros in Extremis

gehabt hatten. Dann warf sie sich in die Seine, da sie nichts mehr taugte'
(352).

Nina's final despair comes from the realization that she has lost the one trait which distinguished her, her raison d'être: the ability to excite others. Nina is the embodiment of the unchangeable, amoral, uncompromising erotic drive. Despite the conscious absence of conventional psychology and of a clear, unambivalent motivation (the result of Einstein's own theory of literature), the figure of Nina comes surprisingly to life as a catalytic force which triggers reactions in everyone in the story. Nina sets off in each male an erotic desire for which he is willing to give up stability, order, morality, even life itself in order to possess her. The females in the story are forced to follow in her footsteps. Relationships of all kinds are established: incest (twice), lesbianism, debauching of minors, procuring; there are two murders and a case of madness. People have the appearance of acting as 'forces' in an abstract play or a ballet, and yet there remains a thin red line in this colportage-like story: the stability of Eros as a unifying force. The constant introduction and elimination of new figures creates the impression of a world gone mad, in which the sex impulse, embodied by Nina, is the only constant.[3]

The story presents great difficulties to the reader. Much of the action can only be established and interpreted through the reactions of individuals in the story. The short, nervous paragraphs do not yield insight into the psychology of the characters involved. We must reconstruct the action by means of sequences often interrupted by other events, or through certain phrases uttered by the characters, or by hints often buried in 'suppressed' passages. Many links are missing which contain important data; the role of the narrative voice is almost completely limited to descriptions, not interpretation. Causality is absent, and the characters act under obscure impulses: they neither ask questions nor analyse their actions.

Like Lichtenstein and Einstein, Hans von Flesch-Brunningen presents his amoral virgin-prostitute in a grotesque light. The novelle 'Der Junitag' (P53 = P366) takes a predictable course when into the 'Ungewaschenheit und Stilwidrigkeit des stäubigen Kleinbürgertums' (41) in which the teacher Hunner lives there enters an element of mystery and chaos in the form of Gretl, with her grey eyes, 'jungfräulich und zum Weinen unschuldig' (35). Hunner, in whom 'jeglicher erotischer Sinn abgestorben [war]' (41), cannot cope with this phenomenon. But precisely because he is so obviously inexperienced in erotic matters, and despite (or rather because of) his grotesquely inappropriate features ('Er hatte ein Gesicht wie ein

lyrischer Lustmörder'[37]), he presents a challenge to the not-so-innocent Gretl: '[Es] erwachte die kleine Bestie in ihr' (41). Under her considerable pressures Hunner's defences go down. In a scene which depends on grotesque contrasts Gretl challenges Hunner to kiss her in his own house. Hunner's reaction is an outburst of passion. The episode takes place against a background of crying children, drunken singing, and a violent thunderstorm. The kind of confusion of levels which this scene exploits is characteristic of the whole love affair. There is a constant doubt in Gretl's mind as to what exactly she wants from Hunner: 'ich bin Jungfrau und muss klug sein,' she claims, but her fickleness and unpredictable character inevitably lead the philistine Hunner to near madness: 'sein Inneres war ohne Weg und Form' (46). The catastrophe comes on the oppressively hot day in June to which the title refers. Once again the encounter borders on the grotesque. Hunner now is like an animal in heat, in whose face one can read 'die Sommerwut der Hunde' (49), whereas Gretl is both diabolical and sexually fascinating. Hunner's killing Gretl, the object of his intense desire, demonstrates the extent of his confusion in the face of this incomprehensible erotic force.

Ever greater intensification of the problematic nature of relations between men and women may be observed in Expressionist prose. Ecstatic love is combined with blasphemy in Alfred Döblin's 'Der Dritte' and Sternheim's 'Busekow'; Meta practices sex with a dead man, if only in spirit; Oskar Loerke shows the breakdown of a marriage ending in suicide, in 'Zimbehl in den Wolken'; the couple is revealed as in eternal conflict in the works of Weiss and Jung (see below). Finally, sex is combined with ever more revolutionary and challenging motifs, designed to outrage the public as well as to widen the scope of erotic literature and to point out the problematic nature of sex in a society shackled by conventional morality. Sex combines with venereal disease, pornography, incest, and blackmail in the stories of Lichtenstein and Einstein; Ernst Weiss's 'Franta Zlin' combines murder, loss of sexual organs, theft; Flesch-Brunningen's 'Der Junitag' murder and attempted rape; Weiss's 'Die Verdorrten' a double abortion, blackmail, and adultery. There are suicides in Loerke's 'Zimbehl in den Wolken' and in Wolfenstein's 'Die Wiederkunft'; there is madness in Oskar Baum's 'Der Geliebte' (P1), Heym's 'Der Dieb,' and Döblin's 'Der Kaplan' (P23). Homosexuality figures in Lichtenstein's 'Der Sieger' (P91) and in Arnolt Bronnen's 'Septembernovelle' (P18); there is lesbianism in Flesch-Brunningen's 'Die Kinder des Hauptmanns' (P54) and perhaps the culmination of this trend is reached in Flesch's 'Der Satan' (P55), in which the recruitment of a complete society into the service of

sex is presented, with multiple orgies, unbelievable excesses, the abolition of all forms of social organization, the collapse of morality, the triumph of crime, anarchy, violence, and chaos. Clearly, to the Expressionists sexuality and eroticism were problematic not only in the form in which society practised and tolerated them but also in the Expressionists' own thinking. We may well ask, therefore, if and in what form the erotic appears under more positive signs, and what larger role sexuality plays in the corrective and idealist aspects of Expressionism.

In the work of four authors in particular, Ernst Weiss, Alfred Döblin, Franz Jung, and Gustav Sack, sex is a central theme. The multiple tensions which exist in erotic relations are revealed in all four, but each treats the theme differently. Although Ernst Weiss's work is Expressionist in form, in intensity and feeling, in diction and speed of narration, and in the overpowering sense of fate which makes his characters act seemingly under an alien compulsion, there is nevertheless in his writings a striving for accuracy of detail, especially in the depiction of the workings of the characters' mind. Wolfgang Wendler writes: 'Bei Weiss finden sich expresssionistische Steigerung und Genauigkeit der Schilderung zusammen' (S246/665). And he argues further: 'Die psychologische Genauigkeit, die Weiss immer beibehält, und darin ist er unexpressionistisch, bewirkt keine Abschwächung.' By contrast, Alfred Döblin works with a prose medium which eliminates to a large extent the reflective function of the narrator and allows for an 'objective' retelling of events without providing motivation or psychology in the traditional sense. At the same time, Döblin's 'parabolic' narration permits subtle shifts into and out of reality, which account for the hermetic quality of his prose.

Franz Jung is perhaps the most complicated. Like Döblin, Jung wanted to break with psychology, with superficial logical motivation. In *Das Trottelbuch* he completely rejects existing realistic and psychological forms of presentation. Jung is obsessed with the wish to make clear to his readers that to him love and sex have the quality of nightmare. Armin Arnold has written: 'Liebe: Das bedeutet die Tätigkeit von zwei Blutegeln, die sich gegenseitig aussaugen; das bedeutet zwei Todfeinde, die sich am liebsten umbringen und auffressen würden; das bedeutet Sadisten, die sich zu Tode quälen, Machtbesessene, die um jeden Preis den andern beherrschen wollen – kurz: Liebe ist etwas Fürchterliches, eine Krankheit zum Wahnsinn' (S10/68-9). As we have seen, Jung's view of sex is by no means unique. Sex and love appear as illness in many works of Expressionism. Even the relatively mild aberrations of Wolfenstein's Felix and

the excesses of Sternheim's heroines and heroes appear to confirm Jung's opinion. By contrast, the writings of Gustav Sack seem both milder in tone and less despairing.

Arnold's paraphrase of Franz Jung's views on love apply with special justice also to Ernst Weiss's gloomy story 'Die Verdorrten' (P140 = P415). The novelle is an unrelenting description of the love-hate relationship between two people who are, against their will, drawn together, who live together, then attempt to escape from each other and finally resign themselves to compromise and sterility. Weiss works with extremes: Edgar's aversion to human contact, his quasi-physical illness when he finds traces of Esther's presence, are in the nature of a neurosis. Yet Edgar is at the same time driven by a need for human contact. On the one hand his feelings for Esther are typical of the exalted adolescent who idealizes a rather ordinary girl into a mystical being endowed with extraordinary qualities (Edgar's attitude is reminiscent of Wlasta's in Brod's 'Das Ballett-mädchen'); on the other he experiences the pangs of love also as a desire for down-to-earth physical release. Neither of the images he creates of Esther is realistic; she is neither 'etwas Tiefes zum Hineinversinken, dem Schlafe gleich und dem Tod' (105) nor something awe-inspiring and mythi-cal-mystical. Consequently, the depiction of the eventual sexual union of the two young people (significantly, in nature's realm in an idyllic setting) is pure mythmaking, of which the 'logische Entzauberung' and the 'kalte Wirklichkeit' (111) are the inevitable and tragic consequence: 'beide ent-stiegen der Dunkelheit gealtert, verwüstet, entgöttert' (113).

Edgar's subsequent efforts to retain independence vis-à-vis Esther result in his near madness; his gestures and speech suggest self-aliena-tion, yet in his conversations with Esther – veritable cascades of emotion – it is not difficult to recognize his wish to end individuation in an ecstatic union. These two impulses are irreconcilable. In their efforts to find a balance between the opposing wishes for independence and for sexual and spiritual union, Edgar and Esther may find temporary relief in the idyllic, tranquil existence of a bourgeois couple, but this respite is brought to a brutal end by the announcement of Esther's pregnancy.

Edgar's attitude towards the future child is difficult to interpret. Although he considers Esther 'das Unentrinnbare' (120), an opinion which has rather negative connotations, he cannot accept a separation from her or a lessening of her love for him. The child would be a threat, and without hesitation, acting as if under external compulsion, he reaches the decision to destroy the child: 'Er zerstörte dieses Kind in seinen Gedanken, dann erst konnte es in Esthers Gedanken zerstört werden, und

am Ende in Wirklichkeit' (121). Yet Esther's acceptance of the abortion is also difficult to understand, unless we suppose an equally strong feeling of 'Unentrinnbarkeit' in her. There is no doubt that the destruction of the child is a sacrifice to her, yet she is willing to enter into the sex act which, since it is interpreted by Felix as kind of pact, anticipates the physical destruction of the child. In fact both partners experience in this act the climax of their desperate love: 'Brust an Brust, Fleisch an Fleisch, und in einer verzweifelten Umarmung umarmten sie ihre ganze Liebe noch einmal' (122). But the moment of 'love' is brief, for now Esther's hatred of Felix is so strong that she leaves him to marry someone else. Even now, however, fate intervenes, for her husband proves to be impotent, and she is 'forced' to look once more to Felix for impregnation. This irony of fate, and the fact that her husband discovers her adultery, tie the lovers even more closely together, to the extent that she even sacrifices her second child. Further children are denied them, and they live out their love-hate relationship in quiet despair. Edgar, 'der Irrsinn und menschenleere Einsamkeit gefürchtet hatte, war verflucht zu endlosem Alter, nie von Esther verlassen, und sie, die Mutter ohne Frucht, verdorrte, ein Strauch am Gestein' (145).

In Weiss's novelle Eros is synonymous with conflict and pain. A lonely individual cannot retain his sanity, yet love is presented as hell. Two indomitable egos clash yet search for each other. Sex is a curse which brings neither relief nor redemption. Weiss's characters lose the ability to judge, to evaluate, and to assert their freedom. The unrelieved sombre tone of this novelle makes even the brief episodes of harmony appear doomed. Weiss's obsession with sex almost forbids any other interest; the world created in these stories is but a theatre in which sexual obsession or aberration can be played out.

Much the same can be said about 'Franta Zlin.' In this novelle Weiss demonstrates not only his obsessive preoccupation with the psychology of sex but with the sex act itself. It is at the same time one of the most fascinating examples of the strengths and weaknesses of the Expressionist prose style, at once dynamic, pulsating, rhythmically innovative, and pathetic, at times even bombastic. Seldom do content and style enter into so close a union as in this story. The tragedy of Franta Zlin is played out against the background of war and defeat, against unrelenting horror, and described in a vocabulary and with images which are at once shocking and appropriate. Especially in the scenes describing the battle of Rawaruska, autumn 1914, what has been described as the cult of the ugly in Expressionism is amply demonstrated. Scenes of grotesque horror set the

stage for Franta's own tragedy. His rape of a Jewish woman on top of an animal cadaver sets the tone of the novelle. A little later he finds a box containing pearls; when he opens the box, the pearls scatter, and one of them becomes lodged between the hoofs of a cow. In later years Franta's memory always brings the image of the pearl together with the sex act.

The first climax of this novelle rich in horrors comes with the destruction of Franta's sexual organs through flying shrapnel. This wound becomes the source of his decline and ultimate destruction because, out of shame and humiliation, and because of his excessive love for his wife, he cannot tell her about it. Instead he seeks refuge in feigned indifference, even rejection, and by practising abstinence. The significance of the pearls now becomes clear: 'Pearls ... when scattered ... relate to the symbol of dismemberment,' writes J.E. Cirlot, in his *Dictionary of Symbols* (S31). At the same time, a pearl in association with an oyster is sometimes recognized by psychoanalysts as representing 'the mystic Centre and sublimation (seen here as the transformation of an infirmity, or of some abnormality).' Both the idea of dismemberment and the sublimation of infirmity seem to apply to Weiss's use in this story.

The couple's attempts to survive after the war through cheating and theft in a destitute and starving Vienna still further alienate them from each other; even Mascha's misery becomes a source of resentment, 'da sie mitten in ihrem Elend so schön war' (P415/172). Franta's impotence is a curse made more terrible by Mascha's unchanged beauty. The novelle's second climax is reached in Franta's forcing his wife to commit suicide. Yet even while she is dying, he is still fascinated by her. Though Weiss's descriptions at this point suggest Franta's madness, the latter's attachment to Mascha remains strong. The suicide is meant to set Franta free: 'Endlich keine Angst mehr um das zerstörte Geschlecht. Keine Scham mehr wegen der Verstümmelung' (174). Indeed, there now comes about a shift, as Franta dreams about living in a house in the country. But external circumstances prevent the idyll from coming true. Also, the sex drive asserts itself again, together with the awareness of the impossibility of satisfying it. Franta's experience with the prostitute Vicky, to whom he shows his wound, reintroduces the motif of the pearls, this time clearly related to the female sexual organ. The encounter ends in disaster, and for the first time there also comes to Franta a feeling of guilt for having killed his wife.

The final scenes, after Franta escapes from a labour camp together with a Russian prisoner of war, reintroduce the motif of the pearls and of rape. In a vision Franta sees the cart with the Jews from whom he took the

pearls. By a complex association, the original rape of the Jewish woman now triggers a sudden release, a climactic orgasm: 'und mit einem Male war Franta ganz hoch beseligt, ganz steil getürmtes Geschlecht, ganz kreisend geballter Mann, hineingewühlt in die weiche Fülle des Fleisches, gute Flut wie weisse Elfenbeinhauer ausatmend in Wogen der Nacht' (185). He has reached at last 'Erfüllung bis zu tiefst gesättigter Lust ... Befreiung ohne Schrei.' In fact, however, he is bleeding to death. Only in death, then, is he granted his most obsessive, inescapable, fatal wish: to be a man once more.

There is a major difference between Ernst Weiss and Franz Jung, not only in the function of psychology in their stories but also in their more general treatment of eroticism. Weiss's fascination with sex reveals itself above all in the obsession with the sex act; hence the central image of the novelle 'Franta Zlin' is that of pearls, associated with the female sexual organ, with rape, with the sex act, and later with impotence. Franta's obsession is to reach the 'weisse Seligkeit' of Sack's 'Teufelszwirn.' Franz Jung, on the other hand, sees the crux of erotic relationships as a mental battle for domination – a battle which he considers inevitable, just as his namesake, C.G. Jung, did. Characteristically, these mental battles are described by Franz Jung not in terms of reflections or narrative intrusions but through dialogue and gestures, which give a dramatic rather than a narrative quality to his work.

Even more than in the case of Weiss, Jung concentrates on the sexual problem. Background, biographical or social, is completely eliminated. Two people confront each other in close-ups which resemble the technique of the cinema. The narrative outlines, shows, and puts before the reader, a situation of eternal conflict, in a sentence structure that is nervous, disconnected, syntactically arbitrary. Jung's style is characterized by apparent gaps between the sentences; in these paratactic sequences all causal connections seem to be dispensed with. His novellen require analytical reading, often a kind of intellectual reconstruction by the reader. Armin Arnold has demonstrated that such a reconstruction often can supply psychological motivation (S10), and Jung's style is therefore less 'fantastic' than that of many other Expressionists. Jung does not aim for the grotesque; his characters do not appear absurd, merely difficult to understand. Economy, a reduction to essentials typical of the group of Aeternists, is Jung's goal.

The short novelle 'Die Liebe wandert' (P74) is a good example of the kind of struggle between man and woman with which Jung's stories are concerned. Böhme's wife exerts such power over him that she convinces

him to seek help in an apparently dangerous situation (typically, the actual circumstances are not made clear) from his friend Paul, whom he has long ago left behind as belonging to his 'idealist' youth. Böhme subjects himself to this humiliation, despite the fact that he not only rejects his past but also the value of his marriage. In his conversations with Paul he submits himself to the latter's well-meant recital of past experiences and ideas, and gradually comes to believe in the possibility of a new life. At the same time, however, the memory of his wife (and *her* possible future role in this new life) fades from him. This, ironically, constitutes the real new beginning and Böhme's freedom.

Das Trottelbuch unites several short novellen with a short novel, 'Die Erlebnisse der Emma Schnalke' (P377). The book is a curious collection of thumbnail sketches, anticipating Nathalie Sarraute's *Tropismes*. The underlying psychological motivations and grounds for the action are revealed only through surface action and dialogue. The interpretation must be analytical, and an active participation by the reader is required. In the programmatic introduction Jung plays a sophisticated game of narrative counterpoint between a story read by a group of young men in a café and certain events taking place during the reading. As a young woman passes by, a young man reads a story of how some men in a drunken mood beat a cat to death. The story serves as a kind of wish-fulfilment for the young men's dreams: the cat signifies woman. But woman is more clever than man, as the next story illustrates. In it a young man implores a woman to stay with him; she proposes a *ménage à trois*. Once this is accepted, the young man commits suicide; his friend and the young woman steal the young man's money and disappear. The reaction to the reading of this tale by the young men in the café is mixed: one tells a joke; another relates a personal love affair; yet another voices cynicism. When the young woman who had previously passed the café now enters with a new lover, she commands respect, not only because of her beauty, but because of the reading of the story.

'Der 50. Geburtstag' relates how Herr König, having left a birthday party for his mother-in-law, Frau Päsel, to have a few drinks at a local pub, is scolded upon his return. Frau Päsel shows both antagonism and sexual attraction for her son-in-law. The argument between König and his wife, in which they discuss adultery, has the earmarks of a mere ritual. König, insulted in his masculine pride, runs off and is disappointed when no one stops him. Later, on the way home in the train, the couple makes up, since they need each other for sex.

'Nächtliche Szene,' which Armin Arnold claims contains autobiograph-

ical references, again deals with a domestic quarrel. Bittner, coming home drunk, is verbally assaulted by his wife and retaliates by calling her a whore. Violence results. When the woman begins to scream, Bittner attempts to calm her down, but now the woman has the upper hand and triumphs in revenge. The neighbours are scandalized, and Bittner runs off humiliated. In his anger he briefly contemplates suicide, but nothing definite is decided in the story.

'Josef' opens immediately with an argument, for which no motive is provided. The man prides himself on his intellectual superiority; the woman rips up the man's portrait. The rest of the story has two foci. The man, left alone, projects his anger upon the crippled, moronic boy Josef, the son of the hotel owner, who, typically, tries to establish contact with a little girl, in a game which resembles that between Böhme and his son in 'Die Liebe wandert.' The man's uncertainty about whether to become even more violent towards his wife or to be more gentle echoes the doubts of Bittner in the previous novelle. Simultaneously, the woman is seen stand-ing in a circle of male admirers. Is it a conspiracy? When she returns to the man, with the intention of leaving him for good, he shuts her up with the story about the boy Josef and his offensive infirmity. In fact the behaviour of the man mirrors accurately that of the disabled Josef.

The novellen contained in the collection *Gnadenreiche, unsere König*in (P376) reiterate the theme of the eternal struggle between man and woman. The first story, 'Die Krise,' depicts the climax of such a struggle during the playing of a game of cards by a man and a woman. Lack of communication is important: though it is said 'Sie sahen sich schweigend an, als ob jeder in dem anderen etwas tief Geheimnisvolles, eine letzte Erkenntnis ergründen müsste,' this is immediately followed by the remark 'Sie merkten nicht, dass sie aneinander vorbeisahen' (6). When-ever the man *does* experience the woman's presence, it is in terms typical of the whole collection, as 'etwas Weiches, Glitschiges, das sich ansaugte und Ekel erregte.' The feeling of intrusion which the man feels is so strong that he wishes 'Weg von dieser Frau' (6). The reasons for the man's discomfort are revealed in a dream he has had. In it he observes the woman standing, as in 'Josef,' within a circle of men, 'die wie Kellner und Zuhälter aussahen' (6). For a brief moment the man senses triumph because he can experience commiseration for his wife, but the idea that all those present are aware of him and that he himself and his sexual inadequacies are actually the object of their ridicule shakes his confi-dence. The dialogue following the account of the dream shows that this dream is the recollection of a past situation, and the man gathers courage

to attack his wife's infidelity. The woman fights back by accusing him in turn, and thus they face each other in mortal combat: 'Sie starrte ihn unverwandt an. In seinen Blicken lag der Todesschrei eines Tieres' (10).

Adultery is also the subject of the next novelle, 'Gnadenreiche, unsere Königin,' told from the perspective of a woman undecided in her love. The story is of incredible density, and difficult to interpret because of an elliptical technique bordering on deliberate obscurity. No names are used; the two men are referred to as 'der Eine' (also 'der Blonde') and 'der Andere' (the husband). The woman's problem – how to tell her husband that she is involved with another man – drives her to stubborn silences, during which her thoughts are with her lover. Her husband suspects the meaning of these silences and implores her to speak. Strangely enough, the novelle suggests the possibility of friendship between the two male rivals. The woman, by contrast, is seen as an obstacle between the mutual esteem of the two men. If homosexuality is not involved in these stories (and the case is by no means always clear), the enmity of men for women is so strong that even enemies can band together and make common cause against women.

Alfred Döblin's attitude towards the erotic, at least in the period in which his two collections of Expressionist novellen were written, is rather more closely related to Weiss than to Jung. Typical of Döblin's cynical approach to sex is a statement he made in his essay 'Jungfräulichkeit und Prostitution': 'Grundaxiom: Jede spezifische Beziehung zwischen Mann und Weib gleich Prostitution ... Denn in den Genitalien Hinweis auf das andere Geschlecht, nicht aber auf den anderen Menschen' (P178/141). Here Döblin touches on what is the central problem of erotic Expressionist writing: the extent to which the relationship between men and women is a way out of isolation and a road to partnership and community. The quest for true union, not only in a physical but in a spiritual sense, underlies even such outspoken and frankly sexual writings as Ernst Weiss's 'Die Verdorrten,' for Edgar not only wishes for a naked body but also for a 'nackte Seele'; his fantasies about Esther, distorted though they may be, tend in the direction of a union as profound as sleep or death. In the case of Döblin there is no doubt a personal factor involved in his rather negative view of sexuality. Roland Links writes: 'Immer wieder ... stellt Alfred Döblin ... die Beziehungen zwischen Mann und Frau als einen gnadenlosen Kampf dar,' a fact which he interprets as 'im Grunde nichts anderes als eine Ausweitung des ewigen Kampfes mit sich selbst, den der Vereinsamte einzeln führt' (S133/17). Döblin's cynicism may also be interpreted as a kind of revolt. Like Sack, Döblin detested the treat-

ment which eroticism received in Impressionism and neo-Romanticism; his reaction against 'eine unter Erotismen, Hypochondrien, Schiefheiten und Quälereien berstende Literatur' (P172/9) inspires a radical treatment.

A good example of Döblin's ideas about the role of women in the world is 'Die Memoiren eines Blasierten' (P25 = P348), in which the hero denounces women as enemies of all peace and tranquillity. Müller-Salget has called it 'eine misogyne Denkschrift' (155/65), but on closer examination this scathing attack is counterbalanced by an obscurely grasped norm. In effect, the attack is also directed against the attacker. The young hero's search for love in his youth is the search for an ideal woman. Unfortunately, he finds only chaos. Under the mask of poetic language, women really only possess sexual drive. The search transforms itself into a flight, out of fear for the 'kreatürliche Bedingtheit' of women (P348/65). Unable to cope with the genital fixation, the young man escapes into the mountains and into solitude. Yet the ideal, though it seems to have been totally abandoned, reaffirms itself in the love story which the hero relates at this point – the story of his affair with a most humble, unattractive female. Instead of exploiting the vulnerable girl as a means of revenge against other women, he is reduced to crying over this very vulnerability. In the first half the novelle attacks the existing conventions about love, the euphemisms obscuring sexual drive; in the second half it suggests that the isolated individual is guilty of not submitting himself to the power of love. Unfortunately, Döblin cannot show this love in operation in the empirical world. Like Heym in 'Die Sektion' and 'Jonathan,' and like Weiss in 'Franta Zlin,' Döblin situates the idyll, the orgasm, and the Erlösung outside reality – at best at the entrance to death. It is interesting, in view of Döblin's cynicism, that he does show the erotic as a first step towards Erlösung.

Döblin is a pivotal figure in erotic Expressionism not only because of the depth of understanding which he demonstrates in his writing but also because he faces in two opposing directions. In Weiss and Jung sex is hell and Eros is a demon; in Döblin there is greater complexity. To be sure, sex is complex and disturbing, but it is not unrelieved pain and suffering, and it does not necessarily lead to destruction, madness, or death. For Döblin sex can be turned into a positive aspect of life, provided that the connection between sexuality and the elemental, between spirit and nature, and between individual and the cosmos can be established.

Two stories may serve to show in what sense the erotic may be seen as release, relief, even redemption. In 'Das Stiftsfräulein und der Tod' (P27 = P348) Döblin depicts the exemplary case of a woman whose uniqueness

allows her to merge with nature and the cosmos and experience this fusion as a kind of sexual ecstasy. One day in spring, this lonely woman, living in isolation, is overtaken by the certainty, at first frightening, that she must die soon. After a period of anxiety, she begins to look upon death in a more positive light. A curious erotic relationship is established between the woman and death. The woman begins to write letters 'An meinen lieben, strengen Herrn, den Tod' (P348/34). She is now prepared for death as for an erotic encounter. But when death finally arrives, he does so not as a tender and considerate lover but as a brutal, passionate 'Bauernlümmel,' who strangles her. Despite the brutality of the action involved, we must see in the surrender to the ecstasy of death – experienced as *erotic* ecstasy – a truly positive attitude. The parallel which Döblin is so careful to establish between the surrender to the act of love and to the merging with the cosmos is clearly meant to show that they are in effect means to the same end.

This seems even more clearly stated in 'Die Segelfahrt' (P26 = P348). The story once again intertwines eroticism and death. In the lovers' failure, initially, to achieve erotic union and thus also to accept death in the sea, there is a case parallel to that of the 'Stiftsfräulein.' The inability of the girl to follow her lover to his death by drowning, and her subsequent ecstatic abandonment to life, illustrate her state of immaturity. Life is but a reprieve, however, for as if drawn by mysterious forces she returns to the original scene of her first encounter with her lover, exactly one year after the man's drowning, and this time explicitly to meet sexual union in death. Müller-Salget sums up the story as follows: 'Die unergründliche Macht des elementaren Daseins, wie sie sich im Meer darstellt, hat hier zwei Menschen, die durch Krankheiten in ihrem Lebenswillen gebrochen waren, ergriffen, sie in der Liebe zueinander geführt und sie so über ihre Vereinzelung und Erstarrung gebracht' (S155/40).[4]

How Döblin envisages an erotic relationship which might be viewed as positive while remaining part of *life* does not become clear from these examples, however; the depiction of Eros in 'normal' life, in social contexts especially, does in fact pose a severe problem for most Expressionists. Where love is glorified, as for example in René Schickele's 'Aissé,' the contrast between the world of the lovers and that of the empirical world contains a violent criticism of the latter, while the description of the erotic idyll has the quality of a dream or escape. Similarly, Heym's depiction of love appears not only as a revolt against the world but by definition possible only in the realm of vision and dream. So great has become

the threat of reality that love is seen as a form of protest against the imperfections of the world.

The idealization of love and its consequent impossibility in a broken world is the theme of Edschmid's 'Die Herzogin' (P33). Against the sordid background of medieval France, the duchess of Ventadorn appears as a guiding light and the symbol of beauty and purity in the life of the hero of this story, the poet François Villon. Villon's momentous meeting with the duchess will determine his further life: 'Der Schein ihres Gesichtes fiel über sein Leben, um es nie zu verlassen' (74). Villon's restless wanderings, his multitudinous encounters with shady characters, his crimes, the violence and passion in his life, and the brutish affairs with prostitutes cannot extinguish the 'Schein' which the duchess has cast on him. Against this image 'selbst die Grausamkeit des Sterbens war gering' (83).

But Villon's temperament and the state of the world make it difficult for him to live up to his ideal. Villon's sensuality is often stronger than his idealism, and his life is a series of brutal and degrading sexual adventures, resembling those experienced by Bertolt Brecht's contemporary hero, Baal. Late in his career Villon states the central problem of his life in these terms: 'Ich habe die tripolitanische Heilige verehrt und nannte sie mit gleichem stinkenden Atem Hure. Die Güte der Herzogin schien mich an, aber ich stahl und tötete' (139). Thus he departs once more from the convent where he had found shelter and, as a typical Edschmid hero, leaves the past behind with a gesture: 'weniger in Drohung und Trotz, aber voll Ablehnung' (141). Villon pushes on, indifferent to whether 'ein Bauer ihn, buhlend, hinter einem Zaun mit der Gabel ersteche, oder Gott ihn im feurigen Wagen wie Elias in den brennenden Himmel reisse' (141).

The latter remark shows to what extent Edschmid sees Villon as moving between the highest forms of idealization and the lowest forms of reality, between 'Hure' and 'Heilige.' At the same time there is some doubt about Edschmid's ulterior motivation. It might very well be that in pointing to the duchess as a model that cannot be realized, Edschmid is also saying, as usual, that the individual must find his own norms and that he must lead his life independent of such ideals, in the full awareness of his 'sinful' and imperfect state but true to his own character. In that case even idealized love may be merely another obstacle thrown in the path of the hero as defined by Edschmid. Quite apart from this, however, the novelle also raises serious doubts about Edschmid as a stylist. The excesses and the rather hysterical tone of his earlier novellen have become quite unbearable here, and one is tempted to deny the author's megalomanic

tale, filled with 'emotion' and 'significance,' the status of literature.

If any Expressionist may be said to have depicted love in a more positive manner while remaining free from both idealization and pathos it is Gustav Sack. The story 'Eva' is a model case of what an uncomplicated, purely sexual relationship can be. In the love between the narrator (a mask for himself) and the peasant girl Eva, depicted against the background of the 1914–18 trench warfare in France, Sack celebrates a natural, vitalistic *sexus* far removed from 'civilization' and the cerebral preoccupations and sterile soul-searching of his colleagues at home.[5]

Nature is particularly important in 'Eva' because, according to Sack, it can bring out true eroticism. This is also the function of the landscape in the story 'Im Heu' (P115 = P406). The vocabulary here aids in setting the erotic union of father and daughter: 'Und mitten in diesen betörenden Klee- und Thymiangerüchen, mitten in dem ungeheuren Kessel von Schweigen und Glut bewegen sich zwei Menschen hin und her' (P406/ 332-3). Like two magnets, they seem drawn to each other: Buchenkamp, a widower, and his daughter Marie. These two people, working with effort, straining and sweating, but with 'Lustigkeit,' gradually grow aware of each other's physical presence, especially when they both remove part of their clothing. Marie experiences the sensuous touch of the grass and associates this with her father: 'so steigt ein wildes Prickeln fiebernd an ihrem Leibe hoch. Und sie fühlt, wie er – denn sie sagt in Gedanken "er" –, wie er ihr folgt, wie sein Blick auf ihrer halben Nacktheit liegt, deren strotzende Fülle das eng am Leibe liegende Hemd kaum umfassen kann; sie fühlt es, aber sie hat nur das eine Gefühl: es ist mir gleich' (334). When her breasts are exposed, she does not cover them: 'Ihr Blick aber fängt an, den seinen zu suchen und zu meiden.' The result is that father and daughter make love together. Sack insists on the great tenderness of the whole episode and describes the two going home 'Hand in Hand, schweigend wie Verliebte' (336). There is no violence, no guilt, even though we are dealing with incest, and when Marie becomes pregnant they insist against the opinion of the world on having the child. Sack's ironic tendency breaks through in the end, when the young child is itself initiated into sex by his mother, yet in view of the tone and setting of the novelle it seems probable that the love experience described is meant positively. Sack detested romanticizing and idealizing love and sex, and, being able to maintain a certain distance from his subject matter through irony and because of his distrust of all-embracing chaotic emotions, he could escape the fate of so many Expressionists whose dualistic thinking resulted in the many aberrations we have encountered before. Dieter Hoffmann writes: 'die Trieb-

haftigkeit konnte bei Sack niemals ... zur Dämonie werden, denn jedes Gefühl, das ihn restlos mitgerissen hätte, fürchtete er als Kitsch' (P406/ 71).

Exemplary of this attitude is above all the short story 'Der Rubin' (P118 = P406), in which tragedy is avoided precisely because the hero can distance himself from his idealized woman and see her as the creature she is. The ecstatic celebration of love in the first half of the novelle is replaced by the realistic depiction of the underlying *sexus* in the second. In the first part the vulgar Madelon is transformed into a divinity; in the second she is called 'Dirne,' and whipped until laughter overtakes both man and woman and their sex play begins anew, but on a more realistic level. The two segments of the story are separated by a scene which takes place in the man's imagination. The soldier awaits his arrest and shoots himself. This *nexus*, the moment of pathos, is a turning point; immediately sentimentality is replaced by anger, which avoids both pathos and kitsch. The love affair is reduced from lyricism to realism, from 'hohe Minne' to sex. As such it is not in any way seen as less desirable. On the contrary, for Sack (and his letters to his wife bear this out) love is by no means diminished for being rooted in the realities of the body.

Several Expressionist novellen and short stories in which Eros plays a large role may be considered to be proposing in the couple a first step towards a new community and utopia. Once again, however, the clash between the ideal and the real may lead to a sense of despair about the possibility of realizing such a utopia; death is often the only way to consummate the I-Thou relationship. As we saw in an earlier chapter, Alfred Wolfenstein postulates in 'Ohnmacht' such a utopia in the freely accepted death of the girl Dika with her beloved. In Heym's 'Jonathan' contact is brief, and only in the visions of death can the idyll become reality. Zait and Hesi, in Loerke's 'Das Goldbergwerk,' project their union into a future which will never be; it is a 'Märchen.' In Max Brod's 'August Nachreiters Attentat,' finally, the utopia is debunked as illusion and kitsch.

The depiction of sexual relationships as symbolic of the imperfect state of the world, with all the cruelty, madness, suicide, murder, and general, perpetual conflicts which flow from it, is relevant to an understanding of the society from which Expressionism originated, and also to an understanding of the Expressionist movement itself. Roy Pascal rightly remarks: 'Where sexuality dominates all else, or where sexuality appears as merely physiological ... it is presented, with or without the conscious connivance of the author, as so great a human deprivation or distortion as

to undermine the whole will to life' (S164/254). The demonic aspects of the erotic in Expressionism thus point to a basic inability on the part of the fictional heroes, as well as the authors themselves, to cope with sex, but also with life itself. Where love appears as an unattainable ideal, life has become impossible to live.

The search of Expressionism for *Erlösung* through sex, when it fails (as it must), means more than personal defeat. It makes questionable the whole concept of *Erlösung*. And yet, even in presenting erotic relations as predominantly problematic, the Expressionist author still refers to the ideal he carries within himself. Even where love fails, the destruction of the ideal does not imply its irrelevance; on the contrary, the ideal becomes more desirable.

The mistake of the Expressionists was that for their idealization and even idolatry they chose the wrong object. The object of ecstasy and worship cannot be finite and immanent; the longing for transcendence has as its appropriate object the transcendental itself. True ecstasy can only be of a religious nature. Martin Buber, in his *Ekstatische Konfessionen*, writes: 'Das, was in der Ekstase erlebt wird ... ist die Einheit des Ich. Aber um als Einheit erlebt zu werden, muss das Ich eine Einheit geworden sein. Nur der vollkommen Geeinte kann die Einheit empfangen' (P333, vol. 1/167). Perfect union is impossible in sex, as the Expressionists show time and time again. Union, if it is to be perfect, can only be achieved in the *unio mystica* with the Creator himself. Inevitably, therefore, the Expressionist's search for ecstasy, for an end to individuation, for *Erlösung*, has to lead him to attempt a 'religious' solution, even in a secular age.

TEN

God and the
Search for Utopia

T HE PRESENTATION of man's imperfect condition in pathos and the criticism of the world in satire and polemics offer an essentially pessimistic outlook on life, though the perfectability of the world is not necessarily denied in either. There exists, however, an escape out of the dualistic and therefore oppressive vision of pathos and the ambiguities and incongruities of the satiric vision, in the form of a projection of future changed societies on the one hand and a more direct but also more intangible *unio mystica* with God or the numinous on the other. These visions are not by definition contradictory, for they hinge on a concept common to both religion and utopia: the idea of a universal brotherhood of man. In the union with God and in the community of man Expressionism saw its most profound dual goals. To be sure, many authors decided resolutely in favour of one or the other, but to speak of Activists on the one hand and Expressionists on the other confuses these issues. In a movement as complex as Expressionism it is not surprising that borderlines between the religious and the profane are not always respected. On the one hand we may see a great deal of secularization in religious or, to use a term borrowed from Wolfgang Rothe, theological writings; on the other hand what seem purely worldly writings (even those dealing with politics, war, and revolution) are frequently infused with religious thought. In the case of writers like Leonhard Frank and Alfred Wolfenstein we may even see the attempt to come to a complete fusion of the two, in the idea of a Christian socialism. But whether in search of the utopia or in search of God, it is the here and now rather than the hereafter which is the concern of Expressionists.

In an article entitled 'Das religiöse Bewusstsein des Expressionismus' Eckart von Sydow noted that the advent of Expressionism had brought

with it a renewal of religious interest, which in view of Nietzsche's proclamation of the death of God appeared to him rather a paradox: 'nun regen sich, zum mindesten in den verschiedenen Bekenntnissen expressionistischer Führer, "atavistische" religiöse Neigungen in ganz unzweideutiger Art' (P281 = P333, vol. 2/266). Sydow goes on to quote Franz Marc's belief in a 'mystisch-innerliche Konstruktion' as the central problem of his generation. According to Marc the goal of the new art must be 'Symbole zu schaffen, die auf die Altäre der kommenden geistigen Religion gehören und hinter denen der Erzeuger verschwindet.' This belief is echoed by Wassily Kandinsky's demand for a 'göttliche Sprache' and by Kasimir Edschmid's statement that art is to be an 'Etappe zwischen den Menschen und Gott' (266).[1]

Sydow's argument is that the artists cited are not only interested in defining art in terms of religion (Johannes Molzahn going as far as calling God himself 'der grosse Expressionist' [269]), but that they also show a preoccupation with religion for its own sake. Indeed, statements similar to those cited by Sydow could be multiplied almost at will. Edschmid's 'Sehnsucht nach dem Unendlichen' parallels Albert Ehrenstein's longing 'nach dem Anderen, Nichtvorhandenen,' and in ficitional writings it is this very longing which destroys the heroes of Oskar Loerke's story 'Die Puppe' and Alfred Lemm's 'Weltflucht.' And yet, characteristic of all these examples is the vagueness with which religion is defined – a vagueness which has earned Expressionism the epithet 'mystical,' though Expressionist longing and striving for a metaphysical dimension cannot really be brought under such an easy common denominator. On the contrary, the original religious impulse does not lead to a consensus but rather to a variety of religious experiences.

The common impulse itself is, as in other domains, connected with the rejection of the status quo – more specifically, with the rejection of conventional notions about God and the church. Expressionist hostility to organized religion is inspired by the belief that religion is yet another attempt by established powers to reinforce an already intolerable hold on society. In Sternheim's 'Heidenstam,' for example, religion is revealed as an attempt to sanction an egotistical, ruthless pursuit of materialist ends: God is the 'Präsident der Gesellschaft Deutschland.' In 'Die Krise der Kirche' Franz Blei accuses the churches of collaborating with the state in maintaining social injustices; for him the clergy are little more than civil servants. Wolfgang Rothe sums up the prevailing arguments of many of the Expressionists against the churches: 'Die Reduktion von Theo-Logie auf Religionspsychologie und Moraltheologie, die Verkümmerung der

Kirche zur "Sittenpolizei" durch die Verwechslung von Religion und Ethik, kurz, das "liberale" Christentum des "Kulturprotestantismus" und die seit der Gegenreformation zur Sakramentsverwaltung ohne prophetischen Schwung verkrustete Katholische Kirche erfuhren … ihr Nein aus dem Munde der jungen Generation' (S199/58).

Particularly when assessing the success of the churches in implementing their social and humanistic goals, the Expressionists found much to criticize. In this they follow the Naturalists, who rejected with indignation the idea that social misery is a God-given condition. Gerhart Hauptmann had already heralded this theme in 1910, in his novel *Der Narr in Christo Emanuel Quint*, and Expressionists continue to treat it throughout the period under discussion. But if criticism of the churches is universal, the alternatives to traditional, organized religion are not so easily recognized. If there is a move away from the belief in conformist piety as a guarantor of redemption, the subjective but in the final analysis conveniently vague and non-committal religion of the Schleiermacher variety is also dismissed.

This latter point is important, since I have repeatedly claimed that subjectivism may be seen as one of the outstanding characteristics of Expressionism. If these writers nevertheless now appear to desire a more objective relationship with God, this is so because at least in *this* domain there is a nagging feeling that subjective philosophy has failed to provide answers. But even though the transcendental seems to hold out some hope of a way out of the apparent absurdity and meaninglessness which follows in the wake of purely subjective speculation, there can be no doubt that there is no return to the old anthropomorphic God with ascertainable attributes, for he can no longer satisfy the needs of modern man. There is, on the contrary, a painful awareness of an enormous distance separating man and God. Intense longing and the realization that God is a *deus absconditus* therefore create much of the religious pathos of Expressionism, and also inform the search for alternatives so characteristic of the period.

The pathos of a distant God is well illustrated in Kasimir Edschmid's novelle 'Der Gott' (P32). The story's hero, Jean François, is frustrated in his attempt to establish, on a tropical island, an idyllic sexual relationship with a native girl, Kalekua. In Kalekua's thinking, Jean François is a god, and a union on a merely human plane would be sacrilege. It is in vain that the hero shouts his defiant insults in the face of the true but hidden God who allows him to suffer. Jean François finally joins Kalekua in suicide, conceived of as a kind of sacrifice. The story demonstrates the 'absoluter

Pathos der Distanz' between man and God of which Emil Brunner speaks (quoted S199/39).[2] Such distance rules out a definition of God based on traditional knowledge. In fact there are many authors who reject the idea of knowing God altogether. Oskar Loerke's message in 'Die beiden Götter,' for example, is one of agnosticism.

The impossibility of knowing God and of interpreting his intentions is also the theme of Franz Jung's disturbing, strangely hybrid prose work 'Saul' (P75). It is a mixture of drama and novelle, showing the extremely frustrating dialogue which Saul tries to maintain with God. Saul's efforts to interpret signs allegedly coming from God lead to acute existential anguish. Isolated from his people, in doubt whether to go into battle against his enemies or to pursue the rebellious David, Saul constantly makes the wrong decisions. Too late he realizes that he has been blinded by God. As Armin Arnold writes: 'Gott spielt mit ihm wie die Katze mit der Maus' (S10/60).

In discussing Expressionist drama Karl S. Guthke has drawn attention to the appearance of a 'grausamer Gott' in many stage works – an indication of Expressionism's gradual disenchantment with its own lofty ideals (S77). But if God does indeed appear as a manipulator of man as marionette, as he does in 'Saul' and in some of Ehrenstein's sketches and stories, it must be remembered that the anguish associated with the search for God does not mean that God himself is cruel and malignant but that the extreme degree of emotional involvement of the author causes this anguish. It is in this light that one would have to interpret, for example, Ehrenstein's near-blasphemous poems which address God and challenge him to reveal himself.[3] Nevertheless, the religious problem ultimately comes to be formulated in terms of the existence or non-existence of God.

A good indication of the doubts which assailed many authors about the existence of God, or more generally the existence of a transcendent Being, is the way in which death is treated by them. Some authors tend to move very far away indeed from Christian values, death often taking its meaning exclusively from criteria relating to the here and now. In Klabund's prose, for example, death is 'golden' when it is heroic (like death on the battlefield); by contrast, it is meaningless when it results from illness. In a similar fashion, Oskar Loerke, in 'Der Sandberg,' rejects suicide for reasons having nothing to do with traditional beliefs but because it is meant there to compensate for the imperfections of life. The story's protagonist is condemned because death in this story is part of what Erika Lozza calls 'die Gegenwelt,' in which 'die persönlichen Wünsche und Sehnsüchte, Hoffnungen und Erwartungen zur vorherrschenden Macht, die die Wirk-

lichkeit und ihre Gesetze entweder übersieht oder verleugnet' are made possible (S137/36). At the same time, death plays a positive and necessary role in Edschmid's thinking because it is associated with his concept of heroism, whose tragic dimension would be impossible without it. It is therefore not surprising that death appears as one of the six 'Mündungen' to which Edschmid refers in the title of his first collection of novellen. In all these cases, whether death is seen as the great comforter or as the great destroyer, it draws its meaning from life rather than from a possible transcendental realm – proof positive that not all of Expressionism has a 'mystic' quality.

The religious character of Expressionism appears even more complex if we attempt an interpretation of its religious symbols. Wolfgang Rothe has claimed that much of the poetry of Franz Werfel and Else Lasker-Schüler uses Christian and Jewish symbolism and vocabulary as *topoi* rather than out of genuine religious conviction. In Expressionist drama too, when we encounter the symbols of conventional religion, such as the cross in Georg Kaiser's *Von morgens bis mitternachts*, or in Kornfeld's *Himmel und Hölle*, the evidence seems to suggest a secular interpretation, though such first impressions can be deceptive.

In focusing on an image occurring in three short works of Expressionist prose, namely that of Christ on the cross, we might illuminate the problem of secularization and at the same time shed some light on a central and complex religious theme in Expressionism, that of *Erlösung*. The fact that Franz Werfel in 'Blasphemie eines Irren,' Ernst Weiss in 'Hodin,' and Georg Heym in 'Der Dieb' all used this image as the starting-point for their stories attests to the burning actuality of the theme. It has in fact been argued by Roy Pascal that 'it may be said to record the heartbeat of "die Moderne,"' its treatment 'illustrating in a poignant way the successes and failures of the artistic imagination' (S164/196). Though the three stories are no masterworks, they do illustrate a variety of approaches to religious themes and are part of the religious debate carried on elsewhere in drama, essays, and lyric poetry.

Werfel's 'Blasphemie eines Irren' (P141 = P324) is a grotesque story. It is the dialogue of a madman. But this madness has the function of exploring a serious problem, for the theme of redemption is announced in the madman's confession that he is God and that he has failed in his mission to redeem the world. Christ's words on the cross, 'Mein Gott, warum hast du mich verlassen?' are quoted in support of this thesis. The explanation of his failure is striking: 'Ach, ich dachte eine ganz geringe Spanne lang, eine ganz kleine Weile lang – an die Tränen, die meinem Tode fliessen werden,

an die Verehrung, an den Beifall' (P324/289). The cross is the 'Prüfung der Götter' in that it provides a most insidious temptation, that of pride, even of pleasure, in martyrdom.[4]

This charge of epicureanism, the source of which we shall trace later, is merely the starting-point for an involved but important discussion of the whole concept of *Erlösung* and its importance to the Expressionist movement. Werfel's story in fact lends itself very well as an introduction to the debate, particularly since it shows immediately the problematic nature of the concept once it is transposed into a contemporary and banal setting.

Ernst Weiss's 'Hodin' (P138 = P415) shows strong parallels with Werfel's story in its combination of madness and religious concerns. Again the symbol of Christ on the cross is interpreted by a pathological first-person narrator, a convicted multiple murderer, who is first drawn into a career of crime when he kills his mother because of her infidelity. Hodin draws a parallel between himself and Christ, on the basis of which he justifies the murder he has committed. The parallel is far from flattering to Christ. He comes under attack for several reasons. First, there is the denial of his birth of woman in his words 'Ich bin keiner Mutter Sohn' (263). This claim indicates, according to Hodin, that Christ preferred purity over the common bond between men. Christ also died a virgin, one more indication of his 'menschenfeindliche Gesinnung' (250); finally, Christ's misanthropic attitude comes out in his death, which Hodin interprets as suicide. Christ 'freed the world of himself,' 'indem er seine Ermordung und Kreuzigung vorspiegelte, um ungestört, also im tiefsten Sinne durch eigene Hand, Selbstmord (nicht des Leibes allein) begehen zu können' (258). Christ is a coward running away from a reality which he was unwilling to change, even though it is a cause of suffering. The reason for Christ's suicide and failure lies therefore, according to Hodin, in Christ's purity. The refusal to engage in sexual activity and procreation makes alternate outlets for desires and passions necessary, and Christ found these in the 'Wollust des Mordens' (267), even though in this case it is only self-murder. Under these circumstances Christ had to fail in his mission.

Georg Heym's 'Der Dieb' (P65 = P372) also presents the combination of madness and longing for redemption, but it climaxes in an actual attempt to bring this redemption about. In the beginning we are close to the spirit and tone of Werfel's 'Blasphemie.' The religious theme is introduced by way of the same reference as in Werfel and Weiss, namely Christ's cry of despair. Once again this indicates failure: 'Damit begrub er seine ganze Herrlichkeit. Im Grauen des Todes hatte er die letzte Wahrheit erkannt.

Sein Werk war umsonst gewesen' (75). As in Werfel's case, Christ's failure is responsible for the continued existence of evil in the world. Two powerful images sum up man's condition: man must fall back into sin 'wie ein Stein zurückfällt, und wäre er bis über die Wolken geschleudert worden'; and men resemble flies 'die aus einem Honigtopfe herauswollen, sie zappeln und krabbeln, aber sie kommen nicht weit, sie müssen immer wieder herunter unten in die Sünde, in das Süsse' (74). During long nights of fasting and praying, of visions and ecstasy, there comes to the hero the revelation that woman, 'das ursprünglich Böse' (74), is responsible for Christ's failure. The verses in the seventeenth chapter of the Revelation of Saint John point to Eve and the Whore of Babylon as the symbols of woman responsible for man's fallen state. Since Christ was also born of woman (Heym's hero deviates from Weiss's on this point), 'so musste alles noch einmal getan werden, denn das Tier war noch nicht bezwungen' (74). The hero intends to steal the painting of the Mona Lisa from the Louvre in order to destroy it, because it is the symbol of blasphemous idolatry of woman. Ironically, the success of the theft ushers in the beginning of the end, for the fascination with the painting as a work of art as well as an object of sexual attraction prevents its destruction until it is too late. When the thief finally decides to burn the painting, the house catches fire and he perishes in the blaze.

Even a cursory reading shows some striking parallels among the three stories. All three present the central figure of Christianity in a dubious light. Redemption has not taken place; Christ has failed in his mission. All three stories express the disillusionment with Christ through the mask of a madman, thereby linking religion and religious quest with madness. All three pose the necessity of another kind of redemption, but there is considerable divergence as to the form this second redemption must take.

A basic dualism becomes evident. These stories reject Christianity and its central figure, yet they demonstrate a continuing quest for a religious dimension and even employ the Christian myth and its symbolism for this purpose. In their ambivalence they are a good illustration of the atavistic tendency to which Sydow referred. But to what extent are these writings in fact religious writings?

Wolfgang Rothe has argued that apparent secularization may in fact be a subtle form of theology; he thereby places himself in direct contrast to Roy Pascal's contention that 'there is probably no more overworked word than "Erlösung" in some secularized [!] form of its range from "salvation" and "redemption" down to "release" and "relief"' (S164/161). In the wake of

Kierkegaard's 'dialectical Revolution,' worldly treatment of religious themes does not *a priori* mean secularization according to Rothe: 'Theologisch relevant kann fortan grundsätzlich auch eine Literatur sein, die sich entschieden dem Menschen und seinem irdischen Dasein zuwendet' (S199/55). And he continues: 'Wer dem Expressionismus also Verweltlichung religiöser Motive und christlicher Gestalten vorwirft, urteilt von einer vorkierkegaardschen Position aus' (56).

The question is in fact whether it was possible for Expressionism to discuss redemption and the redeemer without some degree of secularization. It can be said in defence of Roy Pascal that the concept of redemption itself, and with it the figure of Christ, had long before Expressionism undergone substantial changes. Friedrich Nietzsche is only one link in a chain of ever-increasing secularization. Some degree of secularization can actually be traced as far back as the Renaissance, as I have argued elsewhere (S41), the modified idea of redemption itself providing the momentum for this development.

By the end of the eighteenth century this development reaches a crucial point; so far has secularization advanced that Christ himself can be seen as a historical figure only. The longing for redemption can then be given the character of a psychological trait. In this development Goethe's *Werther* stands at the crossroads. In his letter of 15 November, Werther mentions the bitterness of death in words echoing those of Christ and using the image of the cup of poison. He also quotes Christ's words of momentary despair. This identification with Christ becomes stronger the closer Werther moves towards his decision to commit suicide. In the case of Georg Büchner's *Dantons Tod* the identification works in reverse: where Goethe lifts Werther up to Christ's level, Büchner brings Christ down to the level of man. When Büchner has Danton say 'Es gibt nur Epikureer, und zwar grobe und feine, Christus war der feinste,' Christ is seen as human, and the comment makes of Christ a psychological type. The charge of epicureanism which makes of Christ's martyrdom a form of suicide does not fit the orthodox view of Christ.

The historical and psychological interpretation of Christ and his mission is pursued by many nineteenth-century thinkers. Oron J. Hale writes: 'Reassessment of the central figure of Jesus had ... been a feature of the Modernist movement among Protestant scholars. Beginning with Renan's *Life of Jesus* and David Friedrich Strauss' *Life of Jesus adapted for the German People*, there appeared a score or more of "liberal" lives of Christianity's central figure. All emphasized the "Jesus of history" and

ignored the "Jesus of religion."'[5] Paradoxically, the constant undermining of the 'Jesus of religion' only led to the destruction of the 'Jesus of history' as well. By 1885 Bruno Bauer, Franz Mehring, and Karl Kautsky could claim 'that there is nothing certain we can say about the person of Jesus and that Christianity can be explained without introducing this person.'[6] It was to counter this trend that Albert Schweitzer in 1906 published the first truly challenging reinterpretation of Christ in theological terms, in *Von Reimarus zu Wrede.*

By far the most important analysis of the figure of Christ, however, was undertaken by Nietzsche. Nietzsche had some harsh things to say about redemption, a perverse notion inspired by the concept of guilt, which in turn resulted from the ascetic attitude towards life of all priests, but particularly of Jewish thinkers. The high point of this perverse way of thinking is reached, according to Nietzsche, in the symbol of the crucified God: 'Wüsste man sich ... aus allem Raffinement des Geistes heraus, überhaupt noch einen *gefährlicheren* Köder auszudenken? Etwas, das an verlockender, berauschender, betäubender, verderbender Kraft jenem Symbol des "heiligen Kreuzes" gleich käme, jener schauerlichen Paradoxie eines Gottes am Kreuze, jenem Mysterium einer unausdenkbaren letzten äussersten Grausamkeit und Selbstkreuzigung Gottes *zum Heile des Menschen*?' (S160, vol. 2/781) Nietzsche echoes Büchner's comment in *Dantons Tod* when he calls Christ's idea of redemption 'eine sublime Weiter-Entwicklung des Hedonismus auf durchaus morbider Grundlage' (S160, vol. 2/1192). Its closest relative is 'der Epikurismus, die Erlösungs-lehre des Heidentums,' for which he claims, however, a healthy dose of 'griechischer Vitalität und Nervenkraft.' Nietzsche too sees Christ's mission as a failure, largely because his message was distorted by his disciples. In view of this failure, he therefore proclaims, in *Also sprach Zarathustra*, a second redemption, but of a secular nature, not in the form of a future utopia, but as a state of the individual's heart.

Nietzsche's historical and psychological discussion of Christ clearly stands in the tradition of the secularizing movement of the nineteenth century. Certainly the distance travelled between Kierkegaard and Nietzsche is considerable. That all three prose works under discussion have Nietzsche's interpretation as a point of reference should be clear from the fact that they readily accept Christ's failure. Moreover, the identification with Christ, which we also saw in Goethe's *Werther*, and which provides the motor for the action of these stories, is the result of a 'Nietzschean' analysis of Christ, not as a figura, as in religious writings, but as a

psychological type. Büchner, Nietzsche, Renan, and Strauss provide the background for the attempts of the protagonists of these stories to achieve the status of redeemer.

Is it nevertheless possible to opt for a theological interpretation along the lines suggested by Rothe? A closer examination of the three stories seems to suggest that the case for theology is the strongest in Werfel. Like Nietzsche, Werfel cannot accept redemption as uniquely associated with Christ. But Werfel goes beyond the mere criticism of Christ: he joins some Expressionist and other contemporaries in showing resistance to the idea of *any* kind of divine intervention in history, because, as Paul Tillich remarks in *Kairos*, the wish for the realization of eternity *in* time, which is involved in the traditional notion of redemption, overlooks the fact that 'das Ewige die Erschütterung der Zeit und all ihrer Inhalte ist (quoted S199/56).' In the 'Argument' preceding the play *Paulus unter den Juden* Werfel himself states: 'Das Wesen des Göttlichen ist es gerade, dass es sich mit dem Weltlauf nicht vereinigen kann und in dem Moment, da es die Geschichte berührt, sie zugleich aufhebt' (quoted S199/56). Werfel is therefore forced to break with the traditional notion of redemption through Christ. This has serious consequences for Werfel's world-view. By rejecting redemption Werfel indirectly accuses the utopian Expressionists of shifting their attention from practical and immediate problems to the transcendental notion of redemption. Werfel would have agreed with Roy Pascal's criticism of the Expressionist preoccupation with redemption, which causes practical problems to become 'of a derivative character, second in importance to the subjective, spiritual experience, even acquiring importance only as a means to the spiritual experience and change' (S164/195). The 'sinister side' of the search for redemption, be it in a religious or secular sense, is the abandonment of the hope of changing reality gradually, in favour of a sudden miraculous transformation. For Werfel the corollary of the dismissal of redemption must be the dismissal of utopia also, since it is but a secular form of redemption.

But there are other reasons that the idea of utopia is uncongenial to the madman-God, and here Werfel begins to part company with Nietzsche. In turning to the concept of 'Leid' and in interpreting it as a necessary part of human existence, Werfel reintroduces the idea of guilt and atonement which Nietzsche had so peremptorily rejected. Suffering as a means of personal redemption has no comparable role to play in Nietzsche's philosophy. Rather, Werfel touches on a complex of ideas akin to those dealt with in the novels of Dostoyevsky and Tolstoy. If the madman is indeed a mask for himself, Werfel rejects the preoccupation with utopia primarily

because suffering is a moral good. It is in this context that the outburst of madman against the 'Gerechten' must be understood. Werfel aligns himself with Expressionists like Alfred Brust, who in *Schlacht der Heilande* declares: 'Man kann den Menschen jeden Tag sagen, dass die grössten Sünder dem Himmelreich am nächsten sind; sie begreifen es nicht. Die grossen Christen waren zunächst grosse Sünder' (quoted S199/58). And Emil Brunner goes even further: 'Denn die Sünde ist genau so notwendig wie das Gute' (quoted S199/59).

Such notions about the function and necessity of guilt and suffering are also found in Georg Kaiser's *Gilles und Jeanne* (1923), Hasenclever's *Die Menschen* (1918), Alfred Brust's *Der ewige Mensch* (1919), and especially in Friedrich Koffka's *Kain* (1917). The idea is also stated by Hermann Kasack in *Die tragische Sendung*: 'Die Lösung "durch den Schmerz zu Gott" ist nicht die der Gerechten und Frommen, dessen darum der Himmel nicht wird, sondern des Sünders' (S199/59); it is echoed by Franz Werfel himself in 'Blasphemie' in 'God's' words 'Ich liebe die Sünder ... denn sie sind nicht böse.' Thus, while accepting Nietzsche's rejection of redemption in its traditional form, Werfel goes on to deny the value of utopia and to reaffirm the value of suffering. His interest in a form of theodicy and in the attempt to elevate the dignity of suffering causes the story to have a strong religious flavour, despite the apparently Nietzschean point of view. The story in fact sums up in a nutshell Werfel's gradual moving away from Nietzsche, a development we can also trace in Reinhard Sorge, as Walter Sokel has shown.

That the treatment of Christ by Nietzsche and similar secularizing thinkers also provided the model for Ernst Weiss's 'Hodin' is clear. But whereas in Werfel's case the acceptance of the Nietzschean view of Christ's failure is coupled with an at least semi-religious acceptance of suffering as a means of personal redemption, we feel less certain about the thrust of Weiss's story. There is some ground to see in Hodin a 'Gottverfolgter' and 'Sünder,' but there is little indication that Weiss meant Hodin's career to be a valid road to God. The parallels which Hodin establishes between himself and Christ rather amount to what is a much truer 'blasphemy' than Werfel's. Hodin's attacks on Christ originate in a pathological constitution far too personal to become paradigmatic for a man searching for a religious dimension. Elsewhere, notably in 'Daniel,' Weiss shows that he is a religious writer occupied with the role of the prophet, but along much more orthodox lines. Weiss too takes up the theme of the self-indulgent and egocentric God, but he finally differs from Werfel in that he does not propose a social, human solution to the problem of

redemption. Weiss's religious arguments are in fact only part of the novelle's interest; the main emphasis lies elsewhere, namely, as is usual for Weiss, in sexual and psychological problems, in the motivation for murder, in the neurotic, compulsive behaviour of the hero. Weiss's fascination with (Freudian) psychology leads him to construct a rather complex chain of associations in which the figure of Christ plays an important but not exclusive role. The often obscure language of the novelle facilitates this kind of association, but should warn us also that we are dealing with a highly subjective train of thought, valid only in the protagonist's consciousness.

The problem of secularization becomes even more acute in the case of Heym's 'Der Dieb.' In 'Jonathan' Heym had already hinted at Christ's failure, in the symbol of the crucifix. We ought therefore to be prepared for another 'blasphemy.' Madness, on the other hand, was dealt with by Heym in his cycle of poems entitled *Die Irren*, as well as in the novelle 'Der Irre.' That a form of 'Seligkeit' is reached at the end of the latter seems to suggest, and Rothe has pointed this out, that for Heym madness may be a road to redemption.

The opening of 'Der Dieb' does indeed seem to announce a genuine metaphysical theme; but this impression is quickly dispelled, primarily by Heym's presentation of the hero and by his narrative technique. The hero's speech, characterized by frequent interruptions and interjections, his erratic behaviour and listening to 'voices,' the comparison of the thief's garret to the Garden of Gethsemane – all these elements do not, as in *Werther*, reinforce identification with Christ but only serve to strengthen the impression of a ludicrous discrepancy between the shabby crime contemplated and the alleged sublimity of the thief's 'mission.'

About the magnitude of this mission there never exists any doubt in the hero's mind. Even though his submissive attitude to God's calling is reminiscent of Christ's ('Er lag vor Gott im Staube, er demütigte sich, er riss seine ganze Seele auseinander und liess Gott hineinströmen wie einen Rauch, wie ein Fluidum' [P65 = P372]) it is also curiously tinged with excessive pride: hence the megalomanic tendency in the thief's descriptions of the 'battles' he wages against the charm of the painting. Biblical language runs through the whole novelle, but it only confirms our impression of the madness and fanaticism of the hero. Analysis reveals that the theme of redemption, like the religious theme in 'Der Irre,' serves primarily as the motor of the colportage-like action. The religious content is clearly subordinate. Particularly the end seems to indicate that what fascinated Heym was action for its own sake and the construction of

a tale full of contrasts, bold scenes, and a strong 'Expressionistic' language. The obvious enjoyment in describing the elaborate plans for the theft of the painting, the gusto with which Heym describes the final fire and the death of the firemen, which in effect shifts the focus away from the hero (so that he now becomes little more than an incidental character in the catastrophe), as well as the frequent ironies, all indicate that a rather playful attitude towards the ideas expressed in the novelle are called for.

Our conclusion is clear. The context in which the theme of redemption (and any other religious theme) appears is as important in determining the meaning of a given religious reference as the source from which it stems. But only when, as in the case of Heym, the religious theme or symbol has become mere *Stoff* can we speak of true secularization.

A phenomenon resembling secularization is syncretism. In Expressionism it provides evidence of the movement's search for a binding value-system in the wake of the collapse of Christianity. Interest in the Far East inspired Klabund and Ehrenstein to use symbols and myths of that region. In Klabund's 'Die 99. Wiederkehr des Buddha' the opposition between East and West results in the rejection of the latter. Klabund uses the age-old device of introducing an alien (here Buddha) into a Western society as a kind of acid test of the values held by that society.

At the furthest end of the spectrum of progressive secularization are certain writings which move away completely from established religions and towards a new emphasis on nature as a divine inspiration. This new experience of nature is already evident in Naturalism and is partly a reaction against the antinomy inherent in Christianity between nature and spirit. However, when nature and astral myths are introduced into Expressionist literature, it is usually with a view to reaching a synthesis not between religion and nature but between man and nature, in a radical departure from Christianity.

This is particularly the case in the writings of the philosopher Salomo Friedlaender, who, under the name of Mynona (a palindrome of Anonym), wrote a great number of *Grotesken*. In most of Mynona's *Grotesken* the highest authority in the cosmos is the divine force of nature itself, usually embodied in a celestial constellation or star.[7] Nature is demonized, but not as in Georg Heym, by making it a theatre of threatening forces, but rather by showing it to be friendly, harmonious, and benevolent, albeit often incomprehensible. Nevertheless, Mynona sees man's present-day situation as problematic and therefore usually projects the desirable and secular synthesis between man and nature into the far-away future.

252 Themes of Expressionist Prose

A frequent motif of Mynona's *Grotesken* is that of humans being called to serve a cosmic force. In 'Die silberne Dose' a silver box functions as a token of the existence of a bond between man and nature. A small boy is chosen to receive the box as a gift from the moon because it is his mission to perpetuate the knowledge and understanding of this bond. Children are still close to nature and therefore more suitable for this mission. Similiar close ties between man and nature form the philosophical premise of the story 'Die vegetabilische Vaterschaft' (P106). From nature, it is stated there, there emanates a magnetic force. Flowers have a soul, and they may influence people. The story flows from this idea, and brings it to its logical conclusion by describing the copulation between a male flower and a young girl. Mynona's aim is to destroy the arbitrary barriers which scientific methods have set up between the animate and the inanimate, and to dislodge man from the central position in the universe to which he still clings tenaciously. Though the *Groteske* ends in parody and even self-parody, it shows, like the *Märchen*, its ability to demonstrate philosophical theses, in this case the idea that the whole universe is soul.

In 'Mariä Empfängnis' (P24 = P348) Alfred Döblin gives a similar view of the universe. The singularly introverted heroine Maria (the Virgin Mary) appears to have a particular affinity with her natural surroundings. Not only is she born to be a mother, but she also maintains a mystical relationship with nature. For Maria nature is associated with birth and motherhood. When during a heavy thunderstorm she seeks shelter in a young man's arms, a deliberately ambiguous incident occurs: 'Sie fiel ihm, als die Erde zu beben begann und eine Donnerstimme mit lohendem Purpur und Schwefelgelb aufbrüllte, totbleichen Gesichts in die Arme. In dem dichten Dunkel fuhren Hände ihr über Gesicht und Haare, sie hörte nach dem herrisch befehlenden Donnerschlage heisse Flüsterworte. Er nahm sie hin, die wie ein leichter Ast an seiner Schulter hing, mit ganz entspannten Gliedern und zitternd' (P348/23). Döblin's narration, far from being 'objective,' here has the function of obscuring this episode. The parallelism of anthropomorphized nature and the intervention of the male allows for a process of mystification, first on the part of Maria, who believes in her immaculate conception, then on the part of the narrator himself, who refuses to explain Maria's pregnancy.

Walter Muschg has provided a psychological interpretation of this story which seems tempting at first. Muschg sees in Maria's bond with nature an indication of her incapability of dealing with male sexuality (P348, 'Nachwort'). This leads her to shift the source of conception from

the young man to nature, viewed as divine. Maria calls the child 'Gottes-pfand.' For the modern reader the tendency to explain the mystery in terms of modern psychology – that is, sublimation of an unacceptable and crude reality – is indeed almost inescapable. Knowing what we do about Döblin's aversion to such psychological explanation, however, we should be careful not to fall into this trap. Moreover, if we refer back to the perspective of the Novelle itself, it is possible to arrive at a very different intention. Maria's interpretation of conception as miracle is not necessarily motivated by the Freudian psychology of repression and sublimation; rather, Maria believes the natural world capable of performing miracles, and in a fairly mundane sense the birth of any child is a miracle. But Döblin's intentions are still different. Müller-Salget claims that we are dealing with a 'Vereinigung der universalen Naturmacht ... mit dem menschlichen Wesen,' not so very different from Mynona's 'Vegetabilische Vaterschaft' (S155/48). The novelle appears to be a reinterpretation of an old myth, a parable of the possibility of man's direct contact with nature. To both Mynona and Döblin the idea of a universe in which man is (or should be) closely integrated with nature is basic (see above the discussion of 'Die Segelfahrt' and 'Das Stiftsfräulein und der Tod').

A longing to re-establish harmony with nature is evident also in the works of Georg Heym, Ernst Weiss ('Atua'), and Gottfried Benn (*Gehirne*). It is an important theme in Oskar Loerke's writings ('Die Puppe,' 'Das Goldbergwerk'). The quasi-mystical experiences described in these stories are akin to ecstasy; they place the individual outside the realm of common humanity. They are otherwise possible only during subjective hallucinations. But the subjective vision and the experience of *Entgrenzung* and loss of self which come with such hallucinations (induced or not) must not be equated with the mystical experiences which Loerke, Mynona, or Döblin describe, for these latter experiences are 'objective' – that is, they originate outside the self.

Astral and nature myths are strongly influenced by two movements which came to the fore after 1900, the philosophy of Vitalism and the movement of Irrationalism. Eckart von Sydow argued, in an article cited previously, that Nietzsche had for the first time in European history emphasized the other side of God's duality: 'Diese zweite, unendlich kräftige Hälfte der Göttlichkeit nannte er das "Leben." Diese mythologische Gestaltung des "Lebens" gewann die wundervolle Gewalt und das unheimlich Unbezwingbare der Reden Zarathustras: den allmächtigen Überschwang der Lebendigkeit und des Willens zur Macht' (P333, vol. 2/ 267). In Nietzsche and to a lesser extent also in Bergson are to be found

the roots of the Vitalist movement, which exerted such a momentous influence on the writings about nature here under discussion. The shift to Irrationalism, however, is the Expressionist variety of a more general reaction against the predominant rationalism of the nineteenth century. To the Expressionists, rationalism, synonymous with egoism, is the attempt to maintain the self against outside influences and against others. Rationalism in literature is often embodied by figures who live a purely cerebral existence, consciously avoiding all emotional ties. Such are the cold-hearted fathers of Expressionist drama.

Expressionist forms of Irrationalism imply also a rejection of the achievements of the sciences, as we have had occasion to note. All of the *Grotesken* of Mynona are motivated by the wish to replace the modern scientific *Weltbild* by that of magic, fantasy, and imagination. The *Groteske* offers a singularly appropriate vehicle for the projection of alternative worlds, having different laws. Moreover, by postulating such fantastic contexts it also becomes possible to show the kind of utopia in which the desired New Man may appear. Satire against the sciences (for example, in 'Eines Kindes Heldentat') often goes hand in hand with a serious attempt to show utopia (as in 'Der Sonnenmissionar'). Mynona, Döblin, Einstein, and Benn bear out the statement by Max Picard, 'Der Expressionist ist ... unwissenschaftlich, er lehnt es ab, die Dinge aus dem Chaos nicht anders binden zu können, als dass er für diese Bindung neue Objektformen findet' (P259/337).

It is against this background of a collapse in faith in the philosophical, religious, and scientific *Weltbild* so proudly proclaimed in the late nineteenth and early twentieth centuries that we must see Expressionist attempts to come to a new, more appropriate relationship with God, or at least with a supernatural being. Some Expressionists believe that a direct dialogue with God is possible in privileged moments. In the drama of the movement, the process termed *Wandlung*, the sudden revelation of the true face of reality, often takes the form of a revelation of the existence of God. In prose there is a rather more cautious feeling about such experiences, but two Jewish writers, Ernst Weiss and Else Lasker-Schüler, present cases in which direct contact with God is shown as possible.

For Else Lasker-Schüler the religious dimension is indispensable in art: 'Wir Künstler sind einmal tief ins tiefste Mark und Bein Aristokraten. Wir sind die Lieblinge Gottes, die Kinder der Marien aller Lande. Wir spielen mit seinen erhabensten Schöpfungen und kramen in seinem bunten Morgen und blendenden Abend' (P387, vol. 1/151). The bourgeois,

'ein Schwerphilister,' is a mere 'Stiefsohn,' whereas the artist as visionary is so close to God that he can neither live nor create without him. In the modern world only artists and children still stand 'in der ersten Leuchtkraft Gottes' (148-9). In former days, however, many exceptional men could achieve direct dialogue with God. One such figure, Lasker-Schüler argues, is Christ. He is the perfect man, a prototype for the human species. Christ has shown men the role they must play in the order of creation. Not only are all men closely interwoven with nature; they are also chosen vessels for God's purpose: 'Wir sind das feinste Werk aus Sonne, Mond und Sternen und aus Gott. Wir sind seine Inspiration, seine Skizze zur grossen Welt ... Wir sind das glühendste Werk von Mond und Sternen, nach unserem Modell hat Gott die grosse Welt geschaffen' (146). And of all the men whom God created in his own image, Christ came closest to realizing that which for most men is a challenge rather than a given condition. So close did he in fact come to the ideal that some mistook him for God himself. For Lasker-Schüler Christ is a prophet, an intermediary between man and God. He shares this function with many other prophet-figures in Expressionism, such as the inspired rabbis in the works of Martin Buber and Otto Zarek, and in Lasker-Schüler's own 'Der Wunderrabiner von Barcelona' (P87). Eleasar, the main character in the latter story, is an Old Testament figure whose childlike character allows him in times of persecution and despair to carry a message of hope. God has put him upon earth as a messenger. The whole Jewish people in fact act as such a messenger, since, like Christ, the Jewish people show other nations the road to God through suffering: 'Hinschlachten lässt du deinen Lieblingssohn immer wieder, dass deiner heiligen Namen Posaune die Völker der Christen erwecke, und belohnst ihre scheusslichen Taten mit Erleuchtung' (P387, vol. 1/503).

The idea of prophets as intermediaries is also central to the novelle 'Daniel' (P136 = P332) by Ernst Weiss. The novelle begins with the birth of the prophet Daniel, accompanied by miraculous events, and tells how his parents, King Jojakim and his wife Rahel, separated. This separation leads first to Jojakim's loss of faith in God, under the impact of Nebuchadnezzar's splendid pagan court, and then to Rahel's falling away from God because her faith is intimately bound up with her love for Jojakim. This double loss of faith in Jehova in the first part of the story is then counterbalanced by the ascending line of development in the second half, relating Daniel's story. Though he does not actively seek God, Daniel is nevertheless prepared for his decisive encounter with him, and for God's special mission, through his development in tranquillity and peace. From the

beginning of the story Weiss uses religious vocabulary in connection with Daniel: 'Er stammte von Menschen, doch Menschliches war nichts an ihm,' he writes (9). Like Christ, Daniel is human in form only: 'Du sollst kein Mensch sein,' God tells him, 'es sei denn in deiner äusseren Gestalt. Dich nicht mit Menschentränen lösen, nicht mit Menschenlachen berauschen. Aber du sollst sehen, was kein Mensch gesehen, und hören, was kein Mensch aus Evas Schoss gehört hat' (71). Only by becoming more than a man can the prophet serve God. We are obviously dealing with an idea of mediation which differs from Lasker-Schüler's. If in 'Der Wunderrabiner von Barcelona' the mediation between God and the world was achieved through the word, here we are dealing with a process whereby God in human form partakes directly of the world. Weiss expresses this in a fascinating formula. God tells Daniel: 'Du sollst mein Jenseits sein' (76). The parallels with Christ, which are already strong in the story, are reinforced by this idea that God, having become separated from himself, must be reunited through the intervention of man and through the historical process: 'Ich war einst allein: Geist, Flamme, Rauch und Blut. Seit Urzeiten zerrissen. Nun will ich zurückkehren, mich mit mir vereinen. Ich will dich segnen und du sollst mich segnen ... Denn ich will in der Welt sein in deiner Gestalt' (77). The *unio mystica* between man and God is therefore dependent not only on man's impulse towards God but also on that coming from God. It is Daniel's mission to act upon Nebuchadnezzar and thereby make possible God's intervention in history.

The ideas expressed in this novelle are at once bold and puzzling. The rejection of the human dimension in favour of a mystical union with God is not typical of Expressionism, whose admiration for Christ, for example, was based primarily on his concern for suffering humanity. The denial of Daniel's humanity serves to illustrate the absoluteness with which he embraces the service of God, since God himself depends on it. This rather unconventional idea of God shows to what lengths the Expressionists were willing to go to establish a new relationship with God.

Of course the figure of the prophet points to yet another aspect of Expressionism. The function of the prophet is not only to exemplify the road to God but to bring into focus what lies in the future. The prophet is the proclaimer of what is to be. He announces a better world. In Expressionism he does so not only within the context of a fictional past but, as Rothe points out, within the context of the twentieth-century reality: 'Das Faible der Expressionisten für die archaischen Gestalten des Propheten und des Apostels wird überhaupt nur von [dem] paradigmatischen

Sprechen im Blick auf die unmittelbare Gegenwart her verständlich' (S199/55). The connection between the prophet and utopia becomes visible.

The idea of utopia is related to a new concept of religion in the modern world. Religion can only have legitimacy if it combines, as Sydow suggests, the spiritual, timeless aspect of man with his physical and temporal being. For the Expressionist a synthesis between world and God is a necessity. Particularly after the cataclysmic experience of the First World War there emerges a strong movement to unite religious and social thought in the concept of a spiritual and temporal utopia. It is easy to account for this religious revival by referring to the great feeling of disappointment which the exclusive concern with the here and now of politics had left after the war and the aborted revolution. Paul Kornfeld and Rudolf Kayser, for example, show themselves aware of the limitations of politics. The former writes: 'Man soll nicht hoffen, dass durch Politik der Zustand der Welt verändert wird,' and, with an even greater disillusionment: 'Man bekenne endlich, dass alle Politik ... Verwirrung und Humbug ist' (P230/ 5). This gloomy mood is echoed by Rudolf Kayser: 'Bekennen wir ehrlich, Politik allein bringt uns nicht weiter' (P225/284). To meet the needs of man, not new dogmas and programs are required, but 'der Aufstand von Hirn und Gefühl gegen Herzlosigkeit und Betrieb.' This must lead to a return to religion: 'so wissen wir doch, dass ein Franziskus uns näher steht als ein Lenin' (285).

The socialism of which Kayser dreams has a Christian basis. The two ideas of community and religion coincide in the idea of the brotherhood of man. Time and time again we encounter this idea of a Christian social brotherhood, above all in the essays which Alfred Wolfenstein collected in his periodical *Die Erhebung*. There Arthur Holitscher claimed: 'Wenn im heutigen Stadium des Kampfes sein Ende noch in keinem festen Umriss abzusehen sein mag, so gibt's doch Menschen unter uns, deren Augen das Endziel, sei es die Utopie oder das Paradies des herrschaftslosen Beisammenlebens der Menschen auf Erden nicht abhanden kommen kann' (P220, vol. 2/325). Holitscher sees in Christ's Sermon on the Mount a perfect 'Arbeitsprogramm' (326), and in the ideals of Russian Communism certain affinities with this program. Because both religion and socialism look to the future for the fulfilment of man's aspirations, he claims a virtual identity between the two. So confident is he in fact that the very impulse towards the establishment of both religion and socialism will lead to the establishment of utopia that he claims that the future has already become the present: 'Was heute geschieht, die Bewegung die

sich heute vollzieht, *ist* schon das Verkündete, das Reich der Propheten und Utopiker' (336).

From statements of this kind it becomes clear that there is good reason to agree with Peter Fischer's claim (S60/13) that the traditional division between Activists and Expresssionists as proposed by Wolfgang Paulsen (S166) cannot be maintained. Particularly in the case of Wolfenstein and his comrades the borderline between political and religious thought becomes extremely vague. Wolfenstein speaks, for example, of the goal of all human endeavour as 'die himmlische Vereinigung der Menschen' (P292, vol. 1/275). In the community of mankind, in the love of the neighbour, both eminently religious ideas, Wolfenstein sees realistic goals. Christ himself, from this perspective, can be seen as a revolutionary fighting for a better future. Such ideas may at first strike us as a secularization of religious thought. But because of the need to combine the timeless and the timely and to actualize the key ideas of religion, Expressionists feel justified in trying to attain God through man and man through God. To the Expressionists there are real and obvious parallels between the idea of a social community and the community of souls, and between utopia and paradise.

In the synthesis of socialism and religion Expressionism seems to have reached its logical apex. The movement was not able to advance beyond this point, since those forms of religion which we have previously discussed retained, each in itself, some claim to validity. The lack of coherence among the different members of this literary movement prevented these ideas from being brought to a synthesis. As in all other areas of Expressionism, the treatment of religion is too diverse to be replaced by one felicitous formula. On the contrary, with the collapse of the movement as a historical and political phenomenon after 1920, whatever cohesion had existed dissolved in a flood of polemical tracts of a more ominous, ideological nature.

The collapse of the Expressionist movement in the face of irreconcilable differences of political opinion comes as no surprise if we examine the thinking of that movement about the utopia which remained independent, or at least not directly influenced by religious thought. The variety of religious experiences is certainly matched by an equally great variety of views about the shape of the future society and the nature of the New Man. The multiplicity of proposals for a new society submitted in Expressionist prose prohibits a complete discussion, but some important exam-

ples might be given to demonstrate the complexity of the theme, which, like *Erlösung*, is one of the key elements of the whole movement.

In Alfred Wolfenstein's writings the search for utopia appears frequently as a theme, and from an early date. During many years of living in isolation Wolfenstein became aware of the limitations of the purely individual existence, against which even love, the childhood idyll, and nature are inadequate. At the same time, however, he also discovered the dynamic character of the self as a source of freedom, since the self has a tendency to expand indefinitely. The realization that others share this tendency opens the way towards them, and allows the escape out of isolation and nihilism. Both in his essays and in his fictional works Wolfenstein shows a preoccupation with a community of understanding and loving individuals, each with his own freedom. The whole collection of novellen *Der Lebendige* has been called 'ein einziger Hymnus auf die verstehende Liebe' (S156/8). Especially the story 'Über allen Zaubern' (P149 = P417) gives in a telescopic fashion the whole development of Wolfenstein's thinking, from sterile intellectualism via the 'Wille zur Macht' to the true New Man.

This development takes place in three stages. In the opening sections the law student Franz, confronted for the first time by the metropolis, tries desperately to establish some kind of relationship with it. The city is the 'Stadt der Gewalt,' but Franz, who comes from the country, is 'weich, er ist menschenfreundlich, er ist unsicher, sehnsüchtig' (41). Only one solution suggests itself: 'mache die Vergangenheit zu einem Zufall, wirble hinaus in die Luft und schüttele ab, was nicht zum wurzellosen Flug gehört!' This dynamic metaphor showing Franz's imagination taking flight now leads to a dream sequence in which the past is literally destroyed and the way into the future laid out. To launch Franz on his journey, a phantom appears: it is the law-book in which Franz has been studying, now transformed into a semi-human form. Together the two visit Franz's home town, which has been destroyed by earthquakes. Franz experiences a sense of joy and liberation at the sight of this. He is now ready for the next step, which brings him back to the city: he is to be introduced to the concept of power. He and his companion (we are reminded of Faust and Mephisto) enter a room whose motto, 'Lerne Bewusstsein' (47), is soon revealed to indicate that consciousness here is one of ruthless self-assertion. Wolfenstein describes an unusually bold scene, combining the obscene with the grotesque. Within the circle of demonic onlookers, a nude woman is raped by the phantom law-book, while the spectators

masturbate. This indicates their absolute self-sufficiency: 'Und Franz fühlte die grauenhafte Gewalt der einsamen unfruchtbaren eisfeuers-peienden steifen Anschwellung rings, den schweigenden Chor der Lust, die Gipfel der letzten kahlsten Lieblosigkeit: – Noch liebloser als nicht lieben: der Liebe zusehen' (48). Voyeurism and masturbation represent for Wolfenstein the unqualified triumph of the self. Absolute power entails total refusal of love. But Wolfenstein's own road leads away from this sterile preoccupation with the self, and towards community. Franz revolts against the scene he has just witnessed; in a sudden impulse he embraces the woman and 'ein Funke schlug hervor und zerschmolz mit Getöse die eisige Hölle' (48). The way to others is through the heart. When Franz awakens he throws the law-book out of the window; the 'Wille zur Macht' is rejected in favour of love: 'Über allen Zaubern: Liebe' (49). From now on his direction is clear: out of isolation and 'Zu Menschen – in die Welt – zur Liebe!' (50).

Obviously writings such as Wolfenstein's do not attempt to prescribe how the feeling of love towards mankind may be put into action. What is evident is that, though the orientation towards the world is a manifesta-tion of profane love, the ecstatic intensity with which this love is pro-claimed brings it close to the divine love of the more theologically ori-ented Expressionists.

The destruction of the old world, which Wolfenstein posits as neces-sary in 'Über allen Zaubern' (though it is ultimately not so much Franz's childhood as the 'Stadt der Gewalt' which is in need of destruction), has a counterpart in Werner Schendell's novelle 'Der Flüchtling' (P121). But here the destruction is so complete that the message of hope at the end is almost drowned out. In the dramatic opening of the story Schendell depicts the capture of the revolutionary student Uwe Rehm by the mil-itary in a language and syntax reflecting the hectic pace of events. The style is characteristically Expressionistic, while the scenes which follow intensify the pathos of the situation. With the violence typical of a totali-tarian state Rehm's property is destroyed; he is subdued and chained, dragged through the streets, where he is, however, rescued by his fellow revolutionaries. Rehm manages to escape by freight train into the country and to the sea.

In the mountains, in view of the sea, he begins to review his past. In tranquillity this past now appears to him to have been nothing but a series of violent incidents for which he can no longer find justification. What kind of ideal justifies such violence? Despair over his own short-comings leads him to contemplation of the human condition in general:

'Minderwertig, mechanisiert, verhurt, besudelt, verdorben sind alle. Alle! Deshalb müssen wir ausgerottet werden mit Feuer und Schwert, wir sind eine rote Schmach am Leibe der Menschheit. Wir haben keine Seele mehr, wir müssen sterben' (97). In a vision he anticipates this destruction, from which he himself does not want to be spared. The conclusion of the story is a description of the apocalyptic event. The graveyards give up their dead, in a final apotheosis a gigantic leader, an 'ungeheurer Prophet' (102), takes pity on the suffering, mutilated human beings and receives them into his protection. A virgin appears, and under an 'unendlicher Jubelschrei' forges from the mutilated bodies and dispersed members a new, whole mankind. A sea of fire consumes all: the final vision is one of the Virgin holding her child; the earth is transformed into a ball of hot cinders.

This strange novelle, an obviously impossible attempt to move from the individual to the apocalyptic, operates with allegories borrowed from Christianity; but the virgin and child appearing at the end of the novelle designate not so much the birth of Christ in the Christian myth as the virginal birth of the New Man. Schendell, who represents one of the extreme poles of Expressionism, that of the ecstatic, quasi-religious, seems quite willing to abandon all of creation in favour of an idea that remains sufficiently vague for it to be called a subjective phantasmagoria. The novelle demonstrates a procedure which Fritz Martini, in a reference to Wolfenstein, calls the tendency to project the 'ethische Impuls im Verlangen nach dem geheilten Menschen über die Grenzen der Wirklichkeit hinaus in das Unbegrenzte' (P335/27).

Equally problematic, ultimately, is Kornfeld's 'Legende' (P84). It is his attempt to present the contemporary crisis in a relatively timeless framework. Kornfeld combines in this story a rather relaxed, discursive style of narration with elements of magic and the supernatural. The 'Legende' divides naturally into two parts: the first deals with the problem of power, the second with the nature of the utopia. Part one tells of how the nobleman Wratislaw, who lives in seventeenth-century Bohemia, enters into conflict with his faithful servant Wladislaw when, out of gratitude for service rendered, Wratislaw bestows lands upon the latter. Two equally strong convictions clash. The duke contends: 'Ich will keinen Diener –es ist schlecht'; the servant complains: 'Für soviele Dienste so wenig Gerechtigkeit' (83). Charity is interpreted as a denial of the role of the servant, which is in the nature of things. After scenes of grinding comedy the servant is finally forced to accept the lands, though he also remains a servant. Wladislaw's reaction to the gift is a veritable hatred for the lands,

and he contemplates their destruction until the beauty of the production of these lands makes him decide to take care of them. He begins to prosper; the duke, by contrast, is pursued by bad luck, until he becomes indebted to his servant. The climax of the first part comes when the duke proposes to become the servant of his servant. Interminable tragicomical battles ensue, until the conflict is resolved through compromise: both will give up their property and start a new life together in far-off lands.

The second part of the 'Legende,' though much shorter, is equally important. From a discussion of the intricacies of wielding power the discussion shifts to the description of a society which represents a true alternative to the one just described. During their long wanderings the two men, who in legendary fashion do not grow older and whose faces show 'kein Schicksal' (136), retain a childlike character. Their positive outlook on life, reflected in their reliance on the goodness of their fellow men to support them in their needs, sustains them through the many years. When they finally return to their village, 'wie aus einem Traum erwachend,' they find that no ill has come to it and that their village has prospered. The whole community, a primitive, communistic society, now remains in perfect harmony for many decades. At the end of the nineteenth century, however, forces of destruction arrive in the form of 'civilization': technology, tourism, money, commerce, and corruption. Now Kornfeld lashes out against entrepreneurs and developers, professors and prophets, against false culture, education, science, agnosticism, and mass industrialization. The community disappears in a mysterious and sudden death, nature completing the destruction and eradicating the village.

Unusually severe in its judgment of Western civilization and its inherent evils, 'Legende' represents a retreat into the past rather than a vision of a possible future. The condition for the existence of utopia is isolation from the effects of time and history. But the built-in stasis of this utopia, depicted as an essentially agrarian society, cannot be transposed into the inexorably changing Europe of Kornfeld's own days. The pull of science and technology is too strong to resist, and knowledge itself, the 'apple' of the Garden of Eden, becomes a destructive force. Kornfeld's story is a programmatic piece of writing, but not in the sense of a practical suggestion. It is meant as a warning against the destructive aspects of the modern world. It is devoid of realism and also of psychology. At the same time, this attempt reveals an extreme conservatism and a degree of abstraction from the historical process which justifies Lukács's criticism of the Expressionist movement. Kornfeld's road was deliberately unpoliti-

cal; like Leonhard Frank he saw the road to change in the individual's soul: 'Das Böse verschwindet nicht aus der Welt, es wäre denn, es verschwindet aus der Brust des Einzelnen' (P230/5). The dichotomy of good and evil, with definite religious overtones, plays the dominant role in Kornfeld's thinking. Karl Otten has written: 'Kornfeld ... hat höchstens ein mitleidiges Lächeln für die Schwächen seiner Mitmenschen und steht den Problemen der Zeit, soweit sie nicht Probleme des Einzelnen und seiner Seele sind, kühl und ablehnend gegenüber' (P324/616).[8]

By contrast, the novelle 'Der Anarchist' (P152) by Paul Zech is an attempt to show in more concrete terms how a revolution is initiated. It is far more realistic than Wolfenstein's and Schendell's novellen. The tone is less emotional, though the language reveals in many passages the influence of Expressionism. The story outlines the activity of a mining engineer, Erwin Valotti, during a strike at the mine of Bordeal in the Belgian Borinage. When he arrives, Valotti is introduced to his technicians, three men who work on the great steam-kettles which pump water from the mineshafts. Valotti realizes that whoever controls this monster is not only like the master in Goethe's 'Zauberlehrling' but also holds a key position in a very real and political sense, since it provides him with the tools to participate actively in the strike under discussion. Valotti, though 'management,' attempts to show his solidarity with the workers during one of the mass meetings, but is treated like a spy, despite the fact that he realizes better than anyone else the importance of solidarity. Hearing that his worker Vildrac refuses to strike, Valotti tries to intimidate him, but the attempt fails; Valotti's argument that in a struggle for one's very existence force is legitimate falls on deaf ears. Ironically, Vildrac is killed trying to repair a short circuit. His demise gives Valotti the opportunity to signal to the workers that they must remain united: he blows up the power station.

In the end the engineer's isolation is reaffirmed, however. He remains to the workers a tool of management. In an expressive, Christlike gesture Valotti offers his contribution to the workers: 'auf der höchsten Geröllhalde stand der Ingenieur Erwin Valotti mit ausgebreiteten Armen und sah beschwörend auf die Trümmer, wo die Saat des Neuen aufging.' But he is rather more Moses- than Christlike, for he is not to enter the promised land: 'Ich aber nehme mich zurück.' Zech's criticism of the workers' distrust of a well-meaning middle-class intellectual is characteristic of the dilemma of many an Expressionist writer, torn between the desire to belong and the fear of not being accepted or understood. The new era is

heralded by the protagonist, but he is not to reap the benefits himself. The utopia is a pious wish; the isolated intellectual, a mask of the author himself, cannot make the leap from volition to leadership.

Kornfeld, Zech, Schendell believed, like most Expressionists, that individual change must precede social change. But in at least one work of Expressionist prose the emphasis is not on the individual but on the masses, on mass movement and revolution – in Georg Heym's 'Der fünfte Oktober' (P66 = P372). Typical of the Expressionist approach even in this novelle, though, is the fact that Heym is not concerned with history as such but with the paradigmatic character of a historic event. Moreover, as in most of his novellen, Heym's treatment of a given event involves a process of reduction and concentration. Exemplary in its construction around a dramatic turning-point, the novelle grasps the phenomenon of revolution and *Aufbruch* in its initial state, as a decision to reject the past. Once this decision is made and the masses are set in motion, the story breaks off.[9] It is the moment of decision, the moment between two epochs, pregnant with drama, which fascinates Heym. But unlike his fellow writers Heym does not resort to lofty idealism, but stresses the specific conditions of revolution: the hunger of the masses.

The novelle's opening states the theme unequivocally, but the objective report is quickly abandoned with a shift into the consciousness of the collective hero: the masses. In anticipation of the arrival of the breadcarts, the masses dream a fairy-tale dream: 'Ausgehungert bis in die Knochen träumte es da von Paradiesen der Sättigung, ungeheuren Weizenfladen, weissen Mehlpasteten, die in allen Garküchen prasseln würden' (6). The insistence on food is a leitmotif of the whole novelle; if we can speak of pathos, it is the pathos of the stomach. Heym uses basically two vocabularies. Until the arrival of the orator Maillard and the transformation of the crowd into a political weapon, the masses are compared to animals; after the decision to march on Versailles they are likened to natural forces.

Heym's particular brand of realism is well illustrated in the passages describing the suffering of the starved masses. In the clash between the opulence of the court and the church, and the grim struggle for survival of the poor, striking images take precedence over logical argumentation; yet the rhetoric employed arguably states the case for revolution better than any polemics. In any case, these starving multitudes are well disposed towards the inflammatory rhetoric employed by the great orator Maillard. His arrival constitutes one of the most dramatic moments in history, and Heym indulges himself in stating the case: 'Alle warteten ... in den

furchtbaren Sekunden, in denen die Zukunft Frankreichs gewogen ward, bis die Schale voll Fesseln, Kerkern, Kreuzen, Bibeln, Rosenkranzen, Kronen, Zeptern, Reichsäpfeln, gebettet in die falsche Sanftmut bourbonischer Lilien, voll hohler Worte, Versprechungen, Tafeln voll königlicher Eidbrüche, ungerechter Urteile, harmloser Privilegien, dieser ungeheure Berg alles dessen, mit dem die Jahrtausende Europa betrogen hatten, langsam zu sinken begann' (13). Animal metaphors return: the servants of the king are called 'Bluthunde des Bluthundes, Spinnen der Spinne' (14). The masses themselves are loathsome and detestable, but only in the eyes of the aristocracy; when the dehumanizing metaphors have done their work, and have sufficiently stressed the underlying antagonisms between the two classes, the vocabulary changes, and nature now provides Heym with a new set of comparisons: 'Ein ungeheurer Sturm geballter Fäuste schüttelte sich in der Luft. Die Massen begannen zu schwanken, wie ein ungeheurer Malstrom' (15). The tree in which Maillard has climbed 'ragte heraus wie von düsteren Flammen angezündet,' and Maillard himself resembles 'ein riesiger schwarzer Vogel' (16). From now until the conclusion of the novelle the parallels between the revolutionary masses and nature are a pervasive element of the story. Like a natural flood the masses break through; even Maillard's attempt to stop them no longer has any effect.[10] The evening sky, 'ein urewiges Meer' (17), envelops the masses, but the evening anticipates the morning and the dawning of a new era, 'wo der Sklave, der Knecht der Jahrtausende, seinen Kette abwarf und sein Haupt in die Abendsonne erhob, ein Prometheus, der ein neues Feuer in seinen Händen trug' (17).

The great theme of brotherhood is sounded: 'Sie alle waren unzählige Brüder geworden, die Stunde der Begeisterung hatte sie aneinandergeschweisst' (17). In a final image, Heym makes nature itself participate in the great transformation of the masses and their march towards a better future: 'Eine ewige Melodie erfüllte den Himmel und seine purpurne Bläue, eine ewige Fackel brannte. Und die Sonne zog ihnen voraus, den Abend herab ... Und wie göttliche Schiffe, bemannt mit den Geistern der Freiheit, segelten grosse Wolken in schnellem Winde vor ihnen her. Aber die gewaltigen Pappeln der Strasse leuchteten wie grosse Kandelaber, jeder Baum eine goldene Flamme, die weite Strasse ihres Ruhmes hinab' (18).

As we can see, despite a good deal of realism, what is most striking in this novelle is Heym's fascination with the phenomenon of the masses as such. Heym's enthusiasm for the revolution stems above all from his love of the visual aspects of a crowd moving against the backdrop of nature. In

equating the masses with natural phenomena, in interpreting the *Aufbruch* in terms of fire, storm, and flood, Heym is revealed as an artist rather than a political thinker. Though we must not discount Heym's genuine wish for revolution, the novelle conceives of the initial movement towards it primarily in non-practical terms, namely in terms of allegory. Heym, like most Expressionists, demonstrates a basic unwillingness to come to terms with revolution as a concrete historical event. Heym's description of revolution is a vision, not a program.

If a synthesis of individual *Wandlung* and collective *Aufbruch* can be said to have been attempted at all, it is in Leonhard Frank's famous collection of novellen with the programmatic title *Der Mensch ist gut* (P367). In each of these novellen Frank describes the process which leads from individual change to the fusion with the community, which then undergoes a transformation of its own. The collection is a theme with variations; the theme is introduced in the first story, 'Der Vater' (P60).

Robert, the main character of 'Der Vater,' achieves his transformation with exemplary swiftness and completeness, and goes to work on society in a quasi-missionary capacity. Before the First World War he is a waiter in a restaurant; he tries to compensate for the frustrations of his humiliating job by looking forward to a brighter future for his son, whom he adores and spoils. But Robert's dreams are shattered when his son dies on the battlefield, or, as the authorities prefer to call it, 'das Feld der Ehre.'

Like Sternheim, Frank is concerned with the corruption of language and thought which has occurred in pre-war society and which is intensified during the war. The analysis of the word 'Ehre' leads Robert to realize that he, like millions of other Germans, has been living with a deliberate lie: 'Ehre. Das war ein Wort und bestand aus vier Buchstaben. Vier Buchstaben, die zusammen eine Lüge bildeten von solch höllischer Macht, dass ein ganzes Volk an diese vier Buchstaben angespannt und von sich selbst in ungeheuerlichstes Leid hineingezogen hatte werden können' (P367/9). Enlightened, Robert intervenes in a children's game involving a toy gun and then goes on to address the bystanders as murderers for having forgotten the command of love. In a vision he invokes the dead on both sides of the conflict and pleads for an abandonment of the folly of war. The speech is highly rhetorical, employing questions, paradoxes, and striking images in a technique resembling Expressionist drama. It is punctuated only by the emotional exclamations of the bystanders. The subsequent mass scenes are also reminiscent of contemporary drama. The protest march against the continuation of the war, which results from

Robert's speech, is clearly intended to counterbalance the scenes of exuberance at the outbreak of the war. The ending, an echo of Heym's 'Der fünfte Oktober,' symbolically provides the story with an expanding context, from city to continent, with bells pealing and 'vieltausendstimmigem, gewaltigem Gesang' (22).

The story is typical of Frank's view of the world as a theatre of conflict between good and evil. War is raised to the level of an apocalyptic cataclysm. It is not explained in terms of political, social, economic, or even psychological conditions; instead, war becomes the symbol of moral guilt, and a solution is therefore sought in quasi-religious terms, in atonement and the doctrine of love. The *Wandlung* is not only based on intellectual enlightenment: it has the character of a miracle.

Compared with 'Der Vater,' the second novelle, 'Die Kriegswitwe' (P58), is far less typical. It shows a greater awareness of politics, and its organization follows that of a learning-process. At first this process is very slow. The shock caused by her husband's death in battle does not trigger the widow's revolt immediately; she resorts instead to an 'Abzementierung des Gefühls' (P367/27). It is only through her struggle for survival that her husband's death appears in its proper context. The power of money and the economic implications of war are revealed to her in a grocery store, in which she is refused credit. Again Frank focuses on the use of clichés and slogans as devices for obscuring the truth. The defence of the 'heiligste Güter' is meaningless to a person who has been deprived of all means of subsistence. The alleged 'community of the afflicted' also proves illusory when the widow receives a harsh letter urging her to pay her debts. Through suffering, particularly at night, when the powers of rationalization are low, she arrives at a correct interpretation of war. At this point Robert is reintroduced as one who has already reached true understanding. By a coincidence the widow one day hears Robert speak in public, and she is immediately drawn to him.

In her anguish the widow publicly calls for the destruction of all institutions of government as sources of man's inhumanity to man. This call to violent action is immediately neutralized by Robert's contention, however, that individual rather than collective, 'institutionalized' guilt is involved. The waiter's plea is for passive resistance, not violence. But the attempt by a wealthy businessman to interfere with the demonstration ends in his carriage being overturned and set on fire. For the time being, the question of violence remains unsolved. The progression of the argument shows that Frank's own viewpoint is being voiced by Robert, in which case Frank himself appears to be caught in the dilemma of wishing

for change while rejecting the violence needed to achieve it. The problem of the role of institutions in the process of change is side-stepped because Frank's idea of revolution is 'die Revolution der Liebe' (71). This too is part of the typical Expressionist creed: by the sheer power of words and by evocation and example, it is felt, the world can be changed. The faith of the Expressionist in the power of rhetoric and emotion is enormous.

The next novelle, 'Die Mutter,' shows a decline in political awareness. This time Frank operates with a heavy-handed religious symbolism. Since in the official churches the doctrine of love has lost its vital position, the son, fallen in battle, becomes a Christlike figure. His mother is compared to the Virgin Mary ('die Verklärte' [101]). Yet another protest march ends with the opening up of space, but the utopia remains conveniently vague: 'Die Wahrheit braucht nicht den Ton. Die Wahrheit ist still' (110).

From 'Die Kriegswitwe' on, Frank more and more abandons the pretext of fiction in favour of polemics. Whereas 'Der Vater' had a well-constructed plot and well-defined characters, the last novellen are almost formless; they have become mere vehicles of argumentation and discussion. Unfortunately, this discussion becomes more and more dubious because of its rather simplistic antitheses and abstractions, which reach a climax in 'Das Liebespaar' (P56). This story consists of a series of loosely connected discussions between a doctor who is to identify a suicide in a morgue and the 'resurrected' suicide himself. The latter is a philosopher who has written a book protesting the 'Ungeist' of the German state, which is apparent in its fanatical insistence on technology, geared it seems only to provide the machinery of war and equipment for the disposal of corpses.

In 'Die Kriegswitwe' the problem of violence had remained unsolved. In 1916 and 1917 this was no longer a purely theoretical problem. Opposition to the war had surfaced openly, and the leadership of the Left in a possible revolution is under discussion in 'Das Liebespaar.' The open display of malcontentedness by the Social Democrats might have suggested to the pacifist philosopher that here was a force emerging which might legitimately aspire to the leadership of the nation. But the philosopher rejects the Left on two accounts. First, its past is tainted, for initially it did not oppose the war. The explanation for this lack of protest provides the second reason for the philosopher's rejection of the Left. The working classes, because of their concern for progress in a merely materialist sense, have become immune to the morally problematic aspects of progress: 'Materialismus: angefangen beim entseelten, maschinierten Fabrikarbeiter, über den von Bequemlichkeit stinkenden Kanapeebürger und

über den Kapitalisten, den modernen Philosophen und Dichter weg, bis hinunter zum ersten Diener des Staates. Hier haben Sie die Ursache des Krieges' (132). Such passages reveal Frank's distance from the proletarian masses. No attempts by post-war critics (primarily East German) to claim Frank for the communist cause can hide the fact that in 1918 at least Frank was not at all convinced that a *social* revolution would bring about the utopia. If the philosopher is indeed a mouthpiece for the author, it is clear that at the time of writing Frank had not only retained the vocabulary of German Idealist philosophy but that he was still dominated by the dualism of self and world inherent in that philosophy. In defending 'das reine Ich' against 'das korrumpierte, krummgenagelte Weltgeschehen' (134), Frank sets up a dichotomy that precludes the kind of harmony between individual and society that the Activists sought to realize through political action within the historical process.

'Das Liebespaar' is no longer a serious attempt to integrate the political discussions into a plot. It lacks the interest of the earlier stories because its very abstractness renders it more vulnerable to argumentation which starts from different premises. The formal weaknesses of Frank's art also show more clearly. The protagonists are little more than voices carrying the ideas of the author; psychology is lacking, and repetition turns the story into a pedantic and tedious exercise. The final story of the collection, 'Die Kriegskrüppel,' shows very much the same weaknesses, though the opening scenes, with their description of a hospital tent near the front, are powerful enough. Frank presents an almost grotesque vision of the terrible waste caused by war. Compared with this evocative presentation, the reintroduction of tedious argumentation about the war is a stylistic mistake. But the return of the war-wounded, which leads to a genuine 'Gefühlssturm,' provides Frank with a last chance to convince by the sheer power of words. A truly Expressionist language is used to convey the gestures of those caught in this outburst of emotions: 'Ekstase flammt. Schreie steigen. Die Wahrheit gerät in Fluss. Die Seele tagt' (201). At the height of the march of the crippled, reactions surface which reduce the spectators to animals: 'Menschen, die ihn [den Krüppel] erblicken, brüllen auf und brechen brüllend in die Knie. Elegante Damen brechen im Weinen zusammen und erheben sich als Magdalenen' (203). These exaggerations, painful if not ludicrous, seem to constitute a last desperate attempt to bring about the utopia by the magic of language, by a form of incantation. But the wish to outdo the closing sections of the other novellen is doomed to failure by force of its very repetitiveness.

In the last novellen there is a complete lack of interest in action. These

stories are practically without plot. We are left with a series of dialogues and with descriptions of mass movements. There is, moreover, a mixture of styles that cannot be reconciled. Theoretical, didactic, and pedantic passages conflict with others in which an ecstatic, visionary, and exaggerated Expressionist style prevails, in the attempt to convey *Wandlung* and *Aufbruch*. This mixture of styles must be considered a failure. More importantly, however, the aesthetic failure is paralleled by a failure in the enunciation of political ideas and ideals. Neither the abstract speculations nor the uncontrolled outbursts of emotion indicate how the concept of the New Man is to be realized in the realms which Frank is consciously avoiding: those of economics, of political activity, and of history. Frank's solution of a brotherhood of mankind is not rooted in the realities of history and, like Sternheim's solutions, must be relegated to the domain of pure wishful thinking and phantasmagoria. Thus, while the conflict between the individual and the collective is solved in radically different ways in Sternheim, Edschmid, and Frank, all their solutions break down at the same point: in their removal from reality, in their abstraction, which ultimately reduces these writings to speculations without practical significance.

Frank's failure indicates yet another weakness in Expressionism. Despite the importance attached to the notion of community by almost every writer, it is primarily because of a very private need of the author to break out of his loneliness that he reaches out to his public. Even those poets who celebrate the brotherhood of mankind do not express a social goal but an individual desire to re-establish contact. The writings of Heym, Schendell, Wolfenstein, Zech, and Frank are replete with this problem, despite, or perhaps precisely because they seem to preach community. The hysterical forms taken by the projected *Aufbruch*, *Wandlung*, and ultimate integration of the individual into a transformed society can only be understood against this background of *Weltfremdheit* and the persistent desire to remain autonomous and self-contained. These utopian writings tell us a great deal about the reasons for the failure of Expressionism as a political and social force. While seeking to break away from a multiplicity of doctrines in a relativistic bourgeois society, Expressionism in turn became the victim of a multiplicity of doctrines. Where the subjective view is the only guide to the formulation of theory, no consensus can be established. Though the *private* utopia (as formulated by Heym, Döblin, Loerke, and others) remains possible, if only in a madhouse (as in Sternheim), the *social* utopia, when it is not based on objective and universally valid principles, cannot be achieved. The revolution

that Frank imagined might follow the devastations of war had to fail, because Expressionism of the Frank variety did not even grasp the nature of war.

Eva Kolinsky's admirable investigation of Expressionism as a concrete historical phenomenon confirms on a general level what this chapter has tried to establish by examining the prose writings dealing with utopia (S117). Expressionism, tragically, ends in contradictions and despair, in a mood of resignation and bitterness, paradoxically mirroring the initial despair and sense of crisis which gave rise to it.

CONCLUSION

EXPRESSIONISM is a profoundly dualistic movement in German literature. It is characterized by the existence within one movement of two traditions usually separated: realism and idealism. Like the Baroque, Expressionism is acutely aware of man's fallen state and the loss of harmony between man and nature. This realization gives rise to extreme pessimism and despair, especially in the early phases of the movement. But because the Expressionist carries within himself an ideal by which he judges reality, he often announces with an equally excessive optimism an imminent change and the advent of utopia, be it in personal or social terms.

Agony and ecstasy in Expressionism are by and large the result not of objective and philosophical assessment of the modern situation but of an intensely experienced, existentialist intuition of reality. In the discussion of the writings of Georg Heym, Oskar Loerke, Paul Zech, and Albert Ehrenstein we have seen how the Expressionist moves from personal, unique experiences, which provide him with a basic *Lebensgefühl*, to a more general world-view. Even when he formulates this personal view more theoretically, the Expressionist tends to embrace the philosophy of German Idealism and classicism, notably that of Kant, which is to say a form of subjectivism. The subjective view of reality *can* provide the writer with a sense of freedom and potentiality, particularly in his creative activity, since as subject he is the creator of meaning and world. More often, subjectivism can be interpreted more negatively as the acknowledgment that the world as such is unknowable. The collapse of an ordered and intelligible reality and the loss of a binding value-system, which sometimes leads to a complete loss of contact with reality, may force certain authors and their fictional characters into retreat, into myth

or illusion. In others, a self-destructive and/or aggressive attitude can result – in the case of Ehrenstein of quasi-cosmic dimensions.

The Expressionist subjective vision is determined by the antinomy between the endangered individual and a hostile world. The painful discrepancy between man's aspiration and the limitations imposed upon him inspire the Expressionist to a view of man which yields to pathos. Sometimes, as in Heym, nature itself is seen as driven by demonic forces. More frequently, hostility is directed at society as a danger to the self. At the same time, Expressionism continues, in the tradition of Naturalism, to search for a better society. The problematic nexus of Expressionism comprises on the one hand a concern with the dangers of isolation, alienation, and individuation, and on the other an intense longing for de-individuation, anonymity, and, phrased positively, integration. Since these problems are formulated in terms of absolutes, however, accuracy of observation is sacrificed for 'essential' insights, and practical proposals are rare.

Since German society of 1910–25 was primarily a bourgeois society, the social criticism of Expressionism is most often directed at the middle classes. Determined by mechanistic social and historical factors, by materialism, a sterile and hypocritical morality, by clichés and metaphors, the middle classes are as removed from life in all its richness, variety, and vitality as they are from truth and sincerity. Contemporary society is seen as unnatural and inhuman in both the polemical and the satirical writings of authors like Heinrich Mann, Max Herrmann-Neisse, Alfred Döblin, Carl Sternheim, and Leonhard Frank. Though the severity of the clash between the ideal and the real leads more often to pathos than to satire, 'frozen' institutions, pretentious individuals, and irrelevant value-systems do serve as targets of satire. The bourgeois as philistine is favoured by the milder forms of satire, whereas the capitalist is subjected to attacks of a more violently polemical kind. A genuine social concern, though problematic in its subjective inspiration, forces Expressionists to reject the city with its dangers of de-personalization, its misery and lack of human and humane dimensions. Capitalism, industry, and technology are criticized, as is science. The social concerns of Expressionism climax in the opposition to the First World War, interpreted as the logical outcome of nineteenth-century developments, of materialism and excessive preoccupation with science on the one hand (according to Heinrich Mann, Leonhard Frank, and Svend Borberg) and metaphor and mythmaking on the other (Carl Sternheim). In all cases, however, as I have argued, Expressionist criticism of social reality is based on personal emotions and on dichotomies of a near-abstract nature, such as those of man and

machine (Zech, Lemm), spirit and matter, soul and *ratio*, and, ultimately, of the self and the world.

To escape the conflict between the individual and the collective, Kasimir Edschmid and Carl Sternheim eliminate one pole, society, and stress the self as absolute and exclusive norm. Their road leads them away from society and towards a glorification of the individual. Edschmid creates the myth of the heroic character, master of his destiny, Sternheim that of the self-sufficient, amoral egoist. In Sternheim's prose we are not dealing with satire, despite frequently excessive tendencies and multiple aberrations in his characters, but with the glorification of the egocentric individual, whose every vice is justified as long as it is an expression of his 'eigene Nuance.' Unfortunately, as I have indicated, both Edschmid and Sternheim show severe limitations in content and form, and their one-sided solutions to the problem of self versus world must ultimately be considered failures.

Subjectivism is also shown to be a problematic aspect of the work of Gottfried Benn. The lack of an objective point of reference in the transcendental realm leads Benn to stress the uncertainty and inadequacy of *all* knowledge, and of the modern scientific world-view in particular. Initially, the result is nihilism. Removed from life, from the vital sphere which includes eroticism, Benn's alter ego Dr Rönne seeks support in the adoption of a series of masks, 'forms,' and styles, until a solution is found in the contact with a more primitive, original level of existence, in myth. In Benn's case this process is enlightening, for he conveys the shift from history to myth by means of a shift in language: from the objective, scientific, logical, and causal language of the modern world to the rich, a-logical, poetic associations of a pre-conscious age. But Benn's solution is as problematic as Edschmid's and Sternheim's, and one cannot escape a feeling that Benn is a victim of pose and inauthenticity, a suspicion tragically confirmed by his subsequent adoption, in Nazism, of an ideology flagrantly contradicting the idealistic aims of Expressionism.

Benn shows the self as discontinuous and in a state of collapse. It cannot be sufficiently stressed that in Expressionism the collapse of the orderly view of outside reality is usually paralleled by the collapse of the stable identity of the subject. The endangered self, in confrontation with the world, often seeks refuge in successive illusions, until either death or madness provides a permanent solution to the conflict. The syndrome of confrontation and retreat into autistic worlds (of which Benn also gives an example, of course) can be seen in the writings of Karl Otten, Alfred Wolfenstein, and Oskar Loerke. In Heym and Döblin we encountered the

theme of madness, but also noted the great differences in treatment. Behind the clinical report of Döblin's 'Ermordung' there lurks satire; behind Heym's 'Der Irre' there opens up the perspective of salvation.

Many Expressionists seek a solution to the problem of the self and the world in eroticism. Sex pervades Expressionist prose to such an extent that we may fairly speak of an obsession. In sex there lie ecstasy and communication, but also the danger of self-loss. Factual isolation and obsessive preoccupation with the preservation of the self often stand in the way of true union, and erotic relationships might in fact deteriorate into a battle of egos and sexes, as Franz Jung, Alfred Döblin, and Ernst Weiss show. Sexual conflict is accompanied by cruelty, madness, even death; erotic ecstasy proves a problematic category in the writings of Carl Einstein, Hans von Flesch-Brunningen, and Alfred Lichtenstein, which touch on the grotesque. Even where love is given a positive value, it is often seen as a form of protest, of anarchism. Only in rare cases, as in Gustav Sack, does sex appear both desirable and realizable. The wish for Erlösung through sex must fail, however, since the appropriate object for transcendental striving can only be the transcendental itself; ultimately, the Expressionist search for a stable point must lead to God.

The basic dualisms of the Expressionist movement are repeated in the literature dealing with the search for God and the utopia. The rejection of existent forms of religion is combined with the search for more personal ties with God. This does not mean that Expressionism opted for a form of mysticism: the distance between man and God is absolute, and once again leads to a sense of pathos. The almost exclusive focus on poetry and drama in Expressionist scholarship has led critics like Walter Sokel and Wolfgang Paulsen to over-emphasize the importance of the ecstatic elements of the movement; here an analysis of its prose can have a corrective function. A rich variety of religious experiences, in the form of nature and astral myths (Loerke, Döblin, Mynona) inspired by Vitalist and Irrationalist philosophies are proposed as alternatives to Christianity, but syncretism and a tendency towards secularization, particularly in the writings of Weiss, Werfel, and Heym must also be noted. Before conclusions about the actual 'religious' message can be drawn, however, the context in which symbols borrowed from religion appear, or in which problems such as Erlösung are discussed, must be taken into consideration.

Few Expressionists find the longed-for relationship with God. Ernst Weiss and Else Lasker-Schüler base their faith on the crucial role of Christ and the prophets, whereas Alfred Wolfenstein expresses the belief that religion will provide the basis for the coming utopia. Religious socialism,

the synthesis between social and religious impulses in Expressionism, provides Wolfenstein and other contributors to *Die Erhebung* with what they see as the final solution to the dichotomy of self and world. It could be argued that even in those cases where the utopia is presented in purely secular terms, the fervour with which it is embraced and the means by which it is described still place it in the proximity of religious writings. In the depictions of the individual *Wandlung* and the collective *Aufbruch* of Leonhard Frank, Werner Schendell, and Georg Heym a hymnic, almost ecstatic tone and an abundance of rhetorical and poetic devices indicate a quasi-religious attitude; at the same time, however, these devices betray the limitations of such writings from a purely practical point of view. Because of the inherent contradictions within the movement, as well as its historical position, removed from the centre of power, its concrete successes are limited. Often what emerges is a literature divorced from reality and confined to imaginary flights of fancy. Aesthetic fascination precedes and dominates any true political motivation.

The effective isolation from society of the artist and the adoption of a subjective credo cause Expressionism to move in the direction of ever greater abstraction. The preoccupation with essence and with absolute truth, already evident in the earliest aesthetic writings, such as those inspired by Wilhelm Worringer, is reinforced by social circumstances. Expressionism can be accused of a basic unhistoricity, a move away from objective facts to 'intuited' truths and from exact detail to facile 'cosmic' overviews. Because of the emphasis on the personal vision, formal truths rather than empirical ones become important; the distortions resulting from personal visions are interpreted as desirable, and superior to traditional forms of realism. Distortion brings out the alternative realities of dream, vision, even the grotesque. Distortions are in fact considered to 'mirror' reality better than naturalist and realist methods. They are more appropriate for the rendition of inadequate social and personal conditions; in all cases they serve as a form of protest and indicate the refusal of the artists to function as the mouthpieces of society.

Expressionist art, with its distortions, seeks to revolt against the restrictions of established aesthetics and against a language which has made of man himself a mere object. Expressionists seek to restore to language its function of expressing man's inner world. Hence Expressionists aim for a language which is highly colourful, unusual, often precious and far-fetched. It destroys barriers, though it must be stressed that prose is far less extreme than poetry in its formal innovations. Undue emphasis on writers like Edschmid, Wolfenstein, Sternheim, and Benn might

obscure the fact that much more sober uses of prose exist in Expressionism. Nevertheless, a critical attitude towards language is common to most writers, and metalanguage is widespread. No investigation into this aspect of Expressionism has been carried out, largely because of preconceived notions about Expressionism as a whole. The attacks on clichés, metaphors, kitsch, and stereotype carried out particularly by Benn, Einstein, Sack, Weiss, and Herrmann-Neisse would merit such a study.

Experimentation abounds, often admittedly with dubious results, as Edschmid's mixture of colportage and kitsch and Sternheim's pseudo-objective 'chronicle' style illustrate. The Expressionist movement despairs of language as a cognitive and expressive instrument, yet it cannot replace it by anything other than language. It is this dilemma which makes Inge Jens's thesis of a supposed 'development' in Expressionist prose dubious: her belief that the Expressionists found a solution to the (correctly stated) problem of 'Sprachnot' is without grounds.

In prose, both the strengths and weaknesses of the Expressionist movement become apparent. From the hectic, hysterical prose of Edschmid to the wilful objectivity of Döblin, prose is forced into every conceivable mould. Dramatic prose, lyrical prose, absolute prose are so many names for what are in many cases unsatisfactory attempts at renewal of what Expressionists found to be a stultifying tradition. Generic characteristics are ignored everywhere; psychological motivation, relaxed narration, objectivity, the imperfect tense, the creation of world – all these are either rejected or modified. At the same time, a radically different ideal of identity between world-view of author and created world is set up. What appears to be mere experimentation, therefore, may more often be considered an effort to find appropriate forms for new and uncharted states of the mind and the soul. The intensity with which the artist experiences the pathos of his situation, the urgency with which he must express his *Angst,* and the wish to convey the ecstasy of a religious or secular (erotic) nature will force the writer to approximate the ideal of lyric poetry on the one hand and that of drama on the other. Max Krell, in his preliminary remarks to the anthology *Die Entfaltung,* wrote that many authors broke with the old form 'um durch ihre Optik neues Licht an die Satzgefüge heranzulassen' (P327/x). By blurring the distinctions between the genres and by breaking down syntax and structure the Expressionists sought to express a unique situation by unique means. Predictably, the traditional form of the novelle is little cultivated. Fritz Martini claims that Georg Heym is already on the road towards the 'Kurzgeschichte' (S148/261), and his successors showed little interest in the more traditional structural

aspects of the novelle. In fact, judged by traditional standards, the very concept of prose itself might well be endangered by some of their experiments, as Greulich claims (S75/137). Expressionism has once and for all forced us to question the concept of genre and the characteristics of certain forms within it.

Only in the fewest cases has Expressionism achieved heights of artistic quality. Masterworks belong to periods of classicism; in Expressionism the tensions are too great for the works to achieve the state of stability and self-containment associated with classic art. Too often there is a tragic discrepancy between intention and execution and between traditional form and revolutionary content. Yet with all its weaknesses, prose can be a most suitable vehicle for Expressionist thought, and it is doubtful whether we can arrive at a just evaluation of the movement without an examination of its prose writings; they are by no means to be neglected as a by-product. The very failures of the genre can enlighten us about the movement's more general aims and results. This is particularly the case when we consider the contradictory aims of Expressionist art and Expressionist politics. A major theme of Expressionism is the relationship of art and audience. The Expressionist, usually from a bourgeois background, seeks to extend his art to the working classes. Unfortunately, his interest is often one 'from above,' or determined by mere aesthetic fascination. Even when authors deal directly with the worker's world, they are apt to show a severe misunderstanding of their topic. Though most writers are sympathetic to the workers, the aims of author and worker are very far apart. The artist lives for his art; his pursuit of art must take him out of the realm of definite and finite goals, as Werfel argues, and into the realm of infinite goals. Social and aesthetic revolutions appear inseparable in the documents and manifestos of the period, but in practice they are often contradictory in aim.

Expressionism is not only a literary phenomenon; it also marks a specific moment in German history, in which social and formal revolution united briefly. In early Expressionism the revolt against bourgeois society is carried out as much by the destruction of literary tradition as by attacks on the bourgeois way of life. In this initial stage the writer is in a situation of confrontation. In the activist phase a countermovement sets in. The political content is couched in more regular, traditional forms so as not to endanger and obscure the political message. During the war and the revolution, political concerns become more important, while with the collapse of the revolution there is a hardening of doctrine on the one hand and a change to the more sober art of the 'Neue Sachlichkeit' on the other.

Much of what seemed most precious in the movement disappeared after 1918. The alternatives to social and aesthetic revolution were manifold. Disillusionment and retreat, escape into other worlds, such as the Orient (the novels of Klabund and Döblin), pacts with different ideologies such as Marxism (Heinrich Mann, Leonhard Frank), or Nazism (Benn), or a return to previous positions such as Naturalism and Realism (Döblin and Werfel) colour the literary scene of the 1920s.

It was the formal innovations, regardless of whether they had been conceived as artistically autonomous, or as forms of political message, or yet as forms of communication with society, which proved most vital for the shape of literature after 1945. Those authors who had primarily focused on formal revolution, such as Benn, Döblin, and Heym, turned out to have greater permanence than those who had been activists and politically oriented, such as Wolfenstein, Frank, or Zech, though this does not mean that one should even now neglect this dimension or consider the first group to be the only one worthy of consideration. In a more general sense the separation of ideological aspects from formal ones is impossible in Expressionism. The attitude of writers to their audience is a key element in the understanding of the transformations and modifications of this literature. More than in most literatures, the interaction of content and form plays a crucial role. Even in its final stages, when the movement's failures had become visible to all, the interdependence of content and form, of political message and aesthetic innovation was revealed once more, for with the recoil from politics there was also a moving away from formal experimentation.

Can we say that Expressionism has become historical? In one sense it is: our faith in the power of art to transform political reality has been considerably dimmed since the 1920s. The old Expressionist idea that writers might combine with political activists has not been completely abandoned, of course, but utopia seems further away than ever, and radical change, if it comes, will not be initiated by art and the power of words. In many other ways Expressionism is with us, in the joy of artistic experimentation, in the concern with the power and nature of language, in the continued debate about the problems of cognition, of subjectivity versus objectivity, and in the continued exploration of the inner world, of vision and dream. More specifically, Expressionism has survived in a few major reputations: Benn, Trakl, Heym, Kafka. And now and then, sometimes in very unlikely places, stylistic echoes of Expressionism can be heard. Like the Baroque or Romanticism, Expressionism, as an art of transition, has a relevance to all periods in which great hopes mingle with great fears.

NOTES

PREFACE

1 What Walter Benjamin wrote about his method of presentation, in his study of the German Trauerspiel, is valid for this study also: '[Die Darstellung] wird ... die Zeugnisse geringerer Dichter, in deren Werken das Absonderlichste häufig ist, nicht leichter schätzen als die der grösseren' (*Ursprung des deutschen Trauerspiels*, Stuttgart 1963, p. 45–6).

CHAPTER ONE: INTRODUCTION

1 See in this connection Wilhelm Bausinger, 'Robert Musil und die Ablehnung des Expressionismus' (S17), Claude David, 'Rilke et l'expressionisme' (S34), and Paul Raabe, 'Franz Kafka und der Expressionismus' (S182).
2 Whereby it must be remembered that according to Raabe, 'sich einerseits der Begriff in der frühen Phase der neuen Literatur nicht so durchsetzt wie in der Malerei, dass er aber andrerseits dennoch allen Beteiligten geläufig war' (S179/8).'
3 Notably Geoffrey Perkins sees in the period 1890 to 1910 a number of antecedents for Expressionist modernity, and points to the first performances of the Freie Bühne (1889) and the appearance of the journal *Freie Bühne für modernes Leben*, as well as to the 1892 founding of the Secession in Munich as crucial events.
4 In the correspondence of Kurt Wolff with his writers we have one of the most important testimonies of the importance of publishers to the Expressionist movement (S253).
5 As background to this whole complex it is enlightening to compare the *Aufzeichnungen und Erinnerungen der Zeitgenossen* of Paul Raabe (S328) with

Roy F. Allen's *Literary Life in German Expressionism and the Berlin Circles* (S4).

CHAPTER TWO: FROM CRISIS TO EXPRESSION

1 Bruno Markwardt (S144/393) speaks of a 'Sündenfall der Erkenntnis': 'Das Begreifenkönnen trat zurück hinter dem Ergriffensein.' The collapse of the theory of knowledge is the 'Urphänomen' which inspires, according to Alfred Soergel, all modern writing; modern literature attempts to answer the question 'Wie ist Leben in einer Welt möglich, die ohne Grund ist?' (S219/827)

2 Peter Fischer says of Alfred Wolfenstein, e.g., 'dass er den Vorwurf erheben kann, das Wirkliche sei nicht wirklich, nicht wesentlich, nicht "eigentlich." Das ist ein spezifisch expressionistischer Vorwurf, der sowohl als idealische Menschlichkeit wie als Verblendung zu interpretieren ist' (S60/119).

3 An excellent discussion of the discovery of creative freedom can be found in the chapter 'Pure Form and Pure Formlessness' in Walter Sokel's *The Writer in Extremis* (S220).

4 'Der Expressionismus erbt vom europäischen Symbolismus das mimesis-feindliche Prinzip, er ruft nach Loslösung der Dichtungswirklichkeit von den Anschauungsweisen des natürlichen Lebens,' writes Walter Hinck (S85/359). See also Herwarth Walden (S333, vol. 2/158): 'Kunst is Gabe und nicht Wiedergabe.'

5 Peter Fischer (S60/120) sees in the hope for utopia proof that Expressionism is an extension of the humanistic movement of German classicism, and calls the movement one of a 'historisch verspäteter Idealismus.'

6 The *Expressionismus-Debatte* was initiated in the Moscow journal *Das Wort*. The discussion between Lukács and Bloch (and later Brecht) may be traced by juxtaposing the following collections: Georg Lukács, *Schriften zur Literatursoziologie*, ed. P. Ludz (Berlin 1961); Ernst Bloch, *Erbschaft dieser Zeit* (Frankfurt a.M. 1962) and also *Die Expressionismusdebatte. Materialien zu einer marxistischen Realismuskonzeption*, ed. Hans-Jürgen Schmitt (Frankfurt a.M. 1976). Relevant also is Georg Lukács's 'Grösse und Verfall des Expressionismus,' in *Probleme des Realismus* (Berlin 1955), and his *Skizze einer Geschichte der neueren deutschen Literatur* (1953). See also Werner Mittenzwei, 'Die Brecht-Lukácsdebatte,' in *Das Argument* (March 1968); Leo Koffler, *Abstrakte Kunst und absurde Literatur: Ästhetische Marginalien* (Vienna 1970), pp. 35–49. Brecht's position can be seen in *Schriften zur Literatur und Kunst* (Stuttgart 1967), vol. 2.

7 Precisely this belief of Expressionism would of course go against Marxist beliefs. Nor can it be denied that it causes Expressionist theorists them-

selves a great deal of trouble. For if we believe in an 'eternal' human condition, then the other impulse of Expressionism, the social, reforming, and transformational impulse, with its attendant belief in utopia, would be denied. There is a certain shift in tendencies from despair to hope which can be seen at work in time, but man's changeability remains one of the most vexing problems of the movement.

8 Albert Soergel has already pointed out this difficulty, and notes: 'Die Versuche Carl Einsteins und der anderen "Äternisten" ... reine Hirndichtungen zu schaffen, bleiben vereinzelt' (S219/796).

9 Peter Fischer (S60/125) writes: 'Die bewusste expressionistisch- subjektive Sicht muss zur Verzerrung der 'normalen' Perspektive führen ... weil einzig die Verzerrung das brauchbare Instrument ist, um die schlechte Wirklichkeit aufzubrechen, ihr wahres Gesicht hervorzuholen.'

CHAPTER THREE: EXPRESSIONISM AND THE MODERN WORLD

1 For a discussion of the Naturalist roots of the social concerns of Expressionism, see Ludwig Niemann (S159). Niemann claims that the social question becomes the 'Grunderlebnis' and 'Beziehungspunkt aller Dinge' in Naturalism: 'Die ästhetischen Gesetze werden der soziologischen Zielsetzung untergeordnet' (p. 17).

2 The 'Expressionist' style is so extreme that we cannot help but feel that Mann is parodying it. At the same time we are ironically reminded of the heroic messenger from Marathon, who announced the victory of the individualistic Greek city-states over the slavery and totalitarianism of the Persians.

3 The influence of Freud is recognizable. In a slightly later work, *Das Unbehagen in der Kultur* (1930), Freud analyses the characteristics of mass society as 'der Schwund der Einzelpersönlichkeit, die Orientierung von Gedanken und Gefühlen nach gleichen Richtungen, die Vorherrschaft der Affektivität und des unbewusst Seelischen, die Tendenz zur unverzüglichen Ausführung auftauchender Absichten' (quoted in Rothe, S199/31). Even democracy can be seen as facilitating rather than as deterring the dangers of mass psychology: 'Die demokratische Gesellschaft, deren Grundlage und Ziel eine Gemeinschaft freier Menschen ist, wird zu einer manipulierbaren Massenorganisation, in der jedem Einzelnen seine Freiheit sowohl bestätigt wie geraubt wird' (Emrich, S53/138).

4 Throughout this study the word *Groteske* is used to denote the literary form (*die* Groteske), whereas the word 'grotesque' used both as noun and as adjective refers to the literary concept (*das* Groteske). The latter usage is in

accordance with the English translation of Wolfgang Kayser's book *The Grotesque in Art and Literature* (S105). Consider Kayser's several definitions of the grotesque: 'The grotesque is a play with the absurd' (187), 'an attempt to invoke and subdue the demonic' (188); 'The grotesque is the estranged world' (184).

5 The mythicizing tendency of Zech, e.g., is attacked by Ladislao Mittner (S154/408): 'die zum Mythos erhobene Maschine lässt vergessen, dass hinter ihr die Eigentümer stehen.' Mittner accuses Zech of fatalism, 'dem gegenüber das einzelne Individuum, Opfer des Maschinen-Idols Baal und Sklave des allverschlingenden Monstrum Mammon, nichts bewirken kann.'

CHAPTER FOUR: ART AND SOCIETY

1 It was Georg Heym who wrote in his diary: 'Das Volk ist im allgemeinen noch viel dümmer als man glaubt. Ich sehe das an den Büchern der Volksbibliothek. Die guten Bücher, die ich lese, tragen in 3 Jahren kaum ebensoviele Stempel. Ein Buch von Kipling, ein wahrhaft jämmerliches Buch ist von unten bis oben bestempelt.'

2 Cf. Kurt Hiller, 'Ortsbestimmung des Aktivismus' (P218). For a full discussion of Activism as distinct from Expressionism see Wolfgang Paulsen (S166). Documents of Activism are included in Rothe, P325.

3 For an extremely well-documented and exhaustive study of the phenomenon of the intellectual, see Michael Stark, S224.

CHAPTER FIVE: ECCE HOMO

1 The concept of one's unique and private death is of course also an important theme of Rilke's poetry as well as of his *Malte*.

2 For a discussion of the concept of literary *Jugendstil* see Dominik Jost (S98). Fritz Martini (S148/283) claims: 'Heyms Erzählung [die Sektion] scheint uns an einer sehr charakteristischen Übergangsstelle zwischen den Nachwirkungen des Jugendstils und dem Frühexpressionismus zu stehen.' See also Liede (S132/189). *Jugendstil* is interpreted as a weakness in Heym's work by Liede, whereas Jost proposes a neutral use of the term.

3 The difficulty most prose authors have in depicting the *Wandlung* is quite obvious. In most cases there is a gap in the narration; the characters are then shown as being transformed. The most striking example is the story 'Der Lebendige' by Alfred Wolfenstein.

4 For a discussion of the idea of the scapegoat or the sacrificial lamb see Mircea Eliade, *Le mythe de l'éternel retour* (S51) and Sir James George

Frazer's *The Golden Bough* (New York 1951), chapter 57, 'Public Scapegoats,' and chapter 58, 'Human Scapegoats in Classical Antiquity.'

5 The same difficulties apply, as we have seen, to Loerke's 'Das Goldbergwerk.'

6 Albert Soergel writes about the collection *Der Lebendige*: 'Aus dem gewitterschwülen Dunkel ihrer "seelischen Landschaften" suchen junge einsame Menschen leidenschaftlich nach einem Ausgang: befreit von einer Welt der Finsternis, des Taumels, der Bewusstlosigkeit stehen sie zuletzt am Eingang in eine Welt des bewussten Geistes, der Liebe, der Güte, der Menschenbrüderschaft. Der fliegende Hast ihrer sehnsüchtigen chaotischen Gefühle entspricht ein Stil, der zunächst nur wie eine wilde Bilderflucht anmutet, sich aber doch als mindestens mögliche, wenn nicht nötige [!] Form enthüllt' (S219/584).

7 Sybille Penkert (S170/13) writes: 'eine methodische Trennung von Biographie und Werkinterpretation [ist] unmöglich. Die tiefverwurzelte Beziehung zwischen Leben und Werk spiegelt einen unausgesetzten Prozess von Verwirrung und Lösung, bei dem das Erlebnismaterial sich jedem Versuch der Bewältigung durch das Dichterische hartnäckig widersetzt.'

CHAPTER SIX: PROBLEMS OF INTEGRATION

1 Revolt against parental authority is reflected in the larger context of society in certain protest movements such as the *Wandervögel*, which stressed youth, male virtues, courage, hero-worship and comradeship. The excessive preoccupation with the principle of the group, with *Körpergeist*, is evident in Carl Sternheim's story 'Die Hinrichtung,' though this story must be seen in the context of Sternheim's philosophy (see chapter 7).

2 Similarly, Walter Hinck (S85/351) interprets the revolt against the father as anti-historical thinking, and speaks of a 'bedenklicher Subjektivismus.' Hinck is obviously in the tradition of Lukács here.

3 Klaus Kanzog, in his commentary to the *Gesammelte Werke*, has pointed out that Max Mechenmal has a model in the poet Jakob van Hoddis; the rivalry between Mechenmal and Kohn reflects that between van Hoddis and Lichtenstein himself. It should be stressed, however, that it is a simplification to see in Lichtenstein's prose merely a wish for parody or vengeance. It is not satire with 'Schlüsselcharaktere' which Lichtenstein had in mind, for as Kanzog writes: 'Lichtenstein ist weder Satiriker noch Meister der ironischen Form; er kann die von ihm selbst gestellten literarischen Ansprüche nicht erfüllen' (P389/111). This, I would like to suggest, is due to the intensity with which imperfect reality is experienced. Lichtenstein's shift into pathos is typical of Expressionism.

4 Kuno Kohn has been called Lichtenstein's 'Doppelgänger' by Wolfgang Paulsen (S165/590); Paulsen draws attention to Heine's 'Hassliebe' for himself as an antecedent.

5 Sack's preoccupation with kitsch can be seen in a number of ironic stories discussed elsewhere by me (S37).

6 It should be noted that the German word *Bürger* has connotations of the petty bourgeoisie, whereas the word *Bourgeois* indicates the upper bourgeoisie. In English the distinction is not always clear.

7 Norbert Schöll (S214) claims: 'Die Sentimentalität als Grundstimmung, als Fehlen einer Identität von Subjekt und Objekt, und die dadurch hervorgerufene Leere an gefühlsmässigem Ausgleich, setzt in dieser Form mit der Entwicklung zur modernen Industriegesellschaft ein und ist für die Lebensformen des deutschen Kaiserreichs in immer stärkerem Masse inhalt- und formbestimmend geworden' (p. 64). As primary form of sentimentality he mentions 'das Pathos der Auflehnung gegen diesen Entfremdungszustand; das Zurücksehnen nach einer Zeit und nach Formen einer scheinbar oder offensichtlich noch integralen Kultur; das Sich-Hingeben an ein Über-Ich, ein "Grosses Ganzes"' (p. 65). So formulated, a good deal of *Jugendstil*, but also of Expressionism itself, can be interpreted as sentimentality. In Schiller's concept of 'sentimentalische Dichtung,' however, we have a less polemically formulated literary theory which explains many of the tendencies outlined by Schöll.

CHAPTER SEVEN: PROBLEMS OF AUTONOMY

1 For a discussion of the reception of Edschmid's new prose style see Armin Arnold (S10). For an example of the kind of idolatrous praise heaped upon Edschmid against which Arnold argues, see Lutz Weltmann's book (S245).

2 Max Krell, interpreting Edschmid's style as exemplary of Expressionism, wrote: 'Der Bezirk des Expressionisten und sein Tempo sind nicht mehr an irdischen Imperativ gebunden ... Es ist sternhaftes, nach Kosmischem schweifendes Tempo, das hinter den Realitäten kreist und treibt und innerste Zusammenhänge verfolgt' ('Die neuen Erzähler: Kasimir Edschmid,' in *Das junge Deutschland* 1 [1918], 247).

3 Hans Kaufmann (S102/316) writes: 'Edschmids Helden sind selbstherrliche, von jeder Bindung emanzipierte Individuen, die ihre "Natur" voll ausleben,' but he also makes the point that Edschmid turns these heroes into splendid bodies with little brain (315).

4 'dieser Wille – wie Schopenhauer das unbewusste Lebenszentrum nennt –

auf den sich das neue Menschenbild gründet, ist ein dumpfer Drang und blinder Trieb' (S236).

5 I am using the term 'colportage' here in the sense in which Gert Ueding uses the German *Kolportage*. One definition of *Kolportage*, based on the original French term, merely points to its sub-literary quality and its method of distribution. The more specific term, however, is used in both a sociological and intentional sense. *Kolportage* 'hat an dem unzeitgemässen Abenteuer festgehalten und den Weg nach *aussen* als den geheimnisvollen, Abenteuer versprechenden Dschungelpfad dargestellt, der aus dem *Herzen* der bürgerlichen Gesellschaft herausführt' (S231/83). At the same time, such a turning away from bourgeois society involves a kind of 'Rettungsstil,' as exemplified by 'das grösste Beispiel Kolportage,' Beethoven's *Fidelio*. 'Träumt also Kolportage immer, so träumt sie doch letzthin Revolution, Glanz dahinter' (Bloch, quoted by Ueding, p. 67).

6 Peter Fischer (S60/114) writes: 'Die Unmittelbarkeit der rauschhaften Gewalt ist so genau kalküliert, dass die raffinierte ästhetisch-literarische Vermittlung dabei völlig unterdrückt wird.' Despite this 'cleverness' we cannot escape a sense of discomfort about such 'cosmic' expansions, despite also the reason Fischer supplies for such devices: 'Die auftrumpfende Geste war vonnöten, da die Wirklichkeit selber nichts Lebenssteigerndes zu bieten hatte' (115). Indeed, Fischer appears to me to be correct when he says, 'Der Vollzug der rauschhaften Geste ... gilt für die Sache selbst' (116).

7 Basing his observations on Ernst Bloch's comments on Karl May, and on Bloch's own prose work *Spuren*, Ueding draws attention to the fact that the refusal to remain within bourgeois society, even if it is merely a result of a desire for adventure, carries with it a certain revolutionary impulse (14).

8 Wolfgang Wendler (S247/232ff.) points out the influences of Rickert and Windelband on Sternheim's philosophy. The difficulty of distinguishing between the two categories of thought is recognized by Sternheim, as Wendler points out also (38).

9 'Sein "Kampf der Metapher" galt genau allen Ästheten, die eine "höhere" Welt gegen die von ihm "mit Unbrunst geliebte" wirkliche Welt einzutauschen vorgeben und damit die wirkliche menschliche Welt ruinieren' (Emrich, S53/167).

10 Wendler is aware of this fact: 'Die eigenwillige Sprache Sternheims lenkt den Blick vom erzählten Vorgang selbst ab, erschwert das Verständnis und beeinträchtigt ein sachliches Urteil' (87). In the course of his investigation, however, Sternheim's language is assessed rather positively. The question of language versus thematic content is crucial in much of Expressionism. If appro-

priate form and language consist 'in der zureichenden ästhetischen Bewälti-
gung des Inhalts' (Kofler, S114/23), then both Edschmid and Sternheim chose
problematic forms.

11 The role of war in the development of the 'eigene Nuance' is dealt with more
extensively in my article S36.

12 The male principle is hysterically asserted both in Sternheim's own novelle
'Die Hinrichtung' and in Edschmid's work of course.

13 There is no doubt a reference here to the Expressionists' fascination with
Negro art, of which Max Krell speaks in 'Über neue Prosa' (P333, vol. 2/274),
and of which Carl Einstein's essay 'Negerplastik' is the best example (P189).
According to Wendler (295-6), Thea Sternheim noted that Sternheim had the
painting of the same name by Paul Gauguin in mind. This, and the reference
to Negro art as well as the distortions to which Posinsky subjects Ulrike's
body as she poses for his pictures, have led Liede (S132/90ff.) to suggest that
in the figure of Posinsky all of Expressionism is being satirized, and the
myth of the New Man debunked: 'Er stellt Expressionisten dar, indem er ihre
ekstatischen Gebärden als Pose entlarvt und sie dem Barbaren und Irren
zuerkennt' (92). In view of Sternheim's artistic credo, his wish to chronicle
objectively, this satiric effect would mean that once again intention and
result separate. About Sternheim's position vis-à-vis Expressionism, see
Wendler (S247/62).

14 Liede, pp. 83–99 and p.105. In a footnote on p. 293, Wendler (S247) rejects
Liede's interpretation and blames its mistakes on 'Liedes mangelhafte Ein-
sicht in den Wirklichkeitsbegriff Sternheims.'

15 Wendler (p.198) stresses Sternheim's preoccupation with the problem of the
metaphor in his own writings. He rather insidiously uses the term 'bildlicher
Vergleich' and writes: 'Der Vergleich soll nur anschaulich machen, nicht aber
das Verglichene in die Sphäre einer anderen Bedeutsamkeit heben.' Because
of the difficulty of locating the *origo* of many metaphors, it is difficult to
separate collective ('bad') use and private ('good') use. Liede's interpretation of
many of these metaphors is possibly one-sided, but so is Sebald's contention
that all such metaphors illustrate a neurosis.

CHAPTER EIGHT: AUTISTIC WORLDS

1 Michael Hamburger (S81/325) writes: 'Gottfried Benn accepts [Nietzsche's]
Nihilism as one accepts the weather.'

2 This is a feeling echoed by Carl Einstein in 'Der Snob,' now in *Gesammelte
Werke* (P364/33): 'Wir haben keine Wahrheit mehr, die alten Notdürfte und

Verpflichtungen der Instinkte sind abgeblasst. Die Wünsche hängen hohl und weitfältig um abgemagerte Dinge. Man lernt die Gebundenheit zugleich als Wille verstehen, und da man alles wollen konnte, verloren wir die Werte.' Ernst Nef comments: 'Einstein beschreibt in diesen Sätzen das Zustandekommen und die Situation des modernen nihilistischen Bewusstseins' (S364/12).

3 'Eine der klassischen Erkenntnisse der nachnietzscheschen Epoche stammt von Thomas Mann und lautet: "Alles Transzendente ist tierisch, alles Tierische transzendentiert – " ein höchst seltsames Wort, es gehört hierher. Wenn es nämlich noch eine Transzendenz gibt, muss sie tierisch sein' (*Akademie-Rede*, in P339/995).

4 The present discussion of Benn's prose is by no means the first. But though most critics refer in passing to the Rönne novellen, a full discussion of them as a road towards the goal of an 'organic' transcendence has not been undertaken. Most interpretations focus either on the point of departure in nihilism, as Hamburger does, or they interpret *Gehirne* as a kind of alternate forum for essayistic writing (as Balser does). Even Wellershoff tends to use *Gehirne* to illustrate points made elsewhere by Benn.

5 The sense of smell is a primitive one. Benn distinguishes between 'older' and 'newer' parts of the brain. The former allegedly stores the memory of previous existences. Smell presumably belongs in this older part also.

6 The terms 'progression' and 'regression' are to be understood in the sense which Benn gives them, as should become clear in the discussion.

7 Marion Adams (S1/92) stresses the Art Nouveau influence in these passages, particularly in the choice of the name Edmée, and refers to a 'hothouse eroticism.'

8 Although in his 'Lebensweg eines Intellektualisten' Benn answers the question 'Für die Bewegung und den Geist, für die Reize und Tiefen – gibt es noch einen Zusammenschluss, eine Betastung, ein Glück?' with 'Ja – antwortet Rönne, aber weither, nichts Allgemeines, fremde, schwer zu ertragende, einsam zu erlebende Bezirke ... er erblickt die Kunst' (1903), this is true only as far as the discovery of an appropriate language is concerned. Speculations about the nature of art are absent, and one feels that Benn is adding a dimension in retrospect, to explain his own development away from the 'tierische Transzendenz' elaborated in *Gehirne*.

9 The allusions to Otto Ludwig's *Zwischen Himmel und Erde* can be seen in the erotic rivalry between the two brothers, the religious consciousness, and the symbolism of the state of being suspended between heaven and earth.

10 Typical is the following passage: 'Fahren! Das Poltern der Bahn würde das Brausen seiner Ohren übertönen, das Dunkel würde ihn verbergen. Ah, er

fuhr schon, der schwarze Tunnel streift sich über den Zug wie ein endloser Sack. Geborgen! Die Lichter tanzten und liefen wie Gespenster auf dünnen Beinchen. Es klapperte, es donnerte ... die Tunneltreppen brüllten mit dem Lichte von oben ... Nun war es aber bald, als bohre sich der Zug in prasselnder Eile tief in die Erde hinein, schräg, schräger, jetzt senkrecht ... Nun umgekehrt, fast senkrecht hinauf. Die Fahrt flog ihm entgegen, wie in Stücke geschleudert ... Die Tunnelsteine schienen aus den Wänden zu spritzen, knatterned und pfeifend und donnernd flogen sie ihm an.'

CHAPTER NINE: EROS IN EXTREMIS

1 In a more light-hearted story, but with the conflict of the egos and the refusal to submit to the erotic pull from the opposite sex nevertheless present, Paul Boldt treats of love between adolescents in 'Der Versuch zu lieben' (P13, now also in P324).

2 Klaus Kanzog comments: 'Der Name "Mondmilch" parodiert das von Else Lasker-Schüler häufig verwendete Mond-Motiv; auch Details aus dem Leben Else Lasker-Schülers sind verwendet, aber grotesk verzerrt und zusammen mit anderen Einfällen zu einem eigenen Erzählgebilde umgestaltet worden' (P389/146).

3 'In Einsteins Grotesken steht die Welt knapp vor ihrem Untergang; der Schauplatz wird von Irren beherrscht' (Heinz Graber, 'Carl Einstein,' in Rothe, S200/678).

4 Liede (S132/48) interprets the *Liebestod* in relation to Döblin's nature philosophy; the de-individuation and merger with the cosmos is made possible by love and death: 'Im Tod erst findet die Vereinigung statt als Heimkehr des Einzelnen in den umfassenden anonymen Urgrund.' Along the same lines Müller-Salget writes: 'Der Versuch des Individuums, die Entfremdung aufzuheben, führt ... konsequent zur Aufgabe des Ichs im Tod. Der Einzelne hat nicht die Kraft, von sich aus die Versöhnung in dieser Welt herbeizuführen' (S155/40).

5 Sack's critical attitude towards a good number of fellow Expressionist writers can be seen in the following passage from his correspondence: 'Wenn wir uns scheuen Auges zeigen, was ihr daheim schreibt und zeichnet und malt, wenn wir gar eure Gefühle hören und eure Gesichter sehen, so möchten wir uns in den Wahsinn flüchten: lasst uns für immer ferne von euch, gebt uns für ewig den Krieg, lasst uns nie zurückkehren in euren erbärmlichen Kitsch, in eure erbärmliche Begeisterung, in eure Begeisterung für nichts, in eure Lüge für nichts' (P406/354).

CHAPTER TEN: GOD AND THE SEARCH FOR UTOPIA

1 Cf. Carl Einstein, quoted by Sybille Penkert (S170/51): 'Wie kann man von Kunst als Elementarem ausgehen, – wo diese doch ein Correlat des Religiösen und erst hierin elementar begründet ist ... Wir werden erweisen, dass man aus den Elementen des Kunstwerkes Gott konstruieren und dieser als ästhetisches Phänomen erfasst werden kann.'

2 W.G. Klee (S110/110) calls François an 'ebenbürtiger Gegner' of God because of his 'blendende Konstitution.' Liede, on the other hand, rejects 'Der Gott' as a failure: 'Der positive Entwurf unentstellten Lebens missrät ihm, wie vielen seiner Zeitgenossen, zur Regression in den Mythos' (S132/122). He speaks of a 'Triumph des Irrationalismus, der schlechten Identität von Ich und Natur auf Kosten der Humanität, einer geistigen Autonomie des Menschen' (125).

3 Wendler, in Rothe (S200/656), writes: 'Die scheinbar verzweifelten Anklagen gegen Gott über den grauenvollen Zustand der Welt sind nicht verzweifelt. Sie setzen immer noch Verantwortung bei einer anderen Instanz voraus.' See also Liede, p. 178, about this problem in Heym.

4 This motif of pride in martyrdom of course also appears as the last diabolical temptation for Thomas à Becket in T.S. Eliot's *Murder in the Cathedral*.

5 Oron J. Hale, *The Great Illusion, 1900-1914* (New York: Harper Torchbooks 1971), p. 114.

6 Karl Kautsky, The Foundations of Christianity (New York 1953), p. xi.

7 The influence of the writings of Paul Scheerbart, who had great success at the time with his astral and cosmic novels, like *Die grosse Revolution* and his *Astrale Noveletten* (1912), can be seen in these writings.

8 It is writers like Kornfeld who suggested W. G. Klee's comment: 'Der Expressionismus ist völlig unhistorisch' (141). Klee explains this lack of a sense of history as the result of the wish for a sudden, unique transformation rather than a gradual change through the historical process.

9 The story is a good example of the general embarrassment of Expressionists to show what follows the *Aufbruch*: 'Dem Aufbruch folgt keine Ankunft,' writes Hinck (S85/254).

10 The figure of Maillard is important for the problem of leadership, which is acute in Expressionism. Maillard's role is a dubious one, regardless of the historical veracity of his claims, since once the *Aufbruch* is accomplished, he is swept away and left behind.

BIBLIOGRAPHY

PRIMARY SOURCES

A. Prose discussed in text, first publication

P1 Baum, Oskar. 'Der Geliebte.' *Zwei Erzählungen*. Leipzig 1918 (Der jüngste Tag)
P2 Benn, Gottfried. *Diesterweg*. Berlin 1918
P3 – 'Die Eroberung.' *Die weissen Blätter* 2 (1915), nr. 8, 950–6
P4 – 'Der Geburtstag.' *Gehirne*. Leipzig 1916
P5 – 'Gehirne.' *Die weissen Blätter* 2 (1915), nr. 2, 210–14
P6 – 'Ein Gespräch.' *Die Grenzboten* 69 (1910), nr. 22
P7 – 'Heinrich Mann. Ein Untergang.' *Die Aktion* 3 (1913), nr. 16, col. 431–3
P8 – 'Die Insel.' *Gehirne*. Leipzig 1916 (Der jüngste Tag)
P9 – 'Nocturno.' *Der Sturm* 3 (1913), nr. 144/45, 254
P10 – 'Die Reise.' *Die weissen Blätter* 3 (1916), nr. 2, 244–51
P11 Beradt, Martin. 'Der Neurastheniker.' *Arkadia* 1 (1913), 137–49
P12 – 'Die Nummer am Haus.' *Die Verfolgten. Novellen*. Hamburg 1919
P13 Boldt, Paul. 'Der Versuch zu lieben.' *Das Aktionsjahrbuch* (ed. Franz Pfemfert). Berlin 1917
P14 Brod, Max. 'August Nachreiters Attentat.' *Weiberwirschaft*. Leipzig, Vienna 1917 (written 1912)
P15 – 'Das Ballettmädchen.' *Weiberwirtschaft*. Leipzig, Vienna 1917
P16 – 'Notwehr.' *Arkadia. Ein Jahrbuch für Dichtkunst* (ed. Max Brod). Leipzig 1913
P17 – 'Die Stadt der Mittellosen.' *Weiberwirtschaft*. Leipzig 1917
P18 Bronnen, Arnolt. *Die Septembernovelle*. Berlin 1923
P19 Buber, Martin. 'Der Psalmensager.' *Die Legenden des Baalschem*. Frankfurt a.M. 1916

P20 Döblin, Alfred. 'Astralia.' *Der Sturm* 1 (1910/11), 244–5

P21 – 'Der Dritte.' *Der Sturm* 2 (1911/12), 613–14, 621–2

P22 – 'Die Ermordung einer Butterblume.' *Der Sturm* 1 (1910), nr. 28/29, 220–1, 229

P23 – 'Der Kaplan.' *Der Sturm* 5 (1914/15), 35–9

P24 – 'Mariä Empfängnis.' *Der Sturm* 2 (1911/12), 700

P25 – 'Die Memoiren des Blasierten.' *Die Ermordung einer Butterblume und andere Erzählungen.* Munich 1913

P26 – 'Die Segelfahrt.' *Der Sturm* 2 (1911/12), 549–50

P27 – 'Das Stiftsfräulein und der Tod.' *Das Magazin* 76 (1908), installment 4, 52–4. Also in *Lyrische Flugblätter.* Berlin-Wilmersdorf 1913

P28 Edschmid, Kasimir. 'Der aussätzige Wald.' *Das Forum* 2 (1915), 22–40

P29 – 'Das beschämende Zimmer.' *Das rasende Leben.* Leipzig 1916 (Der jüngste Tag)

P30 – 'Fifis herbstliche Passion.' *Die sechs Mündungen.* Leipzig 1915

P31 – *Die Fürstin.* Berlin 1920.

P32 – 'Der Gott.' *Timur. Novellen.* Leipzig 1916

P33 – 'Die Herzogin.' *Timur. Novellen.* Leipzig 1916

P34 – 'Der Lazo.' *Die sechs Mündungen.* Leipzig 1915

P35 – 'Maintonis Hochzeit.' *Die weissen Blätter* 1 (1913/14), 347–59

P36 – 'Der tödliche Mai.' *Das rasende Leben.* Leipzig 1916

P37 – 'Yousouf.' *Die weissen Blätter* 2 (1915), 586–617

P38 – 'Yup Scottens.' *Die sechs Mündungen.* Leipzig 1915

P39 Ehrenstein, Albert. 'Begräbnis.' *Der Selbstmord eines Katers.* Munich 1912

P40 – 'Kaninchen.' First published as 'Frühes Leid.' *Der Sturm* 3 (1913), nr. 42/43, 248. Also in *Der Ruf* 1 (1912/13), installment 5, 16–18

P41 – 'Lebensbericht.' First published in *Ausgewählte Aufsätze* (ed. M.Y. Ben-Gavriel). Heidelberg, Darmstadt 1961

P42 – 'Passion.' *Der Sturm* 2 (1911/12), 639–40

P43 – 'Ritter Johann des Todes.' *Die Fackel* 12 (1910). Also in *Der Sturm* 2 (1911/12), 699–700

P44 – 'Der Selbstmord eines Katers.' *Die Fackel* 13 (1911), nr. 334/5

P45 – 'Tod eines Seebären.' *Nicht da, nicht dort.* Leipzig 1916

P46 – 'Der Weg ins Freie.' First published as 'Elend.' *Bericht aus einem Tollhaus.* Leipzig 1919

P47 – *Tubutsch. Erzählung.* Vienna 1911

P48 – 'Wudandermeer.' First published as 'Wodianer.' *Der neue Merkur* 1 (1914), 1

P49 – 'Zigeuner.' *Die Fackel* 13 (1911), nr. 321/2

P50 Ehrenstein, Carl. *Klagen eines Knaben.* Leipzig 1913 (Der jüngste Tag)

P51 Einstein, Carl. 'Herr Giorgio Bebuquin.' *Die Opale* 2 (1907), 169–75. First
 complete form: *Die Aktion* 2 (1912), col. 28–41. In book form: *Bebuquin
 oder die Dilettanten des Wunders*. Berlin-Wilmersdorf 1912
P52 – 'Die Mädchen auf dem Dorfe.' *Der unentwegte Platoniker*. Leipzig 1918
P53 Flesch-Brunningen, Hans von. 'Der Junitag.' *Das zerstörte Idyll*. Leipzig
 1917 (Der jüngste Tag)
P54 – 'Die Kinder des Hauptmanns.' *Das zerstörte Idyll*. Leipzig 1917 (Der
 jüngste Tag)
P55 – 'Der Satan.' *Das zerstörte Idyll*. Leipzig 1917 (Der jüngste Tag)
P56 Frank, Leonhard. 'Das Liebespaar.' *Zeit-Echo* 3 (1917), 24–41. Also in *Das
 Forum* 3 (1919), 601–25
P57 – 'Die Kriegskrüppel.' *Der Mensch ist gut*. Zürich, Potsdam 1918
P58 – 'Die Kriegswitwe.' *Die weissen Blätter* 4 (1917), nr. 2, 196–226
P59 – 'Die Ursache.' *Die weissen Blätter* 2 (1915), 399–490
P60 – 'Der Vater.' Originally published as 'Der Kellner.' *Die weissen Blätter* 3
 (1916), 4, 149–59
P61 Herrmann-Neisse, Max. 'Die Begegnung.' *Die Begegnung. Vier
 Erzählungen*. Berlin 1927 (written 1922)
P62 – 'Das Experiment.' *Die Begegnung. Vier Erzählungen*. Berlin 1927
P63 – 'Himmelfahrt zu Gott vaterlos.' *Hilflose Augen*. Vienna, Prague, Leipzig
 1920
P64 – 'Die Klinkerts.' *Die Aktion* 12 (1922), col. 605–27
P65 Heym, Georg. 'Der Dieb.' *Der Dieb. Ein Novellenbuch*. Leipzig 1913
P66 – 'Der fünfte Oktober.' *Der Dieb. Ein Novellenbuch*. Leipzig 1913
P67 – 'Der Irre.' *Der Dieb. Ein Novellenbuch*. Leipzig 1913
P68 – 'Jonathan.' *Der Dieb. Ein Novellenbuch*. Leipzig 1913
P69 – 'Die Sektion.' *Der Dieb. Ein Novellenbuch*. Leipzig 1913
P70 – 'Das Schiff.' *Der Dieb. Ein Novellenbuch*. Leipzig 1913
P71 Jung, Franz. 'Der 50. Geburtstag.' *Das Trottelbuch*. Leipzig 1912
P72 – 'Josef.' *Das Trottelbuch*. Leipzig 1912
P73 – 'Die Krise.' *Gnadenreiche, unsere Königin. Erzählungen*. Leipzig 1918
 (Der jüngste Tag)
P74 – 'Die Liebe wandert.' *Das Aktionsbuch* (ed. Franz Pfemfert). Berlin 1917
P75 – 'Saul.' *Saul. Erzählungen*. Berlin 1916
P76 Klabund. 'Bett nr. 13.' *Der Marketenderwagen. Ein Kriegsbuch*. Berlin 1916
P77 – 'Der dämonische Otto.' *Kunterbuntergang des Abendlandes*. Munich
 1921
P78 – 'Der Kriegsberichterstatter.' *Kunterbuntergang des Abendlandes*.
 Munich 1921
P79 – 'Der Literaturverein.' *Kunterbuntergang des Abendlandes*. Munich 1921

P80 – 'Die 99. Wiederkehr des Buddha.' *Kunterbuntergang des Abendlandes.* Munich 1922

P81 – 'Die schwarze Fahne.' *Der Marketenderwagen. Ein Kriegsbuch.* Berlin 1916

P82 – 'Der sterbende Soldat.' *Der Marketenderwagen. Ein Kriegsbuch.* Berlin 1916

P83 – 'Der wohlhabende junge Mann.' *Der Marketenderwagen. Ein Kriegsbuch.* Berlin 1916

P84 Kornfeld, Paul. 'Legende.' *Die weissen Blätter* 4 (1917), issue 4, 105–70

P85 Krell, Max. *Der Henker.* Darmstadt 1924

P86 Lampl, Friedo. 'Sylvester der Narr.' *Sklaven der Freiheit. Novellen und Märchen.* Heidelberg 1925

P87 Lasker-Schüler, Else. *Der Wunderrabiner von Barcelona.* Berlin 1921

P88 Lemm, Alfred. 'Weltflucht.' *Mord.* Munich 1918 (Die neue Reihe)

P89 Lichtenstein, Alfred. 'Die Jungfrau.' *Gedichte und Geschichten* (ed. Kurt Lubasch). Munich 1919

P90 – 'Der Selbstmord des Zöglings Müller.' *Simplicissimus* 17 (1912), nr. 18

P91 – 'Der Sieger.' *Pan* 3 (1912/13), 252–9

P92 Loerke, Oskar. 'Die beiden Götter.' First published as 'Vor 5000 Jahren.' *Licht und Schatten* 1 (1910/11). New title in *Die neue Erde* 1 (1919), issue 1, 19–21

P93 – 'Das Goldbergwerk.' *Die weissen Blätter* 1 (1913/14), nr. 7

P94 – 'Kaiser.' First published as 'Das Avancement.' *März* 7 (1913), nr. 4

P95 – 'Die Puppe.' *Das neue Pathos Jahrbuch* (1919), 29–33

P96 – 'Der Sandberg.' *Das neue Pathos* (1913), issue 5/6, 4–9

P97 – 'Zimbehl in den Wolken.' *Das neue Pathos Jahrbuch* (1919), 7–14

P98 Mann, Heinrich. 'Ehrenhandel.' *Bunte Gesellschaft.* Munich 1917

P99 – 'Der Gläubiger.' *Berliner Tageblatt,* 20 Apr. 1917

P100 – 'Kobes.' *Die neue Rundschau* 1 (1925), issue 2

P101 – 'Sterny.' *Der Jüngling.* Munich 1924

P102 – 'Der Vater.' *Der neue Roman. Ein Almanach.* Leipzig 1917

P103 Mierendorff, Carlo. *Der Gnom.* Darmstadt 1917.

P104 Müller, Robert. 'Manhattan Girl.' *Die neue Rundschau,* Sept. 1920

P105 Mynona. 'Eines Kindes Heldentat.' *Die Aktion* 3 (1913), col. 14–16

P106 – 'Die vegetabilische Vaterschaft.' *Der Einzige* 1 (1919), 9–11

P107 Otten, Karl. 'Der Sprung aus dem Fenster.' *Der Sprung aus dem Fenster.* Leipzig 1918 (Der jüngste Tag)

P108 Sack, Gustav. 'Aus dem Tagebuch eines Refraktärs.' Written 1914. Published in *Prosa, Briefe, Verse* (ed. Dieter Hoffmann). Munich, Vienna 1962

P109 – 'Capriccio.' Published in *Prosa, Briefe, Verse* (ed. Dieter Hoffmann). Munich, Vienna 1962

P110 – 'Das Duell.' *Das Buch der Toten* (ed. Wolf Przygode). Munich 1919

P111 – 'Die Dirne.' Written between 1913 and 1916. Published in *Prosa, Briefe, Verse* (ed. Dieter Hoffmann). Munich, Vienna 1962

P112 – *Ein verbummelter Student.* Berlin 1917

P113 – *Ein Namenloser.* Berlin 1919

P114 – 'Eva.' Die junge Kunst 1 (1919), nr. 7, 7–9

P115 – 'Im Heu.' Written between 1913 and 1916. Published in *Prosa, Briefe, Verse* (ed. Dieter Hoffmann). Munich, Vienna 1962

P116 – 'Intermezzo.' *Die neue Bücherschau* 1 (1919), 14–15

P117 – 'Reigen.' Published in *Prosa, Briefe, Verse* (ed. Dieter Hoffmann). Munich, Vienna 1962

P118 – 'Der Rubin.' *Die schöne Rarität* 2 (1918/19), 11–14

P119 – 'Der Teufelszwirn.' Written between 1913 and 1916. Published in *Prosa, Briefe, Verse* (ed. Dieter Hoffmann). Munich, Vienna 1962

P120 Schäffer, Heinrich. 'Aus den Memoiren eines Unbekannten.' *Die Aktion* 7 (1917), col. 537–9

P121 Schendell, Werner. 'Der Flüchtling.' *Die Erhebung* 2 (1920), 91–103

P122 Sternheim, Carl. 'Der Anschluss.' *Vier Novellen. Neue Folge der Chronik vom Beginn des 20. Jahrhunderts.* Berlin 1918

P123 – 'Busekow.' *Die weissen Blätter* 1 (1913), nr. 1/2, 6–15, 107–16

P124 – 'Heidenstam.' *Chronik von des 20. Jahrhunderts Beginn.* Leipzig 1918

P125 – 'Die Hinrichtung.' *Chronik von des 20. Jahrhunderts Beginn.* Leipzig 1918

P126 – 'Die Laus.' Chronik von des 20. Jahrhunderts Beginn. Leipzig 1918

P127 – *Meta. Eine Erzählung.* Leipzig 1916 (Der jüngste Tag)

P128 – *Napoleon.* Leipzig 1915. (Der jüngste Tag). Also in *Die weissen Blätter* 2 (1915), 825–53

P129 – 'Posinsky.' *Marsyas. Eine Zweimonatschrift* 1 (1917), 1, 137–62

P130 – 'Die Poularde.' *Vier Novellen. Neue Folge der Chronik vom Beginn des 20. Jahrhunderts.* Leipzig 1918

P131 – 'Schuhlin.' *Die weissen Blätter* 2 (1915), 1125–41

P132 – *Ulrike. Eine Erzählung.* Leipzig 1918 (Der jüngste Tag)

P133 – 'Vanderbilt.' *Chronik von des 20. Jahrhunderts Beginn.* Leipzig 1918

P134 – 'Yvette.' *Chronik von des 20. Jahrhunderts Beginn.* Leipzig 1918

P135 Strauss, Ludwig. 'Das verpasste Verbrechen.' *Der Mittler. Novellen.* Berlin 1916

P136 Weiss, Ernst. *Daniel. Erzählung.* Berlin 1924

P137 – 'Franta Zlin.' *Genius* 1 (1919), 298–308

P138 – *Hodin.* Berlin 1923

P139 – 'Marengo.' *Die neue Rundschau,* Mar. 1926

P140 – 'Die Verdorrten.' *Der neue Merkur.* Munich, Berlin 1920/1

P141 Werfel, Franz. 'Blasphemie eines Irren.' *Die neue Dichtung, Ein Almanach.* Leipzig 1918

P142 – 'Der Dschin.' *Die Entfaltung. Novellen an die Zeit* (ed. Max Krell). Berlin 1921

P143 – *Nicht der Mörder, der Ermordete ist schuldig.* Munich 1920

P144 – *Die Versuchung. Ein Gespräch des Dichters mit dem Erzengel und Luzifer.* Leipzig 1913. (Der jüngste Tag)

P145 Wolfenstein, Alfred. 'Fragment eines Daseins.' *Die Aktion* 4 (1914), col. 238–41

P146 – 'Die künstliche Liebe.' *Die Aktion* 4 (1914), col. 891–4

P147 – 'Der Lebendige.' *Der Lebendige. Novellen.* Munich 1918 (Die neue Reihe)

P148 – 'Ohnmacht.' *Der Lebendige. Novellen.* Munich 1918 (Die neue Reihe)

P149 – 'Über allen Zaubern.' *Der Lebendige. Novellen.* Munich 1918 (Die neue Reihe)

P150 – 'Die Wiederkunft.' *Der Lebendige. Novellen.* Munich 1918 (Die neue Reihe). Also in *Der Anbruch* 2 (1919/20), issue 2, 2–3

P151 Zarek, Otto. 'Der Sprung in den Tag.' *Eos* 1 (1918), issue 2, 130–50. Also in *Die Erhebung* 2 (1920), 37–53

P152 Zech, Paul. 'Der Anarchist.' *Der schwarze Baal. Novellen.* Leipzig 1917

P153 – 'Die Birke.' *Der schwarze Baal. Novellen.* Leipzig 1917

P154 – 'Die Gruft von Valero.' *Der Sturm* 4 (1913/14), 194–6. Also in *Der schwarze Baal. Novellen.* Leipzig 1917

P155 – 'Nervil Munta.' *Der schwarze Baal. Novellen.* Leipzig 1917

P156 – 'Der schwarze Baal.' First published as 'Das Baalsopfer.' *Der Sturm* 4 (1913/14), 26–9. Also in *Der schwarze Baal. Novellen.* Leipzig 1917

P157 – 'Auf der Terrasse am Pol.' *Das neue Pathos* 1 (1913), issue 5/6, 15–20

P158 – 'Das Vorgesicht.' *Der schwarze Baal. Novellen.* Leipzig 1917

B. Contemporary manifestos and documents

P159 Bahr, Hermann. *Expressionismus.* Munich 1916

P160 Ball, Hugo. 'Kandinsky.' [Vortrag gehalten in der Galerie Dada]. Zürich 1917. First printed in *Dvjs* 51 (1977), issue 4, 676–704

P161 – *Zur Kritik der deutschen Intelligenz. Ein Pamphlet.* Bern 1919

P162 Benn, Gottfried. *Das moderne Ich.* Berlin 1920

P163 Bisschoff, F.W. 'Neue Romane.' *Die Flöte* 4 (1931/22), 362–3

P164 Blass, Ernst. 'Geist der Utopie.' *Das junge Deutschland* 2 (1919), nr. 3, 63–7

P165 Blei, Franz. 'Die Krise der Kirche.' *Die Rettung* 1 (1918/19), 65–72

P166 Bock, Kurt. 'Erlebnis und Dichtung.' *Der Zweemann* 1 (1919/20), issue 4, 9.

P167 Bonsels, Waldemar. 'Der Roman als Kunstform.' *Die Literatur* 26 (1923/24), 1–2

P168 Brodnitz, Käthe. 'Die futuristische Geistesrichtung in Deutschland.' First published in *Expressionismus: Der Kampf um eine literarische Bewegung* (ed. Paul Raabe). Olten, Freiburg 1965

P169 Buber, Martin. 'Gemeinschaft.' *Neue Erde* 1 (1919), issue 1, 6–8.

P170 Charve, Michael. 'Die Kritik des Romans.' *Der Kritiker* 1 (1919), nr. 20, 7–9

P171 Döblin, Alfred. 'An Romanautoren und ihre Kritiker. Berliner Programm.' *Der Sturm* 4 (1913/14), nr. 158/59, 17–18

P172 – *Aufsätze zur Literatur* (ed. Walter Muschg). Olten, Freiburg 1963

P173 – 'Bemerkungen zum Roman.' *Die neue Rundschau* 28 (1917), 410–15

P174 – 'Der Epiker, Sein Stoff und die Kritik.' *Der neue Merkur* 2 (Apr. 1921), 56–64

P175 – 'Mehrfaches Kopfschütteln.' *Die Literatur* 26 (1923/24), 5–6

P176 – 'Reform des Romans.' *Der neue Merkur* 3 (1919/20), 189–202

P177 – 'Gespräche mit Kalypso über die Musik. [Dialog]' *Der Sturm* 1 (1910/11), 34, 42, 50–1, etc. [many entries]

P178 – 'Über Jungfräulichkeit und Prostitution.' *Der Sturm* 3 (1912/13), 125–6, 127–8

P179 – 'Über Roman und Prosa.' *Marsyas* 1 (1917), 213–18

P180 Edschmid, Kasimir. 'Bemerkungen zur Prosa.' *Die neue Bücherschau* 1 (1919), issue 1

P181 – 'Der Expressionismus in der Dichtung.' *Die neue Rundschau* 29 (1918) 1, 359–74

P182 – 'Der neue Roman und Wassermann.' *Die weissen Blätter* 7 (1920), 130–7

P183 – 'Über den dichterischen Expressionismus. *Über den Expressionismus in der Literatur und die neue Dichtung*. Berlin 1919, 39–78

P184 Ehrenstein, Albert. 'Österreichische Prosa.' *Der Sturm* 5 (1914/15), 98–9

P185 Einstein, Carl. 'Anmerkungen über den Roman.' *Die Aktion* 2 (1912), nr. 40, col. 1264–9

P186 – 'Anmerkungen I & II.' *Die Aktion* 4 (1914), nr. 13

P187 – 'Brief über den Roman.' *Pan* 2 (1911/12), 477–82

P188 – 'Didaktisches für Zurückgebliebene.' *Die Aktion* 6 (1916), nr. 20/21, col. 268–72

P189 – *Negerplastik*. Leipzig 1915

P190 – 'Totalität.' *Die Aktion* 4 (1914), col. 345–7

P191 Elster, H.M. 'Bücherschau.' *Die Flöte* 3 (1920/21), 162–3

P192 Fechter, Paul. *Der Expressionismus*. Munich 1914

P193 Federn, Paul. 'Zur Psychologie der Revolution: Die Vaterlose Gesellschaft.' *Der Österreichische Volkswirt* 11 (1919), nr. 32, 571–4; nr. 33, 595–8

P194 Flake, Otto. 'Souveränität.' *Die Erhebung* 1 (1919), 338–47

P195 – 'Von der jüngsten Literatur.' *Die neue Rundschau* 26 (1915), vol. 2, 1276–87

P196 – 'Von deutschen Erzählern.' *Das Tribunal* 1 (1919), 60

P197 – 'Die Krise des Romans.' *Die neue Bücherschau* 2nd s., 3 (1920), 87–94

P198 – Preface to *Die Stadt des Hirns*. Berlin 1919, pp. 9–11

P199 – 'Vorwort zum neuen Roman' (= 'Die Stadt des Hirns'). *Die neue Bücherschau* 1 (1919), issue 8–9

P200 Fontana, Oskar Maurus. [Untitled]. *Das Tagebuch* (1927), issue 41, 1653

P201 Freud, Sigmund. 'Zeitgemässes über Krieg und Tod.' *Das Forum* 2 (1915), issue 1, 190–1

P202 Goldschmidt, K.W. 'Literatur und Erotik.' *Erlebte Dichtung*. Leipzig 1912, pp. 207–18

P203 Goll, Yvan. 'Der Expressionismus stirbt.' *Zenit* 1 (1921), 8–9

P204 – 'Vorwort.' *Films*. Berlin-Charlottenburg 1914

P205 Gross, Otto. 'Dic Einwirkung der Allgemeinheit auf das Individuum.' *Die Aktion* 3 (1913), col. 1091–5

P206 – 'Zur überwindung der kulturellen Krise.' Die Aktion 3 (1913), col. 384–7

P207 Haecker, Th. 'Humor und Satire.' *Der Brenner* 12 (1928), 175–204

P208 Hatvani, Paul. 'Versuch über den Expressionismus.' *Die Aktion* 7 (1917), col. 146–50

P209 Haubach, Theodor. 'Kasimir Edschmids Roman "Die achatnen Kugeln."' *Die neue Bücherschau* 1 (1919), issue 6, 16

P210 – 'Wider die Politik.' *Das Tribunal* 1 (1919), 51–2

P211 Heine, Gerhard. 'Vom "Jüngsten Tag" deutscher Dichtung.' *Die Christliche Welt* (1916), nr. 49, col. 938–41

P212 Herweg, Franz. 'Vom literarischen Expressionismus.' *Hochland* 13 (May1916), 232–5

P213 Herzfelde, Wieland. 'Die Ethik der Geisteskranken.' *Die Aktion* 4 (1914), col. 298–302

P214 Herzog, Wilhelm. 'Der geistige Typus des Revolutionärs.' *Das Forum* 3 (1918/19), issue 3, 181–5

P215 Hesse, Hermann. 'Zum Expressionismus in der Dichtung.' *Die neue Rundschau* 29 (1918), vol. 1, 838–43

P216 Hiller, Kurt. 'Expressionismus.' In *Die Weisheit der Langenweile. Eine Zeit- und Streitschrift*. Leipzig 1913, vol. 1, 103

P217 – 'Die jüngst-Berliner.' *Literatur und Wissenschaft*, supp. to the
 Heidelberger Zeitung nr. 7, 22 July 1911, 2–6
P218 – 'Ortsbestimmung des Aktivismus.' *Die Erhebung* 1 (1919), 360ff.
P219 – 'Vom Aktivismus.' *Die weissen Blätter* 4 (1917), 88–94
P220 Holitscher, Arthur. 'Das Religiöse im sozialen Kampf.' *Die Erhebung* 2
 (1920), 322–36
P221 Huebner, Friedrich Markus. ['Der Expressionismus in Deutschland']. In
 F.M.H. *Europas neue Kunst und Dichtung*. Berlin 1920, 80–95
P222 – 'Krieg und Expressionismus.' *Die Schaubühne* 10 (1914), nr. 48, 441–3
P223 Johanna Freiin von Caudern. 'Die neue Kunst.' *Deutsches Literaturblatt* 3
 (1913), nr. 3, 7–8
P224 Kanehl, Oskar. 'Welche Kunst ist unsittlich?' *Die Aktion* 14 (1924), col.
 203–4
P225 Kayser, Rudolf. 'Kinderland.' *Das junge Deutschland* 2 (1919), 283–9
P226 – 'Literatur in Berlin.' *Das junge Deutschland* 1 (1918), nr. 2, 41–2
P227 – 'Der politische Dichter Leonhard Frank.' *Das junge Deutschland* 1
 (1918), 302
P228 – 'Subjektivismus.' *Die Erhebung* 1 (1919), 347–52
P229 Klabund. 'Die neue Prosa.' *Die Flöte* 2 (1919/20), 178–9
P220 Kornfeld, Paul. 'Der beseelte und der psychologische Mensch.' *Das junge
 Deutschland* 1 (1918), 1–13
P231 Krell, Max. 'Expressionismus in der Prosa.' *Weltliteratur der Gegenwart*.
 Berlin 1924. Vol. 1, 'Deutschland,' pt. 2, 137–69
P232 – 'Neue deutsche Romane und Novellen.' *Die neue Bücherschau* 2nd s.,
 3rd installment (1920), 100
P233 – 'Metaphysische Figuren.' *Die neue Rundschau* 28 (1917), vol. 2, 270–6
P234 – 'Romane 1920.' *Die neue Rundschau* 31 (1920), vol. 2, 1413–4
P235 – 'Vorbemerkung.' *Die Entfaltung. Novellen an die Zeit* (ed. Max Krell).
 Berlin 1921, v–xiii
P236 – 'Über neue erzählende Prosa.' *Die neue Rundschau* 31 (1920), vol. 2,
 1190–9
P237 – 'Über neue Prosa.' *Tribüne der Kunst und Zeit*. Berlin 1919
P238 – 'Zur Prosa der Gegenwart. Bemerkungen aus einem historischen Abriss.'
 Die neue Merkur 7 (1924), issue 7, 568ff.
P239 – 'Zur jüngsten Prosa.' *Almanach der Bücherstube auf das Jahr 1920*, 34–
 40
P240 Kurtz, Rudolf. 'Der junge Dichter.' *Die neue Kunst* 1 (1913), issue 1, 1–3
P241 Leonhard, Rudolf. 'Die Politik der Dichter.' *Die weissen Blätter* 2 (1915),
 814–16

P242 Loerke, Oskar. 'Die Stimme des Dichters.' *Revolution* 1 (1918), nr. 2, 14–15

P243 Mann, Heinrich. 'Geist und Tat.' *Pan* 1 (1910/11), nr. 5, 137–43

P244 Mann, Thomas. 'Der Taugenichts.' *Die neue Rundschau* 27 (1916), 1478–90

P245 Marc, Franz. 'Im Fegefeuer des Krieges.' *Der Sturm* 1 (1916/17), issue 1, 2

P246 Martens, Kurt. *Literatur in Deutschland. Studien und Eindrücke.* Berlin 1910

P247 – 'Romane, die bleiben werden.' *Almanach der Bücherstube* 4 (1921), 56–62

P248 Michel, Wilhelm. 'Rede über die Metaphysik des Bürgers.' *Das Tribunal. Hessische radikale Blätter* 1 (1919), issue 1, 13–14

P249 – 'Tathafte Form.' *Die Erhebung* 2 (1920), 348–55

P250 Mierendorff, Carlo. 'Wortkunst. Von der Novelle zum Roman.' *Die weissen Blätter* 7 (1920), 278–82

P251 Molzahn, Johannes. 'Das Manifest des Absoluten Expressionismus.' *Der Sturm* 10 (1919), nr. 6, 90–2

P252 Mühsam, Erich. 'Aufruf zum Sozialismus.' *Kain* 1 (1915), nr. 3, 33–9

P253 – 'Bohème.' *Die Fackel* 8 (1906), nr. 202, 4–10

P254 – 'Idealistisches Manifest.' *Kain* 4 (1914), nr. 1, 1–8

P255 Oehring, Richard. 'Die Internierung des Dr. Otto Gross und die Polizei.' *Wiecker Bote* 1 (1914), issue 7, 1–3

P256 Pander, Oskar. 'Revolution der Sprache.' *Das junge Deutschland* 1 (1918), nr. 5, 147–8

P257 – 'Roman und Mythos.' *Die Flöte* 3 (1920/21), 241–4

P258 Pfemfert, Franz. 'Die Besessenen.' *Die Aktion* 4 (1 Aug. 1914)

P259 Picard, Max. 'Expressionismus. Ein Vortrag.' *Die Erhebung* 1 (1919), 329–38

P260 Pinthus, Kurt. 'Glosse, Aphorismus, Anekdote.' *März* 7 (1913), issue 19, 213–14

P261 – 'Zur jüngsten Dichtung.' *Vom jüngsten Tag. Almanach und Dichtung.* Leipzig 1916 , pp. 230–47

P262 – 'Zuvor.' *Menschheitsdämmerung. Symphonie jüngster Dichtung* (ed. Kurt Pinthus). Berlin 1920, v–xvi

P263 Rilla, Walther. 'Der Bürger.' *Die Erde* 1 (1919), issue 11, 321–9

P264 Rubiner, Ludwig. 'Europäische Gesellschaft.' *Zeit-Echo* 3 (1917), nr. 1/2, 6–9

P265 – 'Der Dichter greift in die Politik.' *Die Aktion* 2 (1912), nr. 21, col. 645–52

P266 – 'Der Mensch in der Mitte. Vorbemerkungen.' *Der Mensch in der Mitte.* Berlin-Wilmersdorf 1917 (Politische Bibliothek 2)

P267 – 'Mitmensch.' *Zeit-Echo* 3 (1917), nr. 1, 10–13

P269 Rychner, M. 'Die Prosa des Expressionismus.' *Wissen und Leben* 13 (1919/20)

P269 Schickele, René. ['Antwort an Flake']. *Die weissen Blätter* 3 (1916), issue 1, 134–6

P270 – ['Expressionismus']. *Die weissen Blätter* 3 (1916), 135–6

P271 Schüller, Hermann. 'Naivität und Gemeinschaft.' *Die Erhebung* 2 (1920), 289–95

P272 Seidel, Curt. 'Deutsche Romane.' *Der Sturm* 3 (1912/13), 218–19

P273 Simmel, Georg. 'Die Grossstadt und das Geistesleben.' *Die Grossstadt. Jahrbuch der Gehe-Stiftung.* Dresden 1903

P274 – 'Die Krise der Kultur.' (Rede gehalten in Wien, Januar 1916). In G.S. *Der Krieg und die geistigen Entscheidungen. Reden und Aufsätze.* Munich, Leipzig 1917, 43–64

P275 – *Philosophie des Geldes.* Leipzig 1900

P276 Smekal, Richard. 'Expressionismus in der neuesten Erzählkunst.' *Donauland* 1 (1917/18), 439–40

P277 Spielhofer, Hanns. 'Die Expressionistische Novelle.' *Die Bücherkiste* 1 (1919), 70

P278 Sternheim, Carl. 'Das Arbeiter-ABC.' *Die Aktion* 12 (1922), col. 205–7, 289–91, 401–5, 463–5

P279 – *Berlin oder juste Milieu.* Munich 1920

P280 Stiemer, F. 'Literaturübersicht.' *Die Bücherkiste* 1 (1919), 6–7

P281 Sydow, Eckart von. 'Das religiöse Bewusstsein des Expressionismus.' *Neue Blätter für Kunst und Dichtung* 1 (1918/19), 193–4, 199

P282 Toller, Ernst. 'Bemerkungen zu meinem Drama "Die Verwandlung."' *Schöpferische Konfession* (ed. Kasimir Edschmid). Berlin 1920, pp. 41–8 (Tribüne der Kunst und Zeit, vol. 13)

P283 Unger, Erich. 'Vom Pathos. Die um George.' *Der Sturm* 1 (1910), nr. 40, 316ff.

P284 Walzel, Oskar. 'Der neueste deutsche Roman.' *Die neue Bücherschau* 1 (1919), issue 1, 10–13

P285 Warstat, W. 'Die Grundlagen des Expressionismus.' *Die Grenzboten* 73 (1914), nr. 20, 312–15

P286 Wassermann, Jakob. 'Der historische Roman in Deutschland.' *Die Literatur* 26 (1923/24), 3–4

P287 Weigand, Wilhelm. 'Der Kunstwert des Romans.' *Die Flöte* 3 (1920/21), 25–31

P288 Werfel, Franz. 'Die christliche Sendung. Ein offener Brief an Kurt Hiller.' *Die neue Rundschau* 28 (1917), vol. 1, 92–105

P289 – *Die Versuchung. Ein Gespräch des Dichters mit dem Erzengel und Luzifer.* Leipzig 1913 (Der jüngste Tag)

P290 Windholz, J.L. 'Die von dreissig Jahren.' *März* 7 (1913), nr. 3, 167–70
P291 Witkop, Ph. 'Die deutsche Dichtung der Gegenwart.' *Deutsches Leben der Gegenwart*. Leipzig 1922
P292 Wolfenstein, Alfred. 'Der menschliche Kämpfer.' *Die Erhebung* 1 (1919), 273–5
P293 Worringer, Wilhelm. *Abstraktion und Einfühlung. Ein Beitrag zur Stilpsychologie*. Bern 1907

C. Periodicals, yearbooks, series

P294 *Die Aktion. Wochenschrift für Politik, Literatur und Kunst* (ed. Franz Pfemfert). Berlin 1911–32
P295 *Das Aktionsbuch* (ed. Franz Pfemfert). Berlin-Wilmersdorf 1917
P296 *Aktionsbücher der Äternisten* (ed. Franz Pfemfert). Berlin-Wilmersdorf 1916–21
P297 *Die Argonauten* (ed. Ernst Blass). Heidelberg 1914–21
P298 *Arkadia. Ein Jahrbuch für Dichtkunst* (ed. Max Brod). Leipzig 1913
P299 *Die Dichtung* (ed. Wolf Przygode). Munich, Potsdam 1918–23
P300 *Der Einzige* (ed. Anselm Ruest & Mynona). Berlin, Magdeburg 1925
P301 *Die Erhebung. Jahrbuch für neue Dichtung und Wertung* (ed. Alfred Wolfenstein). Berlin 1919–20
P302 *Die Fackel* (ed. Karl Kraus). Vienna 1899–1936
P303 *Das Forum* (ed. Wilhelm Herzog). Munich, Potsdam, Berlin 1914–29
P304 *Die Grenzboten. Zeitschrift für Politik, Literatur und Kunst*. Leipzig 1910–21
P305 *Die junge Kunst* (ed. Wolfram von Hanstein). Berlin 1919
P306 *Der jüngste Tag*. Leipzig, Munich 1913–22
P307 *Der jüngste Tag. Die Bücherei einer Epoche*. Neu herausgegeben und mit einem dokumentarischen Anhang versehen von Heinz Schöffler. Frankfurt a.M. 1970
P308 *Lyrische Flugblätter*. Berlin-Wilmersdorf 1907–23
P309 *Marsyas. Eine Zweimonatsschrift* (ed. Theodor Tagger). Berlin 1917–19
P310 *Die neue Kunst. Zweimonatsschrift* (ed. Heinrich F.S. Balmaier, Josef Ambeiger, Johannes R. Becher, & Karl Otten). Munich 1913–14
P311 *Der neue Merkur*. Stuttgart, Apr. 1914–Mar. 1925
P312 *Das neue Pathos* (ed. Hans Ehrenbaum-Degele, Robert R. Schrodt, Ludwig Meidner & Paul Zech). Berlin 1913–20
P313 *Das neue Pathos. Jahrbuch* (ed. Paul Zech). Berlin 1914/15, 1917/18, 1919
P314 *Die neue Reihe*. Munich 1918–21
P315 *Der neue Roman. Ein Almanach*. Leipzig 1917

P316 *Die neue Rundschau.* Frankfurt a.M., Jan. 1890–

P317 *Die Rettung. Blätter zur Erkenntnis der Zeit* (ed. Franz Blei & Paris von Gütersloh). Vienna 1918–20

P318 *Die schöne Rarität* (ed. Adolf Harms). Kiel 1917–19

P319 *Simplicissimus. Illustrierte Wochenschrift.* Munich 1896–

P320 *Der Sturm. Monatsschrift für Kultur und Künste* (ed. Herwarth Walden). Berlin 1910–32

P321 *Tätiger Geist. Zweites der Ziel-Bücher* (ed. Kurt Hiller). Munich, Berlin 1917/18

P322 *Tribüne der Kunst und Zeit. Eine Schriftensammlung* (ed. Kasimir Edschmid). Berlin 1917–23

P323 *Die weissen Blätter* (ed. René Schickele). Leipzig, Zürich, Bern, Berlin 1915–21

D. Anthologies and collections

P324 *Ahnung und Aufbruch. Expressionistische Prosa* (ed. Karl Otten). Neuwied 1957

P325 *Der Aktivismus (1915–1920)* (ed. Wolfgang Rothe). Munich 1969

P326 *Ego und Eros. Meistererzählungen des Expressionismus* (ed. Karl Otten). Stuttgart 1963

P327 *Die Entfaltung. Novellen an die Zeit* (ed. Max Krell). Berlin 1921

P328 *Expressionismus: Aufzeichnungen und Erinnerungen der Zeitgenossen* (ed. Paul Raabe). Olten, Freiburg 1965

P329 *Expressionismus: Die Kampf um eine literarische Bewegung* (ed. Paul Raabe). Munich 1965

P330 *Die goldene Bombe. Expressionistische Märchendichtungen und Grotesken* (ed. Hartmut Geerken). Darmstadt 1970

P331 *Ich schneide die Zeit aus. Expressionismus und Politik in Franz Pfemferts Aktion 1910–1918* (ed. Paul Raabe). Munich 1964

P332 *Das leere Haus. Prosa jüdischer Dichter.* Stuttgart 1959

P333 *Literatur-Revolution 1915–1925. Dokumente. Manifeste. Programme* (ed. Paul Pörtner). 2 vols. Neuwied, Berlin 1961

P334 *Menschheitsdämmerung. Ein Dokument des Expressionismus* (ed. Kurt Pinthus). Hamburg 1959 (original 1920)

P335 *Prosa des Expressionismus* (ed. Fritz Martini). Stuttgart 1963 (Reclams Universalbibliothek)

E. Individual authors and works in book form, reprints, and collected works

P336 Bahr, Hermann. *Expressionismus.* Munich 1920

P337 Barlach, Ernst. *Das dichterische Werk* (ed. Klaus Lazarowicz & Friedrich Dross). 3 vols. Munich 1959–68
P338 Baum, Oskar. *Zwei Erzählungen*. Leipzig 1918 (Der jüngste Tag)
P339 Benn, Gottfried. *Gesammelte Werke* (ed. Dieter Wellershoff). 8 vols. Wiesbaden 1960
P340 Beradt, Martin. *Die Verfolgten. Novellen*. Hamburg 1919
P341 Blei, Franz. *Schriften in Auswahl* (ed. A.P. Gütersloh). Munich 1960
P342 Brod, Max. *Weiberwirtschaft*. Leipzig, Vienna 1917
P343 – *Streitbares Leben (1884–1968)* Munich, Berlin, Vienna 1969
P344 Bronnen, Arnolt. *Die Septembernovelle*. Berlin 1932
P345 Buber, Martin. *Ekstatische Konfessionen*. Jena 1909
P346 – *Die Legenden des Baalschem*. Frankfurt a.M. 1916
P347 Däubler, Theodor. *Dichtungen und Schriften*. Munich 1956
P348 Döblin, Alfred. *Gesammelte Erzählungen* (ed. Walter Muschg). Reinbek bei Hamburg 1971
P349 – *Die Zeitlupe. Kleine Prosa*. Olten 1962
P350 Edschmid, Kasimir. *Frühe Manifeste. Epochen des Expressionismus*. Hamburg 1957
P351 – *Frühe Schriften* (ed. Ernst Johann). Neuwied & Berlin 1970
P352 – *Das rasende Leben*. Leipzig 1916 (Der jüngste Tag)
P353 – *Die frühen Erzählungen*. Neuwied & Berlin 1965
P354 – *Die Fürstin*. Berlin 1920
P355 – *Frauen. Erzählungen*. Berlin 1921
P356 – *Die sechs Mündungen. Novellen*. Leipzig 1915 (edition used). Now also Stuttgart 1967 (Reclams Universalbibliothek)
P357 – *Lebendiger Expressionismus. Auseinandersetzungen. Gestalten, Erinnerungen*. Munich 1961
P358 Ehrenstein, Albert. *Gedichte und Prosa* (ed. Karl Otten). Neuwied am Rhein, Berlin-Spandau 1961
P359 – *Nicht da, nicht dort*. Leipzig 1918 (Der jüngste Tag)
P360 – *Ausgewählte Aufsätze* (ed. M.Y. Ben-gavriel). Heidelberg, Darmstadt 1961
P361 – *Der Selbstmord eines Katers*. Munich 1912
P362 – *Bericht aus einem Tollhaus*. Leipzig 1919
P363 Ehrenstein, Carl. *Klagen eines Knaben. Skizzen*. Leipzig 1913 (Der jüngste Tag)
P364 Einstein, Carl. *Gesammelte Werke* (ed. Ernst Nef). Wiesbaden 1962
P365 Engelke, Gerrit. *Das Gesamtwerk. Rhythmus des neuen Europa* (ed. Dr. H. Blume). Munich 1960

P366 Flesch-Brunningen, Hans von. *Das zerstörte Idyll*. Leipzig 1917 (Der jüngste Tag)

P367 Frank, Leonhard. *Der Mensch ist gut*. Zürich, Potsdam 1918

P368 Hasenclever, Walter. *Gedichte, Dramen, Prosa* (ed. Kurt Pinthus). Hamburg 1963

P369 Hauptmann, Gerhardt. *Die grossen Dramen*. Berlin 1965

P370 Herrmann-Neisse, Max. *Hilflose Augen. Novellen*. Vienna 1920

P371 – *Die Begegnung. Vier Erzählungen*. Berlin 1927

P372 Heym, Georg. *Dichtungen und Schriften* (ed. K.L. Schneider). 4 vois. Hamburg, Munich 1962

P373 Hülsenbeck, Richard. *Verwandlungen*. Munich 1918 (Die neue Reihe)

P374 Jung, Franz. *Saul. Erzählungen*. Berlin 1916

P375 – *Joe Frank illustriert die Welt*. Darmstadt, Neuwied 1972

P376 – *Gnadenreiche, unsere Königin. Erzählungen*. Leipzig 1918 (Der jüngste Tag)

P377 – *Das Trottelbuch*. Leipzig 1912 (Leichtenstein 1973)

P378 Kaiser, Georg. Stücke, Erzählungen, Aufsätze, Gedichte. Cologne, Berlin 1966

P379 Kayser, Rudolf. *Moses Tod*. Leipzig 1921 (Der jüngste Tag)

P380 Klabund (pseud. of Alfred Henschke). *Deutsche Literaturgeschichte in einer Stunde*. Leipzig 1920

P381 – *Erzählungen und Grotesken. Gesammelte Prosa*. Vienna 1930

P382 – *Der Marketenderwagen. Ein Kriegsbuch*. Berlin 1916

P383 – *Kunterbuntergang des Abendlandes. Grotesken*. Munich 1922

P384 Kornfeld, Paul. *Die Verführung. Eine Tragödie*. Berlin 1916

P385 Krell, Max. *Der Henker*. Darmstadt 1924

P386 Lampl, Friedo. *Sklaven der Freiheit. Novellen und Märchen*. Heidelberg 1925

P387 Lasker-Schüler, Else. *Gesammelte Werke* (ed. F. Kemp). 3 vols. Munich 1962

P388 Lemm, Alfred. *Mord*. 2 vols. Munich 1918 (Die neue Reihe)

P389 Lichtenstein, Alfred. *Gesammelte Prosa* (ed. Klaus Kanzog). Zürich 1966

P390 Loerke, Oskar. *Chimärenreiter. Novellen*. Munich 1919 (Die neue Reihe)

P391 – *Das Goldbergwerk. Erzählungen*. Stuttgart 1965 (Reclams Universalbibliothek)

P392 Mann, Heinrich. *Ausgewählte Werke*. Berlin 1953

P393 – *Abrechnungen. Sieben Novellen*. Berlin n.d.

P394 – *Geist und Tat*. Munich 1963

P395 – *Der Jüngling*. Munich 1924

P396 – *Bunte Gesellschaft*. Munich 1917

P397 – *Professor Unrat oder das Ende eines Tyrannen*. Hamburg 1951 (Rororo)

P398 Mann, Thomas, *Buddenbrooks. Verfall einer Familie*. Hamburg & Frankfurt a. M. 1960 (Fischer Bücherei)

P399 – *Das essayistische Werk*. 8 vols. Frankfurt a.M. 1960 (Fischer Bücherei)

P400 Mierendorff, Carlo. *Der Gnom*. Darmstadt 1917

P401 Musil, Robert. *Die Verwirrungen des Zöglings Törless* (1906). In *Gesammelte Werke* (ed. Adolf von Frisé). 3 vols. Hamburg 1952

P402 Mynona (pseud. of Salomo Friedländer). *Mein Papa und die Jungfrau von Orleans nebst anderen Grotesken*. Munich 1921

P403 – *Schwarz-Weiss-Rot. Grotesken*. Leipzig 1916

P404 Otten, Karl. *Der Sprung aus dem Fenster*. Leipzig 1918 (Der jüngste Tag)

P405 Rilke, Rainer Maria. Werke. 3 vols. Frankfurt a.M. 1966

P406 Sack, Gustav. *Prosa, Briefe, Verse* (ed. Dieter Hoffmann). Munich, Vienna 1962

P407 Schäffer, Ludwig. *Die Verfolgten. Novellen*. Hamburg 1919

P408 Scheerbart, Paul. *Dichterische Hauptwerke*. Stuttgart 1962

P409 Schickele, René. *Werke*. 3 vols. Cologne, Berlin 1959

P410 Sorge, Reinhard Johannes. *Werke* (ed. Hans G. Rötzer). 3 vols. Nürnberg 1962–7

P411 Sternheim, Carl. *Gesamtwerk* (ed. Wilhelm Emrich). 8 vols. Neuwied am Rhein, Berlin-Spandau 1964. All references in the text are to vol. IV (Prosa 1), unless otherwise indicated.

P412 Strauss, Ludwig. *Der Mittler. Novellen*. Berlin 1916

P413 Toller, Ernst. *Seven Plays* (trans. Vera Mendel a. o.). New York n.d.

P414 Wedekind, Frank. *Werke*. 3 vols. Berlin (East) 1969

P415 Weiss, Ernst. *Dämonenzug. Fünf Erzählungen*. Berlin 1928

P416 Werfel, Franz. *Meisternovellen*. Frankfurt a.M. 1972

P417 Wolfenstein, Alfred. *Der Lebendige. Novellen*. Munich 1918 (Die neue Reihe)

P418 Zech, Paul. *Der schwarze Baal. Novellen*. Leipzig 1917

SECONDARY SOURCES

S1 Adams, Marion. *Gottfried Benn's Critique of Substance*. Assen 1969 (Melbourne Monographs in Germanic Studies)

S2 Alemann, Beda. *Ironie und Dichtung*. 2nd edn. Pfullingen 1969

S3 Alker, Ernst. *Profile und Gestalten der deutschen Literatur nach 1914. Mit einem Kapitel über den Expressionismus von Zaron Konstantinovic* (ed. Eugen Thurnher). Stuttgart 1977

S4 Allen, Roy F. *Literary Life in German Expressionism and the Berlin Circles*. Göppingen 1974

S5 Anz, Thomas. 'Entfremdung und Angst.' *Expressionismus – Sozialer Wandel und künstlerische Erfahrung* (ed. H. Meixner & S. Vietta). Munich 1982 (Mannheimer Kolloquium 1977)

S6 – 'Die Historizität der Angst. Zur Literatur des expressionistischen Jahrzehnts.' *Schiller-Jahrbuch* 19 (1975), 237–83

S7 – *Literatur der Existenz. Literarische Psychopathographie und ihre soziale Bedeutung im Frühexpressionismus*. Stuttgart 1977

S8 Anz, Thomas, & Michael Stark (eds.). *Expressionismus. Manifeste und Dokumente zur deutschen Literatur 1910–1920*. Stuttgart 1982

S9 Arnold, Armin. *Die Literatur des Expressionismus. Sprachliche und thematische Quellen*. 2nd edn. Stuttgart 1972

S10 – *Prosa des Expressionismus. Herkunft, Analyse, Inventar*. Stuttgart 1972

S11 Arnold, Heinz Ludwig (ed.). *Heinrich Mann*. Munich 1971

S12 Bailey, Dudley (ed.). *Essays on Rhetoric*. New York 1965

S13 Balser, Hans-Dieter. *Das Problem des Nihilismus im Werke Gottfried Benns*. Bonn 1965

S14 Banuls, André. *Heinrich Mann, le poète et la politique*. Paris 1966

S15 Barnouw, Dagmar. 'Literary Politics in World War I. Die Aktion and the Problem of the Intellectual Revolutionary.' *GQ* 52 (1979), nr. 2, 227–47

S16 Bathrick, David R. 'Moderne Kunst und Klassenkampf. Die Expressionismus-Debatte in der Exilzeitschrift 'Das Wort.' *Exil und Emigration. Third Wisconsin Workshop* (ed. Reinhold Grimm & Jost Hermand). Frankfurt a. M. 1972, pp. 89–109

S17 Bausinger, Wilhelm. 'Robert Musil und die Ablehnung des Expressionismus.' *Studi Germanici* 3 (1965), 383–9

S18 Beck, Gabriel. *Die erzählende Prosa Albert Ehrensteins. Interpretation und Versuch einer literarischen Einordnung*. Freiburg 1969

S19 Beigel, Alfred. *Erlebnis und Flucht im Werk Albert Ehrensteins*. Frankfurt a.M. 1972

S20 Benseler, Fritz von (ed.). *Festschrift zum 80. Geburtstag von Georg Lukács*. Berlin, Neuwied 1965

S21 Best, Otto F. ''Epischer Roman' und 'Dramatischer Roman.' Einige Überlegungen zum Frühwerk von Alfred Döblin und Bert Brecht.' *GRM*, Neue Folge 22 (1972), 281–309

S22 – *Theorie des Expressionismus*. Stuttgart 1976

S22 Bloch, Ernst. *Erbschaft dieser Zeit*. Frankfurt a.M. 1962

S24 Boonstra, P.E. *Heinrich Mann als politischer Schriftsteller*. Amsterdam n.d.

S25 Booth, Wayne C. *The Rhetoric of Fiction*. Chicago, London 1961

S26 Brinkmann, Richard. *Expressionismus. Forschungsprobleme 1952–1960.* Stuttgart 1961

S27 – *Expressionismus. Internationale Forschung zu einem internationalen Phänomen.* Stuttgart 1980 (Dvjs Sonderband)

S28 Buddeberg, Else. *Gottfried Benn.* Stuttgart 1961

S29 Casey, Timothy Joseph. 'Alfred Döblin.' *Expressionismus als Literatur. Gesammelte Studien* (ed. Wolfgang Rothe). Bern, Munich 1969, pp. 637–55

S30 Catholy, Eckehart, and W. Hellmann (eds.). *Festschrift für Klaus Ziegler.* Tübingen 1968

S31 Cirlot, J.E. *A Dictionary of Symbols* (trans. Jack Sage). New York 1962

S32 Craddock, Clare Eileen, Sister. *Style Theories as found in Stylistic Studies.* Washington, D.C. 1952

S33 Daniels, Karlheinz. 'Expressionismus und Technik.' *Expressionismus als Literatur. Gesammelte Studien* (ed. Wolfgang Rothe). Bern, Munich 1969, 171–93

S34 David, Claude. 'Rilke et l'expressionisme.' *EG* 17 (1962), 144–57

S35 Denkler, Horst. 'Der Fall Franz Jung.' *Die sogenannten Zwanziger Jahre* (ed. Reinhold Grimm & Jost Hermand). Gehlen, Bad Homburg, Berlin, Zürich 1970, pp. 80–107

S36 Dierick, Augustinus P. 'Two Representative Responses to the Challenge of the First World War: Carl Sternheim's *eigene Nuance* and Leonhard Frank's *Utopia.*' *The First World War in German Narrative Prose* (ed. C.N. Genno & H. Wetzel). Toronto 1980, pp. 16–33

S37 – 'Irony and Expressionism. An Examination of Some Short Narrative Prose.' *New German Studies* 7 (1979), 71–90

S38 – 'Nihilism and "tierische Transzendenz" in Gottfried Benn's *Gehirne.*' *Orbis Litterarum* 36 (1981), 211–21

S39 – 'Culture, Colportage and Kitsch in Kasimir Edschmid's *Die sechs Mündungen.*' *Seminar* 19 (1983), 177–93

S40 – 'The Endangered Self: Some Observations on Subjectivism and Its Implications in Short Prose of Expressionism.' *The Germanic Review* 58, nr. 4 (1983), 141–6

S41 – 'Christ on the Cross: The Theme of Redemption in Some Short Expressionist Prose.' *Neophilologus* 65 (1981), 94–106

S42 Dikkers, S. *Ironie als vorm van communicatie.* The Hague 1970

S43 Dimic, Colette. *Das Groteske in der Erzählung des Expressionismus.* Diss. Freiburg 1960

S44 Drews, Jörg. *Das Tempo dieser Zeit ist keine Kleinigkeit. Zur Literatur um 1918.* Munich 1981

S45 Durzak, Manfred. 'Flake und Döblin. Ein Kapitel in der Geschichte des polyhistorischen Romans.' GRM n.s. 20 (1970), 286–305

S46 – (ed.). Zu Carl Sternheim. Stuttgart 1982

S47 Duwe, Willi. Deutsche Dichtung des 20. Jahrhunderts. Zürich, Leipzig 1936

S48 Eaton, Trevor. The Semantics of Literature. The Hague, Paris 1966

S49 Eibl, Karl. Sprachskepsis im Werk Gustav Sacks. Munich 1970

S50 Elfe, Wolfgang Dieter. Stiltendenzen im Werk von Ernst Weiss unter besonderer Berücksichtigung seines expressionistischen Stils. Bern, Frankfurt a.M. 1971

S51 Eliade, Mircea. Le mythe de l'éternel retour. Paris 1968. (Collection Idées)

S52 Emrich, Wilhelm. Geist und Widergeist. Wahrheit und Lüge in der Literatur. Studien. Frankfurt a.M. 1965

S53 – Protest und Verheissung. Studien zur klassischen und modernen Dichtung. Frankfurt a.M. 1960

S54 Engels, Günter. Der Stil expressionistischer Prosa im Frühwerk Kasimir Edschmids. Diss. Cologne 1952

S55 Ermatinger, Emil. Das dichterische Kunstwerk. Grundbegriffe der Urteilsbildung in der Literaturgeschichte. Leipzig, Berlin 1939

S56 Eykman, Christoph. Denk- und Stilformen des Expressionismus. Munich 1974 (Uni-Taschenbücher)

S57 Fähnders, W. & Rechtor, M. (eds.). Literatur im Klassenkampf. Zur proletarisch-revolutionären Literaturtheorie 1919–1923. Frankfurt a.M. 1974 (original edn. 1971)

S58 Falk, Walter. 'Impressionismus und Expressionismus.' Expressionismus als Literatur. Gesammelte Studien (ed. Wolfgang Rothe). Bern, Munich 1969, pp. 69–86

S59 Feinberg, Leonhard. Introduction to Satire. The Satirist, His Temperament, Motivation and Influence. Ames, Iowa 1967

S60 Fischer, Peter. Alfred Wolfenstein. Der Expressionismus und die verendende Kunst. Munich 1968

S61 Forstreuter, Kurt. Die deutsche Ich-Erzählung. Eine Studie zu ihrer Geschichte und Technik. Berlin 1924

S62 Freedman, Ralph. 'Refractionary Visions. The Contours of Literary Expressionism.' Contemporary Literature 10 (1969), 54–74

S63 Freund, Winfried & Hans Schuhmacher (eds.). Analysen zur Prosa des frühen 20. Jahrhunderts. Frankfurt a.M., Bern 1983

S64 Friedmann, Hermann & Otto Mann (eds). Deutsche Literatur im 20. Jahrhundert. 4th edn. Heidelberg 1961

S65 – (eds.). *Expressionismus: Gestalten einer literarischen Bewegung.*
Heidelberg 1956

S66 Friedemann, Käthe. *Die Rolle des Erzählers in der Epik.* Darmstadt 1969

S67 Fritz, Horst. 'Gottfried Benns Anfänge.' *Jahrbuch der deutschen
Schillergesellschaft* 12 (1968), 383–402

S68 – *Literarischer Jugendstil und Expressionismus.* Stuttgart 1969
(Germanistische Abhandlungen)

S69 Frye, Northrop. *Anatomy of Criticism.* New York 1966

S70 Furness, R.S. *Expressionism.* London 1973 (The Critical Idiom, vol. 29)

S71 Gaede, Friedrich. *Realismus von Brant bis Brecht.* Munich 1972

S72 Girardot, Rafael Gutierez. 'Das Groteske als Sozialkritik in der Literatur
Lateinamerikas.' *Festschrift zum 80. Geburtstag von Georg Lukács* (ed.
Fr. von Benseler). Berlin-Neuwied 1965, pp. 461–71

S73 Glaubrecht, Martin. *Studien zum Frühwerk Leonhard Franks.* Bonn 1965

S74 Gorsen, Peter. *Sexualästhetik. Zur bürgerlichen Rezeption von Obszönität
und Pornographie.* Reinbek bei Hamburg 1972

S75 Greulich, Helmut. *Georg Heym (1870–1912). Leben und Werk. Ein Beitrag
zur Frühgeschichte des deutschen Expressionismus.* Berlin 1931

S76 Groben, Norbert. *Literaturpsychologie. Literaturwissenschaft zwischen
Hermeneutik und Empirie.* Stuttgart 1972

S77 Guthke, Karl S. 'Das Drama des Expressionismus und die Metaphysik der
Enttäuschung.' *Aspekte des Expressionismus. Periodisierung. Stil,
Gedankenwelt* (ed. Wolfgang Paulsen). Heidelberg 1968, pp. 33–58

S78 Gutmann, Paul-Otto. 'Erzählweisen in der deutschen Kurzgeschichte.'
Germanistische Studien 2 (1970), 73–160

S79 Hadermann, Paul. 'Expressionist Literature and Painting.' *Expressionism as
an International Phenomenon. 21 Essays and a Bibliography* (ed. Ulrich
Weisstein). Paris, Budapest 1973, pp. 171–93

S80 Hamburger, Käthe. *Die Logik der Dichtung.* 2nd edn. Stuttgart 1968

S81 Hamburger, Michael. *Contraries. Studies in German Literature.* New York
1970

S82 Hermand, Jost (ed.). *Literarisches Leben in der Weimarer Republik.*
Stuttgart 1982

S83 – (ed.). *Der Schein des schönen Lebens. Studien zur Jahrhundertwende.*
Frankfurt a.M. 1972

S84 Hill, Claude, & Ralph Ley. *The Drama of German Expressionism. A
German-English Bibliography.* Chapel Hill 1960

S85 Hinck, Walter. 'Individuum und Gesellschaft im expressionistischen
Drama.' *Festschrift für Klaus Ziegler* (ed. Eckehart Catholy and W.
Hellmann). Tübingen 1968, pp. 343–59

S86 Hinze, Diana Orendi. 'Trakl, Kokoschka und Kubin. Zur Interdependenz von Wort und Bildkunst.' *GRM* n.s. 21 (1971), 72–8

S87 Hinze, Klaus-Peter. *Ernst Weiss- Bibliographie der Primär- und Sekundärliteratur.* Hamburg 1977

S88 Hohendahl, Peter Uwe. *Das Bild der bürgerlichen Welt im expressionistischen Drama.* Heidelberg 1967

S89 – Wirkung wider Willen. *Dokumente zur Wirkungsgeschichte Benns.* Frankfurt a.M. 1971

S90 Hohoff, Curt. 'Der Expressionismus in der modernen deutschen Literatur.' *Universitas* 26 (1971), 199–204

S91 Horn, H-J. & H. Laufhütte. 'Ares und Dionysos.' *Das Furchtbare und das Lächerliche in der Europäischen Literatur.* Heidelberg 1981 (Mannheimer Beiträge zur Sprach- und Literaturwissenschaft)

S92 Huber, Otmar. *Mythos und Groteske. Die Problematik des Mythischen und ihre Darstellung in der Dichtung des Expressionismus.* Meisenheim am Glan 1979

S93 Husserl, Edmund. *Ideas. General Introduction to Pure Phenomenology* (trans. W.R. Boyce Gibson). New York 1962

S94 Ihekweazu, Edith. *Verzerrte Utopie. Bedeutung und Funktion des Wahnsinns in expressionistischer Prosa.* Frankfurt a.M., Bern 1982

S95 Imhof, Arnold. *Franz Jung. Leben, Werk, Wirkung.* Bonn 1974

S96 Ingarden, Roman. *Das literarische Kunstwerk.* Tübingen 1960

S97 Jens, Inge. *Studien zur Entwicklung der expressionistischen Novelle.* Tübingen 1953

S98 Jost, Dominik. *Literarischer Jugendstil.* Stuttgart 1969

S99 Just, Klaus Günther. 'Von der Gründerzeit bis zur Gegenwart.' *Handbuch der deutschen Geschichte.* Bern 1973, I, vol. 4

S100 Kahler, Erich von. 'Die Prosa des Expressionismus.' *Der deutsche Expresssionismus. Formen und Gestalten* (ed. Hans Steffen). Göttingen 1965, pp. 157–78 (Kleine Vandenhoeck Reihe)

S101 Kauffeld, Rolf. *Erich Mühsam. Literatur und Anarchie.* Munich 1983

S102 Kaufmann, Hans. *Krisen und Wandlungen der deutschen Literatur von Wedekind bis Feuchtwanger.* Berlin, Weimar 1969

S104 Kayser, Wolfgang, *Das sprachliche Kunstwerk. Eine Einführung in die Literaturwissenschaft.* 14th edn. Bern 1969

S105 – *The Grotesque in Art and Literature.* New York 1966

S106 Killy, Walter. *Deutscher Kitsch. Ein Versuch mit Beispielen.* Göttingen 1962 (Kleine Vandenhoeck Reihe)

S107 Klarmann, Adolf. 'Expressionism in German Literature: A Retrospect of Half a Century.' *MLQ* 26 (1965), 62–92

S108 – 'Gottesidee und Erlösungsproblem beim jungen Werfel.' *Der Dichter und seine Zeit. Politik im Spiegel der Literatur* (ed. Wolfgang Paulsen). Heidelberg 1970

S110 Klee, W.G. *Die charakteristischen Motive der expressionistischen Erzählungsliteratur.* Diss. Berlin 1934

S111 Kluckhohn, Paul. 'Berufungsbewusstsein und Gemeinschaftsdienst des deutschen Dichters im Wandel der Zeiten.' *Dvjs* 14 (1936),1ff

S112 Knapp, Gerhard P. *Die Literatur des deutschen Expressionismus.* Munich 1979 (Beck'sche Elementarbücher)

S113 Koch, Thilo. *Gottfried Benn. Ein biographischer Essay.* Munich 1970

S114 Kofler, Leo. *Abstrakte Kunst und absurde Literatur. Ästhetische Marginalien.* Vienna, Frankfurt a.M., Zürich 1970

S115 Kohlschmidt, Werner. 'Zu den soziologischen Voraussetzungen des literarischen Expressionismus in Deutschland.' *Literatur. Sprache. Gesellschaft* (ed. Karl Rüdinger). Munich 1970, pp. 31–49

S116 – *Konturen und Übergänge. 12 Essays zur Literatur unseres Jahrhunderts.* Bern 1977

S117 Kolinsky, Eva. *Engagierter Expressionismus. Politik und Literatur zwischen Weltkrieg und Weimarer Republik. Eine Analyse politischer Zeitschriften.* Stuttgart 1970

S118 Korte, Hermann. *Georg Heym.* Stuttgart 1982

S119 Koskimies, Rafael. *Theorie des Romans.* Helsinki 1935

S120 Kraft, Herbert. *Kunst und Wirklichkeit im Expressionismus.* Bebenhausen 1972

S121 Kreutzer, Leo. *Alfred Döblin. Sein Werk bis 1933.* Stuttgart 1970

S122 Kreuzer, Helmut. *Die Boheme. Beiträge zu ihrer Beschreibung.* Stuttgart 1968

S123 Krispyn, Egbert. *Style and Society in German Literary Expressionism.* Gainesville, Fla. 1964

S124 Krull, Wilhelm. *Prosa des Expressionismus.* Stuttgart 1984 (Sammlung Metzler)

S125 – *Politische Prosa des Expressionismus. Rekonstruktion und Kritik.* Frankfurt a.M. 1982

S126 Lämmert, Eberhard. *Bauformen des Erzählens.* Stuttgart 1972

S127 – et al. *Romantheorie. Dokumentation ihrer Geschichte in Deutschland seit 1880.* Cologne 1975

S128 Lea, Henry A. 'Expressionist Literature and Music.' *Expressionism as an International Phenomenon. 21 Essays and a Bibliography* (ed. Ulrich Weisstein). Paris, Budapest 1973, pp. 141–60

S129 Lebschnitzer, Fritz. 'Georg Heym als Novellist.' *Das Wort* 2 , sec. 10 (1937)

S130 Lehnert, Herbert. *Geschichte der deutschen Literatur vom Jugendstil zum Expressionismus.* Opladen 1977

S131 Lenning, Walter. *Gottfried Benn in Selbstzeugnissen und Bilddokumenten.* Reinbek bei Hamburg 1962

S132 Liede, Helmut. *Stiltendenzen expressionistischer Prosa.* Diss. Freiburg im Breisgau 1960

S133 Links, Roland. *Alfred Döblin. Leben und Werk.* Berlin 1965

S134 Lockemann, Fritz. *Gestalt und Wandlungen der deutschen Novelle.* Munich 1957

S135 Loose, Gerhard. 'Gustav Sack.' *Expressionismus als Literatur. Gesammelte Studien* (ed. Wolfgang Rothe). Bern, Munich 1969, pp. 681–9

S136 Lorenz, Rosemarie. *Max Herrmann-Neisse.* Stuttgart 1966

S137 Lozza, Erika. *Die Prosaepik Oskar Loerkes.* Diss. Zürich 1972

S138 Lüdke, W. Martin (ed.) *'Theorie der Avantgarde.' Antworten auf Peter Bürgers Bestimmung von Kunst und bürgerlicher Gesellschaft.* Frankfurt a.M. 1976

S139 Lukács, Georg. ' "Grösse und Verfall" des Expressionismus' (1939). *Begriffsbestimmung des literarischen Expressionismus* (ed. Hans Gerd Rötzer). Darmstadt 1976

S140 – *Probleme des Realismus.* Berlin 1955

S141 – *Schriften zur Literatursoziologie* (ed. Paul Ludz). Berlin 1953

S142 Marcuse, Herbert. *Kultur und Gesellschaft.* Frankfurt a.M. 1965

S143 Marcuse, Ludwig (ed.). *Literaturgeschichte der Gegenwart.* Berlin, Leipzig, Vienna, Bern 1925

S144 Markwardt, Bruno. *Geschichte der deutschen Poetik.* Berlin 1967, vol. 5

S145 Martens, Gunter. *Vitalismus und Expressionismus. Ein Beitrag zur Genese und Deutung expressionistischer Stilstrukturen und Motive.* Stuttgart, Cologne, Berlin, Mainz 1971

S146 Martini, Fritz. 'Albert Ehrenstein.' *Expressionismus als Literatur. Gesammelte Studien* (ed. Wolfgang Rothe). Bern, Munich 1969, pp. 690–706

S147 – 'Expressionismus.' *Deutsche Literatur im 20. Jahrhundert* (ed. Hermann Friedmann & Otto Mann). Heidelberg 1961, pp. 297–326

S148 – *Das Wagnis der Sprache. Interpretationen deutscher Prosa von Nietzsche bis Benn.* Stuttgart 1954

S149 – (ed.). *Prosa des Expressionismus.* Stuttgart 1970 (Reclams Universalbibliothek)

S150 – *Was war Expressionismus?* Urach 1948

S151 Mautz, Kurt. *Mythologie und Gesellschaft im Expressionismus. Die Dichtung Georg Heyms.* Frankfurt a.M., Bonn 1961

S152 Mayer, Hans. 'Rückblick auf den Expressionismus.' *Neue deutsche Hefte* 13 (1966), 31–51

S153 Mittenzwei, Werner. 'Die Brecht-Lukács Debatte.' *Das Argument*, Mar. 1968

S154 Mittner, Ladislao. 'Die Geburt des Tyrannen aus dem Ungeist des Expressionismus.' *Festschrift zum 80. Geburtstag von Georg Lukács* (ed. Fr. von Benseler). Berlin-Neuwied 1965, pp. 302–419

S155 Müller-Salget, Klaus. *Alfred Döblin. Werk und Entwicklung.* Bonn 1972

S156 Mumm, C. (ed.). *Alfred Wolfenstein, Eine Einführung in sein Werk und eine Auswahl.* Wiesbaden 1955

S157 Muschg, Walter. *Von Trakl bis Brecht. Dichter des Expressionismus.* 2nd edn. Munich 1963

S158 Nadler, Josef. 'Das Problem der Stilgeschichte.' *Philosophie der Literaturwissenschaft.* Berlin 1930

S159 Niemann, Ludwig. *Soziologie des naturalistischen Romans.* Berlin 1934

S160 Nietzsche, Friedrich. *Werke* (ed. Karl Schlechta). 3 vols. Munich 1956

S161 Nolte, Jost. *Grenzgänge.* Vienna 1972

S162 Oehm, Heidemarie. *Die Kunsttheorie Carl Einsteins.* Munich 1976

S163 Orlowski, Hubert. 'Die Herausbildung der faschistischen Literatur in den Jahren 1925–1933.' *Studia Germanica Posnaniensis* 2 (1973)

S164 Pascal, Roy. *From Naturalism to Expressionism. German Literature and Society 1880–1918.* London 1973

S165 Paulsen, Wolfgang. 'Alfred Lichtensteins Prosa. Bemerkungen gelegentlich der kritischen Neuausgabe.' *Jahrbuch der deutschen Schillergesellschaft* 12 (1968), 586–98

S166 – *Expressionismus und Aktivismus. Eine typologische Untersuchung.* Bern. Leipzig 1935

S167 Pawlowa, Nina. 'Expressionismus und Realismus.' *Zur Geschichte der sozialistischen Literatur 1918–1933. Elf Vorträge gehalten auf einer internationalen Konferenz in Leipzig.* Leipzig 1962, pp. 141–59

S168 Pazi, Margaritha. *Max Brod. Werk und Persönlichkeit.* Bonn 1972

S169 – *Fünf Autoren des Prager Kreises.* Frankfurt a.M. 1978

S170 Penkert, Sybille. *Carl Einstein. Beiträge zu einer Monographie.* Diss. Göttingen 1969

S171 Perkins, Geoffrey. *Contemporary Theory of Expressionism.* Bern, Frankfurt a.M. 1974

S172 – *Expressionismus. Eine Bibliographie zeitgenössischer Dokumente 1910–1925.* Zürich 1971

S173 Pfaff, Peter. 'Kasmir Edschmid.' *Expressionismus als Literatur. Gesammelte*

Studien (ed. Wolfgang Rothe). Bern, Munich 1969, pp. 707–15

S174 Piel, Edgar. *Der Schrecken der wahren Wirklichkeit. Das Problem der Subjektivität in der modernen Literatur.* Munich 1978

S175 Quenzer, Gert. 'Absolute Prosa. Carl Einstein's "Bebuquin oder die Dilettanten des Wunders."' *Der Deutschunterricht* (1965), nr. 5, 53–65

S176 Raabe, Paul. 'Das Ende des Expressionismus.' *Der Ausgang des Expressionismus. Wege und Gestalten.* Biberach an der Riss 1966

S177 – *Expressionismus. Der Kampf um eine literarische Bewegung.* Munich 1965 (dtv Sonderreihe 41)

S178 – *Expressionismus, Aufzeichnungen und Erinnerungen der Zeitgenossen.* Olten, Freiburg 1965

S179 – 'Der Expressionismus als historisches Phänomen.' *Der Deutschunterricht* 17 (1965), nr. 5, 5–20

S180 – *Expressionismus, Literatur und Kunst 1910–1923. Eine Ausstellung des deutschen Literaturarchivs im Schiller Nationalmuseum Marbach.* Munich 1960

S181 – 'Expressionismus. Eine Literaturübersicht.' *Der Deutschunterricht* 16 (1964), supp. to nr. 2

S182 – 'Franz Kafka und der Expressionismus. *ZfdPh* 86 (1967), 161–75

S183 – 'Ich schneide die Zeit aus.' *Expressionismus und Politik in Franz Pfemferts 'Aktion.'* Munich 1964 (dtv Dokumente)

S184 – *Index Expresssionismus. Bibliographie der Beiträge in den Zeitschriften und Jahrbüchern des literararischen Expressionismus 1910–1925.* 18 vols. Liechtenstein 1972

S185 – 'Die Revolte der Dichter.' *Der Monat* 16 (1964), 86–93

S186 – *Der späte Expressionismus 1918–1922. Bücher, Bilder, Zeitschriften, Dokumente.* Biberach a.d. Riss 1966

S187 – 'Die Zeitschriften des literarischen Expressionismus 1910–1921.' *Imprematur* 3 (1961/62), 126–77

S188 – *Die Zeitschriften und Sammlungen des literarischen Expressionismus. Repertorium der Zeitschriften, Jahrbücher, Anthologien, Sammelwerke, Schriftenreihen und Almanache 1910–1921.* Stuttgart 1964

S189 Rang, Bernard. 'Die deutsche Epik des zwanzigsten Jahrhunderts.' *Deutsche Literatur im zwanzigsten Jahrhundert. Strukturen und Gestalten* (ed. Otto Mann & Wolfgang Rothe). 2nd edn. Bern, Munich 1967. Vol 1, 'Strukturen'

S190 Rehm, Walther. 'Der Dichter und die neue Einsamkeit.' *Der Dichter und die neue Einsamkeit. Aufsätze zur Literatur um 1900* (ed. Reinhardt Hakel). Göttingen 1969 (Kleine Vandenhoeck Reihe)

S191 Reuter, Helmut Harald. *Der Intellektuelle und die Politik. Beiträge zur*

politisch–literarischen Intellektualität von Schiller bis Handke. Frankfurt a.M., Bern 1982 (Europäische Hochschulschriften 495)

S192 Ribbat, Ernst. *Die Wahrheit des Lebens im frühen Werk Alfred Döblins.* Münster 1970

S193 Riedel, Walter. *Der neue Mensch. Mythos und Wirklichkeit.* Bonn 1970

S194 Rietzschel, Thomas. "Prosa wird wieder Dichtung.' Die lyrische Tendenz expressionistischen Erzählens.' *Weimarer Beiträge* 25 (1979), 75–99

S195 Ritchie, James M. 'The Expressionist Revival.' *Seminar* 2 (1966), 37–49

S196 – (ed.). *Carl Sternheim: Scenes from the Heroic Life of the Middle Classes. Five Plays.* London 1970

S197 Rohrmoser, Günther. 'Literatur und Gesellschaft. Zur Theorie des Romans in der modernen Welt.' *Literatur und Geschichte vom 19. ins 20. Jahrhundert* (ed. H.J. Schrimpf). Bonn 1963

S198 Rosenhaupt, Hans Wilhelm. *Der deutsche Dichter um die Jahrhundertwende und seine Abgelöstheit von der Gesellschaft.* Bern, Leipzig 1939

S199 Rothe, Wolfgang. 'Der Mensch vor Gott. Expressionismus und Religion.' *Expressionismus als Literatur. Gesammelte Studien* (ed. Wolfgang Rothe). Bern, Munich 1969, pp. 37–66

S200 – (ed.). *Expressionismus als Literatur. Gesammelte Studien.* Bern, Munich 1969

S201 – *Der Expressionismus. Theologische, soziologische und anthropologische Aspekte einer Literatur.* Frankfurt a.M. 1977

S202 – (ed.). *Der Aktivismus 1915–1920.* Munich 1969 (dtv Dokumente)

S203 Sack, Paula. *Der Verbummelte Student. Gustav Sack-Archivbericht und Werkbiographie.* Munich 1971

S204 Samuel, Richard H. *Expressionism in German Life, Literature and the Theatre (1910–1924).* Cambridge 1939

S205 Scheffer, Bernd. 'Expressionistische Prosa.' *Jahrhunderwende: Vom Naturalismus zum Expressionismus 1880–1918* (ed. Frank Trommler). Reinbek bei Hamburg 1982, pp. 297–312

S206 Scheunemann, Dietrich. *Romankrise. Die Entstehungsgeschichte der modernen Romanpoetik in Deutschland.* Heidelberg 1978

S207 Schiller, J.C.F. *Sämtliche Werke.* Munich 1967. 5 vols.

S208 Schlenstedt, Silvia. 'Problem Avantgarde. Ein Diskussionsvorschlag Bezugsfeld deutscher Expressionismus.' *Künstlerische Avantgarde. Annäherungen an ein unabgeschlossenes Kapitel* (ed. Karheinz Barck, Dieter Schlenstedt, Wolfgang Thierse). Berlin (East) 1979, pp. 39–54

S209 Schmitt, Hans-Jürgen (ed.). *Die Expressionismusdebatte. Materialien zu einer marxistischen Realismuskonzeption.* 2nd edn. Frankfurt a.M. 1976

S210 Schneider, F.J. *Der expressive Mensch und die deutsche Lyrik der Gegenwart.* Stuttgart 1927

S211 Schneider, Karl Ludwig. *Der Bildhafte Ausdruck in den Dichtungen Georg Heyms, Georg Trakls und Ernst Stadlers.* Heidelberg 1954

S212 Schneider, Otto. *Bedeutung und Gedanke der Einheit in der expressionistischen Prosa.* Diss. Rostock 1949

S213 Scholes, R. & R. Kellog (eds). *The Nature of Narrative.* New York 1966

S215 Schumann, Detlev W. 'Conjunctive and Disjunctive Enumeration in Recent German Poetry.' PMLA (1945), 2, 526, n. 25

S216 Schuster, Ingrid (ed.). *Zu Alfred Döblin.* Stuttgart 1980

S217 Sebald, Winfried Georg. *Carl Sternheim. Kritiker und Opfer der Wilhelminischen Ära.* Stuttgart 1969

S218 Sengle, Friedrich. 'Wunschbild Land und Schreckbild Stadt. Zu einem zentralen Thema der neueren deutschen Literatur.' *Studium Generale* 16 (1963), 619–31

S219 Soergel, Albert. *Dichtung und Dichter der Zeit. Eine Schilderung der deutschen Literatur der letzten Jahrzehnte. Neue Folge: Im Banne des Expressionismus.* Leipzig 1926

S220 Sokel, Walter H. *The Writer in Extremis. Expressionism in Twentieth-Century German Literature.* New York, Toronto, London 1964 (orig. edn. 1959)

S221 – 'Die Prosa des Expressionismus.' *Expressionismus als Literatur. Gesammelte Studien* (ed. Wolfgang Rothe). Bern, Munich 1969, pp. 153–70

S222 Staiger, Emil. *Grundbegriffe der Poetik.* Zürich 1964

S223 – 'Vom Pathos.' *Trivium* 2 (1944), 77–92

S224 Stark, Michael. *Für und wider den Expressionismus. Die Entstehung der Intellektuellendebatte in der deutschen Literaturgeschichte.* Stuttgart 1982

S225 Steffen, Hans (ed.). *Der deutsche Expressionismus. Formen und Gestalten.* 2nd edn. Göttingen 1970

S226 Strelka, Joseph. 'Mynona.' *Expressionismus als Literatur. Gesammelte Studien* (ed. Wolfgang Rothe). Bern, Munich 1969, pp. 623–36

S227 Strich, Fritz. *Dichtung und Zivilisation.* Munich 1928

S228 Stuyver, Wilhelmina. *Deutsche expressionistische Dichtung im Lichte der Philosophie der Gegenwart.* Diss. Amsterdam 1939

S229 Thomas, R. Hinton. 'Das Ich und die Welt. Expressionismus und Gesellschaft.' *Expressionismus als Literatur. Gesammelte Studien* (ed. Wolfgang Rothe). Bern, Munich 1969, pp. 19–36

S230 Todorov, Tzvetan. *Poetik der Prosa.* Frankfurt a.M. 1972

S231 Ueding, Gert. *Glanzvolles Elend. Versuch über Kolportage und Kitsch.* Frankfurt a.M. 1973

S232 Utitz, Emil. *Die Überwindung des Expressionismus. Charakterologische Studien zur Kultur der Gegenwart.* Stuttgart 1927

S233 Vajda, Geörgy M. 'Outline of the Philosophical Backgrounds of Expressionism.' *Expressionism as an International Phenomenon. 21 Essay and a Bibliography.* Paris, Budapest 1973

S234 Vietta, Silvio. 'Grosstadtwahrnemung und ihre literarische Darstellung. Expressionistischer Reihungsstil und Collage.' *Dvjs* 48 (1974), 354–73

S235 – 'Erster Weltkrieg und expressionistische Militärgroteske.' *Das Furchtbare und das Lächerliche in der Europäischen Literatur* (ed. H-J. Horn, & H. Laufhütte). Heidelberg 1981

S236 – & Hans-Georg Kemper. *Expressionismus.* Munich 1975 (Uni-Taschenbücher)

S237 Viviani, Annalisa. *Das Drama des Expressionismus. Kommentar zu einer Epoche.* Munich 1970

S238 Wais, Kurt. *Der Vater-Sohn Konflikt in der deutschen Literatur.* Berlin 1931. 2 vols. (= Stoff- und Motivgeschichte der deutschen Literatur, vols. 10 & 11)

S239 Walter, Hans-Albert. 'Alfred Döblin. Wege und Irrwege.' *Frankfurter Hefte* 19 (1964), 866–78

S240 Weisstein, Ulrich. 'Expressionism: Style or Weltanschauung?' *Criticism* 9 (1967), 42–66

S241 – 'German Literary Expressionism. An Anatomy.' *GQ* 54 (1981), nr. 3, 262–83

S242 – *Heinrich Mann. Eine historisch-kritische Einführung in sein dichterisches Werk.* Mit einer Bibliographie der von ihm veröffentlichten Schriften. Tübingen 1962

S243 – 'Heinrich Mann.' *Expressionismus als Literatur. Gesammelte Studien* (ed. Wolfgang Rothe). Bern, Munich 1969, pp. 609–22

S244 Wellershoff, Dieter. *Gottfried Benn. Phänotyp dieser Stunde. Eine Studie über den Problemgehalt seines Werkes.* Cologne 1958

S245 Weltmann, Lutz (ed). *Kasimir Edschmid. Der Weg. Die Welt. Das Werk.* Stuttgart 1955

S246 Wendler, Wolfgang. 'Ernst Weiss.' *Expressionismus als Literatur. Gesammelte Studien* (ed. Wolfgang Rothe). Bern, Munich 1969, pp. 657–68

S247 – *Carl Sternheim. Weltvorstellungen und Kunstprinzipien.* Frankfurt a.M. 1966

S248 Willet, John. *Expressionismus*. Munich 1970 (Kindlers Universitätsbibliothek)

S249 – *The New Sobriety. Art and Politics in the Weimar Period 1917–1933*. London 1978

S250 Williams, Rhys W. *Carl Sternheim. A Critical Study*. Bern 1982

S251 Wirtz, Ursula. *Die Sprachstruktur Gottfried Benns. Ein Vergleich mit Nietzsche*. Göttingen 1971

S252 Wodtke, Friedrich Wilhelm. *Gottfried Benn*. Stuttgart 1962

S253 Wolff, Kurt. *Briefwechsel eines Verlegers 1910–1963*. Frankfurt a.M. 1966

S254 Zalubska, Cecylia. 'Die kleine Prosa im Expressionismus.' *Studia Germanica Posnaniensis* 2 (1973), 21–8

S255 Ziegler, Jürgen. *Form und Subjektivität. Zur Gedichtstruktur im frühen Expressionismus*. Bonn 1972

S256 Ziegler, Klaus. 'Dichtung und Gesellschaft im deutschen Expressionismus.' *Imprematur* 3 (1966/67), 98–114

S257 Ziolkowski, Theodor. *Dimensions in the Modern Novel. German Texts and European Contexts*. Princeton 1969

S258 Zmegac, Victor. 'Alfred Döblins Poetik des Romans.' *Deutsche Romantheorien* (ed. Reinhold Grimm). Frankfurt a.M. 1974, vol. 2

INDEX

SUBJECTS